29.95

THE COMPLETE GUIDE TO DIGITAL PHOTOGRAPHY

WITHDRAWN

THE COMPLETE GUIDE TO DIGITAL PHOTOGRAPHY

Michael Freeman

The Complete Guide to Digital Photography

First North American Edition, 2001

Published by: Silver Pixel Press® A Tiffen® Company 21 Jet View Drive Rochester, NY 14624 www.silverpixelpress.com

ISBN 1-883403-91-X

Text © The Ilex Press Limited 2001 Images © Michael Freeman 2001

All rights reserved. No part of this publication may be reproduced or transmitted in any form or by any means, electronic or mechanical, including photocopy, recording or any other information storage and retrieval system, without prior permission in writing from the publisher.

All registered trademarks are recognized as belonging to their respective owners.

Produced by: The Ilex Press Limited The Barn, College Farm 1 West End, Whittlesford Cambridge CB2 4LX England

Printed and bound in China

CONTENTS

...

	INTRODUCTION	6	SECTIC	ON 3 TECHNIQUES	126
SECTIC	ON 1 HARDWARE	10		Chapter 11 PEOPLE	128
	Chapter 1 DIGITAL CAMERAS	12	145	Chapter 12 LANDSCAPES	144
	Chapter 2 COMPUTERS	36	- and	Chapter 13 THE URBAN LANDSCAPE	164
	Chapter 3 MONITORS AND INPUT	46		Chapter 14	
	Chapter 4 SCANNERS	52		NATURE Chapter 15	176
	Chapter 5 STORAGE	60		OBJECTS Chapter 16	186
	Chapter 6 PRINTERS	68		ACTION	198
23	Chapter 7 WAYS OF DISPLAY	78	SECTIO	ON 4 NEXT STEPS Chapter 17	204
	WATS OF DISPLAT	70		PICTURES FROM THE IMAGINATION	N 206
SECTIC	ON 2 WORKING DIGITALLY Chapter 8	86		GLOSSARY	216
	IMAGING SOFTWARE	88		BIBLIOGRAPHY AND USEFUL ADDRESSES	222
1 TO 1	Chapter 9 IMAGE-EDITING TOOLS	94			223
	Chapter 10 FILTERS	118		ACKNOWLEDGMENTS	224

INTRODUCTION

Photography, which has been synonymous for 175 years with a light-sensitive emulsion developed in chemicals, is now crashing headlong into the digital world. Of course this is guaranteed by a commercial inevitability, and all the camera

and film manufacturers have recognized the eventual digital changeover, even though it is costing them dearly to implement it. Film will probably never disappear completely, but its role will give it a specialized, and therefore limited, place in photography's future.

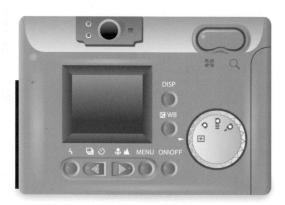

Like desktop computers, with which digital

Back view of typical entry-level digital camera.

cameras suddenly have a promiscuous relationship, and mobile telephones, digital cameras are a disruptive technology. That is to say, they evolved not because the industry thought they would be a good idea, but because the technology made them possible and,

Front of typical entry-level digital camera.

more important, their advantages caught on among users. The manufacturers have been compelled to invest and produce in order to survive. The new technology is disrupting them, and the beneficiaries are the consumers who like the idea of the move to digital—you and I, in other words.

And the advantages of recording images digitally? Many, and they all stem from the simple fact that the images are captured in a processable way—as a string of numbers, if you like. In the course

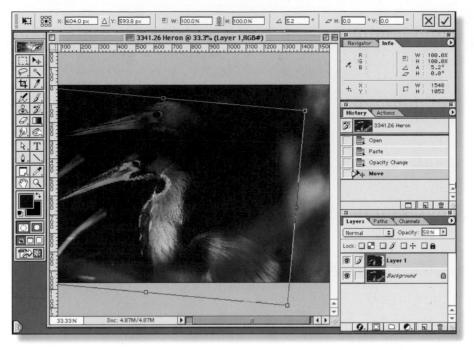

Shot of the kind of window encountered when working with an image-editing program.

7

of processing the image from capture to print (or whatever final form you want), correction and manipulation are easily performed. What is more, none of the changes that you make need incur any loss of image quality. The corollary of this is that digital images don't fade, and copies are identical—in contrast to film-based photography, where each generation of an image away from the original negative or transparency is degraded. If you have a desktop computer and printer, or even a printer alone if it is one of the latest designs, you can perform all the steps yourself at home. No darkroom is needed, and no more trips to the lab.

And while on the one hand this streamlines photography for those who simply want a fast, troublefree means of making pictures, it also offers more control than was ever possible to the enthusiast and perfectionist. Enter the electronic darkroom, neither dark nor messy but a clean desktop with computer, monitor, and a few peripherals. With this hardware you can make the kind of adjustments and fine-tuning that would conventionally be done

The creative use of image manipulation might not help you realize your dreams of riches, but might help you capture them. in a darkroom with an enlarger by a specialist printer: cropping, shading, printing-in, altering contrast, brightness, tone, color balance. In addition, you can now undertake procedures that would be painstaking or even impossible by conventional means, such as sharpening and certain kinds of color adjustment.

The miniaturization of computing within digital cameras means that they are able to perform more and more processing as the technology continues to develop. The practical benefit for us is instant feedback. The camera's LCD display screen shows you the image before you shoot, and then immediately after you have shot; if you don't like what you see, you can delete it and shoot again. Or continue shooting and edit a little later. Depending on the level of the camera, the screen can also display technical information. Beyond all this, the media that digital cameras use—built-in memory and removable memory cards—are reusable, which makes up financially for the higher initial cost of the camera.

Digital procedures are changing photography in more subtle ways, too. The very act of capturing an image from the real world more or less instantly, and then fixing it in an emulsion, gave photography a reputation for unflinching honesty. The camera recorded exactly what the photographer saw at that moment and in that place. Any changes required deliberate intervention, even in the area of expert printing. Digital photography throws much of this out of the window, as correction and manipulation fit almost seamlessly into the process. One of the greatest landscape photographers, Ansel Adams, famously wrote that "the negative is the score; the print is the performance." Digital manipulation provides you not only with a choice of orchestras to perform as you wish, but the chance to rewrite the score.

Digitizing images enables the photographer to enter the territory traditionally occupied by illustrators. Even programs used to generate images rather than to manipulate them, such as Corel Bryce, can be pressed into the photographer's service.

The state

PRINTERS

WAYS OF DISPLAY

SECTION 1 HARDWARE

n the beginning is the pixel, the smallest unit of brightness and color in an image. The word is a contraction of "picture element," and although we may not have thought about them much until recently, they have been around in one form or another for some time. Halftone printing, as used in this book and in almost every other print publication, uses dots of a few pure colors packed closely together to mimic the effect of a smoothly gradated picture. The 19th-century French Impressionist painter Georges Seurat, among others, built up pictures by painstakingly applying small dots of paint to the canvas. The effect is the same: Stand back far enough and the eye fails to resolve the dots, instead processing the information into a recognizable image.

Even silver halide grains on film work to produce a photographic image in a similar way. On exposure, an invisible speck of metallic silver is formed within each tiny crystal, which with later development turns opaque black. In a digital camera, a similarly small sensor measures the light as an electrical charge; when converted into a tone or color it becomes a pixel. Seen in this context, digital photography is less a sea-change than a natural development, using electricity rather than chemicals, inks, or oil paint.

The overwhelming difference is that the signal that senses the light can be processed mathematically, in any number of ways. The silver halide grain, once developed, sits embedded in its emulsion, but the information that defines a pixel can be transmitted, changed, compared with other pixels, and used to manipulate the entire image. This is the promise of digital photography, and it extends from the moment you shoot, through processing the images on a computer, to the final output, which might be a print, film, publishing, or on-screen. If the last, the opportunities extend as far as the World Wide Web, which is very far indeed. And if you have not yet bought a digital camera, the technology for digitizing conventional slides and negatives —scanners of one kind or another—is better and more affordable than ever.

Resolution continues to be the premium quality in digital cameras. The more the better, and the more costly. This is what distinguishes the categories of camera. Before anything else, each model is characterized (and advertised) by how many pixels its CCD array can capture, measured in megapixels (one million pixels). However, the absolute resolution figures have changed massively over a short time. Take as an example the evolution of Nikon"s Coolpix cameras. In 1998 the top models in this series, the 900s, had a resolution of 1280 x 960 pixels—1.2 megapixels. A year later Nikon launched the 950 with a resolution of 1600 x 1200—1.9 megapixels. In 2000 came the 990 with a resolution of 2048 x 1536—3.1 megapixels.

While there are certain thresholds of performance, sensor resolutions continue to improve all round, and for this reason it makes little sense to group cameras by their absolute megapixel performance. Instead, we have three basic categories: entry-level, mid-range, and SLRs. To make comparisons easier, I've included a table for each of these, showing the key specifications, in the relevant pages.

The technology is, and will remain for many years, in development. Computers and computer software have a head start on digital cameras, but all are improving and changing (not necessarily the same thing), and to enter this world of digital hardware you will have to accept rapid obsolescence and products that go down blind alleys. For a while at least, whatever equipment you buy this year will look inferior to the latest models next year. On the other hand, as of the year 2001, the technology is already good enough for most photographers.

REPLACING FILM

hatever the photographic manufacturers may say, and there are still some fairly silly statements being made by companies trying to protect their traditional markets, the entire thrust of digital camera technology is to replace film. It may

take some time, but apart from a few specialized areas, it is certainly happening. Prediction in the field of technology is always risky, but most of the important thresholds in the acceptance of

Most of the important thresholds in the acceptance of digital photography have already been crossed

digital photography have already been crossed. The heart of a digital camera is its sensor, usually a CCD

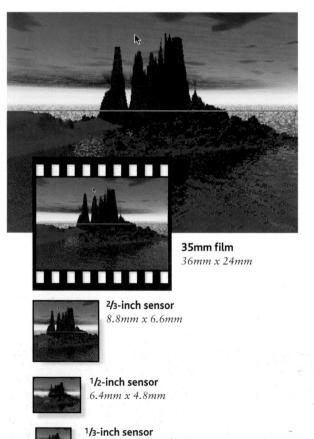

4.8mm x 3.6mm

(charge-coupled device). This silicon chip carries an array of elements called SPDs, or silicon photo diodes, each of which accumulates a charge according to the quantity of light that falls on it. Such lightmeasuring elements are not new – they have, in fact, been used for years in the through-the-lens metering

> systems of cameras. Taking them to the next step of actually recording an image has involved organizing numbers of them in such a way that they can be read in sequence.

Enter the CCD, invented in

1969 at Bell Laboratories. This is an array of SPDs in rows. After the entire chip has been exposed to an image focused on it by a lens, the electrical charges are read, one row at a time, and digitized. When one row, at the end of the array, has been processed, its information is deleted and the contents of the other rows shunted along so that the next one can be read.

In this way, the data from each row is linked, or coupled, to the next one, hence the name "charge-coupled device." The data for the image is transferred to a removable memory card in the camera and the CCD is reset, ready for a new shot.

Like silver-halide film, the receptors on a CCD measure only monochrome light. However, almost any color can be created by combining just three basic ones, known as the additive primaries: red, green, and blue. Color film has three layers of emulsion, each sensitive to one of these, and the result is a full-color image, using what is called the RGB model. The digital solution is similar: Some receptors must be filtered for red, others for green, and others for blue. Here, however, we run into a manufacturing problem, for while the color layers in film are stacked on top of each other, the pixel receptors on a CCD have to be laid out side by side.

At this stage in digital camera technology, pixels are at a premium—the struggle continues to cram more on a chip—and to devote a third of them to each color means potentially cutting the resolution to a third. In the studio, digital cameras designed for still-life

Chip sizes

CCDs and the newer CMOS chips are considerably smaller than a frame of 35mm film, for long the standard medium for most photography. This has an important effect on image magnification and the angle of view, as explained on pages 16–17.

THE MECHANICS OF THE CCD

The individual sensors on the array are in rows, and their charges are read out a line at a time. The first row is read to a register, then to an amplifier, and finally converted to digital form. The charges are then deleted and the next row read. The last charge on each row is "coupled" to the first on the next row, hence the name of this kind of sensor.

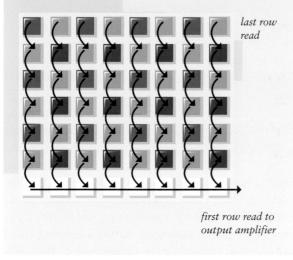

photography overcome the problem by using the entire CCD three times in succession, each through a different filter. Three-pass or three-shot cameras like this lose no resolution, but of course work only with subjects that stay still.

For normal photography, the answer is a compromise. The receptors on the CCD are individually filtered red, blue, and green in groups, but then the missing information is supplied, or "interpolated," from the nearby pixels. Interpolation, as we'll see, is the secret weapon for overcoming all sorts of difficulties, resolution chief among them. It is, unfortunately, processed data—the best guess—and not data from the real world. Nevertheless, it is a visually effective solution, and ultimately the measure of image quality in a photograph is how it looks. An advanced alternative, making its first appearance in the Hasselblad DFinity, is to arrange three chips, one for each color, around a prism that distributes the light equally. This gives the best of both worlds, but suffers from being on the bulky side.

A new competitor to the CCD is the CMOS (complementary metal-oxide semiconductor), which works on the same principle, but is manufactured by the process that is used for making most computer memory chips. It is actually a conventional memory chip with a light sensor in each cell, and so is less expensive to make and has the potential to process the information right there, on site. Indeed, the Foveon imager that uses the prism just mentioned employs CMOS chips.

The big issue remains resolution: How much detail a sensor can capture, and so ultimately how large a photograph can be reproduced. This comes down to a question of pixels—the more the better, without a doubt. Several complex technical issues are involved, but at the time of writing, the better handheld digital cameras have at least 3 million pixels. For the record, the human eye has the equivalent of 120 million pixels, a fine-grained 35mm slide like Fuji Velvia has a little over 20 million, and a full-page picture in this book needs a little over 9 million. Recent advances in CMOS technology include the ability to capture 16 megapixel images, which takes digital photographs to the same resolution as film.

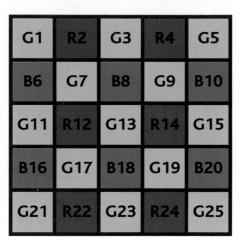

Color interpolation

The sensor array is covered with a Color Filter Array (CFA)—a mosaic of red, green, and blue, one color covering one sensor. This means that for a full-color image the colors must be interpolated for each pixel from the information in the surrounding pixels. This depends on the CFA pattern; one of the most popular configurations, shown here, is the Bayer pattern (covering 25 pixels).

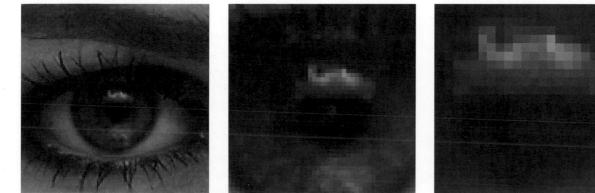

Pixel resolution

Magnifying a digital image reveals, at some point, the individual pixels. Each square is the tone and color information captured by one individual sensor on the CCD or CMOS array. The higher the resolution of the image, the more it can be magnified without the effect visible here, called pixellation, being noticed.

THE LANGUAGE OF DIGITAL IMAGING

aking photographs electronically calls for different ways of measuring and describing them—precise and, of course, digital, which is to say in consistent steps. At this stage in the technology, digital cameras are still pitching themselves against film, and the all-important issue is image quality. For any photograph, silver-halide or digital,

The issue with digital cameras is an all-important difference between optical resolution and interpolated resolution this depends on four things: how much detail it contains; the range of brightness it can record; how true its colors are; and its level of imperfections. Digitally, these are known as resolution, dynamic range, bit depth, and noise.

Resolution is the measure of detail, and depends on the number of pixels for a given area of the image. The most common way of expressing this is per inch, as in 300 ppi (pixels-per-inch). Unnecessarily, there are two other terms in use, lines-per-inch (lpi) and dots-perinch (dpi), which originated in the printing industry to measure half-tone screens. From our point of view they are completely interchangeable, and for the most part I use ppi. The metric figures are commonly prefixed by "Res" (for resolution)—hence 12 pixels per mm, approximately the same as 300 dpi, is called "Res 12." Naturally, the resolving power of the lens determines the detail focused on the CCD.

The big issue with digital cameras, because many manufacturers would like to cheat a little, is an allimportant difference between optical resolution and interpolated resolution. Optical resolution is the real thing, a measure of the actual information focused by a lens onto the CCD. Interpolation is a technique of digital manipulation, in which a program fills in the gaps between pixels to create more information—and so delivers what looks like higher resolution. The result

Resolution

A detail of the same image at 300 ppi (right) and at 1200 ppi (far right). Pixelation has occurred at the lower resolution, meaning that the image has been enlarged beyond its resolution.

Dynamic range

A digital camera or scanner with a limited dynamic range will lose highlights and shadows, particularly in a contrasty scene, as at far left. A wide dynamic range (left) reveals the sun and details in the darker areas.

DIGITAL CAMERAS

is good to the eye, but the magnification is false. When you find a manufacturer trying to pass interpolated resolution off as optical, it is being dishonest and you can trust the rest of the specifications accordingly.

Dynamic range governs the breadth of information from highlights to shadows. Looking at a digital image from a scanner with a small dynamic range is like seeing a print on too hard a grade of photographic paper. Dynamic range is measured on a scale from 0 (pure white) to 4.0 (pure black), but no film or CCD can (yet) capture the full range. The brightest level at which a CCD, or film, can detect detail is known as DMin,

and the darkest DMax. The difference between the two is its dynamic range—if it can record from 0.3 to 3.5, this would be 3.2D.

Bit depth, also called color depth, is the measure of how many different colors a single pixel can display, and being digital, it is a number of discrete steps. For photo-quality images, there must be sufficient steps to fool the eye into seeing a continuous tone. In practice, 256 works fairly well and is, in any case, the maximum supported by most software. Following the usual mathematical notation for large numbers, bit depth is expressed as 2 raised to whatever power. So, 256 steps are 2⁸—that is, 8-bit. Higher is even better, capturing finer nuances. and some cameras and scanners work at 10-bit and 12-bit. Even though the image eventually has to be converted down to 8-bit, it will have benefited. An RGB image with its thrcc channels each in 8bit is often, confusingly, called 24-bit color.

Noise is unwanted information (or "artifacts") that belongs to the process rather than the image, like the hiss and crackle in a poor sound broadcast. Much of this can be removed in the camera by digital signal processing (DSP), but there may be some work to do when you clean up an image in an editing program.

Bit depth

The more bits available per channel for recording color and tone, the more realistic the image (left). At lower bit depths, as here (left), intermediate tones must make do with the nearest equivalent, sometimes giving a patchy appearance. From top to bottom, the bit depths are 5 (32 colors), 6 (64 colors), and 8 (256 colors).

Noise

Some digital procedures, such as JPEG compression, introduce pixel tones and colors that were not present in the original. Known as noise (technically, artifacts), they can be seen here (right), as scattered pixels in the white area of the upper JPEG enlargement. The lower image is uncompressed TIFF.

BITS and BYTES

A contraction of binary digit, a bit is the basic unit of computing, and has two states, on or off —in imaging, black or white. A byte is a group of eight bits, and as each of these has two states, one byte has a possible 2⁸ combinations—that is, 256.

DIGITAL CAMERAS

LENSES AND FOCUS

ne of the key specifications of a lens is its focal length, because this determines the character of the image it delivers. Focal length, measured in millimeters, is the distance from the point in the lens where the light rays that have entered begin to diverge, and the focal plane —where the film or CCD is positioned. The greater

Digital cameras need higher resolution lenses because of the small size of the individual sensor elements the focal length, the more magnified the image will be—magnified, that is, beyond the view that approximates that of the unaided human eye. In principle, the focal length that gives a "normal" unmagnified view equals the diagonal measurement of the image,

and for a 35mm camera that is 50mm. (Well, yes, the diagonal measurement is actually 43mm, but traditionally it has been rounded up to 50mm.)

For more than half a century, most photographic film was 35mm, with a standard frame size of 24mm x 36mm. Cameras were, indeed, built around film,

which imposed certain mechanical constraints (the Leica was designed to make use of 35mm motion picture stock). So, the image area was standardized, and that meant that any given focal length of lens had the same angle of view. 50mm was considered normal, 28mm was distinctly wide-angle, and so on.

All that has changed, for the simple reason that CCDs come in different shapes and sizes, mainly on the small side. With hindsight, it would have been more useful if we had classified lenses by their angle of view. In a broad sense we did, with the categories of wide-angle, normal, and telephoto, but the standard practice of using focal length as an expression of coverage has simply made a muddle out of the lenses for digital cameras. This calls for a rethink, and specifically it means knowing the sensor's dimensions. In this, the number of pixels and the resolution do not matter, but the diagonal measurement does. By way of example, with a fairly common $\frac{1}{2}$ inch CCD, a zoom lens with a range from 8.2 to 25.8mm is the equivalent of

Wide angle

Above all, wide-angle lenses take in more of a scene. This overhead view of a maze at Woburn Abbey, in England, needed a wide-angle lens to include everything from the modest height of about 33 feet (10 meters). The angle of coverage varies according to the focal length, from around 60° (moderate) to around 100° (extreme). Here, the result is the equivalent of using a 20mm lens on a 35mm camera.

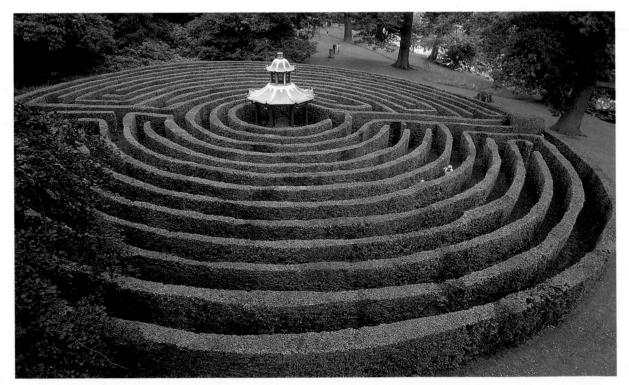

34–107mm on 35mm. So while the 35mm format is still the reference standard for focal lengths, don't expect this to continue for ever.

Another related issue is the image shape, which for decades was a fixed 3:2, but now is not necessarily so. A ratio of 4:3 is common.

Digital cameras need higher resolution lenses because of the small size of the individual sensor elements. The appearance of sharpness depends on both the optics of the lens and on the resolving power of the eye, and the traditional measure of this is the circle of confusion. If you focus a lens on a single point, any points in front of or behind this will become, in the image, a small out-of-focus disk. However, at normal viewing distances for prints, the eye is satisfied with the sharpness of this circle of confusion if it is no larger than about 0.05mm, and this has been the standard for most lenses for a long time. The miniaturization of sensor arrays, however, has rather overturned this. Take a chip with 2000 pixels across the longer side, which measures, say, 20mm. Each sensor takes up just 0.01mm, and to take full advantage of the CCD, the circle of confusion of the lens ought to be no larger than this. As a result, midrange and higher digital cameras now have specially designed highresolution lenses.

FIXED LENS, ZOOM LENS

Entry-level compacts tend to have fixed lenses to keep the price-point low, but the majority of digital cameras feature a zoom lens. The ranges of these differ considerably, and are an important factor to consider in choosing your model. For fixed-lens cameras, some supplementary lenses are available to convert them to wide-angle or telephoto, although this is a fairly clumsy solution. Although not a few photographers prefer to keep things simple and work with just one focal length, a zoom broadens the spread of subjects that you can tackle.

original

1.5x

Normal

A view through a doorway much as you would see it with the unaided eye—an angle of coverage of about 50° and the equivalent of 50mm on a 35mm camera.

Telephoto

This telephoto of canal locks in southwestern England is the equivalent of a 600mm lens on a 35mm camera, and a magnification of 12x beyond "normal."

EXPOSURE

the essentials of making the exposure are the same for digital cameras as those using film. The same two controls interact to deliver light from the lens: the shutter and the lens aperture. The same metering systems are used to measure the brightness of a scene, and then pass this information on to the processor. This in turn instructs the shut-

The essentials of making the exposure are the same for digital cameras as those using film ter and aperture. In fact, electronic metering, long-established in photography, was the first step that cameras took toward becoming digital.

The principles are simple. Slower shutter speeds allow more light to reach the sensor, as do wider aper-

tures, which means that there are different combinations that will deliver the same exposure. The right combination depends on how bright the subject is (the lower the light level, the more restricted the choice),

APERTURE AND *f*-STOPS

The notation for lens apertures is the f-stop, on a scale that goes f1, f1.4, f2, f2.8, f3.5, f4, f5.6, f8, f11, f16, f22, f32, f45, f64 (most lenses operate somewhere in the middle of this range). The reason for the apparent complexity of the numbers is that they are each the ratio of the actual aperture diameter to the focal length of the lens; each refers to the same amount of light passing through, whatever the lens. A higher f-number denotes half the light being passed.

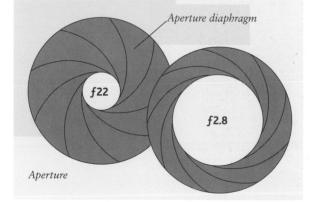

Shallow depth of field

A row of mailboxes makes a good test subject for the depth of field of a normal lens (equivalent of 50mm on a 35mm camera). Wide open at f3.5, the acceptably sharp part of the image extends only a little on either side of the focused point.

Average depth

With the lens stopped down midway to f8, the depth of field is increased to a range from 6ft (1.8m) to 9ft (2.7m).

Extended depth

At minimum aperture, f22, the depth of field is at its maximum for this lens from 4 ft 6 in. (1.4m) to 16ft (4.9m)—taking in most of the view. and on whether or not you need the other effects of the shutter and aperture—namely freezing or blurring motion, and depth of field.

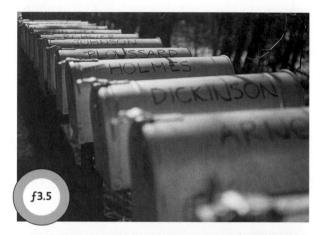

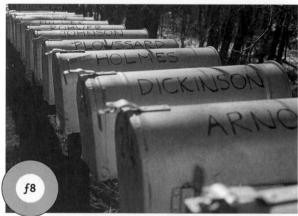

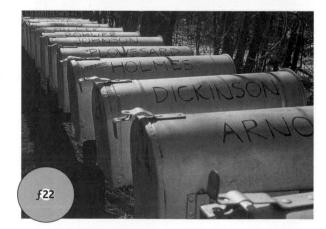

Conventionally, the steps in the range of both shutter speeds and apertures are arranged so that the exposure is doubled or halved. Thus, one step slower than 1/125 sec is 1/60 sec, which doubles the amount of light passed through to the sensor. Equally, one *f*-stop larger than *f*8 is *f*5.6, and it too doubles the amount of light that passes through. On manual cameras one click stop longer on the shutter speed together with one click stop smaller on the aperture gives exactly the same exposure —known as reciprocity. In a digital camera both are controlled electronically, but the principle is the same.

ISO AND SENSITIVITY

Unlike film, digital sensors do not have a fixed "speed," and you can increase their sensitivity to cope with low light levels. Like film, however, increasing the sensitivity reduces image quality. The characteristics of high-speed film are extra graininess and a lower maximum density (weaker shadows); those of increasing sensitivity are noise (similar to grain) and color shifts. For everyone's convenience, sensor sensitivity is given the same ISO rating as film.

In these examples from the Compass camera shown right, the differences are apparent only at magnification, here 400%. Note the color artifacts at ISO 1600.

ISO 200

ISO 800

ISO 400

ISO 1600

With two controls to play with, choosing the best combination usually hinges on movement and depth of field. If the subject is moving, you would normally want to freeze the movement sharply, and that sets a lower limit to the shutter speed. We deal with action specifically on pages 176–7, but suffice to say that 1/125 sec will work in most situations. Set a shutter speed much slower than this and you are likely to see blur in the image, and even camera shake from not being able to hold the camera sufficiently steady.

Depth of field, which is directly related to the aperture size, refers to how much of the image, from foreground to background, looks sharply focused. A wide aperture gives shallow depth, a small aperture increases it. The amount is up to you, and while there are scenes that naturally call for front-to-back sharpness (and so a small aperture), there are many other occasions when you would want to direct attention to just one part of the image, leaving the background, for example, blurred. Depth of field also depends on the focal length of the lens: A short focal length, as in a wide-angle lens, gives more depth of field than does a longer, telephoto lens. Because most digital cameras use lenses with shorter focal lengths than their 35mm equivalents (see pages 16-17), good depth of field is one of their characteristics-whether you want it or not.

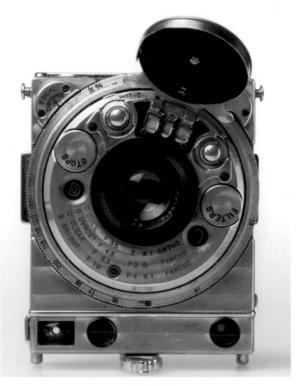

SHUTTER LAG

Compared with conventional cameras, many digital cameras are not so quick off the mark in operation, and there can be a noticeable delay between your pressing the shutter release and image capture. This is because of the various calculations that the processor has to make, including focus, shutter speed, aperture, and choosing the white balance (see pages 26-7). If you are used to the immediate response of a mechanical camera, you may want to test the shutter lag on a digital model before buying.

Compass camera

The details shown left of the camera are taken from the lower left quadrant.

METERING

etermining the optimum exposure for any particular image is mainly a matter of calculation, but it also involves the photographer's personal preference. Through-the-

lens (TTL) metering will now do a good job of analyzing the brightness and contrast of a scene in almost all situations. On the few occasions when it fails, it is There are three basic and widely used metering methods, although not all are used in entry-level cameras: center-weighted, spot, and matrix.

You can compensate for occasionally tricky lighting situations

because there is no way of predicting exactly what the subject is and the intentions of the photographer. Center-weighted metering pays more attention to the center of the frame, on the reasonable grounds that this is where most people will place the main subject. Spot metering measures

just a small central area (marked on

the screen) very precisely, and has more specialized uses. It is particularly good where there is one all-

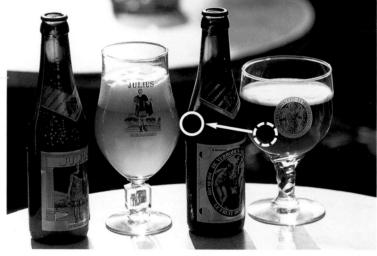

Center-weighted metering

Scenes of average brightness, distributed more or less evenly across the frame (above left), suit this standard metering method.

Spot metering

Only the small central circle is measured—useful for pegging the exposure to one key tone, in this case the beer. which is off-center (above).

Matrix metering

This multipatterned system (left) here holds the white highlights below over-exposure.

important tone in the picture that must be correctly exposed. Since this is not necessarily in the center of the frame, it is normal to measure first, use the camera's exposure lock, then recompose.

Matrix metering, also known as multipattern, divides the picture area into a number of segments. These are measured individually, and the processor then applies proprietary algorithms to decide the priorities of the picture. This is partly a matter of comparing the information obtained with the manufacturer's experience of the way in which most people take pictures. As a

DIGITAL CAMERAS

simple example, a bright band at the top of the frame is likely to be the sky, and is given a low priority.

If your camera allows you to choose between these methods, you can compensate for occasionally tricky lighting situations. Most of the time, matrix metering works well, but the more unusual the lighting, the less predictable the results. A shaft of light in a darkened room falling on an object, for example, would be a challenge to any metering calculation. Matrix metering might make a passable result out of it—but then again, maybe not. This might be an occasion to switch to center-weighted, or even spot, metering. Interestingly, however, these decisions were more critical with film. A digital camera will show immediately how successful the metering is, and you can then adjust the exposure as necessary.

When to choose one metering method over another also depends on your preferred way of shooting, and on how much time you have. If you need total control, and there is no urgency, spot metering is the way to go. One way of using it is to decide which part of the subject represents the midtones, measure this, and shoot. Another way is to set the exposure controls to manual mode, choose the most important part of the scene, measure that, and adjust the aperture or speed accordingly. For example, in a portrait, you might select the skin on the cheek as the key tone, but if it is pale you want it one *f*-stop lighter than average. The spot reading gives 1/125 sec at f8, so you set the camera to 1/125 sec at f5.6. Yet another way of using the spot meter is to take several readings, from highlight to shadow, and calculate the optimum from this.

Flash enters the equation not simply by replacing the available light, but by being able to add a little and fill in shadows. Dedicated flash-either built into the camera or made specially for it by the camera manufacturer—can be controlled by the camera's processor. These on-camera flash units adjust their output according to the distance to the subject, using either the camera's autofocus information or an infrared pulse. An operation whose results were traditionally difficult to predict, fill-in flash is now painless with a digital camera-you can check the effect immediately. There is also a specialized flash function, rear-curtain sync, in which the flash is triggered at the end of a long exposure rather than at the beginning. This has the effect of combining the motion blur from the available light with a sharply frozen flash image.

Rear-curtain flash

In a nighttime street scene such as this Easter parade in Lima, Peru, flash is essential, yet the scene contains important ambient lighting —the candles. The solution is to capture both with a slow exposure, but by choosing the rear-curtain option, the flash exposure is at the end, not at the start, and so satisfactorily "closes" the blurred movement.

Fill flash

Gone are the days of flash or nothing. With TTL metering it is simple and more realistic to use flash to add to a scene rather than to overwhelm natural lighting, as in this into-the-light shot of "legging" through one of England's oldest canal tunnels (below).

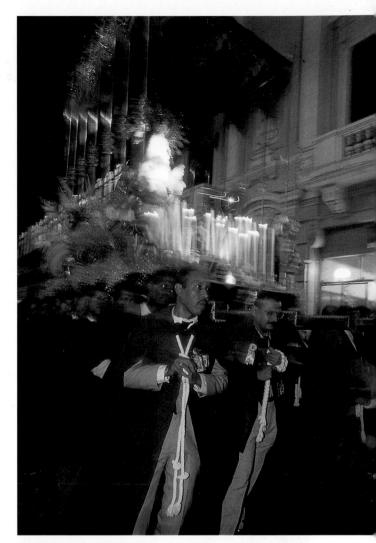

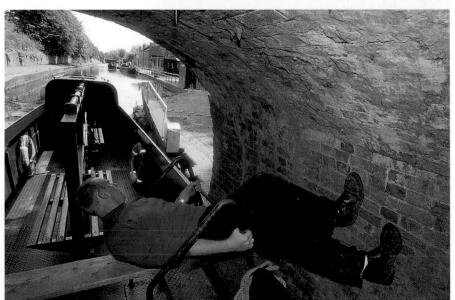

FILE FORMATS AND MEMORY CARDS

n many ways, the most critical part of the digital operation is how the images are saved. Captured one at a time onto the same sensor chip, each must be downloaded elsewhere and purged from the sensor before it is ready for a new shot, as we saw on pages 12–13. Images are saved in a particular "file format," of which there are several, developed by differ-

In many ways, the most critical part of the digital operation is how the images are saved ent organizations over the years. Digital cameras, which are relative newcomers to the digital world, make use of these standard formats, or at least some of them.

Storage space is at a premium inside a camera (because of its size). In order to allow more pictures to be saved, the most common format is one which compresses the information—JPEG. Named from the initials of the International Standards Organization's Joint Photographic Experts Group and pronounced "jay-peg," this is computing's longestestablished system, and has been universally adopted by digital photography as the space-saving way to store images. It can compress files by more than 90 percent to give ratios between 10:1 and 40:1. The camera's software often allows you to choose the amount of compression—higher quality means less damage but also larger files.

JPEG works very well for photographic images, which tend not to have hard smooth edges, and less well for type and line artwork, which do. It is what is called a "lossy" compression method, meaning that some data is thrown away. Because of this, the image is bound to be slightly degraded, but the key is to choose a setting that makes no visible difference. The acid test is a personal one—it works as long as it looks right to

Microdrive

A microdrive is a tiny, high-density hard drive, whose width is less than the diameter of a golf ball. It can be used instead of a CompactFlash or Smartmedia.

Actual size

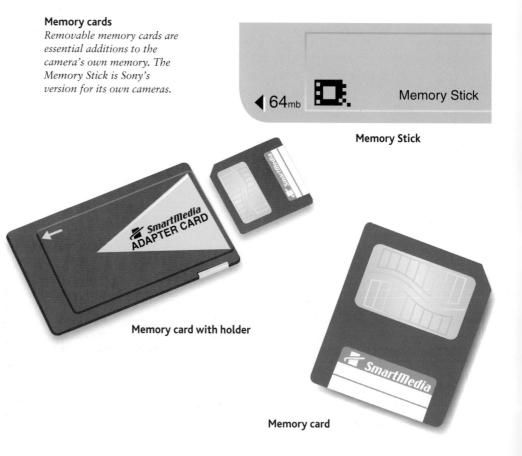

the eye. As you can see from the comparisons here, there is actually very little loss, and what loss there is is mainly in color artifacts at pixel level. Importantly, JPEG can work in 24-bit color—that is, 16.7 million colors, as explained on pages 14–15.

Technically, JPEG uses a system known as Discrete Cosine Transformation to compress, and works on blocks of eight pixels at a time. A new, greatly improved version, JPEG 2000, is being phased in, and this uses wavelet compression to give fewer artifacts (thus better image quality) and about 20 percent better compression. Normally, cameras allow you to choose three levels of compression for each image you shoot. These go under different names, such as Standard, High, and Super-High, but are all equivalent to highest compression/more degradation, medium compression/medium degradation, lowest compression/least degradation. At the start, make your own tests by shooting a range of different subjects at each level of compression, and decide which is the most acceptable for your needs.

Midrange cameras tend to offer, in addition, an uncompressed format, usually TIFF (*see page 19*). Photographs saved in TIFF take up more space than JPEGs, but lose nothing, and it is a universally readable format. A few cameras also offer a RAW format; that is, unprocessed data that is completely faithful to the original capture. The advantage is image quality in less space than TIFF (usually around 60 percent smaller), but it needs the camera manufacturer's own software to be able to read it.

In whichever format, the images are stored in memory, and as this inevitably fills up, digital cameras make use of removable memory cards. The two most widely used are CompactFlash (Types I and II, the latter being slightly thicker) and SmartMedia; most cameras accept one or the other. They are available in different capacities, measured in megabytes (MB). Even higher storage capacity is possible with a Microdrive, which is essentially a miniature hard drive that fits into a CompactFlash Type II slot. Out on its own as a manufacturer is Sony, which has its proprietary media, called Memory Stick, usable across the range of its products.

Once removed from the camera, memory cards can be read by the computer by means of an adaptor that fits into the memory card slot. Many desktop printers now have card-reading slots, which enable you to bypass the computer and print directly.

Uncompressed TIFF

For those cameras that include an uncompressed format, RGB TIFF is standard. The test image is a close-up (400%) of the Compass camera on page 19, showing an area that includes two challenges for compression: fairly hard edges that include diagonals, and a neutral metallic surface. The camera is a Nikon, but its compression offerings are similar to other makes.

JPEG Fine

Lowest JPEG compression and the largest of the three JPEG files shown, but still much smaller than the uncompressed TIFF above. The first impression is how little is lost and how good JPEG is. Close inspection reveals that diagonal straight lines are not perfectly maintained, as in the leg and center of the letter R. Very few artifacts have crept into the gray background.

JPEG Normal

At the medium compression setting, inaccuracies are exaggerated a little more than in JPEG Fine (note the leaking of red from the bottom of the second letter L in DULL), but overall the image is still holding up well.

JPEG Basic

Still a remarkable achievement of compression, although comparison directly with the top uncompressed image shows artifacts. See how the almost imperceptible color difference in the middle of the letter D has been turned into a cyan patch—a feature of false enhancement.

THE DISPLAY SCREEN

ne of the most compelling reasons for using a digital camera is that it adds photographic capabilities. Taking an image directly into the heart of the camera's central processing unit—its small on-board computer allows it to be displayed immediately via an LCD screen, and this is the most immediately obvious

The LCD display allows you to take a considered view of the image and to make adjustments to viewpoint or focal length

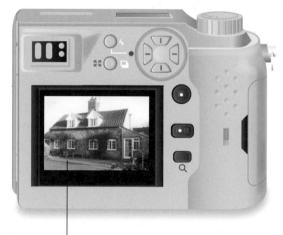

LCD (Liquid Crystal Display)

distinguishing feature of any digital camera. Inconceivable in the days of film, the screen is purely the product of the digital process.

Depending on the make of camera, the screen may be the only view offered, or there may also be a more

LCD display

The LCD is the feature of a digital camera that most obviously distinguishes it from a traditional camera at first glance. The LCD enables you to see what you are photographing and to make adjustments before shooting. traditional optical viewfinder. In either case, the screen offers the possibility to change the way you shoot. At some point in making a photograph, we all have to make a perceptual leap to translate the scene in front of the camera into a framed, two-dimensional image. The photographer's ability to do this has a great deal to do with the success of a photograph, and not everyone finds it easy. Even when it comes completely naturally, the final proof is always the flat image, and even seasoned photographers can have surprises, pleasant or otherwise, when faced with printed results.

The LCD screen steps into this process as an immediate means of proofing—and composing. Although small, it gives you the basic form of the image, in the same way as a frame-by-frame contact sheet. In particular, it allows you to take a considered view of the image and to make adjustments to viewpoint or focal length, and this applies whether you are about to shoot or you are reviewing an image that you have just taken. The one identifiable drawback of the screen is that by offering all these possibilities it can slow down the photography, which is not likely to matter with subjects

price range, come with goodquality LCD screens. The only drawback is that the screen can be difficult to see and use in very bright sunlight. such as landscapes, but which can lose you some opportunities with others, such as people and action.

One type of subject in which it really comes into its own is macro shooting. At magnifications greater than about half-size (1:2), the scale is quite different from normal experience, but the LCD screen translates it perfectly. In another way, with some models, such as Nikon's Coolpix 990, the swivel mount between the lens unit and the viewer makes it possible to hold and use the camera in different positions, such as overhead. In all, working from a screen extends camera handling.

With the images and all their information stored on the memory card, the camera also functions as a playback viewer, so that at any time you can go over what you have shot. This provides the photographer with the unique ability to edit a photo take instantly, which in turn makes for economy and efficiency in shooting. Mistakes can be deleted. This is more than just a mechanical convenience, because, like the display screen, it has the potential to change the way you shoot, in the knowledge that you can edit at any point in the day. There's a caveat here-deleting is actually too easy with a digital camera. Photography on film allows you to rediscover images that you may not have regarded too highly at the time, and to change your mind. You would have to be very confident indeed to make a severe edit of a day's shooting on the spot.

Swivel-mount screen

One feature sometimes adopted by more expensive cameras is a swivel-mount screen. This enables the user to hold the camera at unusual angles.

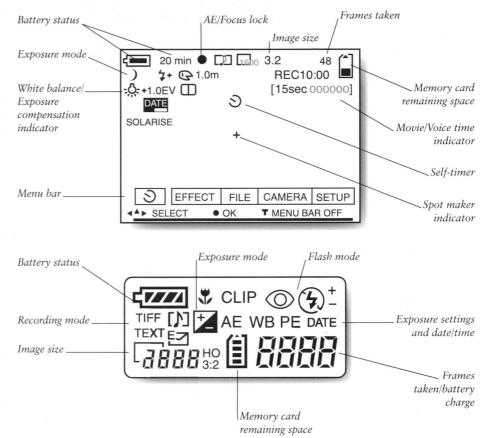

Information given

LCD screens show a wealth of information, in addition to the image about to be taken or already taken. Battery status, exposures taken, image size, and menu bar are all standard features.

IN-CAMERA CORRECTIONS

he display screen is not the only digital extra that comes as standard. Because the image is captured as data, it can be processed, and that opens up a whole world of possibilities. In essence, this is the theme of this book-that the image can be adjusted, worked on, fine-tuned, and that this can be done at any stage after it has been captured by

the sensor. How much data manipulation can go on in the camera itself depends on the power of its processor and on the imagination of the manufacturer. The camera's ability to process the image allows it to display not just the image, but all the information related to it, from the time and date to a map of its tonal values.

This last, the map of tonal values, called a histogram, is the true, objective measure of the exposure,

The camera's ability to process

and as we'll see on pages 108-9 it displays the relative proportions of all the tones, from dark to light. Without delving deeply into the image arithmetic, one look at the histogram can reveal the basic exposure. Black is on

the left, white on the right, and if the pattern falls within it, then the exposure has captured all the tones. If the tones are squashed up against the left, the image is underexposed (probably with some tones lost completely in the shadows); if hard against the right edge it is overexposed. Of course, you have to read

all of this in the context of the type of image takenif low-key and intentionally dark, it would be a mistake to make the histogram look "normal." But at the

> least, one glance will show you whether or not the exposure is as good as it could be. The other information stored, such as date, time, and the camera settings, will be useful later, when cataloging.

> One of the most immediate and valuable processes is color balance.

Natural light varies in color from the orange of sunrise and sunset to the blue of sky light in the shade under a cloudless sky-this is its color temperature.

> Visual white is that of midday sunlight on a summer's day in a temperate climate, but our eyes accommodate to differences too easily to discriminate well. What may look white may not really be, and the CCD will capture reality. One of the most useful camera

The histogram at a glance

One scene photographed at three different exposure settings. The display screen itself is not necessarily reliable for judging exposure (it depends on the angle at which you view it and on how much ambient light there is), but the histogram is objective. In the top histogram, the range of tones is grouped to the left end of the graph—a sure sign of underexposure—while in the bottom histogram there is an empty gap on the left, indicating no dark tones-in other words, overexposure. In the middle image, almost everything is contained, and the result is an adequately exposed photograph.

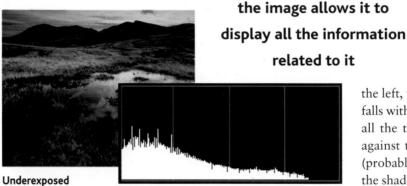

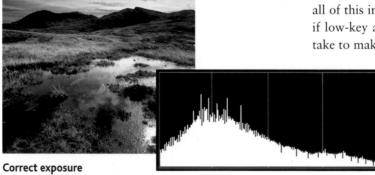

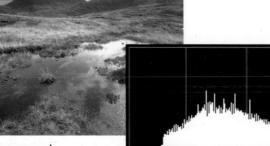

Overexposed

DIGITAL CAMERAS

features is white point balance, a procedure in which the part of the scene in front of the camera that should be pure, uncolored white is recorded just like that. By default, the camera will sort this out by itself, but most cameras also allow you to adjust the setting. It is not only daylight that strays from color neutrality—tungsten light in interiors has a strong orange cast while fluorescent lights are often greenish, though this can vary since they are unpredictable.

Depending on the make of camera, other image improvements are on offer. One of these is sharpening, which is achieved by exaggerating the contrast between the two sides of an edge; on simpler digital

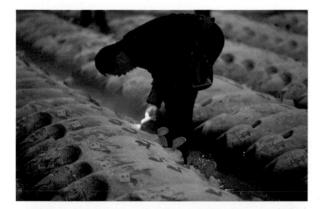

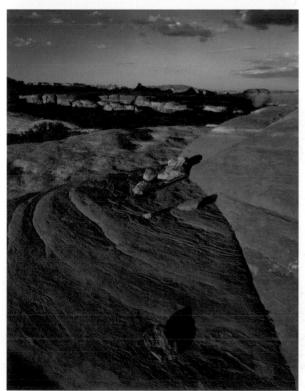

cameras this is available as preset choices, while on more advanced models you can operate it on a sliding scale. Another is tone curve control, which allows you to change the shape of the curve associated with the histogram, and so alter the contrast and the overall brightness of the image.

Some cameras offer features that deliberately blur the distinctions between still photography, video, and sound recording. For instance, a video recording mode allows the capture of a short take of low resolution video in compression or JPEG. Another possibility is to record, via a built-in microphone, a short spoken recording as an annotation to the image.

Guaranteeing the color balance

A digital camera needs a reference from which to calculate the overall color balance. Film already has its color response built in, but a sensor is open to all suggestions. White is the sum of all colors, and so setting that accurately and to neutral is the task of the white point balance. The default setting is "auto white balance," in which by means of complex algorithms the processor decides where in the image the white point should be. Different degrees of manual setting are available, according to the camera. In the upper pair of pictures, taken in Tokyo's Tsukiji fish market, the lighting is tungsten. Uncorrected (left), it has a strong orange cast. With the white balance of the highlights adjusted (right), the overall color cast is more neutral. However, not all scenes merit correction; in the lower pair, a sunset in Utah's Canyonlands National Park, the corrected and printed version (right) looks strange and with too much cyan, because our eyes accept a color cast at sunrise and sunset scenes as perfectly normal.

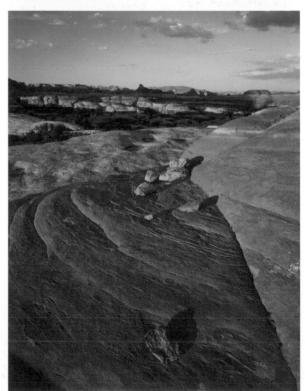

ENTRY-LEVEL COMPACTS

ecause they are in a constant cycle of obsolescence and improvement, digital cameras do not lend themselves to neat classification. As I mentioned in the introduction to this chap-

ter, the pixel resolution of the sensors is constantly being improved. What was good last year may be only just acceptable this year. Nevertheless, whatever the resolution, now or in the future, there will always be a category of camera aimed at photographers entering the digital world.

Entry-level cameras have processing abilities and electronic features not far short of professional models

Flash

Input and output

These are the equivalent of entry-level film cameras, but close comparisons are risky. In the traditional market, starter cameras are inexpensive, very simple, of no great quality, and almost featureless. This does not

Power switch

hold for entry-level digital cameras, most of which are exceptionally well made (this is referred to as "build quality" in the trade) and all of which have processing abilities and electronic features that are not far short

Function select dial

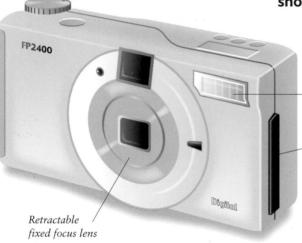

6 8 ⁹

Entry-level camera Film-based, entry-level cameras are often featureless and poorly produced, whereas the majority of digital, entrylevel cameras are well made and provide a number of sophisticated features such as instant playback on the LCD screen and a choice of image compression.

Canon PowerShot A10

LCD display

FujiFilm FinePix 40i

Nikon CoolPix 775

DIGITAL CAMERAS

of midrange and professional models. Nor are the digital cameras disposable in terms of price.

The basic functions for any digital camera at any level are quite comprehensive, including image capture by the sensor, processing and storing the image, a choice of image compression, and instant playback on the LCD screen. Where entry-level cameras differ from more expensive models is in the resolution of the sensor, the choice of sensitivity, the lens quality and range of optical zoom, the number of image-processing options (such as sharpening and overriding the white balance), and the overall complexity of operation. They are also usually compact. The table below shows the specifications for five such cameras, which vary in their resolution (three with one-megapixel sensors and two with twomegapixels). With so much experimentation in design and marketing going on in the industry, cameras in this category tend to have individual features—more so, certainly, than an equivalent selection of film cameras. Indeed, the Canon Digital IXUS could be placed in the midrange category just as easily, being particularly wellconstructed and more expensive. I've included it here for its compactness—one of the features of portable, no-fuss cameras—because it is basically an upmarket jacket-pocket camera.

	UTAL COMPACTS	COMPARED			
	SONY DSC-S30	TOSHIBA PDR-M11	KODAK 3200	CANON PowerShot S10	CANON Digital IXUS
claimed megapixels	1.3	1.3	1.2	2.11	2.11
max pixel resolution	1280 x 960	1280 x 960	1152 x 864	1600 x 1200	1600 x 1200
sensor type and size	CCD 1/2.7"	CCD 1/2.7"	CCD	CCD 1/2"	CCD
image format	4:3 or 3:2	4:3	4:3	4:3	4:3
ISO sensitivity	100	80, 320	100	100, 200, 400	100
lens	39–117 mm (3x)	52 mm	39 mm	35–70 mm (2x)	35–70 mm (2x)
aperture range	f2.8–9	f2.8–8	f3.6-8	f2.8–4	f2.8-4
digital zoom?	yes, 2x	yes, 2x	yes, 2x	yes, 2x & 4x	yes, 2x & 4x
focus	autofocus	fixed focus	fixed focus	autofocus	autofocus
close-focus limit	3cm	90cm	60cm	12cm	10cm
metering	center-weighted, spot	-	center-weighted	center-weighted, spot	center-weighted
white balance correction?	yes, override	yes, 4-point override	yes, 3-point override	yes, 5-point override	yes, 5-point override
built-in flash?	yes	yes	yes	yes	yes
storage formats	JPEG	JPEG	JPEG (3 levels)	JPEG (3 levels)	JPEG (3 levels)
memory card	Memory Stick	SmartMedia	CompactFlash Type I	CompactFlash Type I,	CompactFlash Type I
				Туре II	
LCD screen	2"	1.8″	1.6"	1.8″	1.5"
connector	USB	USB	Serial PC/Mac	USB, Serial PC/Mac	USB

ENTRY-LEVEL DIGITAL COMPACTS COMPARED

MIDRANGE COMPACTS

hile the main issue for entry-level cameras is to provide simple, compact models at relatively low prices, the midrange cameras offer better and better features, beginning with the resolution. As

Midrange cameras share even fewer physical design traits than do entry-level cameras you can see from the table on the next page, which covers the same specifications as those on the previous page, the lenses have a greater range (and are also of better quality), the sensitivity of the sensor can be

varied, and there is more choice of digital formats in which the images can be saved. In addition there are in general more processing options.

Viewfinder

With this emphasis on improving features, mid-range cameras share even fewer physical design traits than do entry-level cameras. The Canon G1, for example, features a flip-out LCD, while the Nikon Coolpix 990 has a swiveling joint between the lens and body to give an optimum view of the display screen at whatever angle of shooting (it can even be held high over the heads of people in a crowd). Because this is a new industry, with developing technology, manufacturers do not feel restricted by what is normal. In fact, at this stage there is no "normal."

The other important factor contributing to variety of camera design is that the digital sensor imposes far fewer constraints on shape than does 35mm film. Several generations of film cameras conformed to essentially the

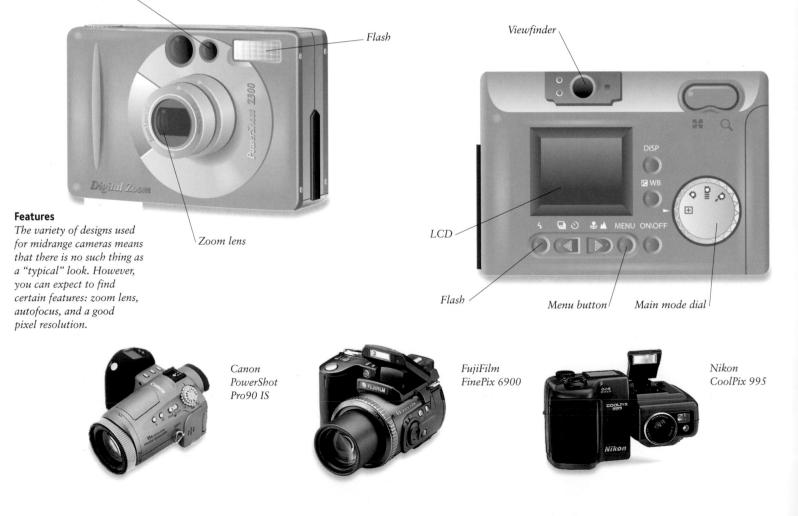

same mechanical features because of the needs of this sprocketed film in cassettes. It was chosen for the Leica in 1925 by its inventor at Leitz, Oscar Barnack, to take advantage of motion picture stock, which was widely available, and this set the standard for almost all subsequent cameras. Loading, positioning across the film gate, winding on, and finally rewinding all demanded a mechanical system that was consistent for most cameras and took up a significant amount of space. Not so in digital cameras, where there is no film to load (the sensor is permanently in place), and where film transport is replaced by an electronic downloading of the image information from the sensor, without moving parts. This has freed designers to experiment with the ergonomics of digital cameras, particularly in this category.

WHAT TO EXPECT IN THE NEXT FEW YEARS

Because digital photography is still essentially in the development stage, future trends are likely to be in two main areas: Technological improvement across the board, and a gradual establishment of industry norms. Digital camera designs are at the moment more varied than those of film-using models, with a high level of obsolescence. This will settle down. We can expect to see:

• More pixels for most cameras, up to a level at which most potential users will be

satisfied—possibly around 6 megapixels.
Larger sensor arrays, and maybe different designs beyond CCDs

- Less chromatic aberration
- Increased dynamic range
- Faster cycle times

• Memory cards with larger capacity In relation to pixels—the key element is picture quality—we will probably see professional cameras going well beyond the 6 megapixel target within a relatively short number of years.

	CANON PowerShot G1	SONY DSC-P1	OLYMPUS C3040Z	NIKON Coolpix 880	NIKON Coolpix 990
claimed megapixels	3.34	3.34	3.34	3.34	3.34
max pixel resolution	2048 x 1536	2048 x 1536	2048 x 1536	2048 x 1536	2048 x 1536
sensor type	CCD	CCD	CCD	CCD	CCD
mage format	4:3	4:3 or 3:2	4:3	4:3	4:3
SO sensitivity	50-400	100 to 300	100, 200, 400	100, 200, 400	100, 200, 400
ens	34–102mm	39-117 mm (3x)	35-105 mm (3x)	38-95mm (2.5x)	38-115mm (3x)
perture range	f2.0–f2.8	f2.8, f5.6 (wide),	f1.8-10	f2.8 & f7.8 (wide)	f2.5 - f7.0 (wide)
		f3.3, ∫9.6 (tele)		f4.2 & f11.3 (tele)	f4.0 - f11 (tele)
ligital zoom?	yes, 2x, 4x	yes, 2x	yes, 2.5x	yes, 1.2x - 4.0x in 0.2x	yes, 1.2x - 4.0x in 0.1
				steps	x steps
ocus	autofocus	autofocus (TTL)	autofocus (TTL)	autofocus (TTL),	autofocus (TTL),
				manual	manual
lose-focus limit	6cm	10cm (wide),	20cm	4cm	2cm
		50cm (tele)			
netering	center-weighted, spot	center-weighted, spot	matrix, spot	matrix, center-	matrix, center-
				weighted, spot	weighted, spot
white balance correction?	yes, 5-point override	yes, 3-point override	yes, 3-point override plus manual	yes, 5-point with adjustment, manual	yes, 5-point with adjustment, manual
uilt-in flash?	yes	yes	yes	yes	yes
torage formats	JPEG	TIFF, JPEG (3 levels)	TIFF, JPEG (3 levels)	TIFF, JPEG (3 levels)	TIFF, JPEG (3 levels)
nemory card	CompactFlash Types 1&11	Memory Stick	SmartMedia	CompactFlash Type I	CompactFlash Type I
harpening?	-	-	-	yes	yes
CD screen	1.8"	1.5"	1/8"	1/8"	1/8"
connector	Serial PC/Mac	USB	USB, Serial PC/Mac	USB, Serial PC/Mac	USB, Serial PC/Mac

MIDRANGE DIGITAL COMPACTS COMPARED

DIGITAL SLRs

eginning in 1936 and onward, the 35mm single-lens reflex film camera was established as the high-end design for handheld photography. Its great advantage was that its viewfinder showed the exact image about to be cap-

A digital SLR is certainly an expensive purchase, but at least the old lenses will work with it tured—a concept familiar now to computer users in the form of the acronym "wysiwyg" (what you see is what you get). This in turn made telephoto lenses practical—the longer ones need to be aimed and focused with an accuracy impossible for a rangefinder cam-

era, at least in the days before autofocus. Digital SLRs occupied the same market position right from the start,

partly because the arguments in favor of being able to see through the picture-taking lens are hard to resist, and partly to appeal to existing SLR users. As those of us who make daily use of SLRs know well, the capital value of the equipment is tied up in the lenses. A digital camera body is certainly an expensive purchase, but at least the old lenses you bought will work with it.

The changeover from a 35mm SLR to a digital version is not completely smooth, however. A few models, such as the Contax N Digital and the Pentax Digital, have a 24mm x 36mm chip—the same size as a frame of 35mm film—but for the moment most have a smaller sensor. That of the Nikon D1 measures 15.6mm x 23.7mm, the Fuji S1 15.6mm x 23.3mm, and the

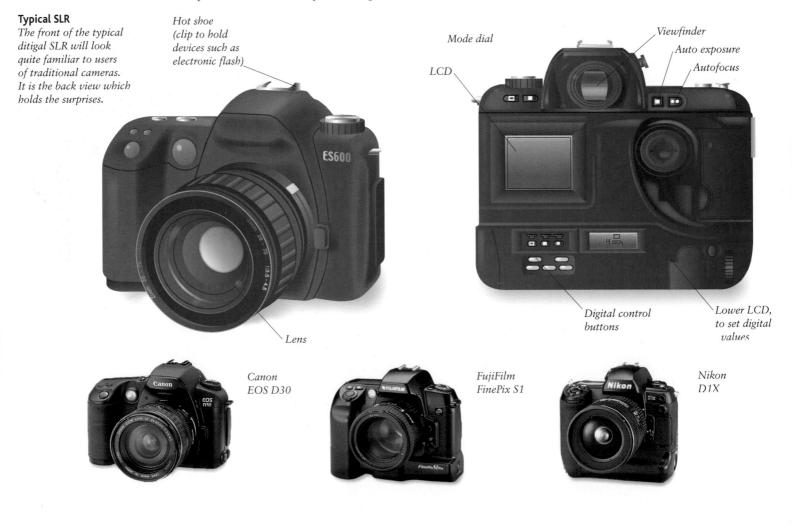

Canon EOS D30 15.1mm x 22.7mm. This means that with SLRs the confusing matter of angle of view that we looked at on pages 16–17 is a real and practical one. No longer is your 50mm standard lens standard, and the 20mm that you thought was a real problem-solver for cramped spaces behaves like a 35mm. This is the reason why manufacturers like Nikon and Canon are introducing new very short focal lengths, inevitably at serious prices. The silver lining to this is that your telephotos are all of a sudden more powerful—my 600mm f4 is now a very serious 900mm.

Another drawback of digital SLRs, which is not immediately obvious, is that changing lenses exposes the chip to the rude environment. If, like me, you are used to leaving bodies lying about with their innards exposed while you rummage for lenses, you are in for a rude shock when you check the image quality with a digital SLR. CCDs are notorious for attracting dust, which will show up on the image as a shadowy patch —and that's apart from the cost of replacing an easily damaged chip. A small can of compressed air, easily obtained in a camera supplies shop, is far more of a necessity than a luxury. This danger is one of the arguments in favor of the fixed-lens SLR, pioneered digitally by Olympus in the E-10, which is essentially a sealed system.

PHASE ONE

Scanning back

00

SCSI cable

Scanning back

SCANNING BACKS

With large-format and medium-format cameras, the problems of trying to cram millions of individual sensors onto a tiny array are alleviated, provided that money is no object. As we see on pages 44–5, computers are the ideal studio companion for an advanced studio camera, and professional studio photographers have been early adopters of digital imaging.

All serious studio cameras now accept digital scanning backs instead of film, and image quality is stunning definitely in advance of film, both in resolution and dynamic range. For still-life photography, and any subject that does not move, the straightforward solution to recording color is to make three exposures in succession, each through a different filter—the so-called triple-pass system. Moving subjects, as in portrait photography, need a singleshot back, but the chip size is much greater than those in handheld cameras.

Studio photographer

For the professional or ambitious amateur photographer the scanning back provides excellent quality in the studio. This shows a three-pass back attached to a Hasselblad.

Camera body /

Large format

Scanning backs enable the photographer to replace film on large-format cameras, as in this $5 \times 4^{\circ}$ camera.

DIGITAL CAMERAS

33

Camera back

ACCESSORIES

ccessories comprise any ancillary equipment beyond the basic camera and principal lenses, and range from useful to gimmicks. Much depends on the kind of shooting you do—street photography, for example, has no use for a tripod, while night photography certainly does. Even the small accessories add weight and bulk, much of

Mechanical cameras needed very little to keep them working, but digital models are more complex which might be unnecessary, so consider what you really need.

Digital photography adds a new tier of accessories, certain of which are vital. Old-fashioned mechanical cameras needed very little to keep them working, but digital models are

more complex and high-maintenance. At the top of the list are the battery charger, spare batteries, and spare memory cards. For the time being at least, you can forget about nipping into a corner store to pick up one of these. If you think you will need access to a computer while you are out shooting, in order to download or edit images, consider carrying your own cables and card reader.

On the nondigital side, an effective camera support is, for many photographers, the key accessory. This usually means a tripod, and is essential for low light conditions and small-aperture shooting, when you will need slow shutter speeds. Macro setups benefit from exact positioning, and still-life shots from precise composition—another tripod use. In portrait photography, a loosely locked tripod head makes it easier to talk to your subject. When setting a tripod up, remember that

low is more stable than high, that the thickest sections of the legs are the strongest, and that an adjustable center column reduces the stability considerably. Test the firmness by gently tapping the end of the lens.

Lens filters used to be high on the list of camera-bag accessories, but color correction software in the camera and the ability to apply digital filters later have obviated the need for most of them. UV and polarizing filters, however, still have a role because of the ways in which they reduce light scattering from a scene; neither can be reproduced digitally. In the case of a polarizer, it only passes light vibrating in one plane, and in practice cuts out reflections from metal and glass, and darkens clear skies at right angles to the sun (also by reducing reflections from the atmosphere). If you use a digital SLR and have interchangeable lenses, you may also need stepping rings to fit them to lenses of different diameters.

Charger unit for camera

Spare memory card

Cable for direct camera-tocomputer connection (here, Firewire)

Filters

Digital color correction has removed the need for most

lens filters, but the effects of

polarizing (bottom left) and

digitally. Stepping rings allow

UV (bottom right) filters

cannot be reproduced

one filter to be used on

different lens diameters-

useful if your camera has

interchangeble lenses.

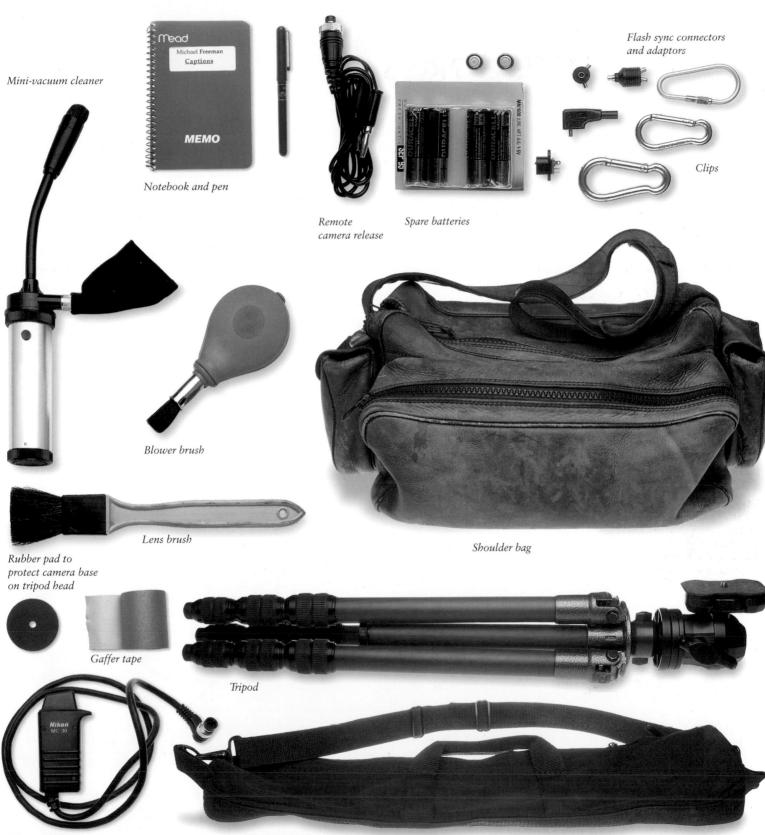

Electronic release

Tripod bag with shoulder strap

35

DIGITAL CAMERAS

THE WORK STATION

t is the computer that takes digital photography far beyond the moment of shooting, and opens up a new world in enjoying and using the photographs. Taking advantage of this means setting up the necessary equipment first, and that raises the question of what is really necessary. Somewhere between spending a little and a fortune lies a kind of ideal—well, let's say a reasonable compromise.

In setting up your workspace, there are three things to consider: what the computer needs, a comfortable working position for you, and good viewing conditions

Typical setup

The physical units of a computer —hard drive, processor, video card, keyboard, and so on—are the hardware. The programing codes that instruct them how to work are the software, and in basic operation the two are inseparable. Most computer manufacturers offer a wide choice of hardware that affects performance, usually processor speed, size of active memory, and storage space on the hard disk, and we look at these on pages 40–41.

Personal computers stand alone, which is to say that they work independently of others, even though they can be connected to each other to pass files along. There are desktops and laptops, and both can perform well enough to handle most tasks in digital imaging which may well not be the only use to which you put the computer. Desktops are variously configured. Some, like an iMac, contain everything, monitor included, in one unit; others, the majority, have the monitor separate from the computer. In addition to this basic setup, you will almost certainly need to connect what are called peripherals—separate pieces of hardware such as a scanner, printer, removable harddisk drive, or a writable CD-ROM drive. Anticipate

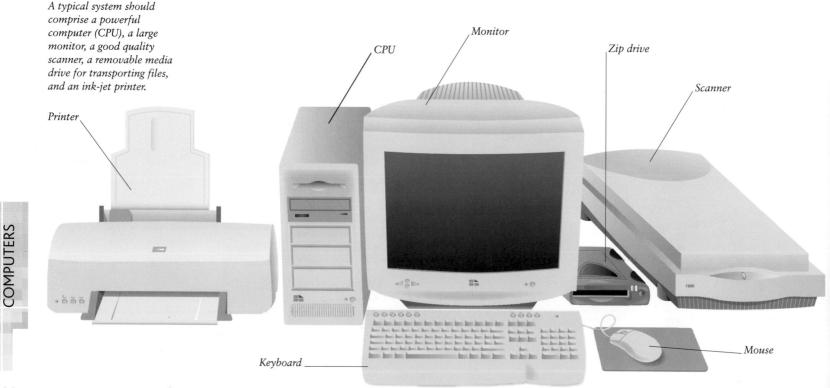

your future needs by making sure that several of these can be connected to the computer at once.

In setting up your workspace, there are three things to consider: What the computer needs; a comfortable working position for you; and good viewing conditions. While most of the machinery is robust, it prefers tolerably clean, dry, and cool air—not exactly an Intel laboratory with air scrubbers, but not a dusty toolshed either. Then, particularly if you spend long periods of time using the computer, you should be comfortable good chair, right height for the keyboard, and so on.

Because color accuracy is so important in judging and retouching photographs, the ambient lighting needs more attention than might be expected. Eyestrain apart, the only reliable way of judging the color and tones is when the ambient light is neutral and is considerably dimmer than the screen. You really cannot rely on daylight if it floods into the room—it varies too much. On the other hand, working hour after hour in a darkened room is not particularly pleasant, and most people make a compromise. Mine is to work in a room with a view of the garden for sanity, with a darkroom blind that I can draw occasionally for critical adjustments. For me that's necessary only when scanning and making overall color corrections, but it's a matter of personal priorities.

Laptops for portability

Laptops are howerful enough for most imaging accompany a digital camera even on location. For cameras its this Nikon D1, which can hey are idea:

A COMPUTER'S DATA HIGHWAY

The electronic pathway for sending data within a computer and between the computer and external devices is known as the bus. There are several types, such as SCSI, Firewire, and USB, each of which has advantages and disadvantages, usually relating to compatibility or speed.

HEALTH TIPS

• Check your working posture very carefully over a period. If, for example, the height of your chair is wrong in relation to the keyboard and screen, you may cause yourself strain after an hour or more of sitting at the computer. In particular, make sure that your arms are not extended and that your wrists are not awkwardly bent.

• Take frequent breaks from working at a computer —image-editing programs are notoriously absorbing. Long periods of work may temporarily affect your eyesight, and may cause repetitive strain injury (RSI), which can have long-term effects.

CHOOSING THE PLATFORM

n desktop computing, which is what we are dealing with, there are many manufacturers but very few platforms, and it is the platform—the operating system—that controls the way the machine works. Nearly 95 percent of PCs run under one version or another of Microsoft Windows; almost a monopoly, you might say (and it has been said). Surprisingly,

Simple clock speed is not the only thing to consider; what matters more is the performance in the program

PC

then, the small minority of machines that use Apple's Macintosh operating system have traditionally ruled in digital imaging. "Traditionally," because sheer weight of numbers and marketing pressure is slowly bringing more imaging to Windows, although not, as

we shall see, for the best of reasons. In addition, there are two platforms that are even more in the minority: Linux and Unix. The former is a freely developed challenge to Microsoft's dominance of desktop operating systems; it is stable, neat, and efficient and the choice of many computer enthusiasts. Unix is a high-end operating system that is also very stable, and allows multi-tasking, but with a notoriously difficult interface—at least until Mac OS X came out, which marries it to the elegant Mac interface.

Macintosh is the choice, by far, of most graphics professionals, and I must declare right at the start my own strong preference for it. I also use a PC, but not for imaging; its job is to run the office database which, fortunately, can bypass the inelegant Windows. The graphic user interface, GUI for short, was invented by Apple, and by comparison Windows is fairly clumsy. Though I'm partisan in this matter, it's not without reason. Whatever the advantages of Windows—and there are some compelling ones—they do not extend far into digital imaging.

The Mac's biggest advantage, taken for granted by those who have never used Windows, is that it has a single video driver at system level. That sounds arcane,

Computer platforms The two main computer platforms are PCs, operating Microsoft Windows, and Apple Macintosh computers which run Apple's own version of an operating system. Essentially the elements of hardware within each carry out the same functions, such as processing information (the Central Processing Unit or CPU), creating the interface for the user (the Operating System or OS), and storing information (on a disk drive).

MAC ADVANTAGES

- Single system video driver
- Easier monitor calibration
- The best graphic interface
- Peripherals easier to attach and configure
- Most graphics professionals use it

WINDOWS ADVANTAGES

- More software and hardware available
- Less expensive
- Program crashes affect active program only

PC laptop

More widely used

Apple G4 laptop

but it means that any kind of calibration works on every Mac and on every video card, and that means it is easy to get the monitor's display to look right. Accurate color is the starting point for working with digital photographs. Moreover, an image-editing program like Photoshop can animate the video look-up table so that any change you make in Levels and Curves (*see pages 108–9*) has an immediate effect. A further monitor benefit is that two screens can be used at the same time.

100

So what advantage does Windows have? Essentially, as stated, one of marketing muscle, and this is hard to ignore. Because so many computers run on Windows, there is a great deal more software available for it. However, this advantage scarcely applies in digital imaging, and some of the best plug-ins for Photoshop run only on Macs. Competition, too, is considerably greater in the Windows world, and prices tend to be lower because of this.

Processing speed is a continually changing feature, with some leap-frogging as each new, more powerful chip is launched. Since Apple introduced PowerPCs its processors have held most of the advantage, but this is by no means likely to persist. Simple clock speed, measured in megaherz (MHz), is not the only thing to consider; what matters more is the performance in the program you use most often. Windows currently scores on multitasking—the ability to do more than one thing at the same time, meaning that you can be working on something else while Photoshop is slowly applying a filter to an image.

In the end, this discussion is important only for first-time buyers. Whichever you have, a Mac or Windows computer, it will work well for digital photography. All the necessary software is there.

WHY THE VIDEO DRIVER MATTERS

A video driver is the software that a computer uses to control the monitor display. It has a look-up table (LUT) of up to 256 colors that enables it to find the closest match to an image that is being converted from 24-bit to 8-bit. Calibrating color, tone, and contrast is essential for accurate work on images, and the various calibration utilities work by adjusting the look-up table to make the monitor behave consistently. The Mac operating system does this very simply. In Windows computers would need different software for each video driver, an almost impossible task.

SPEED, MEMORY, PERFORMANCE

mage editing, which is the software most used in digital photography, needs all the performance it can get. The reason is that a digital photographic image, always stored pixel by pixel as a bitmap, is larger than most other kinds of file. It also has to do with the ambitious operations that image-editing programs can perform on pictures, which are heavy on cal-

Performance costs; make sure that you can upgrade the machine, and begin modestly culation. But performance costs, and it is not easy to predict how much you will eventually need; my best advice is to make sure that you can upgrade the machine, and begin modestly.

Processing speed, which depends on the chip and is given in megaherz

(MHz), has the most influence on performance. It costs accordingly, but as improved chips come onto the market, the older ones become cheaper. Beyond this, everything runs much faster if the work can be performed within the computer's memory, which resides on a separate card. Active memory, instantly available to whatever program you are using, is known as RAM (Random Access Memory), and the rule of thumb is that you need three, preferably five times the size of the image file you are working on. The reason for this is that the program needs to hold copies of the image while you make changes. As you add layers or channels to the image—a convenience offered by good image-editing programs explained on pages 104–5—the size of the file grows, and it demands more memory.

You can allocate some or all of the RAM to a particular program, so for top performance run only one program at a time and give it the maximum. There is, however, a workaround: Image-editing programs and others can use what is called virtual memory by commandeering some of the hard disk, but this is much slower because of the time-lag in having to read the spinning disk.

One last internal piece of hardware of consequence is the video card. Its main purpose is to speed up the rate at which the screen updates the image, and it must also support your monitor's resolution, scan rate, and bit-depth, which for photography should be true 24-bit color. The computer will already have a video card installed, but bear in mind that you may want at some point to improve it.

Cache Settings	Cancel
Use cache for histograms Physical Memory Usage Available RAM: 234121K Used by Photoshop: 80	

You can increase the amount of random access memory available in Windows. The control panel gives the option of letting Windows adjust the memory automatically or you can specify an amount and the drive when you want this available. However, this is only "virtual memory," and is consequently slow.

COMPUTERS

	About This Computer	🔲 👘 🔤 Adobe® Photoshop® 6.0 Info
Disk Cache Default setting Custom setting Virtual Memory O Dn O Df	Image: Second state of the computer state is calculated when the computer starts up. The current estimated size is salculated when the computer starts up. The current estimated size is salculated when the computer starts up. The current estimated size is salculated when the computer starts up. The current estimated size is salculated when the computer starts up. The current estimated size is salculated when the computer starts up. The current estimated size is salculated when the computer starts up. The current estimated size is salculated when the computer starts up. The current estimated size is salculated when the computer starts up. The current estimated size is salculated when the computer starts up. The current estimated size is salculated when the computer starts up. The current estimated size is salculated when the computer starts up. The current estimated size is salculated when the computer starts up. The current estimated size is salculated when the computer starts up. The current estimated size is salculated when the computer starts up. The current estimated size is salculated when the computer starts up. The current estimated size is salculated when the computer starts up. The current estimated size is salculated when the computer starts up. The current estimated size is salculated when the computer starts up. The current estimated size is salculated when the computer starts up. The current estimated size is salculated when the computer starts up. The current estimated size is salculated when the computer starts up. The current estimated size is salculated when the computer starts up. The current estimated size is salculated when the computer starts up. The current estimated size is salculated when the computer starts up. The current estimated size is salculated when the computer starts up. The current estimated size is salculated when the computer starts up. The current estimated size is salculated when the current estimated size is salculated when the computer star	Adobe@Photoshop@6.0 Adobe Photoshop 6.0 Show: General Information \$ Kind: application program Size: 15.5 MB on disk (16,283,732 bytes) Where: Macintosh HD: SYSTEM/SOFTWARE: SOFTWARE: Adobe@ Photoshop@ 6.0: Created: Mon, Sep 25, 2000, 9:10 pm Modified: Mon, Jan 8, 2001, 10:15 am Yersion: 6.0 ©1989-2000 Adobe Systems Incorporated Label: None Comments:
RAM Disk	Bercent of available memory to use for a RAM disk: 0% 50% 100%	Locked
V8.1.1 Mac system On a Mac you can add virtual memory to the installed memory (RAM) of your computer, above. The System Profiler, right, gives you a complete brofile of your computer, covering memory, disk drives, external devices, and so on.	Use Defaults System Profile Moto Soverview System PowerVole Enabler 9.0.4 Muthe enabler: System PowerVole Enabler 9.0.4 Muthe System System PowerVole Enabler 9.0.4 Muthe System PowerVole Enabler 9.0.4 Muthe System PowerVole Enabler 9.0.4 Muthe System PowerVole Enabler 9.0.2 Muthe Dim recoverview Muthe Dim recoverview Muthe Enable 2 cache Muthe Dim recoverview Muther Dim Recoverview Menter Statist: No Apple modern found. Mon Transport Installed: Yes	Adobe @ Photoshop @ 6.0 Adobe Photoshop 6.0 Show: Memory Kind: application program Memory Requirements Suggested Size: 32768 Kinimum Size: 50000 Kinis application may require 12,488 K more memory if moved to another hard disk or virtual memory is turned off in the Memory control panel. Applying RAM to a program Xou can choose how much memory you allocate to a program on a Mac. A window gives you the minimum and suggested sizes, but if you can afford to allocate more, as the photographer has done here for Photoshop,

USING THE SOFTWARE

he camera manufacturers supply software for use with the images, but this varies in complexity and features. The simplest programs are essentially browsers, with which you just look at what you have shot. Up the scale are programs aimed at professional and semiprofessional users, which contain some of the features that you would

Programs aimed at professional and semiprofessional users contain some of the features that you would normally expect to find in an imageediting program

normally expect to find in an imageediting program. This is not necessarily mere duplication, because if you are shooting and saving in the camera's RAW format (see pages 22-23), this software is essential if you want to work directly on the unprocessed image. Remember, however, that RAW formats are developed for the particular camera model, optimized for the manufacturer's technology, and are not usually readable by another program.

Here I've taken what is probably the best digital camera software on the market, Nikon Capture, and used it with a Nikon D1 SLR. As you can see, it provides all the essential imaging controls other than retouching, and to a sophisticated degree. The sharpening control, for example, offers a professional range of options, considerably more detailed than the USB sharpening in, say, Photoshop. Nikon Capture is not in any way typical, because each manufacturer has developed its own software independently, and the interfaces are unique.

The first step is to load the images from the camera into the computer. The most common way of doing this is from the memory card, often through the PCMCIA slot, which most, but not all, computers have. An alternative method, more usually found in midrange and professional cameras than in entry-level models, is a direct cable connection from a port on the camera body to another on the computer. USB and serial interfaces are the most common, but Firewire, where available, allows much faster transfer rates. If the camera has been connected, as it was here for these

1/125 sec-f/22.0

Bird's Eye

ing Mode : Cen

osure Comp : O EV xible Program : OS

日日

327

Information

G B Avg

Exposure Difference: -7 5/12 SpeedLight Mode: None

1)

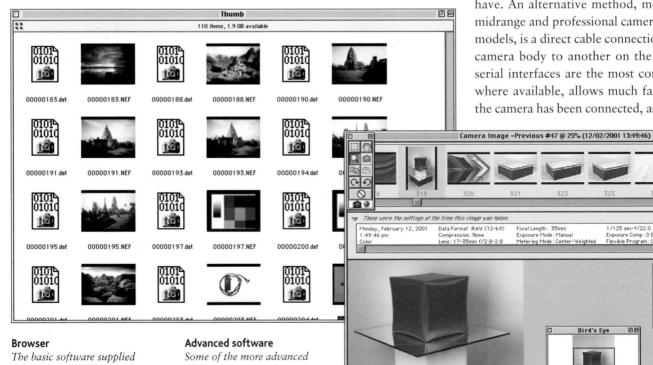

with the camera displays the images taken, once they have been loaded. Typically, as above, they use thumbnail images in a kind of catalog.

digital cameras can be used with software (right) that allows various adjustments and enhancements, and even remote camera operation.

42

COMPUTERS

Color sliders

With Nikon Capture software, a simple dialog box offers basic control over brightness, contrast and the three color channels (below). Ideally, make adjustments while you still have the subject in front of you.

pictures, it appears as a drive on the computer's desktop and largely behaves as one; you have direct access to its memory and store of images.

A simple browser (the example here is Nikon View), will then display small versions of the images once you have given it a Create Thumbnails command. From this browser window you can delete images, and also copy

them onto the computer's hard drive, but to open them you will need an image-editing program. Nikon Capture, however, displays the thumbnails as a strip and produces an enlarged version of any one. It will save images in any of the standard file formats, for opening in Photoshop or equivalent software.

The main features, however, are those for image enhancement, and include adjusting the white balance, brightness, contrast, color balance, tone curves, and sharpness. All of these compare with the key features in Photoshop, with the advantage that here I'm working directly on RAW images, from which nothing has been deleted and to which nothing has been added. Color adjustment, as in an image-editing program, can be performed the simple way, with color

Curves control

More sophisticated

adjustment is possible

operations were used:

the gray-point dropper.

Removal of red and

neutralizing the shadow color with

with Curves. Here, two

sliders, or with the Curves dialog, for a greater degree of control.

In addition to the software that the camera manufacturer provides, there are many other programs available for viewing the images, some of them, like Microsoft Photo Editor for Windows, already built into the operating system. Netscape and Internet Explorer will also open JPEG images, as will any image-editing program, image browser, and numerous small viewing utilities. We will take a closer look at these other aspects in chapters 5, 8, and 9.

USM SHARPENING

Unsharp Mask sharpening gives great control, through adjustment of intensity, halo width, and threshold. The examples below show (top to bottom) no sharpening, appropriate sharpening, and too much sharpening. It is safer to apply sharpening to a copy of the image than to the original.

COMPUTERS

43

SHOOTING WITH THE COMPUTER

igh-end digital cameras can be used with a computer, and not merely as a first step in the process of digital imaging. Connected to a computer through a high-speed bus,

such as Firewire, and with the help of specific software from the camera manufacturer, a camera such as the Nikon D1 used here can be operated from the computer, with some star-

💰 File Edit View Image Camera Settings Window Help

In this kind of circumstance the computer really can add a new dimension to photography

11:36

c-f/29.0 Comp: 0 EV

Program: OS

DE

tling advantages. This kind of use is intended mainly for studio shooting, although with a laptop computer there are no real limits to the location chosen. This linkage makes most sense when the camera is set up on

Exposure Mode: Manual

Exposure 1 (Exposure 2) Storage Mechanica

\$

a tripod in front of a static subject, as in a still-life set, and in this kind of circumstance the computer really can add a new dimension to photography.

The example here is a very straightforward situation—photographing a single

cumstance the can add a new bhotography automatic exposure adjustment that would be normal

A SIMPLE STILL LIFE

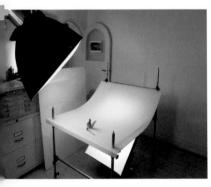

Initial setup The lighting set features a translucent light table lit from below with a diffused flash, while the principal light is another flash fitted with a softbox. A small mirror is used to lift the shadows on the opposite side.

Shutter Speed: Shutter Speed: Aperture: Shutter Speed: Aperture: Shutter Speed: Shutter Speed:

Masking out flare

The first exposure is correct

surrounding lit background

is causing slight flare. The

remedy is black card masks

fitted right up to the edge of

the picture frame (right).

at f29 (above), but shows

what I should already

have known-that the

Camera Control Camera Control

Shoot and check

Another shot is taken via the computer (above). An examination of the histogram (below) shows that the exposure is good, and that it is definitely an improvement on the previous one.

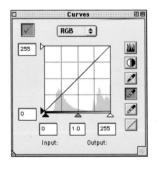

44

—is that they allow both the quantity and quality of light to be fine-tuned. The disadvantage is that you do not always get what you see.

In traditional photography, I would first measure the flashes with a meter, adjust the balance between the two, set the aperture accordingly, and make a Polaroid test. If I didn't have a Polaroid back for the camera (heaven forbid!), I would bracket the exposures very widely. The Polaroid, though, would tell me more than just the correct exposure, and would be a proof, or preview, of the final shot.

Now, however, I can work in a different, more confident way. With the camera on a tripod, I line up the shot according to my experience, take the meter reading, but then walk away. A Firewire cable connects the camera to the laptop on a desk, and the software—in this case Nikon Capture—has a camera control panel that allows me to operate all the essential settings: ISO sensitivity, shutter speed, aperture, focus, and color balance. One click fires the camera and the flash. The LCD screen of a laptop is not trustworthy for fine judgement (*see page 47*), but given the software tools available this is not necessary. I keep the Curves window open, and in the few seconds it takes for the just-exposed image to load onto the computer and appear on the screen, all the exposure information loads up to appear with it. A histogram underlies the curves, and that immediately shows how accurate the exposure has been.

One thing is immediately obvious, and I should have thought about it before—I'm losing image contrast because of light flooding in from the surrounding light table. The solution is standard—to mask off the area just outside the camera view. Reshooting confirms that this works, and that is that. Shooting with the computer has given me both instant feedback and a final image, which I can open immediately in an imageediting program for definitive confirmation.

Finished image

A final check of the Photoshop histogram (below left) shows that all is well the figure occupies the bellshaped curve on the left, while the right-hand cluster represents the background. The gap in the middle indicates that there are no mid-to-light tones, and that the figure is strongly separated from the background.

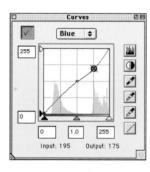

Neutralizing the shadow

The soft shadow below the silver figure has a slight blue cast, and because this is in the lightest part of the tonal range, I correct it by lowering the blue channel curve in the highlights, while pegging the midtone (above).

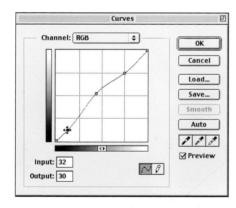

Increasing midtone contrast

The midtones could do with better separation. In Photoshop, I peg the shadows and highlights, which are good, and then raise the curve at its midpoint (above).

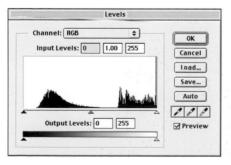

MONITOR TYPES

or the bulk of computer users, a high-quality monitor is a pleasant addition, no more, but for photographers the best is mandatory. Whatever you see on your screen, and manipulate, will eventually be output in some form or another. It is absolutely essential that the image you see on screen is sufficiently true to how it will finally appear. Good mon-

It is absolutely essential that the image you see on-screen is sufficiently true to how it will finally appear itors are costly, but it is worth spending as much as you can, and the only feature that you might consider compromising on is size. The others—resolution and color depth in particular must be as accurate as possible. As for size, larger is better and healthier.

The size of each pixel as it appears on your display is first determined by the screen's resolution. This is usually given as the number of pixels horizontally times the number vertically, as in $640 \ge 480$, which is low resolution, or $1024 \ge 768$, which is relatively high. The software may allow you to alter the screen resolution, although normally you would only do this to see how an image would look on another monitor. Switching down to a lower resolution increases the size of all things on the screen, but they appear less sharp.

The larger the screen, the higher the resolution it needs for images to appear the same size and in the same detail. When it comes to making comparisons with camera, scanner, and printer resolutions, which are in pixels (or lines or dots) per inch, the standard figures used for monitors are either 72 ppi or 96 ppi. These are not precise however, and the actual number depends on the resolution and monitor size. 72 ppi used to be the norm, but most monitors now are closer to 96 ppi.

BIT DEPTH

MONITOR COLORS

	Overall bit depth	Number of colors
Bitmap	1	2
Grayscale	8	256
Indexed color	8	256
High color	16	65 thousand
True color	24	16.7 million

Grayscale

256 separate tones, but all in one channel—offering a complete monochrome range from black through gray to white.

256 colors The same number of distinct tones as the grayscale, but divided between three channels—red, green, and blue—with poor fidelity.

Setting bit depth

You can set the hit depth of your monitor using the Display or Monitors control panel.

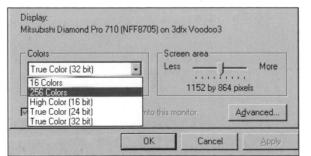

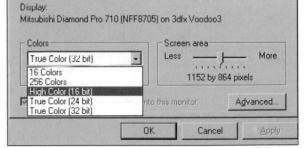

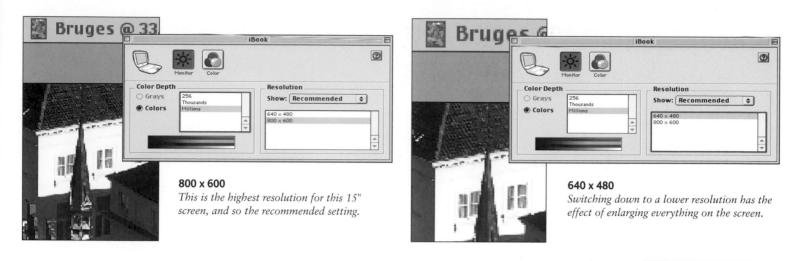

Monitors work in RGB, and so in theory can display most colors. How many in practice depends on the bit depth. Older machines were limited to just 256 colors. The maximum is actually a little over 16 million, or 24-bit color, but this needs a suitable video driver. Now, almost all systems have such a driver, and, indeed, working with photographs absolutely requires the maximum. A setting in the Control Panel allows you to switch between bit depths. The alternative to the standard cathode ray tube monitor is active matrix, which allows a very thin screen, and so makes laptops possible. However, the angle at which you view the screen still makes a difference to the brightness of the image. Simply put, you cannot properly judge brightness and color by eye. If that is all you have, go by the numbers and use the onscreen densitometer and the white, gray, and black point droppers; then check the printed results.

RESOLUTION

The most common resolutions, measured in pixels, for the three most common sizes of monitor display (measured diagonally in inches) are as follows: 14" 640 × 480 15" 800 × 600 20" 1024 × 768

WHAT TO LOOK FOR

- 24-bit color depth
- High resolution
- Size: the larger the better
- Calibration software, either with the monitor or the imageediting program

Display Mitsubishi Diamond Pro 710 (NFF8705) on 3dfx Voodoo3 Colors Screen area Less More True Color (32 bit) 16 Colors 1152 by 864 pixels 256 Colors High Color (16 bit) 🔽 True Color (24 bit Advanced. True Color (32 bit) DK Cancel

Thousands of colors

realistic.

Doubling the bit depth from

colors, which looks close to

8 to 16 gives 65,000 separate

Display: Mitsubishi Diamond Pro 710 (NFF8705) uri 3dfx Voodoo3 Colors Screen area Less More True Color (32 bit) 16 Colors 1152 by 864 pixels 256 Colors High Color (16 bit) True Color (24 bit) Advanced.. True Color (32 bit OK Cancel

Millions of colors

The highest monitor quality,

24-bit color, gives about

as the human eye can

the same number of colors

distinguish-16.7 million.

MONITORS AND INPUT

CALIBRATING FOR ACCURACY

resh out of the box, a monitor will probably give a reasonable-looking picture. Working with photographs, however, demands more than "reasonable"; the display must be quite accurate. Calibration gets you closer to accuracy—in shape, brightness, contrast, and color fidelity.

There are two stages. The first ensures that the dis-

Calibration gets you closer to accuracy—in shape, brightness, contrast, and color fidelity play is working to specification with the computer's operating system. The Windows operating system, for example, produces a darker image than does the Mac's (a gray gamma of 2.2 against the Mac's 1.8; see below). The calibration software supplied with the

machine usually has a clear sequence of on-screen instructions. By the end, a true gray should look neutral on your monitor, as should whites and blacks.

The second stage is to match the monitor display to the way you work, and if most of your time on the computer will be spent in an image-editing program, a utility such as Gamma, supplied with Photoshop is ideal. While this is not the same thing as professional color management (*see pages* 76–7), it goes a long way, particularly if you have a simple workflow (which is to say, camera to image-editing to your own printer).

VIEWING TIPS

- Choose the lighting conditions of your workspace carefully: they should be consistent, and neutral in color temperature.
- Wait until the monitor has warmed up before judging colors.
- Select a plain gray screen background to help your color perception.
- If your monitor has adjustable controls, tape them over so that they cannot be altered inadvertently.

If you scan images on film, you will also need, at some point in the scanning process, to compare the results on the screen with the actual slide. Given that you have adjusted the screen to be as accurate as possible, you must also find a way of viewing the slide critically. Holding it up to whatever light is available simply won't do if you are trying to match colors and tones. After spending longer than I should relying on the white wall of the house across the garden, I came to see the sense of buying a color-corrected lightbox. While one of these may look much the same as an ordinary lightbox, the combination of special tubes, filters, and translucent plastic makes them significantly more expensive. One saving that you can usefully make is to buy a small one. Because you will usually be viewing only one transparency at a time, the smaller the better, since a large surrounding bright area will actually interfere with your color and tone judgement.

CHANGE THE GAMMA TO SEE THE SHADOWS Adobe Gamma Description: ANCs Profile Load... 🗆 🕅 DSCF0014 copy2.tif @ 12.5 🗉 📮 🔲 📓 DSCF0014 copy2.tif @ 12.5 🗉 🗐 🔲 🌃 DSCF0014 copy2.tif @ 12.5 🖽 🗄 DSCF0014 copy2.tif @ 100 Brightness and Contrast Phosphors: Trinitron 😫 Gamma 🔲 View Single Gamma Onl 4 1 12.5% IIII 12.5% 4 1 \$ 2.2 Desired: Windows Default The gamma control, shown here as supplied for Macintosh and 2.2 for Windows. Change White Poin Hardware: 9300°K (cool whit... \$ Measure...) with Photoshop, allows you to switch instantly them to make shadows more visible; you Same as Hardware between 4 different settings. 1.8 is standard can also alter color warmth. 5000°K (warm white) Assistant... 0°K (davlight) 0°K (cool white

CALIBRATION SOFTWARE

Velcome to the Apple Monitor Calibration Assistant!

This assistant will help you calibrate your monitor and oreate a oustom ColorSyno profile. With a property calibrated monitor, software that takes advantage of ColorSync can better display images in their intended colors.

Expert Mode - This turns on extra options

Select the gamma setting you want for your monitor. (Watch the picture on the right to see the effect as you click the different options.)

This is the traditional setting for Mac OS computers.

You may want to select this setting if you are working with images to be displayed on television or PC-compatible computers.

Select the white point setting you want for your monitor

6500 Cooler - equivalent to midday sunlight. 9300 Coolest indonr lighting - the default white point of most monitors and televisions.

None No white point correction performed

🔘 D50 Warm yellowish lighting - standard for graphic

Select a target gamma

🖲 1.0 Standard Gamma

2.2 Television Gamma

No Correction (native)

Select a target white point

arts work

2	Monitor Color	0
	c Profile	

Introduction

Programs to assist you in calibrating your monitor are included as standard with the computer. The one below left is for a Macintosh, and follows a sequence of steps initiated (left), beg brightnes

moving on to gamma—the monitor's color characteristics *—and the white point (how* warm or cool the whites will look). The images below right show stages of calibrating a PC running Windows. The software supplied with the machine usually gives clear instructions.

initiated by a dialog box	
(left), beginning with	3dfx Voodoo3 Properties
brightness and contrast,	General Adapter Monitor Performance Color Management
Monitor Calibration Assistant	These settings let you select the default color profile for your
	monitor. This affects the colors that you see on your monitor.
Monitor Calibration Assistant!	Current monitor: Mitsubishi Diamond Pro 710 (NFF8705)
u calibrate your monitor and create a With a properly calibrated monitor,	
tage of ColorSync can better display lors.	Default monitor profile: Diamond Compatible 9300K G2.2 copy
The steps to calibrating a monitor are to adjust the following settings:	Color Profiles currently associated with this device:
Brightness and contrast (on some monitors) Gamma (color contrast)	Diamond Compatible 9300K, G2.2 copy
 Gamma (color color data acteristics Monitor color characteristics White point (warmth or coolness of white) 	
ins on extra options.	
Click the right arrow below to begin.	
	Add <u>R</u> emove <u>S</u> et As Default
Monitor Calibration Assistant	
	OK Cancel Apply
you want for your monitor. (Watch	
see the effect as you click the	
	Adobe Gamma
setting for Mac OS computers.	Description: DiamondTron Monitor G22 D93 Load
secting for File Compare 5.	
t this setting if you are o be displayed on television	Brightness and Contrast
puters.	
After you have done this step, click the right arrow.	Phosphors
	Phosphors: Custom
Monitor Calibration Assistant	Gamma
e point	View Single Gamma Only
ing you want for your monitor.	
owish lighting - standard for graphic	Desired: Windows Default 2.20
uivalent to midday sunlight.	Desired: Windows Default _ 2.20
nnr lighting - the default white point nitors and televisions.	White Point
pint correction performed.	Hardware: Custom
	Adjusted: Same as Hardware
After you have done this step, click the right arrow.	
430	OK Cancel Wizard

USING MONITORS SAFELY

The human eye did not evolve staring at a display screen, and long periods spent in front of one-not at all unusual if you are retouching an image -can cause eyestrain. Most modern CRT monitors overcome flicker by having a high screen refresh ralethat is, the image is traced over by the electron gun at more than 70Hz. As for low-frequency radiation, the effects are disputed. However, it has been stated by reliable authorities that radiation from monitors is much lower than from natural sources and from appliances such as electric razors, and so is not a risk. Most monitors now conform to the Swedish standard MRP II. In any case, low-frequency radiation is less from the screen than from the back and sides. As a general precaution, you might work no closer than an arm's length from the screen. LCD monitors have an innocuous flourescent light source.

49

THE INPUT DEVICE

Ithough the essential input from our point of view is the digital photograph, the way you work on the image demands what the computer industry calls input devices. The two standard ones, common to all desktop computers, are the keyboard and the mouse. As these are supplied with the machine, the only reasons for replacing them

Imaging software customarily allows many operations to be performed by either the mouse or the keyboard are ergonomic, and there are different designs from independent manufacturers. The way a mouse fits into the palm of the hand tends to be a matter of personal preference. An alternative is a trackball, which is essentially a mouse on its

back, worked by rolling the ball with your fingers.

Imaging software customarily allows many operations to be performed by either the mouse or the keyboard. While the nature of working with photographs tends to involve drawing, painting, dragging, and so on—which are more intuitively done with a mouse keyboard strokes have the advantage of being faster, and they can be made with your other hand. Professionals usually make greater use of the keyboard because they are familiar with the strokes through experience. In certain procedures, when a dialog box is open and prevents the mouse-operated cursor from being clicked anywhere else, keystrokes are the only way of operating—for instance, zooming in and out of an image. All in all, it's a good idea to learn the keystroke alternatives (they are displayed in the dropdown menus).

You can customize the mouse operation through software accessible from the computer's control panels —the tracking speed, double-clicking speed, and the appearance of the track it leaves across the screen. Mice from independent suppliers often have a choice of buttons that can be customized to mimic keyboard strokes such as Ctrl-click, or command-click on a Mac.

However, for a natural, intuitive way of editing an image, nothing beats a pen and graphics tablet. While it adds to the cost, this electronic drawing board with a stylus is perfect for any freehand drawing action and image editing involves plenty of these. The working area of the board represents the area of the screen, and when the stylus—a plastic pen—is held within a fraction of an inch of the board, it activates the cursor. Pressing down on the point is like clicking with the mouse, activating the software tool you have selected. In no time at all, working with a stylus becomes like using a physical pen or brush on the surface of the image. This is highly appropriate for the tools that an image-editing program provides. Like the screen, it needs to be calibrated—a simple procedure through

Mouse types

Mouse setup

Even the simplest mouse comes with software that allows you to customize it. The most important adjustment is the tracking speed—how fast the cursor moves in relation to the mouse itself. If you use the mouse for brushwork in imaging, it is essential to tune this tracking to the length and speed of your brushstrokes.

50

the software provided. Among the many choices you are given are the feel of the tip, the angle at which it will respond, and the functions of different buttons on the stylus.

The pioneering company, and still the leader in this technology, is Wacom. Their tablets all use a cordless stylus, which has many clear advantages. The most technologically advanced of all graphics tablets is the interactive display tablet. This arguably introduces a new category altogether. The Wacom PL500 incorporates a 15-inch interactive display of the image, and with a pressure-sensitive pen you can draw and erase directly on the screen. Essentially this is a draw-on monitor, with 15-million true-color bit depth. The price is currently outrageous, but if it catches on, this will doubtless come down.

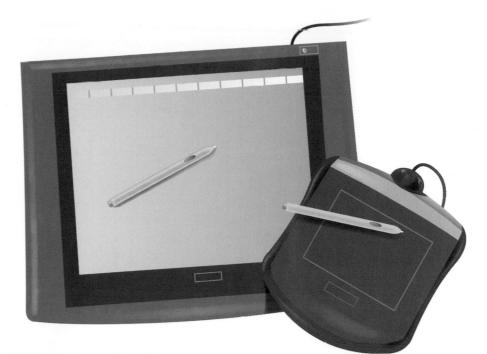

Mapping V	Pop-up Menu	Tablet Buttons	Tablet Mode
- Positioning Mode 	ర్టీమీ 🕒 Mouse Mode	Orientation Q Landscape	
Tablet Area Entire Tablet		Display Area	
O Portion of Tablet		Portion of Display	Reset Tab to Default
		Aspect	Revert Tab
	Advanced Mapping	 Proportional To Fit 	Copy Setting: To

Graphics tablets

The tool par excellence for imaging brushwork is a cordless stylus and graphics tablet. This also has software for customizing the way the stylus behaves. Part of the setup procedure for Wacom, the best-known manufacturer, is shown here, and includes mapping (how the geometry of the tablet corresponds to that of the screen), the angle of tilt at which the stylus will respond (which depends on the way you normally hold a pen), extra functions that you can add to the forefinger button and eraser, and the tip pressure (from soft to firm, right).

MONITORS AND INPUT

SCANNING BASICS

ven with the explosion in digital camera technology, silver-halide film is not going to disappear in the near future, and even when we've all converted there will still be all those transparencies and negatives already shot and hanging in the files. The tool for digitizing conventional photographs is the scanner, and the desktop scanning indus-

The dynamic range and the color accuracy are critical, and both depend on the bit depth try remains very healthy.

Film carries an extremely high density of information, and the task of the scanner is to capture as much of it as possible. For most photographers,

resolution is the prime concern, although it is only one of the relevant image qualities, including dynamic range, bit depth, and noise suppression. Because by far the majority of film is 35 mm, scanning resolutions need to be high to be useful. A frame measures $36 \ge 24$ mm, and to enlarge this for printing at, say, 10 inches wide, the scanner would have to work at 2100 ppi. As you would expect, high-end scanners resolve the most detail. The resolving power also depends on the quality of the optics and on the accuracy of the mechanics.

There is more to a good scan than this, just as there is when shooting with a digital camera. The dynamic range and the color accuracy are critical, and both depend very much on the bit depth. Good scanners work at higher bit depths than do most image-editing programs—10 or 12, giving 30-bit and 36-bit color respectively in RGB. When the files are converted downward to the normal 24-bit color, they have a

SCANNERS

High end, low end

This 35mm Kodachrome transparency was scanned by different machines, from professional to desktop. Direct comparisons are difficult because the resolutions vary, and except for Photo CD, the scans were at maximum optical resolution. At left is the entire image on a drum scanner, and on Photo CD (below left) the high and low limits.

Flatbed scanner In recent years, flatbed scanners with transparency heads have greatly improved. This good quality desktop model, a Linotype-Hell Saphir, has a maximum resolution of 1200 x 2400.

PPCD

Kodak's Professional Photo CD is an advanced version of the PCD, but with an extra, higher resolution of 4200 ppi. Nevertheless, the results from this scanner do not compare with a drum scan.

Drum scanner Best results, obvious in resolution and dynamic range, are from a professional drum scanner, in this case a Crosfield Magnascan.

PCD

The Kodak scanning service, using a CCD scanner and workstation. Despite many advantages, the actual scan resolution and dynamic range are average.

Film scanner

A high-quality CCD film scanner, in this example a Leafscan, approaches the quality of the drum scan. better dynamic range and finer color gradation. The quality of the optics also contributes. Noise degrades the image with a random pattern of "wrong" pixels, and the better-quality scanners are able to suppress it more effectively for better results.

Finally, there are the usual conveniences, or lack of them—the range of color modes that the scanner supports, its speed, ease of use, compatibility with the system you use, and with output devices. And, not least of all, there is price. You largely get what you pay for.

There are scanning services that you might consider as an alternative. The best-known is Kodak's Photo CD, which has its own proprietary format. It has been around for long enough to be well supported by programs like Photoshop, but opinions differ about the quality of the scans. Despite Kodak's large investment in the system, the basic equipment is a CCD film scanner, and the specifications are beginning to date. Have some test slides scanned and decide for yourself.

Interpolation

This 35mm slide of a covered wagon (above left), was scanned twice. First at the scanner's maximum optical resolution of 4000 ppi (left), and again at a higher, interpolated resolution of 10,000 ppi (above). The loss of sharpness in the interpolated scan is obvious.

USING PHOTO CD

Kodak's PCD format

Kodak's film digitizing service operates mainly through highstreet outlets. Its proprietary "Image Pac" has a set of five resolutions on the amateur CD. The so-called "Base" is at screen resolution of 72 ppi, while there are two smaller files for thumbnail images, and two larger ones.

D:\COREL\800

2048x3072

300 pp

RGB 8 Bits/Channel

Candscape

C Portrait

KODAK Photo CD 4050 K-... 👻

KODAK Photo CD 4050 E-6 V3.4

KODAK Photo CD 4050 K-14 V3.4

ODAK Photo CD Color Negative V3.0

KODAK Photo CD Universal E-6 V3.2

KODAK Photo CD Universal K-14 V3.2 Std Photo YCC Print

-

+

Kodak PCD Format

	Source
	Pixe
A A C	F
1 the Cont	Fil
21 Contraction and a	Destina
	Resc
Image Info	Color
Original Type:	Orion
Product Type:	Orien

		X
	Levels	
	Channel: RGB + Input Levels: 0 1.00 255	OK Cancel
	a within the second	Load Save Auto
0040.PCD	Output Levels: 0 255	Preview

Photoshop correction

Dynamic range remains a problem with some images in Photo CD. Here, typically, the highlights are blown out. The histogram shows that the image's tonal range exceeds the maximum at both ends: shadow and highlight.

ONLY OPTICAL RESOLUTION COUNTS

As with digital cameras, it is essential to pin down the optical resolution of a scanner from its specifications. All scanners include software that will interpolate the real measurements upward, and all scanner manufacturers are happy to claim these higher figures. What you are paying for, however, is the optical resolution, and you may well be able to do a better job of interpolation yourself later in an imageediting program, if you need it.

TYPES OF SCANNER

here are three groups of machine: Drum scanners, which are the top-of-the-line professional choice; slide scanners, which use a CCD array and usually fit on a desktop; and flatbed scanners, also CCD and designed for larger originals like prints and other kinds of flat artwork. All of them perform the same basic function of digitizing

All perform the same basic function of digitizing images in a form that can be loaded into a computer images in a form that can be loaded into a computer for editing and manipulation. Which to use depends on the kind of image you have-and on the quality you need. Scanners come equipped with their own software, the quality of which can make a

tremendous difference to the final scan, but they all save their files in formats that can be opened easily by image-editing programs. Like external drives, scanners connect to the SCSI or USB port on the computer.

Drum scanners, though very expensive, offer the highest quality-indeed, the yardstick against which you can measure all scans. The film is taped to the circumference of a transparent drum, which then spins. A photomultiplier converts the reading taken from a narrow beam of light into a digital signal, at one pixel width for each revolution. These are the workhorses of the printing industry, and have tremendous capabilities that demand a high level of operator skill. Their two advantages are resolution and dynamic range. Maximum optical resolutions are in the range from 8000 to 18,000 ppi, depending on the model, while the density range approaches the maximum of 4.0D. When you need the very best, it is worth paying a bureau to make a drum scan.

Film scanners are most photographers' choice. While they use a CCD array, and are rather less sensitive than a drum scanner's photomultipliers to the full range from highlights to shadows and with lower resolution, the best give virtually professional quality. They use a row of sensors known as a linear array, as opposed to the CCD matrix in a digital camera, and this row reads the transparency a step at a time. In operation, a light source travels along the transparency

TWAIN

In order to coordinate different makes of scanner and the editing programs that must be able to open their files, there is a widely-used set of standards known as TWAIN. Most scanners are TWAIN compliant, but check your choice before buying.

35mm scanner

Some film scanners accept only 35mm film. The speed of scanning varies, as does the quality.

Film scanner In a typical film-scanner the transparencies are fed in from the side.

54

SCANNERS

and this is focused by a lens and mirror onto the sensor strip. Good film scanners can give optical resolutions up to 4000 ppi with a density range approaching 4.0. Many models accept only 35mm film; a few take medium-format as well.

Flatbed scanners are also CCD devices, with a large glass platen on which the photograph, or artwork, lies face down. The most common size has a scanning area of around 11 x 17 inches for prints and a little less for transparencies (which makes them useful for large transparencies but less so for 35mm). As in a film scanner, the CCD array is a long row of sensors covering the width of the bed, and onto which the scanner optics focus a thin slice of the picture. Most flatbeds, even in the moderate price range, offer an optical resolution of 1200 ppi, using CCD arrays with 8640 elements. Incidentally, it is common for manufacturers to claim a higher resolution along the length, such as "1200 x 2400 dpi." Ignore this. It simply means that the array is being stepped in increments half the width of the sensors, and that is not a true optical improvement. Density ranges can be as high as 3.7–3.9.

WHAT TO LOOK FOR

- Accepts the size and type of originals that you mainly use
- Sufficient resolution
- Good dynamic range
- Bit depth

Linescan

200

Good software

Color-corrected viewer

Wherever possible, compare the on-screen result with the original. Specially colorcorrected transparency viewers are made for this purpose with calibrated light sources and filters. The light intensity is deliberately low, and for small transparencies the viewer also should be small, to avoid a glaring white surround.

Drum scanner

Drum scanners give excellent results, but are priced at a level that is accessible only to commercial users.

Flatbed scanner

The flatbed is the most familiar type of scanner to computer users, here shown with transparency adaptor. Many modern flatbeds come with modules enabling you to scan transparencies as well as prints.

THE SCANNING **OPERATION**

ood scanners (and any other kind are a waste of money for photography) offer a sophisticated array of settings, which can be daunting at first. However, if the software is well written, as most are, you could do worse than

follow the automatic setting-the default. The scanner first makes a quick pass over the image; this is the prescan, and the purpose is to analyze

the values. The image is displayed on the screen, so you can adjust it to how you want it to appear.

For most photographers, image quality can never be too high. Surely, then, the higher the resolution of a scan, the better? Well, it depends on how you are going to use it, because cost, hard-disk space and image-processing time are all important-and they all rise with the resolution. There are three standard kinds of output for an image: on-screen, printed, or onto photographic film. Which you choose determines the resolution that you need. In any case the best idea is to scan to the actual size it will be used.

Screen images are fairly straightforward. The resolution is around 72 ppi and the most common monitor size is 15-inch diagonally, so that if you are intending to post the image on the Web, 800 x 600 pixels is the reasonable maximum. Even that is full-screen, a size that most Internet users prefer to download; for speed of loading, most photographs are initially displayed much smaller, such as 200 x 150, or even as thumbnails.

Print is in two main forms-desktop printing and lithographic-but for both you should work at the same resolution of 300 ppi. In half-tone reproduction (repro) for lithography the image is screened, i.e.

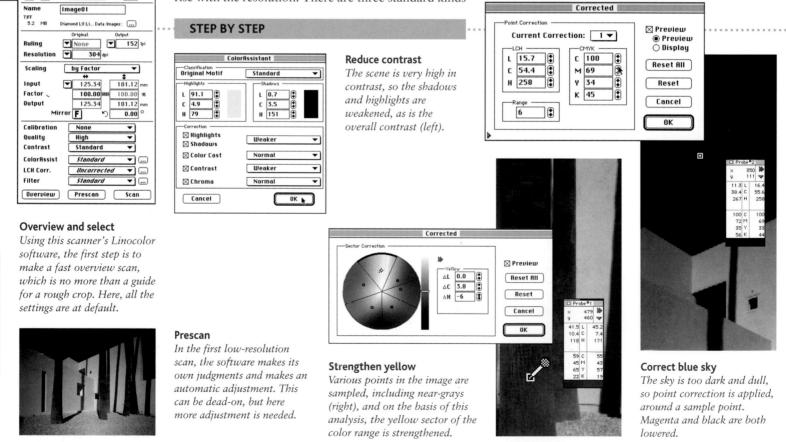

For most photographers, image quality can never be too high

SCANNERS

converted into a grid of dots. The screen frequency for high-quality printing is typically 150 lines per inch; the rule of thumb is to prepare the digital image with twice that amount of information—300 ppi.

Real photographic quality is much higher. For making a colour transparency, a film recorder usually outputs at 1200 ppi. As a glance at the table (right) shows, a high-resolution image is very large. Whether it's convenient or even practical to edit an image of such a size depends on the memory and performance of your computer.

NECESSARY RESOLUTION

Output as	Image area	Re	solution	Fil	e size
	mm	inches	metric	RGB	СМҮК
Typical Web site thumbnail	32 x 24	90 ppi	35 ppm/Res 35	30 KB	38 KB
Fullscreen Web site image	226 x 169	90 ppi	35 ppm/Res 35	1.4 MB	1.8 MB
Postcard-sized print	152 x102	300 ppi	120 ppm/Res 12	6.2 MB	8.2 MB
8"x10" print	203 x 254	300 ppi	120 ppm/Res 12	21 MB	28 MB
16"x20" print	406 x 508	300 ppi	120 ppm/Res 12	85 MB	107 MB
Typical magazine full page	200 x 300	300 dpi	120 ppm/Res 12	26 MB	33 MB
Magazine double-page spread	400 x 300	300 dpi	120 ppm/Res 12	50 MB	67 MB
6x6 cm film	55 x 55	1200 ppi	480 ppm/Res 48	20 MB	27 MB
6x7 cm film	55 x 70	1200 ppi	480 ppm/Res 48	26 MB	35 MB
4x5 inch film	95 x 120	1200 ppi	480 ppm/Res 48	75 MB	100 MB

Channel: Lightness ¢

Lighten shadows

After the high-resolution scan, further adjustment is made in an image-editing program. The shadow areas are lightened with the curve, making sure that the lighter tones are not affected.

Clean up

As always with a scan, dust and blemishes are recorded. These are retouched here with the cloning tool.

NEWTON'S RINGS

When the film original comes into contact with the glass of a flatbed scanner (film scanners have no glass), there is a risk of interference patterns known as Newton's rings, as with slides in a projector. Removing them from the image is possible but tedious: Paint a soft-edged mask in your image-editing program, apply a slight amount of Gaussian blur, then restore the appearance of the film grain with a noise filter (as below, showing before and after). Or try repositioning the transparency and rescanning. Better still, mount the film between two sheets of card to keep it out of touch of the glass.

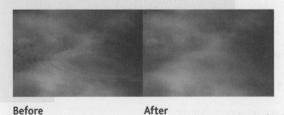

COLOR GAMUT

Lab, RGB, and CMYK

These are the three gamuts, or color spaces, most commonly used in image editing. Lab (right) is by far the largest, and has much to recommend it as a working space, as nothing is lost (see page 77).

THE PERFECT SCAN

hile a scanner's own software can produce good-quality results at its automatic default settings, a skilled operator can usually do better, particularly when the image is in some way difficult. By this, I mean a high-contrast range, or particularly subtle gradations of color (as in flesh tones), or a concentration of tones

A good scanner deserves to be used to its full potential—and an average machine can always be made to perform better in the highlights or in the shadows. A professional-quality scan takes more time and skill, but a good scanner deserves to be used to its full potential —and an average machine can always be made to perform better.

As in all aspects of digital imaging, first think of the output. You should always tailor a scan to the exact use to which you will put it. This means knowing the size, the file format, resolution, and all the special needs and quirks of the printer—or other output device. In fact, there are two opinions as to what constitutes perfect. The more obvious is that the scanned image should look as good as possible, be sharp, with bright highlights, deep shadows with detail, and saturated colors. The other opinion holds that it is better to capture the maximum amount of information, even though the result may look rather flat, so that adjustments can be made later, in image-editing.

Really this is a question of spreading the workload between scanning and editing. It partly depends on personal preference, but also on which program's tools are the more efficient. For the best resolution, try to stay within the optical resolution of the scanner. If you need a larger image, make a test between interpolation on the scanner and interpolation in image-editing and check it at 100 percent.

WHITE POINT/BLACK POINT

The trick in using these is to find the lightest, or darkest, part of the image that contains detail. Do not choose specular highlights such as reflections off chrome, or the black film rebate outside the image. Once selected, you must then decide which value to enter—a matter of judgement. Avoid solid white (0) and solid black (255); a slight tone, such as 2 for the white point and 253 for the black, is likely to be better. Much depends on the photograph.

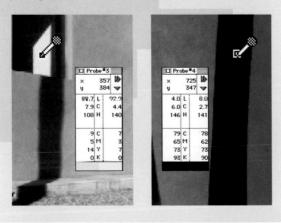

DOUBLE SCANNING

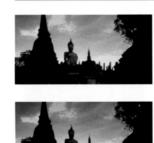

Shadows and highlights Using the software to adjust the tonal range, two scans are used for this challenging photograph—one capturing shadow detail at the expense of highlights, the other maintaining the brightest parts of the sky while losing the deep shadows.

The setup

The first prescan uses the default settings, and limits the range (top). The contrast box is then set to Lights, which concentrates on the upper end of the tonal range.

es: [....]

▼ 152 Þ

100.00

CLEANING UP

The final stage is to import the scan into an imageediting program and fine-tune it. Working methods vary, but mine is as follows, and I do it immediately after scanning while the idiosyncrasies of the picture are still fresh in my mind:

• Compare the on-screen image with the original. For this it is essential to have the original transparency on a color-corrected light box next to the screen. The light levels of the screen and light box should also match each other.

• Check the histogram (in Levels in Photoshop) to see if there are gaps left and right, and consider closing these up.

Use Curves to make any necessary color adjustments.
Starting in the top left corner at 100% or even 200% magnification, work your way down to the lower right corner, removing all blemishes with the clone tool.

• Sharpen as necessary with USM.

	e: Normal	:		
Opacit	y:	100	×	
Advanc	ed Blending			
Fill Opacit	y:		×	
Channel	s: 🗹 L 🗹 A 🗹	B		
Knockou	t: None 😫			
	Blend Interior I			
Ble	nd lf: Lightness	•		
	This Layer:	0	255	
-				-
	Underlying Layer:	70 /175	255	
	4			-

Blending the pair In an image-editin

In an image-editing program, the highlight scan is placed in a layer above the shadow scan, and blended by eye with the sliders. The two layers overlap in the midtones, where most care is needed in the blending.

	Y- 14	
1		
	11	
27.		the last of the last

In practice, most of the skill in scanning goes into maximizing the dynamic range. You can check this by first making a quick lo-res scan, opening it in an imageediting program and looking at the histogram (*see pages 108–9*). If it doesn't fill the graph from left to right, it doesn't use the full range possible. Essential tools in the prescan are the white point and black point selectors (eyedroppers). Use them to set the ends of the range: the lightest and darkest points. Even so, there may be certain clusters of tones—say, from the midtones to the medium-dark shadows—in which you want extra separation. As a last resort this can be worked on later, in an image-editing program.

High-key and low-key photographs always fool the sensors, just as in the camera, because they are a matter of judgement. The first is light overall, the second dark overall, and of course that's how they are intended to look. The automatic settings that the scanner would like to apply would render high-key images

muddy and low-key ones washed out in the shadows, but even ignoring this, they are difficult because you are trying to hold detail while keeping one end of the range pegged close to an extreme, cither light or dark. Lowkey images are a particular problem because CCD scanners have difficulty reading deep shadows. The

answer is to use the white point for high-key and black point for low-key.

There is a way of extending the dynamic range. It is tricky to pull off, but is a valid technique. Make two scans, one of them pegged to

> the highlight, the other to the shadows. In each case you will have lost information at the other end of the scale, but by combining them in an imageediting program, you can have the best of both worlds. Load one image on top of the other in a layer, and use the blending sliders. This calls for some experimenting, and the settings vary according to the mode.

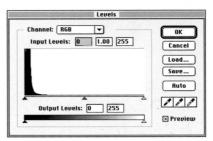

Low-key images

Some pictures are intended to be dark, like this black swan on a lake in shadow, but the scanner has no way of knowing this. Set at automatic, it is likely to produce a version that is too pale (top). As it should be (above), there is plenty of rich black, and the histogram, with all the tones crammed to the left, in this case is perfectly correct.

SCANNERS

INTERNAL, EXTERNAL

he first place of rest for digital images, whether from the camera or scanner, is likely to be the hard drive on your computer. The storage capacity of these varies, but is usually substantial—in the order of many gigabytes. However, digital photographs are among the most space-hungry

Sooner or later, your hard drive will fill up: the answer is removable storage

MAINTAIN YOUR HARD DRIVE

Writing, rewriting, and removing files gradually fragments a disk. Where there were once large tracts of open space into which entire folders of files could be placed, the disk gradually becomes a patchwork of data, akin to unplanned urban sprawl. This means that new files must be put wherever the system can find space, so that the heads take longer to write and to read. Use a utility such as Norton every so often to defragment the disk.

files in computing. The entire text for this book, for instance, takes up less than one megabyte on my laptop, while one RGB TIFF image from a 3megapixel Nikon D1 occupies 7.8 MB. Sooner or later, your hard drive will fill up.

When you move into image editing, file sizes increase dramatically as you add layers and make copies. Moreover, any reproduction-quality image will need tens of megabytes; for instance, around 30 MB for a full-page color picture in a magazine. Photographers are raised on image quality, and most of us will take the highest resolution option if given a choice. Moreover, you will often want to move pictures from one computer to another, and large image files take a very long time to transfer by e-mail.

The answer is removable storage: Some means of

Zip drives

These removable hard disks, in the form of cartridges, are one of the standards in desktop computing. If you are sending image files out for printing, or are buying a highresolution scan, the bureau will certainly have a Zip drive. The cartridges are in 100 MB and 250 MB sizes.

keeping image files accessible but out of the computer. There are several very different systems available, and each has its own particular advantages. Cost is one issue, but also consider the storage capacity (for this reason floppy disks are not suitable), how secure the data is, and how widely used the system—if you send image files to a service bureau, a printer, a friend, or a client, it will have to be in a form that they can use (email, as stated above, takes too long). A secondary issue is speed—some media allow faster access than others —but if you move images between the hard disk and the removable storage only occasionally, this is not particularly important.

There are two costs: the drive and the media. A magnetic drive like a Zip, for example, is inexpensive because of its popularity, but the disks themselves are relatively expensive. On the other hand, a CD-R recorder is more costly, but the disks are not. The data must also be safe—that is, long-lasting and not vulnerable to damage. Magnetic media have the disadvantage of being susceptible to magnetic fields—place them near a strong magnet and the entire image may be lost for ever. CDs are much more rugged. So why bother with magnetic drives at all? First, the drives are cheap;

Magneto-optical

Also known simply as optical, this technology makes use of a magnet to give polarity, and a laser to write and read data. They have the advantage over other magnetic devices of the information not being susceptible to magnetic fields.

STORAGE

Media	Number of images				
	Typical 3-megapixel JPEG basic	Typical 3-megapixel JPEG normal	Typical 3-megapixel JPEG best	Typical 3-megapixel TIFI uncompressed	
File size	300KB	700KB	1.3MB	8MB	
250 MB Zip	800	350	200	30	
650 MB CD-R	2100	928	500	81	
1.3 GB MO	17,300	7400	4000	650	
2.6 GB DVD-RAM	31,300	13,400	7200	1175	

second, most computer users who work with images have them. And, being easily rewritable, you can use them over and over.

Finally, the computer world is even more impermanent than the real one. Inventions are superseded, some more quickly than others, and products sometimes fail for business reasons. As a consumer, you may find it difficult to predict these failures. Few people in the early 1990s would have expected SyQuest removable hard disks to disappear from the scene. They were the desktop industry standard, but the company failed to meet the competition, and now we have Zip drives instead. Of all such media, CDs will probably end up having the longest life of all, not least because most

CDs

Varieties include CD-R (writable), CD-RW (re-writable), and PC-RW. These are CD-ROMs on which you can store large amounts of data—650 MB on each—by using a CD writer. A hard polycarbonate substrate carries a groove, which in the process of recording is followed by a laser to burn a series of spots. A metallized layer on top forms a tiny pit, which can be read by a lower power laser. CDs are ubiquitous, cheap, and the data stored on them is relatively safe.

computers have a built-in drive. But even they have challengers like DVD.

CDs now have such a deeply entrenched user base that the introduction of DVD (Digital Versatile—or Video—Disc) technology has forced drive manufacturers to design devices that offer more compatability than ever before. The latest DVD recorders allow you to record not only 4.7Gb DVD-ROMs (read only) and DVD-RWs (re-writable), but also our old capacity-challenged 650Mb friends CD-Rs and CD-RWs, providing you with the means of staying compatible with the past as well as taking advantage of new developments—but at a price, of course.

In use, most removable media are straightforward. The drive connects to a port on the computer, often USB, and you install the software onto the computer. Insert the cartridge into the drive, and it loads automatically with the icon appearing on the screen.

WHAT TO LOOK FOR IN REMOVABLE STORAGE

- Widely used by others
- Storage capacity (MB or GB)
- Long-lasting
- Permanent or re-writable?
- Likelihood of obsolescence

DVDs

With a DVD re-writable drive, you have the option of writing to the DVD format developed for movies and large data storage. DVDs are currently available at around 5 gigabytes and over 9 gigabytes.

61

BACKUPS AND ARCHIVES

hings will sometimes go wrong, especially in computing, and often for obscure reasons. Always remember that it is easier for a

digital photograph to be deleted by accident than for a slide or negative to be destroyed. However, copies are identical to the original, unlike those of silver-halide film, and

Copies are identical to the original, unlike those of silverhalide film, and easy to make

Although there is hardware and software available dedicated just to making backups, you can use any procedure that suits your working method. In fact, method

> is the key, because it takes a small but necessary amount of self-discipline to make backups regularly. While easy to do, it's also easy to put off, because it takes time just when you want

easy to make, so there is every good reason to to make them regularly. As the polite version of the maxim has it, "to prevent messups, make backups." of

to shut down the computer and go away.

There is, actually, a formula for working out how often to make backups of your work. It is the amount

System	Pros	Cons	Best use
Zip	Widely used	High storage cost	Short-term storage
	Cheap drives	Cartridges vulnerable to magnetic fields,	Sending image files to
	Fast	impact, dust	bureaus, printers, etc.
		Expensive cartridges	
		Limited capacity	
Magneto-optical	Cartridges impervious to magnetic fields; rugged	Expensive drives	Long-term storage
	Quite widely used	Slow	Sending image files to
	High capacity	Disks vulnerable to scratching	bureaus, printers, etc.
CD	Disks impervious to magnetic fields; very rugged	Expensive drives	Archiving
	Images permanently stored	Disks vulnerable to scratching	Transferring large files
	High capacity		
	Multiplatform		
DVD	Extremely high capacity	Expensive drives	Archiving
	Increasingly used	Disks vulnerable to scratching	
	Disks impervious to magnetic fields; very rugged		
	Images permanently stored		
Таре	Cheap drives	Searching slow	Cheap high-volume storage
	Cheap tapes	Tapes vulnerable to print-through, magnetic	for short periods
		fields, dust	
		Needs backup software	

WHICH STORAGE SYSTEM?

STORAGE

of time backingup takes in relation to how long it would take to redo all the lost work without flying into a rage, and so depends not only on how quickly you work, but how short your temper is.

Backups are easiest to do on the hard drive—just make a copy—but they remain vulnerable to a computer crash. It's safer to make them to a removable drive—and then remove the backup to another room. DAT drives are the standard professional backup medium in computing, because they can handle huge amounts of data and use software that plans the backup without your having to think about it, such as updating only the parts that have changed since the last backup. Nevertheless, the drives are not cheap.

For most desktop users, the simplest method is to use the fastest removable drive that you have, buy a few cartridges and rotate them. So, if you were to backup every week and used four cartridges, you would have four progressive copies that rotated monthly.

Archives are permanent storage, and so have some of the functions of backups, but demand that the data remains unchanged and readable almost for ever—has "integrity" in computerspeak. That lets out magnetic drives and tapes and favors CDs and DVDs. Nevertheless, these are vulnerable to scratching, which means handling them carefully, keeping them in their jewel-cases, and not using them as coasters. As your collection grows, you will then have to

find a way of cataloging them and keeping some reference of what is where. That is the job of imagemanagement software, yet another program to play with, which is explained on the following pages.

An intriguing alternative to all of this is on-line storage. This is a service to which you send digital images and which then makes them available for viewing on a Website (FotoAlbum and Zing are examples). Be circumspect if you use one, unless you have boundless confidence in the typical dot.com business model. Give them copies, keep the originals.

CD-ROM archive

My own archiving is on nonrewritable CDs. As soon as I have accumulated about 600 MB of new images, they are burned onto a new CD, which is titled in sequence (98, 99, 100, and so on) and labeled. An image manager (next page) keeps track of everything.

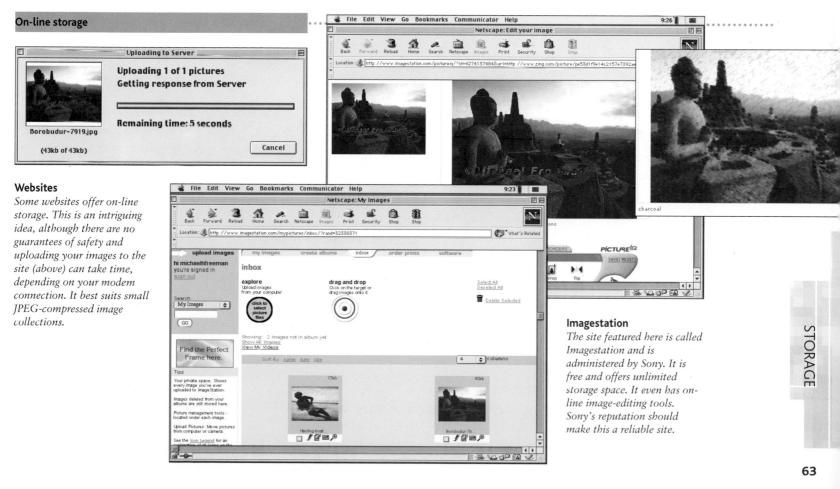

MANAGING THE LIBRARY

mage managers (sometimes called media asset managers in the tedious jargon of professional imaging) are programs that collect images and their information in such a way that they can be viewed, cataloged, arranged, and organized. There are a large number of them and, as you might expect, they vary in their ambitions (also in their achievements).

Only a computer database can keep track of all this, but it requires careful planning

Those supplied with the camera tend to be fairly simple because their main job is to transfer images to the computer; at the opposite end of the scale are databases for managing large collections at a professional level.

Some, like Photo Wallet and Piccolo, concentrate on acquiring images direct from the camera's memory card, and have special drivers that can acquire images from most, if not all, makes of digital camera. Others, like Cumulus, are primarily visual databases, and have a powerful search engine that allows them to find images anywhere on the hard drive or in any media that are connected to the computer, and to search among file information and entries

> written by the user. Yet others, like PolyBytes' PolyView, include imageediting tools. All of them will print thumbnails, usually in a choice of sizes and layouts, so as to give the equivalent of a traditional contact sheet.

> There is no shortage of choice, and while you should certainly investigate which of the many specifications best suits your needs, the core functions are generally the same. Much more important is what you do with the image manager, and that means planning how to catalog your picture

library. Digital images call for a new way of thinking about photographs. The basic unit is no longer a slide or negative, but an image that has no physical presence. Moreover, there may be several versions as you alter them. If you follow normal practice you will be building up an archive on CDs or similar media.

IMAGE AND VARIATIONS

In the example here, the image number has a suffix if it is a version of an original. Retouched and corrected images are considered versions, but substantially altered images are treated as originals; in both cases, the original source(s) is identified. CDs, the basis of the library, are numbered consecutively as they are written, and filed in order on a shelf.

Record		
#	unique number	
Title/subject	simple name	
Description	more detailed	
Where	place shot (not applicable if	
	created in the computer)	
When	date shot or created	
Keywords	for searching	
Source	original digital (camera), from film	
	(scanner), edited digital or CGI	
Other version(s)	if altered digitally	
Size & format	file size (MB), color mode, file	
	format, compression	
Physical location	which drive if digital, or which	
	tray/cabinet of film	
#	17118.15	
Title/subject	IceHotel lobby	
Description	Chairs carved out of ice	
Where	Kiruna	
	Lapland	
	Sweden	
When	Mar 6, 2001	
Keywords	ice, hotel, chair, cold	
Source	original (D1)	
Other version(s)	117118.15/01 (enhanced blue)	
Format	3.1 MB RGB TIFF uncompressed	
Physical location	CD #105	

WHAT TO LOOK FOR IN AN IMAGE-MANAGEMENT SYSTEM

- Compatible with your platform
- Can read all the file formats you are likely to produce
- Allows you to add information
- Efficient search engine
- Ability to change the file name

The first step to keeping chaos at bay is to give each image a unique locator number. This can be in any form, but numerals make searching easy, and you may as well make the system logical, such as numbering in the order in which the photographs are shot, or beginning with the year. The next step is to identify where each digital image is stored (such as on what number CD) and, if you are scanning slides and negatives as well as shooting digitally, you will also have to identify where the original film is kept. Other information you record depends on what is important to you,

Presentation

Most image managers work in a similar manner, with the initial interface a window containing thumbnails, as in this catalog opened in iView 2.8.6, a shareware program. The window can be adjusted in size, and the thumbnails then reorder automatically. To add images, the manager searches the available drives, including whatever removable storage is loaded, and creates its own thumbnails.

but do not include so much of it that it becomes a chore to catalog each picture.

Only a computer database can keep track of all this, but it calls for careful planning before you start. The record for each image is likely to carry more information than if you were filing film, partly because you will need to create links between the different versions of an image, and partly because there is much more technical information associated with a digital image —its file size, how it was scanned, what was done to it, and so on.

USING THE IMAGE MANAGER

iphoto.fdb - Ur Portfolio Desktop Edition - [d io Desktop Edition - [di - 01 -1812 ing 91 of 91 rec 800003.P.. 800090 P., 800001 P., 800002 P. 800004.P... 800005.P... 800006.P... 800007.P... 800008.P.. 800009 P 800010.P... 800011.P.. 800012.P. . 800013.P... 800014.P... 800015.P... 800016.P... 800017.P... 800018.P... 800019.P. . 800021.P. 800022.P. . 800026.P... 800027.P... 800028.P. 800029 P 800020 P 800023 P 800024 P 800025 P 800036 P 800037 P 800039 P 300030 P 800032 P 800038 P 900031 D 800033 P 800034 P 800035 P General Keywords | Fields | 800044.P... 800045 800013.PCD 4372 K File Size File Type: PCD COREL BOONCORE Modily Diate: 07/03/1995 01:42:18 Catalog Date: 10/05/2001 16:53:28 Indate Date: 10/05/2001 16:53:28 Create Diate: 07/02/1995 01-42-18 ive group with head decora Cancel

Customizing thumbnails

A dialog box allows you to customize this image manager, Portfolio Desktop Edition 5.0.2 from Extensis, to suit your way of working. This includes choosing the information to be displayed and the size of thumbnails large to the left, small above.

Entering information

For each image, descriptions, keywords, and search fields can be added by the user, in addition to the basic information automatically stored by the program. This information can then be used for searching and display.

IMAGE FILE FORMATS

here are numerous ways of storing computer images. These are called file formats, and they differ according to the computer platform whether Mac, PC, Linux, or Unix—and they differ again according to the hardware and software. None of this would matter very much if you only had to work with one, but in practice you will have to deal

Each file format has features that make it more suited to one kind of image or use than another with several, as the images you work on are moved from one application to another: Scanner to computer to an image-editing program to the Web, and so on. Digital cameras, relative newcomers to the digital imaging scene, all comply with the long-estab-

lished file formats, in particular JPEG and TIFF.

Each file format has features that make it more suited to one kind of image or use than another. Working with photographs, you need to be familiar with half a dozen and have a nodding acquaintance with another few. They are identified by a suffix to their name, such as .pic, just like any other kind of file. Just to confuse matters, some file formats, like JPEG, are also methods of compression.

Image compression is the key to keeping large images manageable, as we saw with digital cameras. It is a solution to the usual digital problem of memory and speed—if memory and storage space were unlimited and all files could be moved around instantly, we wouldn't need compression. But they aren't and can't and we do. This is a highly technical area, but because of its implications for the quality of an image, it's as well to be aware of what happens.

We're talking about bit-mapped images here and, without compression, the program simply counts all the pixels and their values in an order it can reproduce. Imagine a landscape photograph taken on a sunny day; start at the top row of pixels and check them off one by one. Because the sky is blue, some of the pixels will have the same value—on the first row, say from the 93rd to the 140th. Instead of logging the values for each, you could write, in much less space, that 93 to 140 were at such-and-such value. That is, in fact, more or less how one well-known compression system, LZW (Lempel-Ziv-Welch), works. Most methods, though, are more complex.

Compression can be either "lossless" or "lossy," which are fairly self-explanatory. LZW is lossless, and when the image is decompressed, nothing has been lost. However, lossless compression does not reduce the file size very much—perhaps by 50 percent. If you want a small file, lossy compression such as JPEG is the solution, but you will lose some detail. You can select the amount at the time of saving the image. Depending on how you intend to use the photograph, the amount of loss may not matter so much, but you should make your own tests at different settings before settling for a particular level of compression—and compare the results at 100 percent magnification. It is not, however, useful for image-editing, because it compresses each time you save an image, thus degrading it.

FILE FORMATS

TIFF (.tif)

As we saw on page 23, TIFF files (Tagged Image File Format) are used by digital cameras for saving photographs without compression and in a widely readable form. Originally developed by Aldus, TIFF has become a standard in image-editing. It supports 24-bit color and some versions allow lossless LZW compression, which can reduce file size by more than 50 percent.

PICT (.pic)

A standard image-editing format for the Mac only.

BMP (.bmp)

A contraction of "bitmap," BMP files are a Windows standard, and are device-independent, meaning that they do not rely on the method used by each different monitor to display color. In this way, BMP addresses one of Windows' chief imaging drawbacks (*see pages 38–9*).

NATIVE OR TRANSFER

Digital cameras and imaging software may use their own proprietary way of writing images, known as a native format, to take full advantage of their special features. Other programs cannot read these, so images are usually saved in a transfer format.

QUALITY OR SIZE

Uncompressed TIFF The standard against which to judge compressed versions the best quality that the camera or scanner can deliver.

LZW-compressed TIFF This system is lossless, does not degrade the image in any way, and so is perfectly safe to use and reuse.

JPEG High quality Compared with the two images to the left, the highest quality JPEG shows little loss of detail or change of color.

JPEG Low quality At maximum compression all kinds of destruction takes place, to detail and color, with many artifacts.

In this close-up of Greek religious medallions, imaged in the most common file formats, loss of quality with compression is visible only at substantial enlargement, and is most obvious at the greatest compression (the right-hand pair of the four). Interestingly, at maximum compression you can also see the 8-pixel-a-side compression blocks.

Photoshop (.psd)

The most widely used of all image-editing programs has its own native format to cope with layers, transparency, and other special features.

JPEG (.jpg)

Described on pages 72–3, JPEG is a storage format as well as a compression system. The compression uses a mathematical procedure called the discrete cosine transform (DCT) and JPEG takes as long to decompress as to compress. A new improved version, JPEG 2000 uses wavelet compression instead of DCT for 20 percent higher compression, better color preservation, and the addition of a lossless compression setting.

CCD Raw (.crw)

A digital camera raw-data format used by higher-end cameras (*see pages 32–3*), it contains more information than TIFF or JPEG, but needs the camera manufacturer's proprietary software to open and read it.

Photo CD (.pcd)

Kodak's scanning service for delivery on CDs uses its own format, Image Pac, for storing images that are each available in five resolutions (six on a Pro-Photo CD). An image-editing program like Photoshop can open these files.

GIF (.gif)

The Graphics Interchange Format was developed by Compuserve for transmitting images, and is widely used on the Web. However, supporting only 256 colors, it is intended for illustration rather than photographs. It supports LZW compression.

EPS (.eps)

Encapsulated PostScript files were devised by Adobe for PostScript printers and are used in drawing programs and for export to printers. Bitmap editing is not possible on them.

WHY TO AVOID COMPRESSION

A typical photograph contains a mass of irregular detail, which compression is not good at handling. Almost every piece of photographic equipment aims to improve image quality. Lossy compression goes in the opposite direction, although at minimum compression the effects may be undetectable.

PRINTING

rinting is both a science and an art. At the commercial level, such as in producing a magazine or a book like this, it is best left to professionals, but at a personal level, any computer owner can easily achieve good results with desktop printing. However, there is such a range of technology in use among desktop printers that we will have to look

Any computer owner can easily achieve good results with desktop printing at each type at a time, but here I'd like to introduce the principles that they have in common, which are quite different from the methods used by digital cameras, scanners, and monitor screens for handling pictures.

In everything I've dealt with so far, colors have been created by combining red, green, and blue (RGB), the so-called additive primaries. A printed image, however, works by reflection, and uses a different set of colors: cyan, magenta, yellow, and black (CMYK for short, with K used for black to avoid any confusion with B for blue). The first three-cyan, magenta, and yellow-are the opposites of RGB on the color wheel, and each can be created by mixing two of the others, so that green and blue, for example, makes cyan. Because printing inks and pigments are laid down on white paper, they absorb light, so that in theory at least, cyan, magenta, and yellow on top of each other make black. For this reason, they are called subtractive primaries. In practice, because ink spreads into the paper, the result is dark brown, so a separate black ink is added. A few more colors are possible in RGB than in CMYK, as you can see from the diagram on page 57, although CMYK can create some colors that RGB

COLOR SEPARATIONS

Color complexity

This British ceremonial military uniform appears at first to contain blocks of simple and clearly differentiated colors. However, when broken down for printing each single color is made up of a combination of all four inks.

Cyan

Yellow

Cyan, magenta, and yellow

Black

Four color separation

Color printing usually uses four plates. Printers can adjust the intensity of any of these in order to achieve the balance that is closest to the result desired. Unlike RGB color, the printing process requires a separate black.

PRINTERS

cannot. Image-editing programs, as we'll see, can convert from one to the other, but in either case throw some colors away. RGB screens are only capable of displaying red, green, or blue colors, so CMYK colors are simulated by blends of these three. Because the color ranges are slightly different, however, there are some mutually exclusive shades, and the RGB simulation will choose the nearest color, sometimes resulting in a slightly inaccurate match. If you convert unnecessarily from RGB to CMYK, your photograph will lose some of its range. Desktop printers, although they print in CMYK, make their own conversion from RGB, and that is the color model to work in. In commercial printing, like this book, photographs and illustrations are scanned in a process that makes four passes over the

HALFTONES

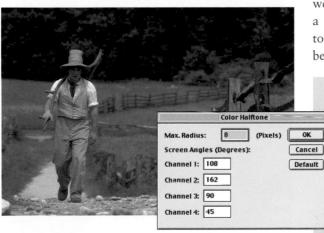

Halftone simulation In some image-editing programs such as Photoshop, you can simulate the

appearance of halftone

screening on-screen. The

dialog box allows you to experiment with different screen angles The effect is deliberately exaggerated in the image below.

image. Each one "reads" for one of the CMYK colors, from which individual printing plates are made.

The second big difference in the way that printing reproduces a photograph is that it uses dots to create the illusion of smooth changes in color and tone, and at high magnification they show up as a pattern. A photograph has continuous tones, so the printer needs a mechanism for converting these into the dot pattern. The traditional method is called halftoning, in which each of the four printing colors is converted into a screen of dots. Fewer or smaller dots in an area of a color screen gives more weight to the other colors, while the more empty spaces there are between dots, the more white shows through and so the paler the color to the eye.

Most desktop printers do something approximating this, called dithering. Fortunately this does not demand many decisions from the user. Only if you were preparing an image to go directly for repro on a printing press would you have to calculate halftone screens for yourself—and even then it is usually better to leave it to the experts at the other end.

DITHERING

Dithering is a process whereby a printer (or computer) mixes pixels of different colors so as to suggest that more colors are present. Although the number of colors appears greater, the cost is lower resolution, as shown in this detail (right) of a temple in Miyajima.

PRINTERS

INK-JET PRINTERS

n the late 1990s desktop printing broke through an important barrier, and started to make photographic quality available at a low price. Interestingly, the type of machine that achieved this was the lowly ink-jet printer, which was considered entry-level in the printing world. Epson pioneered the technology, and others have followed.

The quality of reproduction from even an inexpensive machine is remarkable

What made this success important was that suddenly, for most people, the entire process could be completed at home, in one place. Printer manufacturers quickly recognized this golden opportunity and are now

working hard to take photo prints away from retail outlets. They make their money from the inks, which is why the printers themselves are such good value. Of course, this means that your operating costs can be high, but there are solutions even to that, as you can save money by using third-part suppliers and continuous inking systems.

The quality of reproduction from even an inexpensive machine is remarkable, and from the more advanced models specifically designed for photography you can expect results almost indistinguishable from a real, continuous-tone photograph (on the right

paper). There is, however, a catch, and that is durability. Most ink-jet prints run if water is dropped on them, and they fade. Both of these limitations are being reduced by new developments, such as fade-resistant inks (Ilfojet Archiva is claimed to take twenty years to fade by 25 percent) and archival paper that has a

Image quality Enlargement of ink-jet printed image.

Desk-top printer

The humble ink-jet printer, standard accessory to even low-cost domestic PCs, produces good color results with the normal four-color ink-jet, and even better if the model takes six colors.

Although a standard for storing object-orientated files, ink-jet printers are not usually capable of handling the Postscript graphics-more correctly termed Encapsulated PostScript (EPS)-that are commonly output by vectorbased drawing applications. Software solutions known as RIPs (Raster Image Processors) are available for many printer models. These enable Postscript graphics to be reprocessed in way that can be interpreted and printed by the printer.

special ink-receiving layer that also resists fading, or is coated with an anti-UV film, but don't expect too much of them. That they look good for a year or two if handled carefully is in itself a triumph of technology.

Ink-jet printers are loaded with liquid ink in cartridges—at the least cyan, magenta, and yellow in a color cartridge, and a separate cartridge for black. Better quality is possible if more inks are included; these are usually a light cyan and a light magenta (with the extra colors this is known as CMYKcm or CcMmYK printing). As the printing head passes over the paper, hundreds of tiny nozzles squirt these inks into clusters of small dots to make up each pixel in the image, and the combination of these overlaid inks, which are transparent, determines the color. Some printers can vary the dot size as well, so as to achieve even more subtle color variations.

As with digital photographs and scans, resolution depends on the number of pixels per inch—or rather, the number of dot clusters that fill the pixels, and a top resolution of 1400 dpi is usual. However, there are

Qimage Pro v12.0 (c)1998-2001 Digital Domain Inc. - 🗆 × File Utilities View Images Queue Prints Page Settings Help Display: 1600x1200, 24 bit, 120 dp.jont Actual: 7.6 x 10.2 in. (314 x 314) Defaults (size = inches) Folde C:\CAMERA\c2500 ▼ Size: 2.00 x 3.00 Dptimize Copies: 1 🕂 🗟 Quick Size 2 S: Browse Folders -{C}1999-10-14 17 5 (C)1999-10-08 18 2 (C)1999-10-08 17 2 (C)1999-10-06 13 4 (0)(0)1999-10-14 -{Q}1999-10-06 13.3 {Q}1999-10-06 13.2 {Q}1999-01-01 00.2 two.jpg ? hree.jpg ++ Print Processing F Print Image/File Info T Hairline Border Global Filter soft2.jpc soft1.ipa smalgrid.jpg short.jpg soft.ipa Monitor ICC: OFF View/Print Queue: 4 images Printer ICC: oly-p4UU-monacu(epsui) 7 MB - ep: 🔺 C:\CAMERA\c2500\{Q}1999-10-08 18.25.11.jpg <6.00 x 4.00: 27 DPI -Interpolation: Max/High/Lanczos :\CAMERA\c2500\(Q)1999-10-14 17.56.33.jpg <2.00 x 3.00: 571 DPI -2 MB - ep Spool All pages at once CAMERA\c2500\Q}1999-01-01 00.20.00.jpg <2.00 x 3.00: 571 DPI - 2 MB - ep + 1 page in the queue

A CHOICE OF PAPER

There are four key figures to check when buying paper for any type of printer with the aim of achieving photographic-quality output: weight, thickness, opacity, and brightness. These parameters are usually printed on the paper packs. Weight (which is broadly related to thickness) is quoted in grams per square meter (g/m²). A heavyweight, glossy paper would typically have a weight of 255g/m², corresponding to a thickness of 0.25mm. Such papers would have an opacity of around 97% and a brightness of around 92%.

It is particularly important with ink-jet printers to ensure that the paper used is compatible with the ink. Some printers and inks are tolerant of different papers whereas others (notably Epson) are less so. In cases of incompatibility, inks will dry more slowly and the full resolution of the picture is often lost. Color casts and reticulation (a surface texturing) can also result from using incompatible media. It is important to ensure that selected media are capable of photographic quality (or "photorealistic"), results—some aren't. Some papers offer us "archival" quality—permanence for up to 100 years. Unsurprisingly these papers do cost more. other factors in printing, and the size of the drops of ink makes an important difference. The smaller they are, the better the resolution looks, with good printers using up to three dozen for each pixel. Beyond this, even a high-resolution ink-jet print is unlikely to look as good as dye-sub print (see the following pages) made at 300 dpi.

INK SAVINGS

One of the frustrations of most printers is that the entire color cartridge must be replaced when just one of the inks has emptied. One way around this is to acquire a continuous inking system. This is a set of large reservoir bottles connected by trihing to permanent cartridges in the printer. After connecting them and using a vacuum pump to draw up the ink, nothing else needs to be done but keep the bottles filled.

PRINTING FROM MEMORY CARDS

You don't have to use a computer to print images from a camera's memory card. Some printers will print directly from the memory card and even allow some basic manipulations. Insert the memory card into the printer slot and print off an index print showing thumbnails of the images. You can then select the images you want to print.

Optimizing printing

Programs such as Qimage Pro, shown here, streamline the process of producing highquality prints from digital cameras. Made to work with any desktop printer, they offer such features as resizing, noise reduction, and sharpening.

DYE-SUB PRINTERS

onsiderably higher up the price range, dyesub printers really do produce prints of photographic quality, without halftoning. They achieve this by transferring dyes from a roll or ribbon onto paper in such a way that they can control the density of the color. "Dye-sub" is short for "dye sublimation," a process in which solid dye is

Dye-sub printers really do produce prints of photographic quality, without halftoning vaporized directly onto paper without going through a liquid stage. Oddly enough, this is the wrong description for all but a few machines, though the name has stuck. Most transfer the dye by diffusion caused by heating, so they

are also called, more accurately, dye diffusion thermal printers. The few exceptions, like Kodak's Approval machines, use a laser for true sublimation.

The transfer roll carries consecutive panels of cyan, magenta, yellow, and black dyes, each the size of a page (this is a costly technique), and the receiving paper is specially prepared to absorb the dye in vapor form (also costly). As the first color panel on the roll passes over the paper, a thermal printing head vaporizes the dye, which diffuses directly onto the surface of the paper. The process is repeated for the other three colors, in perfect registration.

The reason for going to all this trouble is that the process makes it possible to vary the amount of dye the key to a continuous-tone image. The hotter the head, the more dye is vaporized. The temperature of the heating elements in the head can be adjusted, very quickly, to any of 256 settings—in other words, 8-

Dye-sub printer

Although dye-sub printing is, by digital industry standards, an "old" technology, its continuous-tone reproduction is ideally suited to photography. The quality remains superior to that of ink-jet printers, despite recent improvements in the latter. bits for each dye, which is exactly what is needed for photorealism, giving a total of 16 million possible colors. The dyes are transparent, so they are overprinted, doing away with the need for halftoning or dithering. Each printed dot is a square, which matches the pixel in the image, and is denser in the center than around

Image quality

This enlargement of the same image as was shown on page 70, now printed on a dye-sub printer, shows the superior results produced by this type of machine in relation to those from an ink-jet printer.

72

PRINTERS

the edges. Dark dots fill up the square completely, while the light dots fade out to white.

Color laser printers, although at their best capable of photorealistic images, for the most part do not yet match the quality of ink-jet machines, and are expensive. The colors are in four separate (CMYK) toner cartridges, and are transferred to the paper indirectly, via a belt or drum. The laser beam focuses on the belt and creates an electrostatic charge. Toner is attracted to this, one pass for each color, and the paper is then heated to fuse the toners that have been deposited. No special paper is needed.

CHOOSING PAPERS

Though laser printers struggle to match the photographic quality of even a midrange ink-jet printer, care must be exercised in the selection of paper. It is best to select paper advertised for color laser printers for general purpose and rough-proofing in the 90–160 g/m² range. For more exacting work, such as final copies of photographic reproductions, good quality papers and board can be used.

Though laser printers can use "any" paper, use of other media (including equivalent ink-jet media) can, at best, produce poor results and, more significantly, damage the laser printer mechanism—which may prove costly to mend. General purpose photographic-quality papers are not designed for the temperature ranges experienced in a color laser.

Most dye sublimation printers (whether small desktop devices or the large industrial variety) can also print onto most papers and additionally onto treated fabrics and metalcoated boards, achieving proof-like quality. Conversely, some specialized desktop printers, such as Fujifilm's Thermal Autochrome models, require equally specialized paper dedicated to that specific printer, and the use of any alternative can result in serious damage to the machine.

Laser printer

Laser printers used to be regarded as supplying superior quality, but often do not match ink-jet printers. However they have the advantage of printing color pages much faster.

Color laser images A detail of the same image, enlarged from a print made on a color laser printer.

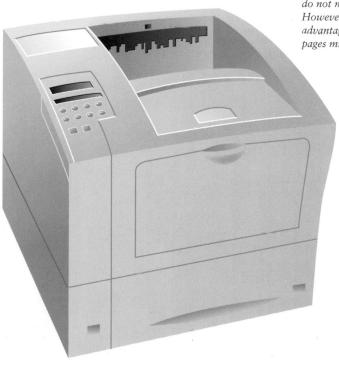

PRINTING SERVICES

he best printing quality comes, not surprisingly, from high-end printers, but most people would be hard put to justify the expense of buying one just for their own use. There are, in addition, some advanced technologies that go beyond the desktop—Pictrography and Iris printers in

If you must have the best, and if you need a large print, then you should look to use a printing service

Postcards to go

An on-line service from Adobe offers a procedure (below, left to right) for creating postcards from users' images uploaded to the site. This particular service then addresses the cards, inserts a message, applies postage, and delivers them to the post office (limited to certain countries). particular. If you must have the best, and if you need a large print, then you should look to use a printing service, which will take an image file delivered on something like a Zip or a CD.

One of the most outstanding printers is the Fujix Pictrography, which uses a unique system that makes silver-halide prints in 24-bit color depth, containing 16.7 million shades of color. The results are smooth and rich, with all the subtlety and range that you would expect from a top-quality conventional photographic print. Blacks are dense and the image is as stable as that of a photographic print. The system uses a photosensitive donor paper, which is exposed by a laser diode scan so that a dye image forms. The donor paper is moistened and transferred by a heat process to the final receiving paper. The latest version of the machine is capable of printing at a

resolution of 400 dpi at up to 18 inches x 12 inches.

PREPARING AN IMAGE FOR A PICTROGRAPHY PRINT

For best results, you should deliver the image as an RGB file in any of the standard formats that can be opened in an image-editing program such as Photoshop. The bureau will scale the image to fit the print area, but of course your original file should not be significantly smaller. The Pictrography printer has a wider color gamut than your monitor screen, so most bureaus offer the option of "Color Match" or "No Color Match." If the former, the print will match your screen view as closely as possible; if the latter, the print will have the widest possible range, but will not exactly match your screen.

The other high quality printing process of note is one pioneered by the Iris G Print printer from Scitex. Iris prints have acquired a special reputation in fine-art photography as the display of choice, even though the system was originally designed for prepress proofing. Devotees claim superiority, particularly in the dynamic range, over even platinum prints, long

PRINTERS

PREPARING AN IMAGE FOR THE IRIS PRINTER

As for the Pictrography, files are normally accepted as RGB TIFF or similar, and at 300 ppi, or at least 200 ppi. So, for example, for an 10in x 8in (250mm x 200mm) print, a 300 ppi image would have to measure 2400 x 3000 pixels, which is 7.2 million for each channel, thus an uncompressed file of 21.6 MB. If 200 ppi, the file would be only 9.2 MB.

considered in black-and-white photography to be without parallel. The Iris is an ink jet printer, but many steps removed from desktop models. One reason for the excellence of the prints is the precision with which the dots are applied by the nozzles. Each pixel in the image is treated as a matrix of 64 dots in an 8 x 8 cell, and the head can vary the size of each dot.

The inks developed for the Iris are more durable than those for desktop printers—for example, Endurachrome ink from ColorSpan is claimed to be resistant to fading and color shift for 25 years under average indoor light conditions. This improves even more if high-quality rag paper is used (images can be printed on any medium that accepts water-based inks). The Ixia is a successor to the Iris G Print (which may be discontinued).

If you still have true faith only in silver-halide film, and are not overly concerned about cost, a film recorder may be your ideal output. These machines create transparencies from digital images in a way that is a little like the reverse of high-end scanning. They work by aiming a tight beam of light onto photographic film and tracking the exposure line by line, as a drum scanner does. Control over the size and tracking of this beam makes it possible to produce very high resolution images—around 1200 ppi and higher. They normally output large-format film, either individual sheets or a 9.5 in (240 mm) roll. Both Kodak and Fuji make 100 ISO electronic output film.

In all dealings with service bureaus, you will have to face the matter of color management, described on the following pages. If you are going to do this sort of thing regularly, it pays to develop a relationship with a service bureau, which can steel you through the pitfalls. They can, for instance, provide you with a test transparency and its corresponding digital image on disk. Load the image into the computer, place the transparencies on a (color-corrected) light box, and adjust the monitor until the test on screen looks as close as possible to the transparency. Use the calibration software described on pages 48–9.

An alternative that some bureaus are prepared to accept is for you to send them both the digital image and the original transparency. They then make their own (low-res) scan and compare the differences. From this, they can create compensation curves—a special LUT (look-up table) for your images—provided they are all scanned the same way. Indeed, if they make the scan in the first place, they will be responsible for the overall color accuracy.

ON-LINE PRINTING

An alternative to taking your image to a bureau is to use online services. These can generally be accessed on photo sharing and album Websites (see pages 84-5). Whether these are convenient will depend on how long you are prepared to wait for the prints to be mailed, the cost of mailing, and, indeed, the upload time to send an image of sufficient quality.

PRINTERS

COLOR MANAGEMENT SYSTEMS

eeping the color of a photograph the way it should be is one of the most vexed issues in digital imaging. There are two reasons why it is so difficult: First, because no reproduction system, whether it be a monitor screen or a print, can come close to the full range of our eyes; and, second, because of all the different machines that there are

from different manufacturers. As in the rest of the computing world, the inability of different equipment and software to talk the same language to each other is the cause of endless grief for the user. Calibrating the moni-

A color management system translates the colors from the camera to the color space of the printer

tor (pages 48–9) is only part of the solution, although certainly an essential first step.

The answer, as is the way with computers, is yet another piece of software—a color management system, CMS for short. Its job is to translate the colors from the color space in which the image was created (camera, scanner, or computer) to the color space of the output machine (such as a printer). Each piece of equipment has a different way of displaying the num-

bers which are used to identify a particular color (*see box*), and a CMS relies on knowing this this is the color profile of the machine. The International Color Consortium (ICC) has set up a standard for all of this,

which Photoshop, for example, follows.

Color management systems include Linotype-Hell's LinoColor Color Management

Module, which is used in Apple's ColorSync[™] from Apple Computer and is the basis for Microsoft Image Color Management, Kodak Digital Science Color Management System, and EfiColor[™] from Electronics for Imaging, among others. However, the cure can be more painful than the problem, and you can count yourself very lucky if the calibration works the first time, particularly if you have a machine running Windows. As we saw on pages 38-9, the Mac platform has the advantage of a single video driver that works with all monitors and all video cards. Windows, however, has to suffer the varying standards of different manufacturers.

Unless or until you choose to tailor the procedure exactly to your needs, the best advice, if you use Photoshop, is to choose one of the small number of predefined settings under Color Settings. As elsewhere, if in doubt, rely on the default—

BY THE NUMBERS

The different modes define the color of each pixel with absolute accuracy, in whatever way a machine displays them. Mid-gray is 147, 147, 147 in RGB, 0%, 0%. 0%. 50% or 43. 32. 31 in CMYK, 62, 0, 0 in Lab, and 494494 in HTML. Because the standard color depth of a pixel is 256 steps (see page 15), the RGB numbers go from 0 to 255. CMYK uses percentages, while Lab uses a scale from 0 to 100 for lightness and -120 to +120 for the two color scales.

PRINTERS

MODEL, MODE, AND SPACE

In the often confusing jargon of color management, there are three essential terms. A color model is an overall principle for describing color; some but not all of these are also modes, which are the actual ways in which digital images are stored. HSB stands for hue, saturation, brightness (also known as HCV-hue, chroma, value) and is based on human perception, making it the most intuitive. RGB uses three color channels to do much the same thing, while CMMC reproduces color in a way approximate to ink on paper. Lab uses one channel of luminance (lightness), one on a scale from green to red and one from blue to yellow; it was devised in 1931 by the Commission de l'Éclairage (CIE) as a device-independent standard, based on human perception tests. These three are all modes. Other modes, with restricted colors, are grayscale, indexed (just 256 colors), and bitmap (black and white only). Color space, or color gamut, is the range of colors possible in a model. Lab has the largest, and so is often used as an intermediary. RGB is the next largest and CMYK the smallest, but both can display certain colors that the other cannot.

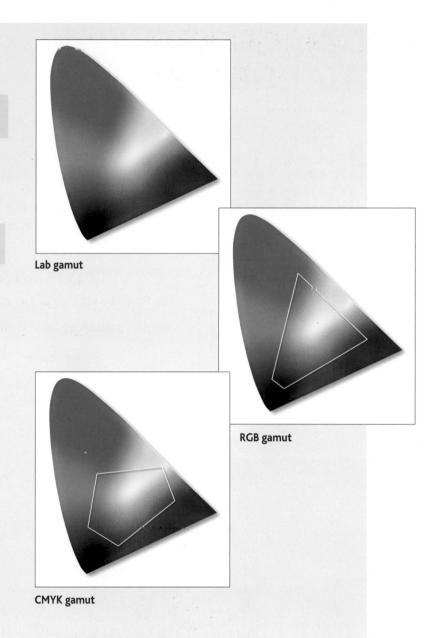

software and hardware experts have put a lot of work into them. However, if you'll forgive this mild piece of computer heresy, consider first whether you really need to go through the entire exasperating process.

Perfect color management is essential for professionals who send files for output on unfamiliar equipment, but many photographers have just a single line of production—from camera to computer to printer and if you own all of these you will find it is possible to coordinate them by hit or miss. This "bulls-eye" method involves getting a little closer each time; while a computer engineer might sneer at it, I offer it as a manageable alternative for people who like experimenting and working intuitively.

Whether you use a CMS or not, at some point you will have to test the accuracy of your system. The best way is to take a physical test image, such as a print that contains difficult tones like flesh, and color control strips; photograph or scan it, view it on the screen in your image-editing program, and output it. If all is well, it should appear roughly the same throughout. If not, keep adjusting!

DIGITAL DISPLAY

n contrast to the complexities of color management and the rather complicated relationship between RGB and CMYK color gamuts, viewing your images on a computer screen is simplicity itself. Image capture is digital, the screen is digital, and the well-known computer acronym wysiwyg comes into play—what you see is what you get. There is

Viewing your images on a

computer screen is simplicity

itself: image capture is digital,

the screen is digital

no imagination or calculation involved in translating from one medium to another.

That said, operating systems, monitor bit-depths, and types of screen do vary, and it is important to know what your

images will look like on a computer screen other than your own. Between the two principal platforms,

Windows and Macintosh, there is a brightness difference: An image prepared on a Mac will appear darker on a Windows machine. Photoshop has a preview simulation that shows you how it will appear. If you are posting images by e-mail or on the Web, there are some optimization procedures to follow in order to ensure that your image will look as good as possible on

> the widest range of monitors. Photoshop, for example, has a useful control: the Save for Web dialog (*see pages 84–5*).

> For the simplest display of all—a single picture—there are any number of programs that

will open an image that you have saved in one of the standard formats such as TIFF, PICT, or JPEG, and an image-editing program is not essential. QuickTime, for example, sometimes comes with the operating system and works quickly and efficiently. A step beyond this is a slideshow, in which you assemble a group of images to play as a sequence, allocating the time that each appears on the screen. Again, probably the easiest, instantly available, software is QuickTime. The movie player has simple on-screen buttonlike controls to play and pause the slideshow, but you will first have to save an animation of the images as a QuickTime Movie. There are a number of ways of doing this, including Photoshop's ImageReady.

In quite a different way, but still digital, is the digital picture frame. There is already a reasonable choice of these stand-alone thin picture frames that feature a flat LCD display, from manufacturers such as Polaroid, Sony, and Nikon. Typically, they accept memory cards, and some also receive downloaded images via a modem. Software usually allows you to set the time for which an image is displayed, and they can run slideshows. A more professional, and very expensive, alternative is a digital projector, which is useful should you need to make presentations to a large audience in a darkened room or theater.

Slideshow players

Among the many programs for arranging a timed sequence of your images onscreen (most digital camera software permits this), QuickTime comes preloaded on most computers.

Polaroid PhotoMax Digital Frame

This stand-alone system, which is only 10 x 8in (25 x 20cm) lets you connect with the Web and download images without the intervention of a computer. You can edit images with the PhotoMax software.

Nixvue Digital Album

Weighing only 11 ounces (320 grams), this portable storage device is designed specifically for digital photography, and will download the contents of CompactFlash, SmartMedia and Memory Stick removable memory cards onto its internal 2.5 in. hard disk, which has a 10 gigabyte capacity. The stored pictures can be displayed on a television or data projector via a video output, with a remote control option.

Digital projector

A professional, though expensive, way of displaying images from your computer is via a feed to a projector.

IN PRINT

n the last chapter we looked at the types of print that you can make, or have made, from a digital image. But what then? How do you display them to their best advantage? Given the usual caution about not exposing them to excessive ultraviolet which means, essentially, keeping them indoors and

prietary glassed frames are suitable, but for a profes-

sional result, you should consider mounting and using

Ideally, mount the print onto a thick board,

such as museum board, which is available from

art material suppliers. Dry-mounting attaches

away from daylight as much as possible—the classic treatment is the framed print, just as for a regular photographic print, hung on a wall or mounted in a freestanding frame on a desktop or shelf. Any of the usual pro-

an overmat.

There are endless possibilities using your own imagination from within an image-editing program

with a dry-mounting press or an ordinary iron applied through a protective medium such as cloth or paper. Alternatively, you can use corner mounts stuck to the backing board with archival linen tape, or else diagonal slits for the corners, cut into archival backing paper which is itself then attached to the board.

> The final touch is an overmat. This is a "window" cut into board that fits over the print and under the glass. The conventional style for prints to be displayed in galleries is a mat cut with a bevel edge, sloping

inward toward the print. Doing this is a skilled operation, but it can be fairly easily learned, and is made all the easier if you have a professional mat-cutter. The mat-cutter is pushed against a T-square to get absolute precision in the end result.

In combination with an overmat, or in place of it, there are digital framing solutions, produced with the help of third-party software for an image-editing program. PhotoFrame from Extensis, for example, is a dedicated plug-in for creating frames around images, as shown here. Other software on the market includes Sucking Fish (though you would hardly guess it from the name) and Media Spark. These are time-saving plug-ins, but there are also endless possibilities using your own imagination from within an image-editing program. In the old-fashioned vignette the image fades gently out to white around the edges. These were produced in the old days by burning out a surround in the darkroom under the enlarger, but now to get the effect you simply need to create a shaped mask with a very soft edge. You then select the outside of this, and quite simply delete.

Apart from single prints, there are also albums and portfolios, with printed sheets mounted between covers. Loose-leaf binders are the easiest to use, and if you insert the prints into glassine sleeves, you avoid damaging the print with punched holes. My own portfolio is constructed just like that, with customized engraved aluminum covers.

Vignetting

A technique associated with old photographic portraits, vignetting involves a gradual fading toward the edges. A plug-in filter from Media Spark has adjustable controls for this effect.

80

Beveled edges

An adjustable bevel edge to simulate a 3-D effect, titled Deko-Boko (right and above), is one of several framing filters available as a plug-in from the wonderfully named Sucking Fish series.

SOUTH-

PhotoFrame

6

8

A dedicated framing program from Extensis, called PhotoFrame (left), works as a Photoshop plug-in, and is loaded with a number of vaguely art-type effects. The frames are adjustable in various parameters, and can be rotated and used to crop the image.

A printed portfolio

LUMILLINITY IN THE OWNER

One simple and neat method of mounting prints in a booklike form is to insert them in a loose-leaf binder with glassine sleeves. There are endless designs available; this one has a durable hinged aluminum cover.

CD-ROM AUTHORING

he professional approach to digital presentation is multimedia authoring—a step not to be taken too lightly, or you are likely to get bogged down in yet another computer diversion. The term "multimedia" is a little dated these days, with its expectations of mixing pictures, text, sound,

video, and interactivity into a new experience. This is far too complicated a mix for most purposes, certainly for just displaying photographs, and a less

Authoring brings an extra level to a presentation. It lets you make links

elaborate plan of attack has a lot to recommend it.

However, authoring can bring an extra level to a

presentation. It allows you to make links so that the

person looking at it can navigate through it. The open-

ing screen can offer a number of choices—a menu—of

other screens, and these in turn can lead to others.

Using a book as an analogy, this is like jumping straight

from the contents page into a chapter or page of the

book, and jumping again from there to other pages. If

this sounds strangely familiar, it is because Web sites

appear to work like this. The principles are the same,

Director's logical top-down approach makes the building of complex (and even interactive) CD-ROMs simple. The screen here shows how an initial screen leads through to a menu of subsidiary screens. It pays to avoid over-complex scenarios that could baffle or intimidate those less familiar with the media.

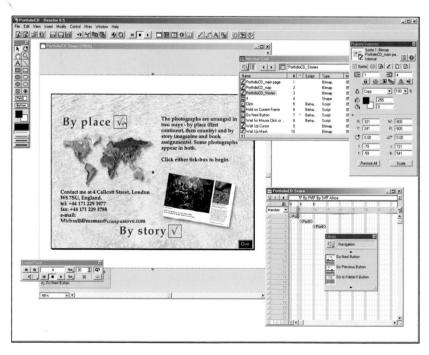

although the usual medium for multimedia authoring is the CD-ROM. If you have a hundred photographs that you want to include, uncompressed for top quality, at the "small" fullscreen size of 640 x 480 pixels, they will take up approximately 100 MB, and the 640 MB capacity of a CD-ROM is ideal.

> Multimedia CD-ROMs went through a boom-and-bust cycle in the 1990s, and so commercially have a somewhat tarnished reputation. But, as long as you

don't need to make money out of them, they are a convenient means of delivering photographs with professional style. You can add context in the form of stories and captions, make them entertaining, and set them in graphic surroundings that enhance them.

There are several authoring programs, with Macromedia Director the established professional one, as Photoshop is to image editing. Navigation works like a branching tree, and the best tip of all is to sketch such a tree right at the start. An example in this case will explain the theory more, and the one to the right is my CD portfolio—or rather, a few screens from it. There is nothing too fancy about it, and that is deliberate.

If you do bother to go to this trouble, the experience will at least not be wasted for anything you do for a Website. Navigation is a straightforward concept, but applying it well needs a certain amount of abstract planning and anticipating how other people will want to follow it.

Lessons from my experience in producing a commercial CD-ROM—not without its difficulties include the following:

- Make your photographs available as large as possible, but accessed from thumbnail versions so as not to slow things down.
- Use clean, not complicated graphics.
- Make the navigation obvious, not clever.

 Put any technical effort into making the program run as fast as possible.
 In short, keep it simple. Give the user an easy time, and leave the puzzles to computer games.

Macromedia Director

Search by place

Like most authored programs, this one branches from a main menu. This is a photographic portfolio with a strong travel orientation, so I needed to offer two ways of accessing the images. "By Place" works from a map; clicking on a continent brings up a choice of countries, and within each of these a set of images. Each image can be enlarged to full-screen, with or without a caption.

WAYS OF DISPLAY

83

ON-LINE

he ultimate public forum for photographs is the Web, which is teeming with sites offering anyone the opportunity to display their pictures, whether artistic, esoteric, or banal. Technically, the Web is geared for handling digital images, and the issue is not finding a Website but choosing between the very, very many.

With so many organizations only too happy to invite you to have your own Web page, there is no need to do it the hard way Seriously Web-minded photographers will probably take the full step and create their own Website, but to do this in a professional-looking way demands both some effort and knowledge of HTML (HyperText Markup Language), and this is beyond the scope of this book. However, with so many commercial organizations only too happy to invite you to have your own Web page and photo albums, for most people there is no need to do it the hard way.

The most relevant of these are photo-sharing Websites, most of which make it extremely easy to join them. The purpose behind most of them is to tempt customers like you to buy products such as photographic goods and printing services. For that reason, there is advertising on the site and you may be deluged with offers. To find these sites, use a search engine and type in "photo share" or something similar. Among the

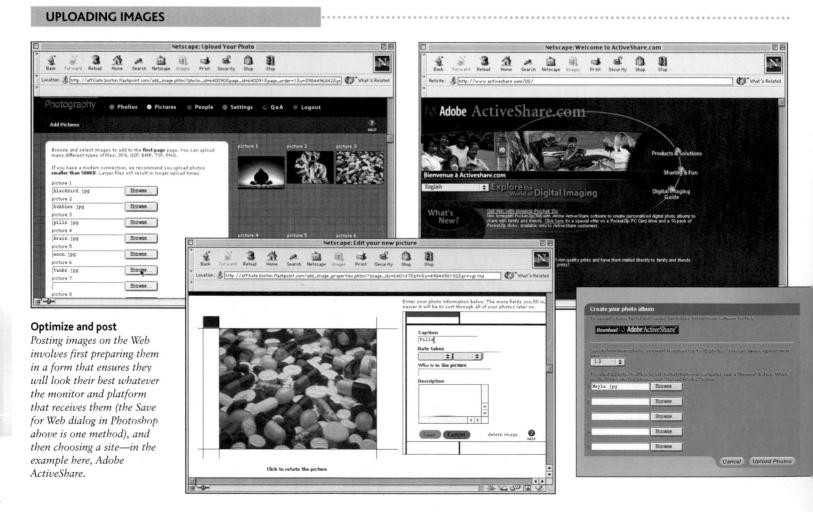

large and reputable sites, those run by Microsoft (MSN) and Sony (Imagestation) are definitely worth looking at. You will have to upload images to the site, and using an ordinary telephone line and modem this can take time.

Your images belong to you, meaning that they are your copyright, unless you choose to sign the right away. That said, copyright protection is a complex legal area, all the more so since the Web is an international medium. Posting your images on the Web for all to see also runs the risk that someone may unscrupulously acquire them and use them.

This is the less sunny side of the Web; if you can get onto a Website without having to subscribe in some way, you can usually extract any picture you see. In all honesty, this is not as serious a problem as some people like to think, given the ocean of free and low-cost images available, but it is as well to take some precautions. The first and most obvious one is to post only

WATERMARKING

low-resolution images, certainly nothing larger than full-screen, 600 x 800 pixels.

Another precaution is to overlay your name and a copyright symbol on the image. This will deter almost anyone, although it will also spoil the appearance of the picture. The procedure, shown here, is straightforward: In an image-editing program, type the overlay in its own layer, then choose a blending option that embeds it in the image below. My preference is to type in a light color and blend as Difference.

Watermarking is more subtle. It embeds in an image coded information that is invisible, or nearly so. The best-known product is Digimarc's watermarking software Picturemarc, included with Photoshop. However, it is not an infallible system, even though in theory the watermark can be traced. More than this, watermarking does degrade an image, as in the example shown here. You should decide for yourself whether or not this is acceptable.

Embedding a copyright notice

The simplest protection, and a highly effective one, is visible watermarking, provided that you do not mind the obvious interference with the image. In an imageediting program, type a copyright notice in a separate layer (in some programs the layer is made automatically), large, bold, and fairly wellcentered so that it cannot be cropped out. Then choose one of several layer blending options to embed it into the underlying image in a way that is difficult to remove here, my own preference is "Soft Light" in Photoshop, which gives a blended effect that is not as insistent as a pure color.

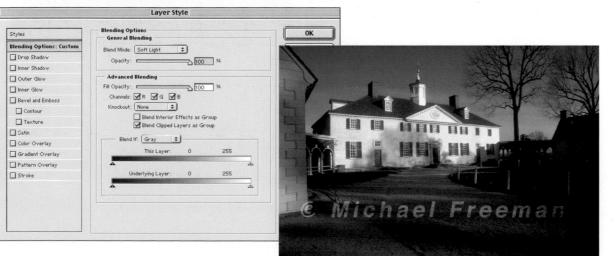

SECURITY ALTERNATIVES

• Put a visible copyright notice on the image.

Pros: easy and obvious. Cons: can be cloned away or cropped out unless it is big and central, in which case it obscures the photograph.

• Embed a digital watermark.

Pros: in theory survives resizing and printing, and can be traced.

Cons: in practice does not often survive alteration and can often not be traced; also degrades the image.

• Limit access to the website, as do stock agencies.

Pros: big discouragement to theft, which could be traced fairly easily. **Cons:** restricts exposure.

Protection

software that

prevents downloads.

Pros: it works. **Cons:** needs a plug-in

to view.
• Keep images small.

Pros: small images are not much use commercially. Cons: small images are not much use commercially.

SECTION 2 WORKING DIGITALLY

nce a photograph is on the computer's hard drive, either as an original digital image from a digital camera or scanned from slide or negative, there are almost no limits as to what can be done with it, or added to it. The means are various kinds of software, of which the most relevant by far for photography are image-editing programs. As will become clear in the following chapters, imaging software is a universe of its own making—an absorbing computerland somewhat detached from reality. There are so many products and processes that only a full-time computer professional could hope to embrace it all. That is not our purpose here. Photography comes first, software engineering afterward.

It is the unique realism of a photographic image that sets it apart from illustration, and creates special requirements of imaging software. Unless you are deliberately converting a photograph into stylized artwork, the overriding principle in image-editing is to maintain the photograph's believability. This means appreciating the ways in which a photograph manages to convey realism, both technically and artistically. Image qualities in a photograph are complex—in tone, color, and texture—and many contain idiosynctasics that an illustrator would not think of.

From a photographic point of view, there are ascending levels of manipulation in image-editing—a kind of scale of procedure. They are, in increasing order of change and complexity:

- retouching
- repair and correction
- enhancement
- alteration
- image creation.

The basic principles of retouching in digital photography are the same as in film photography, but it is easier and more effective. It is mainly concerned with removing dust, scratches, and the new artifacts introduced by digital processes. The next step, repair and correction, involves removing blemishes, tidying up images, and salvaging spoiled negatives and transparencies. The new possibilities in digital imaging mean that you can and should judge photographs to new standards—on the one hand, be more of a perfectionist, and on the other realize that a damaged original can sometimes be a perfectly useful starting point.

Beyond this is enhancement, improving the image according to your ideas, unrestricted by the way the view looked at the time. For example, an overhead electricity cable might spoil a landscape or obscure part of a building, the braces on a child's teeth may show up in an otherwise special portrait, the sky may be boring. These, and countless other similar "problems," can be removed, altered, and replaced according to preference.

At a certain point, particularly when you begin to combine different photographs into one, enhancement becomes alteration. The image is not just an edited version of the original, but something substantially new. This is not for everyone, either technically, because it demands skill and time, or ethically, since it goes against the grain of photography as a true, honest record. Taken to the extreme, however, in creating entirely new images that blend illustrations and even objects generated in the computer, digital manipulation goes beyond photography itself. As the book's final section, Next Steps, shows, digital imaging is also a new medium in its own right.

IMAGE-EDITING PROGRAMS

WHAT TO LOOK FOR

- Number of features Ability to work with high-res, 24-bit color images
- Convenience of interface
- Third-party software support
- Channels and/or layers
- What file formats?
- Efficiency of masking and selecting

here are two completely different ways of processing an image with a computer. One is pixel by pixel, more or less as you see it on the screen. This is known as bitmapping. The other method works by carrying just the information needed to describe a set of lines or shapes-the mathematical formula-and is known as object-oriented or

vector graphics. The differences between the two are significant, although not very obvious from what you see on the monitor. The complexity of detail and soft-edged shading that is so characteristic of photography

and to choose from is of this type.

Photographs from the digital camera are bitmapped: the obvious way of editing them is a pixel-based program

E AD

% 6.003 inches × 7.115 inc

ed-1 @ 100% (Laver 1.RGB)

> Draw rec

The screen display is only an approximation of the actual image that you are working on. A bitmapped image can be at a much higher resolution than the screen image, as you can see very easily by zooming in on a detail. Photographs from the digital camera or a scanner are bitmapped, and so the obvious way of editing and manipulating them is a pixel-based program.

However, as we saw on pages 40-41, processing millions of pixels at a time is demanding for the computer, and one alternative is to somehow save some of the processing until later. One way of doing this is to

makes bitmapping the usual operation of choice, and work on only part of the image: A program may allow most of the software that you are likely to encounter just a small section to be loaded up. Another is proxy processing, pioneered in 1993 by Live Picture, in which all the moves you make are saved to a separate file, displayed to screen resolution but applied to the final image only at the end.

> As it happens, the market is dominated by one program, Adobe Photoshop, and while its dominance

> > .ock: 🗆 📑 🗖 📾

0. .

ensures that most other appropriate software is compatible with it, it is not without drawbacks. Working digitally, you would be forgiven for thinking that this was an Adobe world, and there is a tendency to follow Adobe's way of doing things and terminology. In fact, there are a number of other image-editing programs, each with its own adherents and each with special features, including Corel Photo-Paint (Windows, Linux), Deneba Canvas (Windows, Linux), Paint Shop Pro (Windows), Ultimate Paint (Windows), and GIMP (Linux). There is life beyond Photoshop.

There are also simplified programs aimed at the very casual amateur and with limited features. Some, like Adobe Photodeluxe, are bundled with digital cameras and scanners, and appear to have been put together by marketing departments, substituting a condescending, dumbed-down interface for a useful toolox. They are not necessarily easier to use for the kind of tools and procedures a photographer needs. An alternative is the midlevel type of image editor, such as Photoshop Elements or Canvas 7 SE-these are much less expensive than the full versions, but retain the basic tools.

Image-editing programs have matured over many years, and are now extremely rich in features. There is usually more than one way of achieving the same result. There is no "correct" method, only different approaches that suit different users or images.

00 +

1 9 K.

14

9

9, Q

Ŷ. D.

Click object to select

Corel Painter

PAINT AND DRAWING PROGRAMS

omputer imaging is not, of course, limited to photographs, even though these are our special interest. You can create images with a computer, even perfectly photorealistic ones, and from time to time you may want to combine an illustration with a photograph. Illustrators' software comes in two varieties, paint and drawing pro-

In addition to highly accurate outlines, drawing programs are also excellent for creating complex shading and gradients grams, and while for most photographers they are probably not worth the expenditure, they can have occasional uses. If your inclination is toward handpainted effects or extreme manipulation, they may be for you. On the other hand,

the painting and drawing features in a full imageediting program may be sufficient.

Paint programs are pixel-based and usually have the facility to import and work on photographs as well as to create pictures from scratch. Working in the same way as image-editing programs, their features converge, and the difference is one of design rather than technology. Because they concentrate on handpainted imagery, they provide a much wider choice of tools for applying color including, as you might expect, such specialized ones as charcoal sticks, chalk, water spray, and colored pencils. In addition, paint programs offer a wide choice of media, including many kinds of paper, canvas, and so on.

Drawing programs use vector operations, which are clean, efficient and suited to hard-edged, precise objects. For a pixel-based program to calculate a solid red circle, for example, it would have to count the pixels and their position line by line. A large circle would take up more space in memory than a small one. A vector operation, however, would simply generate the mathematical formula for drawing a circle, adding that everything inside was red—a matter of a few bytes. Because the information about a shape is used, rather than its appearance, it can be reproduced perfectly at any scale. The only limitation is the resolution of the output device.

In addition to highly accurate outlines, drawing programs are also excellent for creating complex shading and gradients, and if you zoom in on the screen image, you can see that the image stays cleanly drawn at any magnification. Because most digital images will eventually be output in pixel form, a last step in the production of an image created as a vector graphic is rasterization, in which the file is bitmapped. However, good image editors now include vector graphics within the program, and for the occasional use that a photographer might need, they are sufficient.

DRAWING OPTIONS

Adobe linear and radial gradients

Illustrator enables you to create shading and gradients. To add, say, a color highlight to a round object, use the radial gradient (right), adjusting the color values with the sliders. For a straight object use the linear type (far right).

PAINTING PRIORITIES

Surfaces

Because painting programs are intended primarily for freehand illustration, the texture and appearance of the media is important (unlike in photography, where the surface is usually featureless). The first step in making a new paint illustration is to define the surface—often paper of one kind or another. The controls shown to the right allow different textures, strengths, shininess, and lighting direction, as well as color and brightness.

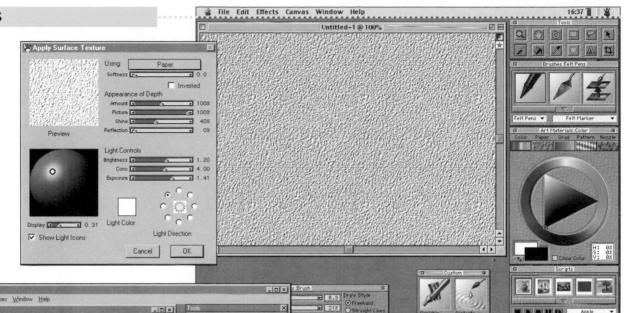

Palettes

9

Sun

4910

AX

As with most imaging software, several palettes are available (above), and can be located anywhere on the screen. In this program, Painter Classic, they include Tools, Brushes, Art Materials, Controls, Scripts (procedural sequences), and a Custom Palette to hold whatever you need at the moment.

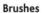

The variety of implements available is much more comprehensive than in imageediting programs designed for photography, and include many kinds of brushes, airbrushes, water drops, chalk, and here a felt pen (right), and a palette knife that behaves as it would with thick oil paint (above).

3-D AND THE MAGIC OF CGI

reating objects and scenes within the computer, by means of software rather than importing them from the real world, is known as computer-generated imaging, or CGI. Paint and draw programs do this to an extent, but the purest means are 3-D programs, which have a limited but important role in manipulating photo-

Adding a 3-D element to a photograph is a serious alteration of reality

graphs on the computer. Like drawing programs, they are object-oriented, and were originally designed for applications such as engineering and architecture where there is a need to create objects that can be rotated and viewed

in perspective. The beauty of 3-D programs from our point of view is that most of them can render the surface of an object with great realism—real enough for it to be dropped into a photograph and look completely at home among the other real elements there.

As with drawing programs, the use you can make of them in a photograph depends very much on their realism. Simple geometric shapes like spheres, cubes, and triangles are potentially useful—and particularly if you use texture-mapping to wrap a photographic image around one of these objects. At its simplest, think of a photograph of a texture—a pattern of bricks, water, or even an aerial view of a landscape. Wrap this around a sphere and you can produce a photorealistic but decidedly strange object.

3-D CGI, which can be incredibly complex, owes its development to the movie industry, where it has for the most part played the same role as in digital photography: Providing seamlessly blended photorealistic

AN IMAGINARY LANDSCAPE

Wireframe modeling

square grid) below. The

of wireframe shapes.

normal representation when

working in 3-D is in the form

Several different terrains, one of them highlighted in red, intersect, with a cloud layer above and a base plane (the

Rendering

In this program, Bryce, an on-screen button initiates rendering, which takes place in a series of top-to-bottom passes, beginning with large blocks of 32 x 32 pixels (left), reducing each time (below), until a final oversampled anti-aliasing pass.

Atmosphere

A separate menu gives a choice of sky color, haze color, and density, fog color and density, type and complexity for cloud, and the position of the Sun, or Moon (below).

Materials editor

The characteristics of each terrain element can be selected through a dialog box (above) that offers both presets (which can be edited) and the raw parameters.

IMAGING SOFTWARE

Cloud layer

The materials editor was also used to give transparency to the band of clouds encircling the peaks.

Adding the Moon Once the model was rendered, I added a photograph of the Moon in Photoshop behind a selection of the peaks (below).

Layer opacity To blend the Moon as if seen through the atmosphere, I weakened the opacity of its layer.

Final image

The complete landscape, right, with some color adjustment performed in Photoshop for a dark, lowering amosphere.

objects. Its first important use was in 1989 in The Abyss, followed closely by Terminator II, both from the special effects studio ILM. The basic working method for all 3-D programs, such as the popular Ray Dream Designer, is to work on "wireframe" models, and the most common way of generating these is from a set of "primitives," or basic shapes, such as a sphere, cube, or cylinder. These can then be scaled, stretched, distorted, and treated in various ways to arrive at the final shape. Texture and color are then chosen, light sources added, and the camera viewpoint selected. The final stage is for the program to compute all of this as a bitmapped image.

On the scale of manipulation that I introduced earlier, adding a 3-D element to a photograph is a serious alteration of reality. If your prime interest is in taking photographs and reproducing them pretty much as you saw the view, then 3-D is probably a skill too far, and not for you. However, it is not all to do with building complex solid objects. One variety of 3-D software, of which the best known desktop program is the fairly inexpensive Bryce, is the landscape generator. In its ability to manufacture hills, rocks, lakes, and skies realistically, it is a valuable partner in digital photography.

NATURAL LANDSCAPES FROM SOFTWARE

Two features make a 3-D landscape generator complementary to photography. One is the random and fractal type of calculation it uses to create relief features such as hills and rocks. Another is the quality of its rendering engine, the subprogram used to calculate the effect of different lighting on an invented 3-D object. The best quality, and slowest, is ray-tracing, which actually does trace each ray of light between the source and every tiny polygon on the surface of an object.

THE IMAGE TOOLBOX

sually designed to be so convenient that you hardly notice it, the interface is as important to a piece of software as the shape, feel, and layout of a camera body. It is your first sight of the program, and the means for using it. Software developers spend an inordinate amount of time researching and designing their interfaces, and as

The most-used part of the interface of an image-editing program is its toolbox

a user you should find it comfortable to operate. The graphic user interface (GUI) developed by Apple was one of the reasons for the Mac's original dominance in imaging work. Unable to reproduce some of the Mac's best

features for legal reasons, Microsoft's Windows runs a slightly poorer second in design.

The most-used part of the interface of an imageediting program is its toolbox-the "container" that holds the various imaging tools such as brushes, eraser, and selection shapes. It may float, so that you can place it anywhere on the screen or dock it next to an edge, or it may be fixed. In either case, the tools it offers are

displayed as icons-small representations that are meant to be as obvious as possible. The other controls reside in drop-down menus along the top, in palettes that can be opened and closed, and in dialog boxes that appear whenever a particular operation offers detailed choices. Many of the controls can also be activated by keyboard strokes, and after the initial learning process, these tend to be favored for their speed by people who are thoroughly familiar with the program.

The term "tools" strictly covers any subprogram that applies an effect. They are handled by the cursor on-screen, which the user can move and activate with a stylus or mouse. For many people, however, the true tools are those that work as if held by hand-chiefly the paint and draw tools. These include the pencil, paintbrush, airbrush, eraser, and pen, all of which are designed to work as intuitively as their namesakes, and for this reason above all, a graphics tablet and its stylus are the perfect physical device (see page 51).

The pencil draws a hard-edged line, the paintbrush has a soft edge (meaning that the pixel values fade from full-strength to zero across a width of a number of pixels), and the airbrush adds a soft-edged effect as long as you press down on the button. The size of all three can be varied, and even their distinguishing features, like fade-out, can be edited. In addition, the eraser can be set, in Photoshop, to work as a block exactly as it appears on-screen. Apart from this last one, which is used for total removal and so should leave no edge when finished, all the hand-tools need anti-aliasing for realistic use on a photograph (see opposite).

There are dedicated tools for producing particular effects, such as smudging (pushing pixels rather like a finger on wet paint, and not to be confused with the British vernacular for hack photography), cloning (see pages 112-13), dodging and burning, sharpening and blurring. They use the intuitive hand tools in applying their effects, so that using a brush is by no means limited to applying a color. The Sharpen and Blur tools, incidentally, apply the rough-and-ready versions, not the controllable USM and Gaussian blur, and are not recommended for serious use (see pages 120-21).

BRUSHES

Pencil

Paintbrush

Airbrush

TOOLBOXES

ACTIVE AND INACTIVE ICONS

In many programs, the icon of a tool changes according to its use. For instance, if you select an area of the image and then choose a tool to perform some action on the selection, the icon changes when you move it across the selection boundary.

Se

Adobe Photoshop Photoshop gives you a

choice of cursors, seen here in Windows.

ANTI-ALIASING

Most digital devices, such as monitors, display pixels as adjoining squares. This is perfectly precise for horizontal and vertical edges, but creates problems with diagonals, which reproduce as jagged steps unless they are treated. The solution, essential to use in photography, is anti-aliasing, an interpolation method that smoothes the edge by altering the corners so that they merge more gently with the background. As a general rule, always keep anti-aliasing switched on.

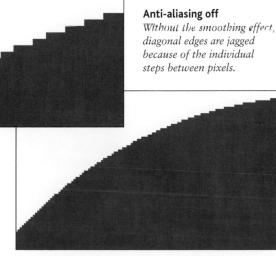

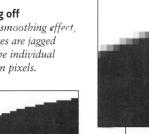

Anti-aliasing on The corners of the steps are

filled with an average between the dark and light sides of the edge.

DIMENSIONAL CHANGES

he image-quality controls on a digital camera give you a choice over the image size when you are shooting. If you are scanning a slide or a negative, you have even greater control. In both these situations, shooting or scanning, it makes sense to decide how you are going to use the image and so how large it needs to be. You can change it later,

Changing the size of a bitmapped image is by no means as simple as it is with a regular photograph but sometimes at a cost to the quality. Nevertheless, for all kinds of reasons, the size of an image often needs to be adjusted. To take just a few examples, you may want to post a low-resolution version of a high-quality image on the Web. In compositing

two or more images, you will nearly always need to enlarge or reduce one to make the combination work; you may want to make a print larger than the digital camera delivered. In every one of these cases, resolution, determined by the number of pixels, is the key factor, as we saw in section 1. Changing the size of a bitmapped image is by no means as simple as it is with a regular, continuous-tone photograph. The problem is that the pixels that make up the image are not locked into a scaleable relationship they are only arranged next to each other. If you were resizing a photograph with an enlarger in the darkroom, you would simply change the magnification by moving the lens away from or nearer to the film. With a bitmapped image, however, the computer has to make a series of calculations that either remove some of the pixels (if you are reducing the image) or add new ones (if enlarging). You'll see various ways of

SIZE AND RESOLUTION

With a digital image these two are always linked, and you must specify both. A $5\frac{1}{2} \times 8\frac{1}{4}$ in image for the printed page at 300 ppi needs many more pixels than the same size for a 72 ppi monitor. The "Image Size" dialog box in an image-editing program has all the necessary information.

 Pixel Dim 	ensions: 90	0K		OK
<u>W</u> idth:	640	pixels		Cance
<u>H</u> eight:	480	pixels	®	Auto
— Print Size	::			
Width:	16.93	cm	J	
Height:	12.7	cm	®	
Resolution:	96	pixels/inch	-	

Upsizing

For a demonstration of the relative efficiency of different methods of interpolation filling in the gaps—I chose this Kodachrome original of two Shaker elders. The original, right, will be resized to 150%, which is close to the safe limit. expressing this in computer jargon, such as scaling and resampling, but it all comes down to the same basic operation, and not surprisingly, it does not always work well.

Whether the new image is acceptable or not depends on two things: The technique used by the computer to rework the pixels (called interpolation) and the degree of change. Interpolation essentially makes an informed guess of how the new pixels would look, based on the original ones. This is easier and generally more successful when reducing (downsampling) than when you are increasing the size of the image.

As for the degree of change, much depends on what loss of quality you are prepared to accept. As a rule of thumb, try to avoid increasing the size by more than 50 percent. After resizing, the new linage will alman certainly need to be sharpened (using USM, *see pages* 120–21), particularly if it has been reduced. Beyond all this, it may be that the output device, such as a printer or film recorder, will do a better job of resampling than you can yourself.

More straightforward than resizing are the procedures for changing the area of the image that is displayed. One is cropping, which simply involves cutting into the picture, discarding some of its outer parts. The other is to increase the area of the "canvas," adding blank

space to the image on one or more sides. This is an essential step if you plan to extend the image, such as hy immering the sky area or compositing with another image. Another simple dimensional change is rotation, while nonsymmetrical changes are distortions, the most useful of which is perspective control.

Cropping

One of the simplest dimensional changes is to crop, and this has no effect whatsoever on the remaining part of the image—shown within the bounding box.

Nearest neighbor

This is the weakest, though fastest, method. When resampling, the quality loss is apparent in the pixel blocking and poor anti-aliasing, which is particularly noticeable in the contrasting spectacle frames. It is more suitable for artwork in the way it preserves hard edges.

Bilinear

Considerably better than the above, although with an obvious softness. This, however, can be corrected with USM sharpening, and the results in this case would be almost indistinguishable from the Bicuhic below.

Bicubic

Theoretically the highest quality interpolation method, this gives a result similar to a sharpened version of Bilinear. Even so, it is clear from the clumping of colors that the image would not stand much more upsizing.

SELECTION TOOLS

ne of the first decisions in image-editing often the first step after making simple global corrections—is to select the area that you are going to manipulate. The change may be as little as altering the color, or as great as moving the selected part to another image entirely, but in all cases making the selection is a fundamental

procedure. Because selection is so important, all image-editing programs offer a choice of different methods; there is even third-party specialist masking software available. The more sophisticated the program, the

Because selection is so important, all image-editing programs offer a choice of different methods

mage-editingto draw around the edges of the
area you want to select; hence a
freehand drawing tool, known
as a "lasso" in some programs.
Normally, you need to completewhatever shape youdraw by joining up the line to its

The simplest, most practical

method, in principle at least, is

better the range of tools. Some put the selection entirely at the tip of your stylus, while more complex tools work automatically in some fashion. Certain subjects are better suited to one method than another, while personal preferences play a part. My personal preference is for working on a mask. With experience, you will be able to assess at the start which selection tool to use, and find your own preferences. Often, it is a case of which tool to use first, because a combination can frequently be more effective than one alone.

start point, and this means outlining the selection in a single move of the mouse or stylus.

The fastest but least useful tool for photographs is

a regular geometric shape, such as a rectangle or an

ellipse. Called in some programs a "marquee," this

works very simply by letting you drag over the image to choose its size, shape, and position. When you

release the mouse button or the pressure on the stylus,

the area inside the box is selected.

For objects with precise edges—a car, for example —a better option is a path. This is essentially a vector outline which plots straight lines or accurate curves between points. It demands some experience in using Bézier curves, which are adjusted by means of two protruding handles at each point. When complete, the path can be converted into a selection.

MASK PAINTING

This image of fingers grasping rose petals, containing differences in edge softness, called for varying amounts of precision in the selection. The choice of tool for this was to paint in a mask layer, using different sizes and precision of brushes. Typically, you would start with a small brush to make the outline, then fill in beyond it with larger brushes.

The most intuitive way, to my mind at least, is painting a mask, which the better programs provide The term is a hangover from the days of compositing on film, when an opaque frisket or rubylith mask was laid over the image and cut away as needed to reveal only the parts wanted. The digital equivalent works as a layer in which you can use any of the tools to obscure or reveal areas of the image. You can choose the color and opacity in which it appears on-screen for your own convenience (these have no effect on the image); typically a color is chosen that contrasts strongly with the underlying image, with an opacity strong enough to show what you are doing even with delicate airbrushing but weak enough to show a little of the obscured area (try between 60 percent and 80 percent). Photoshop allows you to switch between mask and selection mode at will. When you save a selection, it lives in its own channel, and is available as a mask. Instead, you can work in a dedicated masking layer.

1. 5

& Ø. Ø. ⊡ ♦.

₽. T

87 G

0

900

For precise, clean edges, as in this Gulfhawk aircraft hanging in a museum, the tool of choice is a path. Bézier curves, adjusted by their handles, can be fitted to any complexity of curve, such as the propellors and cowling. The usual procedure is first to draw the approximate path, then return to it and adjust the handles for a precise match.

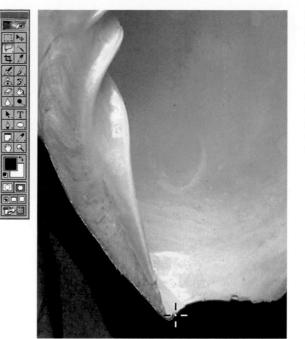

Lasso tool

In this image of a rare shell, the outline was simple enough to follow using one of the basic tools, the lasso. With this, the outline is drawn freehand. There is a variation of the lasso which is partly automated, forcing the line being drawn toward the nearest edge.

SELECTION TOOLS: AUTOMATIC

he most sophisticated and adjustable tools are automatic selectors (such as the Photoshop tool called the "magic wand"). They work by including all the adjacent pixels that have a similar value. You can set the tolerance of this value,

and so control the area that the auto selector outlines. So, for example, if you click on an area of white, the auto selector will sample all the neighboring pixels, and select all the connected white ones. A dialog box lets

You can choose the degree of similarity between pixels that will be selected, thereby limiting or extending the selection

drag the selector tool across an area and selects from that extended sample. Yet another, the Photoshop "magnetic" lasso, searches inward from a rough outline, and can be adjusted to search up to a particular distance and to detect edges that are less or more obvi-

ous (defined by contrast from one pixel to another).

According to the program, there are ways of adding to or subtracting from an auto selection—for example, by holding down a particular key and click-

you choose the degree of similarity between pixels that will be selected, thereby limiting or extending the selection. In the case of white, if the tolerance is set to its minimum, the program will choose only pure white pixels that are connected to the one you click on. A higher tolerance will include pale gray and light pastel colors, but again, only contiguous pixels.

One variety of auto-selection tool seeks the edges of an area you are working within; another lets you ing outside the selected area, or by choosing commands that broaden the selection ("Grow" in Photoshop), or add similar pixels that are not adjacent ("Similar" in Photoshop). A typical working method is to fine-tune the auto selection as closely as possible, and then add and subtract detailed areas as necessary, saving the selection regularly. The calculations involved in all this are considerable, and you may have to wait some time for this selection tool to complete its task. It works best

💰 File Edit Image Layer Select Filter View Window Help 16:56 Tolerance: 15 🔄 🗹 Anti-aliased 🗹 Contiguous 🔲 Use All Layers 📼 Puracé 3314.03 @ 66.7% (RGB#) PIE 600 650 700 750 800 -] Þ. 1 4 832 412 LT H Despeckle Channels Opacity: 100%) ock: 🗹 🖬 🗆 🖉 🕂 🗆 🔒 3 B Background 6

Separating the sky

A good place for experiment is an area of clear sky in a photograph. Typically, this shades from one part of the image to another: say, from a darker blue above to a paler color near the horizon. If you click on the bluest area at an average setting for the auto selector, it will probably choose some, but

not all, of the sky. If you start again with a broader setting, the selection will cover more of the sky. Then add to selection by Shift-clicking in the darker and lighter areas. Finally, use the Similar command to add gaps between leaves. Ensure you have not picked up areas you do not want.

IMAGE-EDITING TOOLS

when the area you want to select is well defined; if similar pixels border it (such as shadows under a dark object or a blue dress against a blue sky), the auto selection will "leak" over.

Finally, you can select automatically by preset values, such as a certain color, highlights, or shadows. In Photoshop, this is Color Range under the Image menu, and the dialog box allows tolerances to be set. This

COLOR RANGE

With this image of a sorbet with wild strawberries, the object was to restore, and even enhance, the redsun ideal airanmentance for selecting by color range, using the dropper and adjusting the

threshold (fuzziness) with the slider. The intense red colors of the wild strawberry sauce had been lost slightly in image capture, which sometimes happens with hues involving magenta.

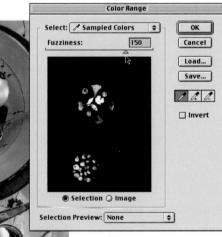

1. Select reds

contrasting green.

3. Selection as mask Viewed as a mask, the red colors have been completely selected, but one problem with this method is the sharp pixel edges of the selection.

procedure works in the same way as the Similar com-

mand, and so needs the same amount of care in use. In

particular, you should check what has been selected

down to pixel level before applying any changes. Pixels

of one color may be scattered in unexpected parts of

the photograph, and major changes to them might look

strange and abrupt. View them in mask mode, and con-

sider applying a blur to blend any changes more smoothly.

Color Picker

Select Quick Mask color:

Only Web Colors

We will be working with

selection has been made.

as the selected parts are

red, it is important first

to change the mask

2. Mask color

a mask. Once the

Edit: Master Hue: Saturation Lightness:

4. Blur

OK

Cancel

Custom

C: 39 %

M: 0 %

Y: 60 %

K: 0 %

OK

Cancel

● H: 120 ° ○ L: 86

∩ s. 100 % ∩ a: -92

○ B: 100 % ○ b: 83

O R: 0

O G: 255

OB: 0

00FF00

Quick Mask Options

Opacity: 80 %

Color Indicates:

O Masked Areas

Selected Areas

A slight Gaussian blur was applied to the mask, softening the pixel edges. This helps to blend any changes with the surrounding, unretouched areas.

5. Enhance

Huc/Saturation

\$

0

0

+25

8 4 2

With the selection now softedged, the Saturation slider in the HSB control was moved to a higher setting, for the final image.

OK

Cancel

Load...

Save...

Colorize

101

SELECTIONS: EDGE CONTROL

hough this may sound too obvious to mention, the success of a selection lies in its edges. The goal in selecting and working on areas of a photograph is to maintain reality, and this means ensuring "seamless" joins between the different parts. Any problems will invariably show up as soon as

number of curves, and not difficult to select successfully with a hard-edged tool, such as a pen drawing a path. On the other hand, hair, fur, and distant leafy trees can take you into digital hell. Yes, their edges are precise, but they are so fine, detailed, and complex that at any normal resolution they are too small for individual pixels.

you make alterations to a selection, such as color changes.

There are actually two kinds of edge problem in a photographic image: The degree of precision, and the interaction of objects with their surroundings.

The goal in selecting and working on a photograph is to maintain reality, and this means "seamless" joins between parts

Precision depends on physical nature. The outline of an automobile is both hard and composed of a limited

The simplest solution, inelegant in theory but fine in practice, is to fudge, by slightly blurring or blending the edge. As you can see by zooming in to high magnification or by examining a slide under a magnifying

lens, this is in any case how photographs work to our eyes. At a certain level of detail, we accept a slight blur as evidence that there is more we could see-if we were closer. It's an illusion that works. Anti-aliasing (see page 95) does this slightly, but it is not enough.

The basic procedure is to feather the edge by a very small amount: one or two pixels. Feathering is related to anti-aliasing: It adds a transition border just beyond the edge, creating a blur. You can reach the same effect by applying a blur filter (see pages 120-21) to a mask channel, or by working over the mask edge by hand. Yet another technique, if the original or new background is obvious and consistent, such as white or black, is to use the variable blend controls to make the unwanted color transparent.

A rather different problem is background, or more accurately the original physical surroundings. An extreme case would be a curved reflective surface (the hood of an automobile, for example) seen against a brightly colored backdrop, say red. If you select the car and then place it against a neutral or differently colored background, the red highlights will come with it and betray the move. In addition, some selection procedures simply pick up pixels from just outside the selection in a kind of fringe, but these are straightforward to remove by applying a command such as Photoshop's Defringe, which "pushes" the colors from within the image that are close to the edge right up to the edge itself.

This shot was for the cover of a book on ageing. To avoid color fringeing when the image of the couple was transferred to the watchface, a pale grav paper background was used in the studio. This

with the clothes to enable the use of the auto selection tool, but not so much as to create a visible edge. A soft drop shadow was finally applied on the watchface behind the couple.

Hand retouching is certainly an option, but very time-consuming. One technique is to drop the selection onto the new background, keep the selection active, and use the cloning tool (*see pages 112–13*) to replace just the color along the edge.

However, the most sophisticated method is smart masking, in which edge control is included in a form of automatic selection. This goes under different names according to the software (for example, Photoshop calls it Extract with Smart Highlighting, Extensis calls it EdgeBlender), but whatever it is called the principle is always the same: The program searches along an edge roughly defined by the user and applies progressive transparency to drop out the background. It calls for various tolerances to be specified, and then creates a complex mask which can later be retouched at will. Naturally, this technique demands considerable user input, in both skill and judgement, but the results are well worth it if you are undertaking any serious photographic retouching.

REMOVING A BACKGROUND

Washed-out sky

Photoshop's Extract command is used on a photograph of a pre-Columbian tomb taken in dull light (above). See pages 158–9 for the retouched version.

Гill

Once a closed edge has been drawn in, the interior can be filled with a single click. This area is now protected.

Preview and clean up

Using the large dialog box (right), the effect of the extraction can be previewed, and any mistakes identified. In this case, extra detail work is needed on some gaps between leaves. With a smaller brush size than for the edge definition, these small gaps are retouched (about)

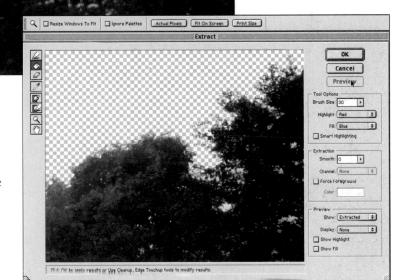

Extraction applied

Once the edge has been defined as perfectly as possible, the final extraction command can be applied. Once this is done, the sky is completely removed, and the scene can be dropped in over any other sky.

HIDE THE EDGE-SELECTION

The highlit selection border—"marching ants" in Photoshop can obscure or distract from the exact appearance of your retouching as you work. As long as you can remember where the border is, consider switching It offi

CHANNELS AND LAYERS

ecause colors are recorded and stored individually (red, green, and blue, or cyan, magenta, yellow, and black), each inhabits a channel (*see page 99*). A color image typically has three channels in the case of RGB or Lab, or four if CMYK, and in an image-editing program they behave like stacked layers, one behind another. More importantly, you can add new channels, called alpha channels, in which to store masks (this happens auto-

Channels can be switched on and off individually, and are a valuable resource in professional-level editing matically when saving a selection in Photoshop). Channels can be switched on and off individually, both to view and to work, and are a valuable resource in professional-level editing.

Color adjustment, as explained on the following pages, makes use of the

color channels, and the two most important controls— Levels and Curves—allow channels to be selected individually. Selecting color channels directly has only limited uses, but one that you should not ignore is that certain image artifacts, like noise and grain, are more pronounced in one channel than the others. Working just in that channel makes it easier to make corrections, with less interference to the rest of the image.

Masks are held in the alpha channels, and apart from working on them as already described (pages 98–9), you can make different masks interact by combining their channels in various ways. For instance, two or more masks can be added together, or one mask can be subtracted from another, or they can intersect. In this way, masks for different parts of a picture can be created individually and then combined.

The only drawback to channels is that they take up space, according to how much pixel information they contain, and as memory and storage are always likely

Layers, a vital component of any good image-editing program, are self-defining. Different images or parts of an image can inhabit different layers. The entire image behaves as if you were viewing it from above, with the layers superimposed. The usefulness of layers lies in keeping the images separate for editing, although it is usual to collapse, or "flatten," them for displaying or transmitting the finished image.

CHANNEL CALCULATIONS

Channels can also be used in a mathematical way, by combining them according to the numbers. This means performing the same operations described so far, not by eye but by typing in percentages and other values. Being counterintuitive, channel calculations are understandably not very popular with creative workers, least of all among photographers—most of us prefer to see what we are doing. They do, however, score highly on precision and reproducibility, and for these reasons have a place in illustration and artwork. Two requirements are that the images are identical in size and that all the files are open.

to be at a premium, you will often have to weigh the advantages of channels against the disadvantages of slower operation and occupied disk space. Not all file formats preserve channels, although TIFF, PICT, PSD, PDF, and Raw do.

Layers need less explanation: They are a convenient working method in which different parts of a picture, and effects, can be kept separate until everything is finished. As the illustration shows, they are stacked vertically like sheets of film and are transparent until something is added to them. The entire image is the effect of looking down through them from the top. They are optional in that an image straight from the camera or scanner consists of just one base layer; if you want to add a new picture element, you can create a new layer and place the element in it.

The advantage of working with layers—and in some programs you can add hundreds—is that you the community of a shore until you are builded with the overall result. Each layer affects only those underneath, and you can change the stacking order; each layer can also be made more transparent if wanted. Layers are virtually essential for compositing, and have every advantage except that they increase the size of the file. They are accepted by even fewer file formats than are channels (Photoshop layers can be saved only in TIFF, PSD, and PDF), and the normal procedure is to flatten the image (that is, combine all the layers) when the work is finished. However, if you have enough storage space, it is as well to save a "work file" of the still-layered image.

CHANNELS

RGB

Red channel

Green channel

Blue channel

Alpha channel

Channels

A color image contains either three or four channels, one for each color component, depending on whether it is RGB, Lab, or CMYK. Each of these channels can be edited individually. In addition, any number of alpha channels can be created, to hold selections. In fact, saving a selection automatically creates a new alpha channel, as in the example here, where an outline of the girl's head has been saved.

Channels window

IN J GE-EDITING TOOLS

COLOR ADJUSTMENT

ne of the beauties of a digital image is that its colors can be altered in any imaginable way, subtly or radically. All full-strength programs offer a number of ways of adjusting color—perhaps too many. You can apply these to the whole image, or to a selected part of it. The controls are described on the following pages.

There has never been complete agreement on the range of colors and how they work We live with color all the time, and without thinking about it find it simple and intuitive. In fact, it is complex and its nature is disputed, not least because it is only partly an optical matter, partly to do with perception.

Throughout the history of art there has never been complete agreement on the range of colors and how they work. Color adjustment means that we have to go back to the complications of color models, modes, and spaces (*see pages 76–7*)

The three main modes for a full-color image are RGB, CMYK, and Lab. There are arguments for using each of these, but remember that what you see on the screen is RGB; it is true to RGB mode, but not to the others. Also, as we saw on pages 76–7, the color space of each of these is different, and while you can switch from RGB or CMYK to Lab without losing anything, switching any other way will throw away color information. Also they each have a few colors that are impossible for the other. As a rule, try to stay in the

mode in which the image was created; it will be easier.

Despite all the scientific talk of modes and gamuts, the primary tool in color adjustment is your own judgement, and most of the process has to be done by eye. They are, after all, your photographs, and only you can say how they should look. As long as you trust the accuracy of your monitor display, the first step is to assess the basic image. Does it look too dark or too

WHITE, BLACK, AND GRAY POINT BALANCE

Click a part of the image that you think should be a pure white with the white-point dropper and the brightness range will be adjusted accordingly (a refinement is to change the value of the dropper to a few points less than 100 percent, for photographic realism). The same goes for pure blacks, but be aware that most shadows are far from black. Also useful is the gray-point dropperuse it to click on any area that should be neutral (it doesn't matter whether dark or light) and the image will be readjusted around that as a gray tone.

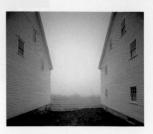

Gray-point dropper

The original photograph of Shaker buildings in the fog at Sabbathday Lake, Maine (above) has a pronounced blue cast from a clear sky over low fog. While this is, in its way, attractive, it can be corrected by clicking the graypoint dropper and clicking it on one of the wooden walls (below). This automatically adjusts all three curves in an RGB image, as you can see from the breakdown to the right.

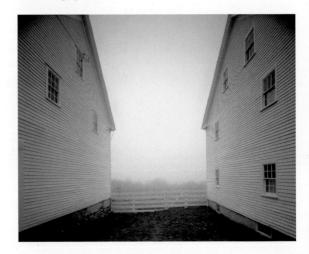

light? Is there a color cast? If so, is it one you want, or not? Three useful tools available in the Levels and Curves dialog boxes are the white-point, black-point, and gray-point droppers, which make automatic "corrections." Even if you don't choose their effect, they give a good preview.

Intellihance Pro

This third-party plug-in from Extensis facilitates color correction (and other correction procedures) by providing immediate onscreen comparisons so that you can preview the effect of a change side by side with the original and with other possible alterations. A single click then applies it overall.

- 0 ×

OK

Cancel

Load...

<u>h</u>ur ditt

Auto

-

Conventionally, a densitometer is a highly specialized piece of equipment. In the digital world, however, it costs nothing and can be very useful indeed. You can check, for example, how deep the shadows are in a picture, and how pure the highlights. Typically, once you have opened up this tool's window, it will give you a running read-out of the pixels where the pointer is, and for each channel, so that you can

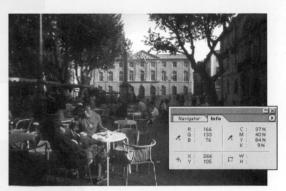

measure the color. What pives it special value is that it works independently of the monitor. A deep shadow may look black on the screen, but in reality be weaker than you want it. Another useful help is employing Photoshop's Threshold command to reveal the highlights in an image.

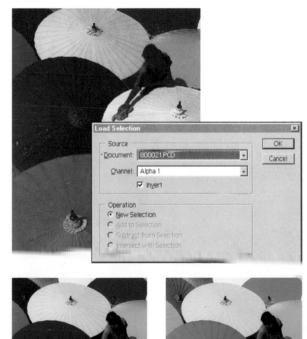

Changing colors

Among the procedures available for making strong changes to color are the hue slider in HSB, the channel mixer control, and Replace Color, which performs two operations in sequence: A selection and then a hue change. Choose the subject carefully before applying this kind of gross alteration. In this case, the girl was first solacted and then held back figure the shanger

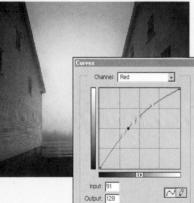

An even more powerful ability is that of altering colors in just part of the photograph. For this, simply make a selection in one of the ways described on pages 98–9. The selection can be a physical object in the picture or, more usually, part of the scale of color or tone —say, on the highlights, the midtones, or the greens.

LEVELS, CURVES, AND LESSER METHODS

here are four basic methods of adjusting the values in an image, two of them simple (for beginners), and two genuinely useful. The starter methods—preset scales and variations —remove complications by presenting an easily understandable interface, but suffer for the same reason by hiding the fine controls that allow delicate manipula-

It is worth the effort of mastering the controls that work on the histogram and characteristic curve tion. They may have some value in getting up to speed when you start color adjustment, but for the ability to fine-tune an image, it is surely worth the effort of mastering the professional controls that work on the histogram and characteristic curve.

A histogram, not the friendliest of devices, is nevertheless extremely valuable for judging the dynamic range of an image, from shadows to highlights. Essentially, it is a map of the tonal values—overall and by individual color channel—and like a map is easy to read with practice, despite its confusing first appearance. The range of tones is laid out horizontally like a cross-section in 256 steps, the height of each column representing the predominance of that particular tonal value in the picture. For a positive RGB or grayscale image, the shadows are on the left and highlights on the right; in CMYK they are reversed.

Adjusting the histogram (the Levels box in Photoshop) by means of sliders underneath alters the brightness or contrast. The center slider changes the overall brightness, while closing in the sliders at the ends increases the contrast. Doing this to individual color channels alters color brightness and contrast. Opening the histogram is a useful first step in assessing the image, and if there is empty space at either end, closing in the

out losing any information.

HISTOGRAMS

The histogram of any picture tells you exactly how its tones are distributed. The left image is deliberately low-key, with its tones pressed against the left. The center shows a normal scene with a full tonal range, while the right image, mainly whites, is biased toward the right.

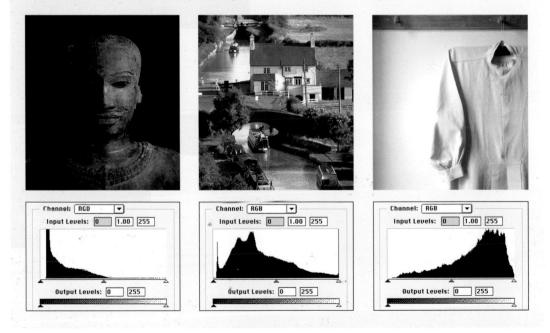

Any photographer familiar with film theory will recognize the characteristic curve that plots the response of film on a scale of exposure against density. In the digital world, the similar curves control is the most sensitive and powerful of all color adjustment methods. It maps the image values as they are (the horizontal axis), against what they will become when you change them (the vertical axis). To begin, they are represented as a 45degree diagonal line, but by pushing or pulling this, you can change anything. Dragging a point on the diagonal line upward increases brightness; to increase contrast, make an S-shaped curve-which is what a high-contrast silver-halide film has. In other words, you can alter the tonal values of any image at will. For photorealism, keep shape changes small and smooth; sharp angles will look posterized.

end slider will increase contrast with-

CORRECTING STREET LIGHTING

Sodium vapor lights

The night-time view of Brussels' Grande Place is awash with the limited for the second state of the second lamps. Impossible to correct by normal lens filters, the solution is digital. Because only the buildings are affected, select the yellowgreen areas, and change them in Replace Color.

Replace color

First, select a color chosen with the eye-dropper; second, operate the sliders in the Hue, Saturation, and Brightness model.

RESTORING A FADED PHOTOGRAPH

Density and color *Maximum density has*

lowered (weak shadows) and the overall color shifted (toward red), in this 20-yearold transparency. With the Curves control use the dropper to analyze where on each of the individual curves different parts of the image lie.

Separate curve adjustment The key is to adjust each color channel individually. Red shadows need strong reduction, while blue shadows need to be clipped entirely. Finally all three together are tweaked, above.

BLACK AND WHITE

he black-and-white print has always been a vehicle for displaying the craft of imagemaking, not least in fine-art photography. Darkroom skills, with their emphasis on image control, have played an essential role in

black-and-white photography. Digital imaging is now usurping traditional expertise because of the possibilities it offers for even finer control over the image, but this has not meant that the craftsman-

Digital imaging is now usurping traditional expertise because of the possibilities it offers for even finer control over the image

ship involved is any less. The techniques are new, the process not as messy, but the judgement and eye of the printmaker stay the same.

Grayscale mode is designed for black-and-white images and, because it discards color information, it occupies one channel only. File sizes are correspondingly smaller than RGB or CMYK, and in general you might say that this is a simpler operation all round. The two

adjustments are tone and contrast. With only one ink for the printer to use, you are spared the awkwardness of color management.

Well, yes, up to a point. The problem is the old one of bit depth, which for digital reasons

described on page 15 is limited to 256 per channel. As there is only one channel in grayscale mode, that means 256 steps from light to dark, and "steps" is sometimes unfortunately the right word. A smooth gradient needs a greater bit depth, otherwise it appears banded. The very presence of color distracts from this, and applying noise to three or four channels individually further reduces it. How, then, to extend the dynamic range of the print? The classic solution, long used in the printing industry, is to use different inks for different parts of the tonal range; this is called a duotone. Photoshop is well equipped to create these-and also tritones and quadtones. To use this technique to its full, the curves for each ink should be adjusted-typically the black would be concentrated in the shadows while the second color, often a gray, would be concentrated in the midtones and highlights. This procedure is useful only if the image is going to be printed traditionally.

Another way of getting more out of a black-andwhite image is to tone it. At the very simplest, this means applying a subtle color, such as sepia or a dull gold, but if you apply different colors to different parts of the tonal range you can achieve more complex, deeper effects. The first step is to convert the monotone image to a color mode—RGB, CMYK, or Lab. For a straightforward toning effect, simply adjust the color balance using sliders.

More interesting is split toning, in which different toning colors affect different densities of the image. This is performed using adjustment layers, see top right.

DUOTONE

Grayscale original

In this grayscale image of a ruined Cambodian temple, there is a reasonably full range from shadows to highlights, yet it has just 256 tones in digital form.

Duotone conversion

To improve the depth and range on the printed page, the same image is converted to a duotone, with a gray ink chosen as the second color. The Curves control allows the two inks to be concentrated in different parts of the tonal range black for the shadows and gray for the midtones.

	Duotone Curve	
	5: % 70: % Car	K Icel Id Ve
Ink 1:	Black Loa PANTONE Warm Gray 9 CVC Sav	id
Ink 3:		eview
lnk 4:		
Overprint C	olors	

IMAGE-EDITING TOOLS

SPLIT TONE

Split toning

Tone Balance

The starting point is a grayscale high-contrast image of a Washington beach photographed into the sun.

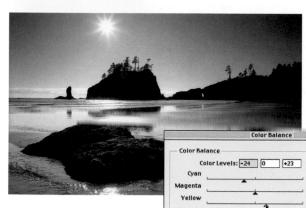

Convert to RGB

The first step is to convert the image to RGB. These three channels are now available for color adjustment, and in one layer the shadows are made cooler. In a second adjustment layer the highlights are made warmer.

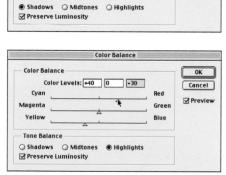

Rec

Greet

Blue

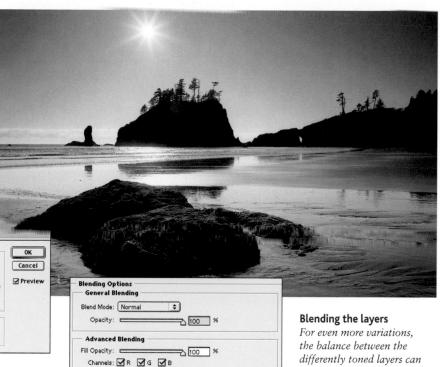

be altered according to taste. By using the layer blending controls, the warmer tones of the upper layer have been held back from the upper 175 / 255 highlights and lower shadows so as to produce a more subtle result.

SEPIA TONE

A flat middle range

While overall contrast of this image of an old steam tractor is high (from the sky to the deep shadows), the midtones as a whole lack contrast. Pegging the upper and lower

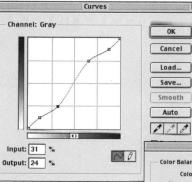

ends of the scale on the curves graph allows the central section to be manipulated independently.

Sepia toning

Knockout: None

Blend If: Gray

This Layer

Underlying Layer

\$

Blend Interior Effects as Group

Blend Clipped Layers as Group

\$

0 /85

255

In an adjustment layer, use of the color balance sliders gives the image the digital equivalent of sepia toning, one of the most-used traditional print toning techniques. The midtones are moved toward red and yellow to simulate the effect.

Color Balance		
Color Balance Color Levels: +50 0 -50 Cyan Magenta Yellow	Red Green Blue	OK Cancel
- Tone Balance O Shadows Midtones O Highligh Preserve Luminosity	its	

IMAGE-EDITING TOOLS

111

CLONING

y the use of a very simple principle—copying from one part of an image to another-one particular digital tool has brought a small revolution to photographic retouching. All serious image-editing programs have a version of the cloning tool, so-called for its ability to reproduce patterns of pixel. Mastering it is worth every effort.

Cloning might have been invented for photographers

First, select with the cursor the point on the image from which you want to copy (holding down a particular key); next, move the cursor to the

area you are going to change, and begin applying. The simplicity of the operation belies its powerful effect, for it allows in a small number of brush strokes the removal of an unwanted object from a picture, replacing it with something that looks perfectly realistic.

Cloning (unimaginatively called the rubber stamp in Photoshop) might have been invented for photographers, because it allows you to work from within the image. In this, it removes all the difficulties of analyzing colors and inventing patterns that would blend in with a picture; instead, you can work with textures that are already there. The cloning tool behaves essentially as a real-time copy-and-paste operation, applied touch by touch (and for this reason, when it comes to large areas of an image, you might find it more productive to use the Copy and Paste functions instead). Above all, it is a tool that is invaluable for backgrounds and textures.

While the cloning tool is very easy to learn, using it well takes consideration and practice, not for any technical reason but because you are painting with real-

DIFFERENT STROKES FOR DIFFERENT TEXTURES

In preparing to clone, look at the textural qualities you will be working with, and adapt the brush to suit them. The two scales that will most affect the operation are from soft to precise, and from random to ordered. While this is by no means a rule, try a soft-edged brush and some transparency for softer textures like clouds, but a harder edge and 100 percent opacity for precise ones like the wooden wall below. For random textures like the leaves of a tree, Nonaligned mode and repeated applications may help keep an irregular appearance, while an ordered texture such as bricks may be better copied in Aligned mode-and carefully positioned to match the pattern.

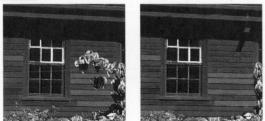

THAI HOUSES

A cut-off image

The scanned original of these Thai houses was shot with a special wide-angle lens that can be shifted for perspective control, but one unwanted hy-product was black masking in the corner. Cropping it out would also have lost part of the houses.

Diameter:		70	p×
Hardness:		+100	=] %
Spacing:		25] %
_	Angle	100000] ^] %
\bigcirc	Roundness		

Setting the brush

Because the original image was a large-format transparency, scanned to high resolution, a particularly large brush was needed. The radius, measured in pixels, and the hardness, were first adjusted, then cloning commenced (above).

life textures and the goal is to keep them believable. There is indeed much of the painter's craft in using the cloning tool, and to this end there are several options from which you can choose to refine its effect.

Most importantly, the cloning tool works in the manner of any of the brushes in the toolbox, which you can modify by size, softness, and shape. A soft edge, as from an airbrush, helps blend the source with the target—but also adds a blur that would be inappropriate for hard details. The tool can be set to either Aligned or Nonaligned: With the former (the usual setting) the source stays the same distance and direction from the target as you move the brush; with the latter the source stays in the same place. A degree of transparency can also be applied for soft blending in areas of indistinct texture, but just as with a soft-edged brush it has a blurring effect—this can affect even the film grain on scanned images.

Where to clone from is a decision that depends entirely on the particular image. An ideal cloning source is an area of texture that is relatively large and consistent, and which does not contain distinctive ele-

ments that would be recognized if repeated. Often, the choice is between cloning from near or far: Using a nearby texture guarantees a close match when you are retouching indistinct areas with gentle gradients, like skin or sky, while using a distant source hides the repetition of a recognizable texture.

Extending rainforest

For use in a special-effects composite, the aerial photograph of a river in the Amazon basin (left) was altered by cloning forest textures across the top of the image (below).

Angle of attack

If the interpret of the interpret floorboards (courtesy of the wide-angle lens), the angle of aligned cloning needed to be altered with almost each stroke. The orange arrows above show the different angles diagramatically. The relative consistency of the floorboard texture made the cloning operation fairly simple, and certainly effective (right).

GO WITH THE FLOW

Pay attention to the alignment of various elements in a texture. and maintain these with your brushstrokes, changing direction as necessary and reselections the acource frequently. Using many short strokes often assists a realistic effect, as does varying the size of the brush, starting with a large size and finishing up with a smaller one.

COMPOSITING: THE ESSENTIAL SKILL

t the heart of serious digital manipulation is the combination of different images, a tradition that goes back almost to the beginnings of photography. Anyone who believes that combining photographs is a child of digital imaging should look at the work of Man Ray in the 1920s and 1930s, and Angus McBean and Clarence John

In nearly all photographic compositing, the images should blend together in some kind of relationship Laughlin in the 1940s. It seems that the urge to play with our perceptions of reality has always been there; digital imaging now makes it possible to do a perfect, seamless job.

For obvious reasons, layers are ideal for compositing, but the proce-

dure draws on all the techniques that I have just described: selection, scaling, color adjustment. But it

also needs the ability, which is much less easy to pigeonhole, to see how different images might work together. This needs an eye for perspective, lighting, and the many subtle qualities that give a photograph its character, for the ultimate success depends to an extent on your choice of images. Color values are easy enough to adjust, but lighting is not. Look at the direction and strength of shadows; if they do not match, it may be extremely difficult to retouch them. Beyond all this, compositing calls for imagination—experimenting is all very well, but for an effective composite you should have in your mind a fairly good idea of how it should finally look.

As we are dealing with photography, I will bypass the common kind of composite in which objects are simply laid down in isolation and at different scales, as

ANALYZING THE COLOR RANGE

One give-away in a badly composited image is that the elements have color values that are obviously different, perhaps because of different lighting conditions, digital cameras, or film. These can usually be adjusted, and while experience will help

you spot them in advance, a rough aid is to convert a copy of each image into indexed color mode, choosing the local palette, which finds the 256 most common colors in that image. Then open its colour table to view these.

Similar tones

If, for example, you were looking for a landscape and sky background against which to composite this head, the palette analysis for each shows that they would match reasonably, though with fewer reds in the landscape (this could be adjusted).

STILL-LIFE CONSTRUCTION

The two main elements are a bowl of noodles and Japanese kelp, each selected.

Paste behind The bowl is pasted behind a partial selection of the kelp.

Brush shadow Inverting the kelp selection, an airbrush is used for a delicate shadow.

Select soy sauce Droplets of soy sauce are selected and then pasted under the kelp, as shown right. in a catalog. That is really a page-layout technique. In nearly all photographic compositing, the images should blend together in some kind of relationship, and in a realistic comp the blend must be seamless. Achieving this complete believability is a matter of skill.

Of the different methods of combining photographs, ghosting is the easiest. In this, one of the images is made slightly transparent, so that the other, full-strength image partly shows through it. Apart from conceptual photographs (for example, a sequence of a figure walking or running, ghosted and overlapping to show motion), the photorealistic reasons for needing this generally revolve around atmosphere, as in the image here of the moon. Place the image, masked as naccorry in its own layer and either adjust the overall transparency or use the blending controls.

Fading is another method; in this, one image blends very gradually into another, usually on one side. If the effect is meant to look artificial, as it usually is, all you need to concentrate on is a smooth and elegant blend. The normal technique is to fade one of the images to complete transparency, using the gradient tool. Either apply the tool directly (to a duplicate of the image for safety), set to "Foreground to Transparent," or for more control make the gradient in a mask layer.

Most realistic combinations, however, call for a clean comp, and this relies very heavily on good edge control, as described on pages 102–3. Following this, think through the logic of the combination to see what else is needed to help an added object sit more realistically in its surroundings, especially whether there should be shadows or reflections, or both.

MOON BEHIND CLOUDS

Two elements Dusk over the Catskill mountains in New England, and a NASA model of the Moon.

Paste Moon into one layer A selection of the Moon is placed in its own layer, over the background for positioning.

Cloud layer to the front *The layer order is reversed, and the two layers blended to weaken the* Moon.

A duplicate background layer is selectively brushed in to strengthen the clouds for the final result (below).

Retouching

PANORAMAS

he enduring appeal of the panoramic photograph, which traditionally needed a special camera able to create a wide, long image, lies in its all-embracing character. It is the view from an overlook, the sweeping vista, and very much a part of landscape photography. Digital imaging has revived it by simply removing the need for a special

The beauty of this is that it needs no planning, no special equipment to carry around, just a reasonably steady hand camera; software can now construct a convincing panorama from a sequence of regular frames.

The procedure is known as stitching, a variety of compositing in which photographs taken from left to right (or vice versa), overlapping slightly,

are joined side by side. It can be done automatically with a special program, and ideally with a dedicated camera mount, or by hand. Panoramas are now a feature of many digital cameras, with stitching software such as Canon's Stitch Assist. Other specialized stitching software includes Apple's QuickTime VR, Authoring Studio for the PowerPC, Live Picture's PhotoVista, Roundabout's Nodestar, PanoramIX, Orphan Technologies' PanDC, and VideoBrush Photographer. Photosuite 3/4 and some camera software also let you stitch vertically, to simulate wideangle views. Most software will make a passable job of stitching handheld photographs, provided that they are more or less in a line and that there is sufficient overlap (ideally 50 percent) for the program to recognize the same features in adjacent images. The beauty of this is that it needs no planning, no special equipment to carry around, just a reasonably steady hand. Nevertheless, for precision, a panoramic head is better. This graduated rotating attachment fits between the camera and the tripod head, and allows you to make consistent steps between the pictures. The alignment is always better with a longer focal length of lens, because there is less distortion toward the edges of cach frame, and the mount should allow rotation around the optical center of the lens-its nodal point.

A purely digital invention that takes panoramas beyond all of this is immersive imaging. Here, the

SPECIAL REQUIREMENTS

Stitching software varies in its demands, but they may include the following:

• A rectilinear lens, as most are, but fish-eyes are not: straight lines in the scene appear as straight lines in the image.

- The camera stays completely level as you rotate it.
- The camera rotates around the optical center of the lens.
- Images overlap by 50 percent.
- Exposure stays the same for each image, not adjusted automatically. A cloudy bright day is easier than bright sunshine.

stitched panorama is intended to be viewed on-screen as a kind of movie in a window of normal proportions. By means of left and right buttons, or a slider, or by placing the cursor on the image and dragging it, you can pan from side to side. These immersive panoramas, so-called because they give an interactivity that helps the impression of being inside the scene, have been given a boost by the Web, which is an ideal medium for showing them. 360-degree panoramas are common, while the professional and expensive IPIX system delivers a complete spherelike image. For output, some systems provide their own viewers, which can be a limitation when posting movies on the Web; the most popular viewing format is Apple's QuickTime VR (QTVR), available for Mac and Windows.

Scene photography, as it is called, is just one aspect of immersive imaging. Its reverse is object photography, in which an object rotates in precise steps in front of the camera. This is then converted into a movie in which the viewer can observe the object from different angles at will—perfect for museum pieces and, more commercially, products offered for sale on-line.

BANGKOK'S GRAND PALACE

Overlapping sequence

From a vantage point overlooking the Temple of the Emerald Buddha in the Grand Palace, I took a exquined of shots handheld, from left to right, overlapping each by approximately 50%.

Vertical format

To get the maximum resolution, I shot vertical frames, and used the longest focal length that would take in the tallest part of the scene —in this case, the golden chedi on the left.

PanoTools

Using freely distributed software, PanoTools 2.2, from Helmut Dersch, the frames were prepared by selecting corresponding "control points" in pairs of frames, in the individual program PTPicker. These were then used by a second program, PTStitcher, to create the panorama automatically.

DECONSTRUCTING THE DIGITAL FILTER

n traditional photography filters are used in front of the lens (sometimes inside in the case of long telephotos and fish-eyes), and work by restricting or altering the light that enters. There are two groups: What we might call the "workhorse" filters that correct and balance the light and which are simply a part of the basic process of recording an image as effi-

You can make a copy of the original (with no loss of quality at all) and experiment as much as you like ciently as possible, and effects filters, which make very obvious artificial changes and are of frankly limited appeal. Workhorse filters include color correction, light-balancing, and UV, while examples of effects filters are starburst, prism, and colored "grads"

Polar Coordinates

OK

Cancel

that change the hue of a sky. A few varieties fall somewhere in the middle: Polarizers that enrich blue skies and modify reflections, for example, and neutral grads that darken skies.

ALGORITHMS: DIGITAL IMAGING'S FORMULAS FOR CHANGE

An algorithm is a set of rules that determines step by step the actions to be taken in answer to a specific problem. In computing it is a series of steps designed to perform a particular operation in a logical fashion which is the only way in which a computer can work. Algorithms are at the heart of digital filters, which apply a complex series of changes to all the pixels across an image (or selected part of it in a repetitive fashion). The Custom Filter box in Photoshop (below) allows you to create your own algorithm for application across the entire image.

FILTERS FOR EVERY TASTE

Remapping

Even the mundane, as in our test image of a salmon head, can become strange under the influence of some of the offerings from image-editing programs and their thirdparty suppliers. Applying Polar Coordinates, a built-in filter in Photoshop (above right), totally distorts the image into a circular swirl.

Cancel OK

Art and texture

Stroke Length

Spray Radius

Stroke Dir: Left Diagonal

Brushstroke effects and similar "artistic" media imitations are common choices, as in the Sprayed Strokes from Photoshop (above). Another possibility is altering the apparent texture, the purpose of the Metallic Filter (left), which applies the sheen and shading of metal, and offers a color choice for different metals.

Sprayed Strokes

OK

Cancel

12

20

In digital imaging electronic filters perform all of these effects, and more. Like their optical equivalents, they range from the merely useful to the exotic, and so invoke a similar range of opinions among users the obviously sensible ones have many unobtrusive applications which are widely used, while the show-off filters (such as those which give "painterly" effects) are disdained by purists, who consider them as having little more than a novelty value.

Digital filters are certainly the equivalent of their optical counterparts in the effect they have over an entire image (or a selected part of it), but they work in quite a different way: Each one uses an algorithm (see box) to transform a pixel's surrounding neighbors. All imaging tools work by creating a mathematical rola tionship between pixels, and filters are no different they just do it consistently over an area that you have selected. To understand the basic operation, imagine a block of pixels, five across by five down. This matrix, as it is called, gives one pixel in the middle, surrounded by two in each direction. By assigning values to each of the central pixels, such as +1 or -3, you can instruct the computer to do such things as lighten or darken the adjacent pixels by a set amount. The operation has two stages. The first is to take the measurements for each pixel, beginning with its color values; it may then, for instance, search in every direction for the nearest pixel that has similar values. The second stage is to make changes, which might be to darken it, lighten it, even move it. While you can manage without knowing any of this, for those who like to tinker with the engine, Photoshop offers a doit-yourself practice area: go to Filter...Other...Custom.

It doesn't take a great deal of imagination to see that the possibilities are much greater than with optical filters. Digital filters read the image at the finest detail of resolution, and the instructions for what to do next are unlimited—they certainly don't depend on optice Practically one of their most attractive features is that you do not have to decide whether to use them at the time of shooting. Instead, you can make a copy of the original (with no loss of quality at all), and experiment as much as you wish with that. This is a good reason not to bother with the filter effects offered in digital cameras—it is better to shoot a normal image with the full amount of information, then filter it with the more powerful versions of the effects in an imageediting program.

Mosaic

A textural effect optimistically called Stained Glass breaks up the image into a pattern of interlocking polygons, which then each receive a single averaged color from the pixels that they cover.

FILTERS

SHARPEN, BLUR, AND NOISE

he workhorse filters of digital imaging are those that give sophisticated control over image sharpness, or lack of it, well beyond the abilities of optical filters. In photography as it was, sharpness was never an issue—simply, you could never have enough. In practice, photographers didn't express it like that, because only two factors controlled

Now, digitally, you can sharpen any image—not just as much as you want, but more than you want it: lens and film. If you could afford it you would have had the highest resolution lens, while with film the compromise was speed: The price for the best resolution was slow response. In either case, few photographers wanted anything but the sharpest image. This,

after all, kept medium- and large-format photography thriving long after the sell-by date.

Now, digitally, you can sharpen any image—not just as much as you want, but more than you want. The sharpness of an edge depends on how abrupt the transition is from light to dark, or from one color to another ("acutance" in textbook photography). A basic Sharpen filter simply exaggerates the difference in brightness between adjacent pixels. Sharpen More is an option offered by many editing programs; it just increases the difference. However, this is an unnecessarily crude way of going about things, and I recommend never using either of these. Instead, the sharpening filter of professional choice is the Unsharp Mask.

Its name may sound contradictory, but it comes from a long-established technique used in the printing industry for sharpening detail without affecting smooth-toned areas. In the old-fashioned—and infinitely more timeconsuming—way, a slightly-out-of-focus lith copy was sandwiched with the films. The digital version hunts for edges in the picture—line boundaries of pixels that contrast with the pixels on the other side—and applies the sharpening just there. Areas between the edges, which by definition are relatively smooth, are left alone. In practice, the USM filter, as it is usually called, gives you control over this. In the dialog box you can choose not only the strength (Amount) but also the distance from the edge that will be affected (Radius), and how different the edge pixels need to be from their neighbors before the filter gets to work (Threshold).

The occasions for sharpening are many, not least because different outputs call for different degrees of sharpness. You can judge on-screen results and those from your own printer by eye, but if you plan to send the image to a service bureau or repro house, check with them first. It may be that they will want to control the sharpening themselves, and may prefer an unsharpened image. Any significant resizing, up or down, together with distortions and effects, invokes interpolation automatically (*see pages 96–7*), and calls for sharpening afterward. Always apply sharpening last of all, and if you apply USM in several small amounts rather than all at once, the effect will be smoother.

Blurring calls for less refined judgement than does sharpening because it throws image information away. Usually, as with sharpening, there are three standard varieties: Blur and Blur More, which reduce contrast

CLEANING UP THE SKY

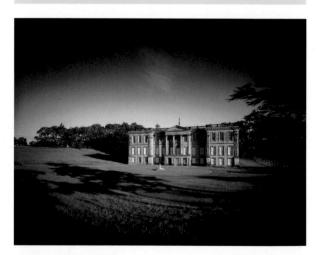

Dust from film and scan *Scanning a film original usually reveals dust and marks, particularly at high resolution, as in this example of a view of a country estate in England. Dust on the film can be reduced by cleaning* with a blast of air and a brush before scanning, but other blemishes may be embedded in the film image itself. The part of the image that usually shows these up most acutely is the sky.

ALLOW FOR IMAGE SIZE

Sharpening depends on resolution and image size. In a 10 MB image, for example, the pixels are relatively smaller than in a 1 MB version, and so need a larger Radius setting, and often a greater Amount. between neighboring pixels, and the more controllable Gaussian, which is the filter of choice. The Gaussian filter blurs the midtones more than the highlights and shadows, and allows you to set the Radius. Specialized blurring filters such as Motion, Radial, and Spin are really effects filters (see pages 124-5). Selective blurring is useful in retouching to obscure blemishes, to reduce the apparent depth of field by blurring the background or foreground, and as an aid to smoothing blends.

A noise filter adds artifacts in a digital imitation of film grain, and while it can be used for the once-fashionable grainy effect, it has a more functional role in reducing the banding created by the Gradient tool. Even though Photoshop now offers a dithering option for this, a little extra noise helps even more, as in the example on page 188. And, of course, if you blur part of a scanned film image you will lose the natural grain; add noise to restore it. Despeckle and Median filters, while they appear in the Noise menu, work more as blurring tools. Despeckle does what its name suggests by searching for areas of color change and then blurring all except transitional edges, so that it preserves detail. Median averages the brightness of a range of pixels-you set the radius.

SHARPENING

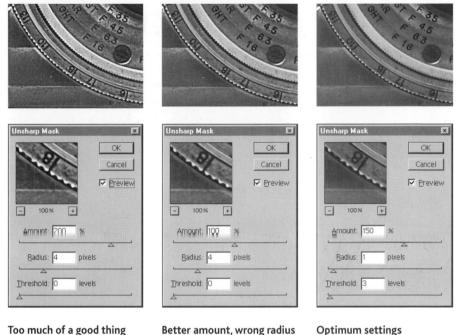

100% is better, but possibly

too little. The slightly blocky

effect shows that the radius is

too high.

Too much of a good thing

Resist the temptation to oversharpen. The bright edges are clear evidence of this, and 200% is usually extreme.

Optimum settings

For this image, these settings work well, with the threshold increased to protect texture in flat areas that need no sharpening.

Sky auto-select Automatic selection on the sky chooses similar tones and colors. Continue adding until the full area is covered.

Expand and contract

To include the larger marks, expand the selection by a very few pixels, then contract by the same amount to pull back from the edges.

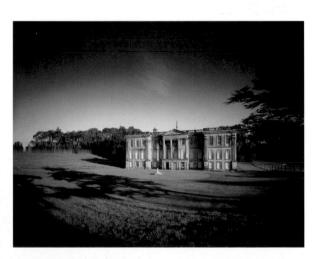

Dust and scratch removal

With the sky—and only the sky-selected, the blemishes are removed all at once with a Dust and Scratches filter. First set the diameter of the removal so that it includes (almost) all the marks. Then, as removal involves blurring, increase the threshold with the slider until the background grain is unaffected. Check the edges of the area to which you applied the filter before saving-mistakes are easy.

FILTERS

DISTORTION FILTERS

he filters that change shapes are more complex than the workhorse filters. The effect can be marvelous, but the principle is fairly straightforward. The pixels themselves, of course, are not actually moved, but their values are, which visually amounts to the same thing. The only limit to the kinds of distortion possible is the imagination of the pro-

The only limit to the kinds of distortion possible is the imagination of the programer gramer, and the effects of many are so extreme and peculiar that the image is no longer a recognizable photograph. However, a few selected filters stay within the creative uses of the photographic universe.

The simplest of distortions is stretching in one direction, which is really no more than resizing along only one axis. Some real-world scenes can stand this more than others—natural landscapes, for example, and skies—and it is a technique to note when compositing in order to match different images. More interesting for photography is the perspective filter. This progressively stretches an image from one side to another, and so can correct that bugbear of architectural photography—tall buildings that appear to lean backward (*see pages 166–7*).

Another class of filters distort from the center outward, and according to how you set them the middle of the picture will bulge outward or appear to be sucked in. A Pinch filter in Photoshop does this, with an easily-understandable control in the form of a mesh that distorts in preview. This is more useful when applied to carefully selected areas. A Spherize filter does much the same in reverse (but both can be reversed anyway), but the proportions mimic the bulging of a sphere (see this in use on pages 140–41).

A Ripple filter, in its ability to imitate the surface of liquid, has some occasional use, but be forewarned that its precision and regularity give ripples that are rather too clean to look natural, and need more timeconsuming work. Creating a water surface in a 3-D program such as Bryce may be a better option. Other distortion filters, like Spin, Shear, Twirl, and Zigzag, do pretty much what you would expect of them, and are far removed from photographic realism.

ENHANCED SPHERIZING

Distortion by brush With some limitations, it is possible to apply distortion with a freehand brush. The heavy calculations involved tax a computer's processing abilities, but this problem is solved by applying the brush first on a preview image. The larger the brush size, the more completely the entire image is involved in the distortion.

OK Cancel Brush Size : 100) Brush Pressure : 10) Stylus Pressure econstruction Mode : Stiff \$ Reconstruct Revert Freeze Area el: none Invert Thaw All View Options Show Frozen Areas Show Image Show Mesh Mesh Size : Medium 🗘 Mesh Color : Gray \$ Freeze Color : Red 🗘

Basic elements

The starting point for this image of a forest contained in a glass sphere is a photograph of the Hoh rainforest near Seattle and artwork of a window frame and a sphere (to add the dark shadow at lower right).

Spherize filter

As a first step, a 100% sphere is applied to the window artwork, later to be overlaid on the forest.

FILTERS

DISPLACEMENT MAPS

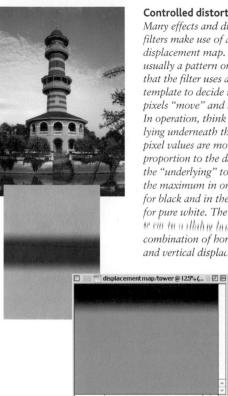

Controlled distortion

Many effects and distortion filters make use of a hidden displacement map. This is usually a pattern or gradient that the filter uses as a template to decide which pixels "move" and how far. In operation, think of it as lying underneath the image: pixel values are moved in proportion to the darkness of the "underlying" tone, from the maximum in one direction for black and in the opposite for pure white. The direction or run in a allachar lana wa w combination of horizontal and vertical displacement.

Making the map

Mid-gray gives zero displacement, and is used for the background in this grayscale image. Because I want to shift only the central part of the tower, I make a black to gray gradient, then add a mirrored copy to give a central black band.

Applying the map

The dialog box allows horizontal and/or vertical displacement to be entered. lurge ship to the right.

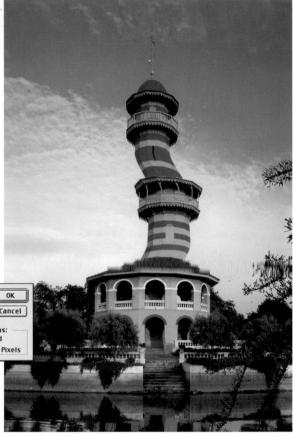

Compositing the spheres The spherize filter was then applied to the forest shot (top left), and the spherized window combined with this. Added realism comes from a blurring of the window highlights and the application of the often misapplied lens flare filter. The final result, combined with artwork and CGI (right), symbolizes conservation.

ffects filters are a catch-all collection of filters that do strange and unrealistic things to images. There is no end of them, both from the makers of image-editing programs and third-party suppliers. They have an undeniable novelty value, like toys, but for the most part the challenge for users is to find sensible uses for them. Nevertheless, for your con-

Effects filters have an undeniable novelty value, like toys, but for the most part the challenge for users is to find sensible uses for them

sideration, here are some. In this book I have used a number of them, but on reflection I can't help thinking that some of the results are rather shallow. Most were done in an early enthusiasm for their oddness, which I suppose is natural, but I can't see myself revisiting too many of them.

Blocks

Type:

Size: 40

Depth: 20

Despite the ingenuity of some of these filters, it is difficult to take them too seriously. The biggest danger is that they are off-the-shelf products, and like royalty-free clip photography can end up recognizably all over the place, not just in your image. By way of an example, consider Lens Flare filters, which are a model of clever invention, and realistic, too. They might have been invented for photographers to add the imperfection of reality. However, the effect stands out a mile, and you can always see when they have been used.

Apart from the filter sets that come with imageediting programs, even more varied and versatile filters now come from third-party developers. These are plug-ins (see pages 88-9) that run as miniprograms, with their own interfaces. Not surprisingly, Photoshop is the main beneficiary-in the software industry, market leaders attract the most third-party action, and this in turn helps to keep them popular. The best-known are Alien Skin's Eye Candy, Kai's Power Tools (KPT), Flaming Pear, and Series 1 through 4 from Andromeda.

Elements

A pale neutral background, a CD-ROM, and an image which will appear to be disintegrating into the CD.

Extrude

Extrude

Random Q Level-based

O Pyramids

Pixels

The Photoshop Extrude filter gives the impression of an image turned into threedimensional blocks, but work is necessary to make the effect realistic.

OK N Cancel

Add perspective

The distortion tool is used to angle the image for a perspective effect.

Blending the CD

Blending controls are the simple way to knock out the white background of the CD-ROM and reveal the desert background.

FILTERS

Eye Candy

Eye Candy is an extensive series of filters from Alien

Skin. It includes this edge glow effect, applied here to a selection.

Blade Pro

This filter from another thirdparty software house, Flaming Pear, adds a bump*mapped texture, which can be adjusted with several control sliders.*

a las transformentes antes des services de la service d	W	arn		
	X Shear X Amplitude Y Compress & Y Shear X Amplitude &	Δ	Cancel	ок

Lightning

A simple way to produce a complex effect (left), from the Xenofex series, also from Alien Skin. Preview

Turbulence

This is an extreme and dynamic filter from Kai's Power Tools (KPT), the filter pioneer of digital imaging. The interface design is distinction: like u or have u.

Warp

Warp (left) is a distortion filter with six parameters from Greg's Factory Output. It is operated by a strippeddown, no-nonsense dialog box, the opposite in philosophy from those of KPT.

Outline the blocks To give the appearance of fragmentation, the paths tool is used to outline some of the

extruded block edges.

Delete the edge The selected blocks at the right edge are deleted to give the appearance of a random break-up.

Digital symbol *This fragmentation of an apparently pixellated image* *into a CD-ROM illustrates the concept of digital storage for a magazine feature.*

SECTION 3 TECHNIQUES

n this section I introduce photography's main subject themes, each of which has its traditions, styles, and skills. Naturally, this is from a digital point of view, but most of the fundamentals are the same as for film photography. Whatever kind of camera you are using, if you are shooting a portrait you still need to understand lighting and how to bring character and expression out of your subject. If you are shooting action, you will have to make the same choices of shutter speed and timing whether there is film or a CCD behind the lens. Each chapter begins with a consideration of these basics before moving on to what digital techniques can add.

Photography has always been a peculiar mix of the technical and the creative, often in conflict but with neither able to function without the other. Only a good working knowledge of the equipment and materials allows photographers to express their ideas, but too great a fascination with the technical side tends to be at the expense of the interesting things going on in front of the camera. The digital component in photography opens up wonderful possibilities, as long as you keep them in perspective. In this chapter (and throughout the book), I'm attempting to integrate the two worlds of photography and software, but the anchor is always photography.

In principle, digital equipment and techniques have brought two areas of change to photography. One is in shooting, the other is the follow-up—what a professional would call postproduction. It is this second stage that has the potential to alter radically the way photographers think about their craft. The captured image is no longer embedded in an emulsion, but is a string of numbers, this will not necessarily appeal to people who like to think of a photograph as a physical entity. It does mean, however, that the image is now raw material that can be worked on for improvement, enhancement, or whatever.

This is clearly the moment to pause and consider how far to go with digital procedures. Yes, there are ethical considerations, and for the most part they revolve around the well-worn theme of photography being truthful. The great American photographer Edward Weston wrote, "Only with effort can the camera be forced to lie: Basically it is an honest medium," and this was in defense of what he called "straight" photography, the product of a clear, enquiring mind and eye rather than "the saucy swagger of self-dubbed 'artists'." Weston obviously had an axe to grind, but the digital ability easily to manipulate images out of the truth has reopened the discussion.

The editor of a fine but short-lived photography magazine called *Reportage* commented in its first issue, "These changes [electronic manipulation] can be defended as creative interventions. But while photography can, of course, be used for self-expression, for art, its documentary role needs to be protected. It may be difficult to draw a line between these two kinds of photography, but it is essential that we do." Well, without apology, I am not going to suggest how to draw that line. It is a personal matter and you can do that for yourself. Here are the techniques.

NATURAL LIFE

enri Cartier-Bresson, the greatest of all reportage photographers, believed that photography gave the "opportunity of plunging into the reality of today." As soon as cameras and film were capable of recording scenes in exposures shorter than a few seconds, people and their lives became photography's most popular subject.

The major division is between shooting life as it goes on around us, and stepping in to shoot a portrait of someone face to face There are endless ways of going about this, but the major division is between shooting life as it goes on around us, and stepping in to shoot a portrait of someone, face to face. In the first case you are an observer, in the second you are creating the circumstances for the photograph.

Observing people is, in fact, the first essential skill for photographing them going about their normal lives. This kind of shooting is all about timing and viewpoint —being in the right position to capture a particular movement, gesture, or expression—and being observant helps you be prepared for what happens next. Of course, what exactly constitutes that telling or elegant gesture is a matter of personal preference, and different photographers will choose differently.

Midday break

A cyclo driver in Phnom Penh, Cambodia, rests from his physically demanding work during the heat of the day.

Ice cream

A private moment in a public place, on a street corner in Tuscany, shot with a medium telephoto lens.

Turning observation into a photograph in this kind of situation means for the most part remaining unobserved. This is not the same thing as being hidden after all, this is not wildlife photography from a hide but it does call for blending in with the surroundings. That means being unobtrusive and not behaving like a photographer. Small, quiet cameras are the ideal, and compact digital cameras are the quietest of all. Even if you have seen a likely picture in advance, pointing the camera in anticipation—waiting for someone to walk into the frame or complete some action—will usually

ruin your chances. It is much better to wait for the moment, then raise your camera and shoot immediately. If there is a rule anywhere at all in this, it is not to hesitate, even for a second or two.

Each lens focal length has its own value. A normal focal length (the definition is that the angle of view is close to that of the eye) has much to recommend it, simply because it captures more or less what we naturally see. The long tradition of reportage photography certainly favors it—look at the work of Cartier-Bresson and Robert Frank, for example. Wide-angle lenses are the choice for shooting crowded places and for showing people in their setting. They are particularly easy to use because the framing does not always have to be so precise, and the greater depth of field guarantees overall sharpness without precision focusing. One special use that they have for candid pictures is that if you shoot close to people and frame the shot so that they are off-center, it will look to them as if you are focusing on something else.

A long focal length lets you put some distance between yourself and the person you want to photograph, and that usually makes it easier to remain unobserved. Given that, you may not have to shoot quite so much on the spur of the moment—several seconds of freedom to choose can make all the difference in capturing the right gesture or expression. The disadvantage of a longer lens in street photography is that there are likely to be more things passing between you and your subject, such as traffic and passersby.

Remembering the figures on pages 16–17, the focal lengths equivalent to normal, wide-angle, and longfocus are different from those for 35mm film cameras, and vary from model to model. A normal lens for many compacts is in the region of just 7mm, while for an SLR like the Nikon D1 it is around 35mm.

Palio

Once a year, in the Italian city of Siena, the different wards of the city compete in a no-holds-barred horserace. Strong emotions and local pride are the order of the day. Capturing these calls for a quick response.

AT WORK

here is one broad class of situation in which people behave naturally, yet where a photographer does not need to make an effort at staying unobserved. Work is usually considered to be a fairly open activity, although in most circumstances you do require some initial permission before you sit in and take photographs. Generally

People who take pride in their work are likely to be more than usually receptive to a photographer speaking, people place their daily work in a different category from their private lives. In particular, because it has a very logical purpose, most find it completely understandable that it should be considered as a subject for photography. They might be suspi-

cious of your motives if you photographed them walking along the street, but for you to shoot them at work makes perfect sense. "Work," of course, covers a wide range of activities, not all of them visually interesting. Indeed, some of them are not particularly interesting even to the people doing them, and the best subjects for photography are those in which the worker takes a pride and those that are unusual. People who do take a pride in their work are likely to be more than usually receptive to a photographer. If you handle the request well, you may find that you are welcome because of your interest as long as you don't disrupt the proceedings. Usually, the work itself absorbs the person's attention, leaving no time to be self-conscious.

As a subject for photography, work lends itself very well to sequences of pictures that tell a story, and in the case of something being produced, you might consider making a kind of miniessay that follows the process through from start to finish. The easiest kinds

Electronics

Reconstructing one of the earliest computers at Manchester University. For an impression of the complexity of the wiring, I used a wide-angle lens from very close, adding small hidden flash lights.

Adobe

A bricklayer working in the way of the ancient training in New Mexico, unselfconsciously assessing his

work. His stance makes the picture more successful than the more product than bricklaying actions.

of work to photograph are physical, simply because they have more visual possibilities, and more action. In any case, most have a rhythm and idiosyncrasies, all of potential interest.

In general, this kind of shooting falls somewhere between the reportage photography of the previous pages and the portraits that follow. The workplace and the activity vary too much to suggest a common set of techniques, but the viewpoint—and so the focal length of lens—deserves special attention. If the particular work is continuous or repetitive, you might consider using a tripod: In this situation there would be time to set it up, and in an indoor setting it is a good solution for shooting with available light, because you can use a slower shutter speed.

Digital cameras have a natural advantage here in that not only are they sensitive to low lighting (meaning that you can set a high ISO rating), but you can adjust the sensitivity as you go, from shot to shot. In the old days you would have had to load a new roll of film each time. Nevertheless, if the available lighting is still too low for a reasonable shutter speed, you will have to consider adding light. The professional solution is to set up mains-powered lighting, either flash or continuous tungsten, which turns the situation into something like an elaborate portrait session and cannot help but be disruptive.

In ordinary circumstances, on-camera flash will help. At full-strength it will do the job of recording the scene, but the quality of lighting suffers. A better

alternative is usually a weaker setting combined with available light—fill-in flash, in other words. When there is very little ambient light, one technique is to use rear-curtain flash, available with some cameras, in which the flash is triggered at the end of a longish exposure. There will be motion blur because of the exposure time, but the final flash concludes the movement with a sharp image.

Surgery

An American doctor inspects a sick child in a Papuan clinic. In a situation like this, photography must be quick, unobtrusive and not get in the way of the work. Natural light, no flash.

Scriptorium

A calligrapher and one of his staff discuss the progress of a seven-year project to handwrite the Bible on parchment. Natural light with one extra photographic lamp to fill in shadows.

CASUAL PORTRAITS

ith a portrait, you have the cooperation, more or less, of your subject. At the least, they know they are being photographed, and will put up with a certain amount of direction. Beyond this, there is a dis-

Beyond a few commonsense matters of lighting and the

tinction between impromptu portraits, taken as the situation presents itself, and formal portraiture, in which you plan everything in advance.

In most ways, the casual approach is the easier. The ingredients of a successful portrait are simple enough: an attractively lit good likeness, capturing something of the person's character at its most pleasant.

The ingredients of a successful portrait are simple enough: an attractively lit good likeness, capturing something of the person's character at its most pleasant.

choice of lens, there are no technical rules.

Expression and gesture are just as important here as in candid reportage photography, so some of the same techniques apply. Many people have a tendency to stiffen up at the idea of having to present themselves

> to the camera, and rather than make a production of it, you will usually preserve what spontaneity exists by being as quick as possible. Do whatever you can to keep the atmosphere relaxed and light-hearted, and if the occasion is like that in the first place—a party or a gathering of friends so much the better.

Simplicity is the key, even if it means accepting a less-than-perfect setting. As much as you can, go with

SKYLIGHT COLOR CAST

Blue shade

Dappled shade in bamboo forest on a sunny day was the setting for this impromptu portrait of a young hill-tribe girl in northern Thailand. The overall lighting quality is good, but light reflected from the blue sky inevitably affects the shadows, especially on the silver.

Neutralizing the blue —in t The gray-point dropper is of the

selected in Curves. The important skill here is to choose a part of the image that should be truly neutral —in this case the midtones of the neck ring. Try several almost-neutral areas to get a feel for the effect. The operation affects principally the red channel, as shown.

what exists. If by choosing your viewpoint you can shoot without asking someone to move, you are likely to gain in mood and natural expression what you might lose in technical perfection. In any case, just a slight change of location may give you a less fussy background or more attractive lighting.

Shooting outdoors usually simplifies the lighting, although some conditions, notably bright high sunshine and a featureless gray cloudy sky, are best avoided. A good compromise, if you can find it, is soft, hazy sunshine, which gives good modeling but avoids hard shadows. A moderately low sun also helps. To lighten shadows on the opposite side, try placing your subject close to a white wall. Indoors almost always calls for flash, because of the lower light levels.

Being absolutely prepared with your camera is essential, and that means being familiar with it. Few people can hold an expression for more than a few seconds, and if you have to fiddle with the camera, you will probably lose it. Decide quickly how to frame the person: close in on the face, head-and-shoulders, a three-quarter shot (including the torso), or full-figure. In most cases, the lens focal length of choice is longfocus, simply because it gives the least distorted proportions to the face, and so is the most flattering. Its other advantage is that its limited depth of field helps to throw the background out of focus, and so concentrate attention on the figure.

Canal life 1

A restorer of wooden barges in the English Midlands. We talked while I shot several frames. The most natural moment was when he glanced away at someone approaching.

Canal life 2

A husband-and-wife team delivering coal and fuel up and down the canal system. I used a wide-angle lens to stay close and simply followed their daily round.

REMOVING RED-EYE

Red-eye is caused by on-camera flash reflecting directly off the subject's retina. Many cameras have a method of reducing it by making the flash flicker lightly before the full discharge—this causes the person's pupil to contract slightly. In any case, red-eye is easy to remove digitally. Zoom in tightly and select the red; use the Saturation slider to remove all color, then darken it. Digital camera software often includes a procedure to deal with this, but you can usually do the job better yourself by hand.

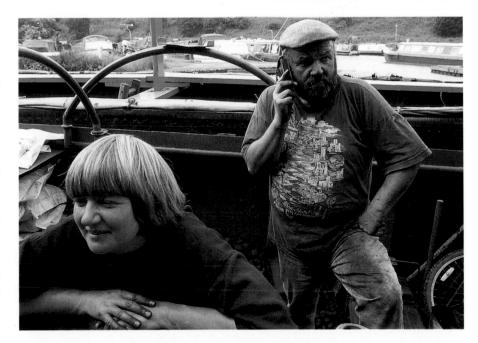

A CONSIDERED LIKENESS

n a planned portrait, the lighting and background are set up in advance, and while there is no chance of spontaneity, you can create an attractive, well thought-out setting. If you have a tripod, this may be one of the occasions to use it; once having decided on the composition of the shot, you can lock the camera onto it and concentrate on talking to your sitter.

Bear in mind where you are going to place the person in the frame when you setup Bear in mind where you are going to place the person in the frame when you setup. For complete simplicity consider a plain backdrop (in a studio, rolls of seamless paper are standard),

but by scouting around the location you should also be able to find some interesting corners.

As for lighting, if in doubt go for one large principal diffused light slightly to one side and slightly from the front, then fill in the shadows on the opposite side with either a reflector or a second, weaker light. There

Natural light

For this portrait, the writer's study was the most appropriate location in the context of the article that the photograph was illustrating. Sunlight through the single window could have been used more simply by shooting from one side, but I chose backlighting for its more interesting effect, particularly on the hair. Problems to be overcome were potential flare (I used a lens shade), and the face being too dark (I added light from the right to fill in shadows).

are countless other ways of doing it, but this gives predictably pleasant modeling to the face. If you are using photographic lights (preferably mains-powered flash), fit the main light with either an umbrella, white or silvered, or a soft-box, as in the portrait below.

If you don't have access to studio lighting, diffuse daylight from a window also gives a soft directional

Flash and ambient light Here, I wanted to retain the atmosphere of this oldfashioned study, which meant a slow exposure to use the low-wattage desk lamp. At the same time, the situation called for soft modeling, which I added in the form of a large flash unit placed at the left and heavily diffused with a soft-box reflector.

effect, but keep the person close to it; avoid direct sunlight, or diffuse it by drawing net curtains if there are any. Use the camera's white point balance control to make sure that the overall color is neutral—particularly important if sky visible through the window is blue. When using natural light like this, some fill-in lighting from a camera-mounted flash may be valuable, but be careful not to drown the daylight with too strong a setting. Check the setup with a test exposure; this is always easy with a digital camera.

An extra light from behind the sitter, but out of camera view, can enliven the setup. In a studio, the usual method is to fit one lamp with an attachment that concentrates on the back and side of the head; this highlights the hair. The strongest effect is when the light is just outside the picture frame, but take care that it does not cause lens flare—either use a good lens shade or fix a piece of card a little in front of the camera and to one side to block the light.

Capturing the right moment is equally important as in a casual portrait, but the situation is rather different. Rather than shooting quickly and catching the picture in one or two frames, you already have the composition, lighting, and background worked out. The one thing you do not have is a spontaneous expression, and that may take some encouragement. Some people are easy and natural in front of the camera, but many are self-conscious to some degree or other. If your sitter needs to be put at ease, keep a conversation going-but avoid shooting when he or she is talking, or you will catch them with their mouth open. The traditional photographic advice used to be to shoot plenty of film, despite the expense, with a digital camera there is not even a question of this being an extravagance. Be prepared to shoot a number of frames at

the start purely to get the person relaxed and accustomed to the camera. Edit the shoot in the camera and delete the useless frames as you go along.

Isolating face and hands

This lighting approach aims at a stronger, more dramatic effect than usual. A main, diffused light at right illuminates just half of the face, while a second light behind and to the left, just out of camera view, defines the edge of the cheek and hair. A black velvet backdrop and a black shirt contribute to the low-key result.

KEEPING FLESH TONES NATURAL

Natural light, and available lighting indoors and at night, varies in its color temperature (see pages 148-9), and flesh tones suffer more than most subjects from an overall color cast. Shooting in outdoor shade under a blue sky is a special problem, as at the time it does not seem particularly blue to the eye. The digital solution is to set the white point balance in the camera. In any case, however, this is easy to correct later in an imageediting program.

White point

Sun and blue sky inevitably create a blue cast to shadows. Even though slight in this portrait of a former Miss World, it was important to reduce its effect on the skin tones. The white point chosen was in the clouds directly above the subject.

BASIC RETOUCHING

imple vanity has kept retouchers busy since portrait photography began. Retouching originally took place on the print, a much easier medium to work on than a negative because of its size and because paper is less delicate than film. The tools were fine camel-hair brushes, and later the airbrush. A painter's skills were essential for a good effect.

Digital retouching comes without the frustration of making a slip that can't be corrected Skill with a brush is still important in image-editing programs because the paint and draw tools are, sensibly enough, modeled to behave as traditional hand-held tools. The brush is what software designers like to call the

nonvein areas shows

where they lie on the

manipulate to reduce

repeat this procedure

for other small areas.

Lightness curve,

which I then

the difference

between them. I

metaphor for this. Digital retouching, however, comes without the frustration of making a slip that can't be corrected. It also makes all kinds of retouching possible—whatever you can imagine. Actually, the uncorrectable slip does exist in image editing, but only when the program is not configured to undo mistakes and you have not saved a copy or two. However, there are procedures for avoiding it.

Protecting your work is one part of the working method, and in retouching this is almost as important as the techniques themselves. It applies to all the photographic subjects, not just people, as retouching is common to all, and can make a great difference.

CLOSE CLONING

Among the several tools available for this kind of work, I personally prefer the cloning tool, used with a slightly soft edge and from very close. In particular, I used this to remove the lines of the face, by cloning from the areas between them. More delicate retouching is possible by setting the brush to Lighten, Darken, or Color, rather than Normal (which replaces everything). I worked at 200% magnification for maximum control.

ENHANCING THE ORIGINAL

The starting image has two

main problems: overred skin

and a pattern of veins, both

to correct the veins. I first

convert the image to Lab

the Luminance channel.

mode so that I can work in

on the cheeks. The first step is

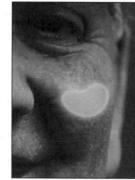

Paint mask

I paint a small area of one cheek as a mask, to limit the vein adjustment, which will be delicate.

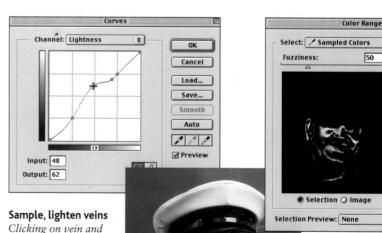

With the cheeks deveined, it's time to work on the color, using the Color Range selector. As before, I do this for a small selection of red, and will repeat the procedure for slightly different red hues.

\$

OK

Cancel

Load...

Save...

1 4 0

□ Invert

PEOPLE

Original

A PLAN OF ACTION

It pays to decide in advance what you will retouch, and how far to go with each effect. In this example, I indulged my own vanity—it's my face and I can do what I like with it. First on the list is the crow's feet at the corners of the eyes (and the lines on my forehead). Then the hair: Tidy it up, darken the graying at the front, and attempt a little restoration (but adding hair, as in real-life surgery, is very difficult and time-consuming if it is to look realistic!). Finally, the shadow under the chin.

As retouching is about detail, first examine the image at 100 percent magnification. It is important to remember that on the screen, lesser magnifications simply do not show detailed blemishes; it's not a matter of peering more closely. Go through the image in an organized way, say from left to right and row by row. If you click the scroll bar itself rather than scrolling with the arrows, the display will jump neatly onward, one step at a time.

With practice, you can assess the retouching that needs to be done as you do it, but to begin with, it may be better to look at everything first and plan the actions. There are two kinds of defect: Artifacts from the camera and blemishes on the subject's face. Artifacts include anything that was not part of the image focused by the camera lens, such as rogue pixel values from

JPEG compression or dust and scratches on a scanned photograph. Blemishes include spots and skin imperfections, and are a matter of judgement.

In principle, work on the smallest defects first, then the larger ones, and choose the brush size to suit. A small brush allows more control, but takes longer, so a compromise is needed. Whatever the blemish, it is the background that is important, because that is what you are trying to restore. For this reason, the cloning tool is by far the most useful; for areas of skin, keep the edges of the brush soft, and harden them only for sharp details like hair, eyes, and teeth. For a large blemish, copying and pasting a patch may save time (cloning is, after all, a real-time version of this).

Retouching

The author before and after, enjoying one form of selfimprovement that you can actually achieve.

Edit:	Master	÷	OK
	Hue:		Cancel
	Saturation:	-12	Load
	Lightness:	-3	Save
		141	Colorize

Reduce red

With the HSB color control, I reduce color by adjusting all three sliders. I repeat this two more times for different reds.

Whiten teeth The final touch, while we're about it, is to whiten the teeth, using a brush set to luminosity, and choosing a near-white.

IMPROVING LOOKS

here is a fine distinction between simple retouching and cosmetic enhancement. One slides into the other. Digital photography and the possibilities for easy alterations in imageediting make the differences even fuzzier. The techniques are the same, and it may not be any more difficult to do one or the other. With a traditional print,

The tricky part here is choosing which parts to leave alone

you would have thought twice before launching into any alterations (and flesh tones can be so delicate that major color retouching usually called

for a costly dye transfer print). Digitally, once you start basic retouching, there is no great step into alterations of the kind shown here. One of the procedures most in demand is to improve the complexion, which usually means smoothing the texture and making the color more even. A blurring brush will work on a small area, but most changes to the complexion need to be worked over a large part of the face, and for this the procedure is to make a selection and then use a filter. Make sure that you have already completed any basic retouching, because a blurring filter works only on quite fine detail. Large freckles, for instance, will convert into an unpleasant mottling, and need to be removed one by one with the cloning tool.

Prepare this selection carefully. The tricky part here is choosing which parts to leave alone: Even though

SOFT FOCUS

A technique used in traditional portrait photography is soft focus (not the same as unfocused), achieved with a lens filter that gives a diffuse effect without losing sharp detail. The digital version is much better, not only because of its variable effect but because you don't have to decide on its use when shooting, but can apply it later. Make a duplicate layer and apply Gaussian blur. Then set the blend option for this layer to Lighten; for extra adjustment, increase the transparency. This treatment is purely a matter of taste, so judge the effects by eye and err on the side of moderation.

+

200%

Radius: 4

the cheeks can take a high degree of smoothing out, some of the fine lines around the eyes, nose, and mouth, should remain, or the overall effect will look airbrushed and artificial. Whether you prefer to paint all of it as a mask, or begin with a lasso selection, you will probably have to finish off the edges in a masking mode. The idea is to make the edges soft so that the selection will blend imperceptibly, and to vary the density of the selection mask in proportion to the strength of the smoothing effects that you will apply. Save the selection so that you can return to it later if necessary.

The primary filter is the Gaussian blur, which allows control over the radius, according to the strength of the effect you want. For an extra measure of control, applying it to a duplicate layer above the original will let you vary the transparency as well. Next apply any color corrections that are necessary, but only by a very small amount. To reduce any artificiality in the smoothing, experiment with the noise filter.

APPLYING LIPSTICK

Color brush

First select the color you would like in the toolbox, and choose Color mode for the brush. This will overlay only color on the lips.

Begin brushing

With an appropriate-sized brush, soft-edged, begin applying the color, just as with a real lipstick.

Cosmetic changes can go much further than this. For instance, the entire skin color can be altered, such as to add a suntan. In this case, begin the selection by color, then add or subtract as necessary in masking mode. You may need to blur this selection to avoid a pixellated effect, in which case apply Gaussian blur to the entire mask channel. After the skin, look at individual facial features: The eye color can be changed (just the iris), the pupils enlarged; teeth made more even and whitened. Adding hair to a receding hairline is very difficult, for the same reason that hair transplants are a challenge—the spacing of the roots. If you really need to do this, try the cloning tool set to "darken," but it is a lot of work.

Chine Phile

Select and lighten To add a gloss effect, first make a selection of the painted area, open Curves, peg the shadows and midtones, and raise the highlights.

Digital lipstick

The final result, almost as good as the real thing, For cafety, and comparison, this is usually best performed on a duplicate layer.

Enhancing green This young Sikh girl in Amritsar, India, had striking pale green eyes, but it seemed to me that the image had not captured the color as I remembered it.

Select and alter

Using a soft-edged paintbrush in mask mode, I first painted over the visible parts of the iris. Going back to the selection, I used the evervaluable Hue-Saturation-Brightness control to shift the hue a little and increase saturation, for the final result, right. It is important not to overdo the end effect.

Edit: Master	CH2020 (024) 100
	3035 B.C.
Hue: 40	
Saturation: [14]	
Lightness:	
<u> </u>	
1 1	V 1

DISTORTION

ven small changes in the proportions of a face can have a major visual effect—weight loss, weight gain, a swelling here or there, all can change the overall appearance. Digitally this opens up all kinds of possibilities, without involving any serious retouching skills. The basic tool is a distortion filter of one kind or another.

Even small changes in the proportions of a face can have a major visual effect The principle here is displacement —moving parts of the image in one direction or another—which is what distortion filters do. In detail, pixels are moved, and if part of the picture is

being stretched, values are interpolated to fill in the gaps. If compressed, pixels are removed. One of the simplest filters is the type that either draws the image in toward the center, or expands it away from the center, according to the amount that you specify. In Photoshop this is called, appropriately, a Pinch filter. Positive values "pinch" the image—squeeze it toward the centerwhile negative values expand it. A Spherize filter has a similar effect in reverse, with the proportions less exaggerated toward the center. One use for this technique is to restore normal proportions to a face that has been photographed close-up with a wide-angle lens.

More interesting is selective distortion, in which you choose facial elements and alter them relatively. In effect, you choose some parts of the image to come forward and others to go back, and so make it look threedimensional. The first trick is to make a very softedged selection, so that the distortion blends in with the rest of the face, and for this airbrushing in a Mask channel is ideal. The second is to airbrush shading to complement the 3-D effect, but very delicately. For more extreme distortion there is dedicated mesh-warping software, available as stand-alone programs, such as Pictureman Rubber, or as part of an image editor, as in Corel Photo-Paint. A freehand alternative is a deformation brush, such as PenTools' Super Putty plug-in.

CHANGING FOCAL LENGTH

Wide-angle proportions Photographed with a lens slightly shorter in focal length than normal, the woman's face above has the characteristic slight distortion, especially in the front part of the face and the nose. A digital solution is at hand, however, using the Spherize filter.

Radial gradient The first step is to apply a radial gradient in a masking layer that will leave the hair, ears and edges of the head unaffected. These can be retouched by hand for more detailed control.

The Spherize filter used inversely will "shrink" the selected area. It does so progressively because the selection has been made as a gradient.

PHOTO CARTOON

A puffed-up jacket

The idea here was to "inflate" an already bulky bomber jacket. Note the distortion already introduced by the use of a wide-angle lens. The further distortion will be applied to a duplicate layer.

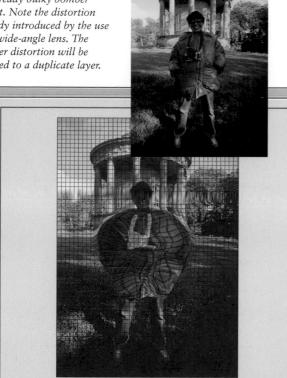

OK Cancel Tool Option Brush Size: 50 1 sh Pressure : 50 🕨 Stylus Pressure econstructio Freeze Ar View Option Show Frozen Area Sh Sh M Mesh Size : Medium 💲 Mesh Color : Gray \$ Freeze Color : Yellow

Paint distortion

The program here, Liquify, allows distortions to be previewed in real-time in a large window. A brush has the effect of sweeping areas of the image in a liquid motion. The camera and strap were "protected" with a mask (below) while applying the distortion to the inverse selection.

Checking resolution loss A close view of the distortion (above), with the protected camera still selected, shows considerable pixel damage to

the heavily distorted areas, but since the red jacket contains little important detail, this needed minimal correction.

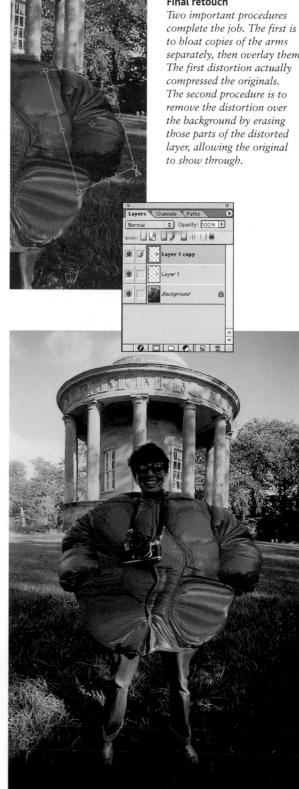

Final retouch

separately, then overlay them.

MANIPULATIONS

wo of the most practical reasons for making major changes are to remove or replace the background, and to alter the composition of a group shot. Background changes can be as simple as taking out an unfortunate mistake like the clichéd telegraph pole growing out of the subject's head, and as ambitious as transporting the person to a

purged officials from group photographs in Stalin's

time. From our point of view, it makes little difference

to the technique or the range of skills used in the operation whether it is the background or the person that

is being moved. Both call on the same skills and tech-

cloning, as in so much digital manipulation. The more

The two principal techniques are compositing and

niques that were described on pages 94-117.

completely different location. Removing someone from a group shot (or adding them to it) has obvious uses, and recalls those anonymous retouching heroes of the Russian Revolution who painstakingly removed

Removing someone from a group shot recalls those anonymous retouching heroes of the Russian Revolution

straightforward of the two is cloning, and this may be all that you need if the job is removing a person. Much depends here on the complexity of the background, and in particular on how much of it needs to be replaced. The ideal one to start from is a fairly consistent but anonymous background with random textures, such as trees, sky, or water. In this case, not much

to make a selection, then copying and pasting it into

the required position. If you do this you need to take

care over the edges, which will call for careful blending. The pasted selection is easier to work with if you

place it in its own layer; then, when you have applied

deselection, you can use a combination of cloning tool

and eraser to work it into the background.

invention is needed to create a new background that looks entirely natural and plausible.

uching heroes Revolution areas is better done by using a freehand drawing tool

Two originals

The background for the shot above was felt to be a little too featureless. A more interesting landscape with similar diffuse lighting (below) was chosen from the files.

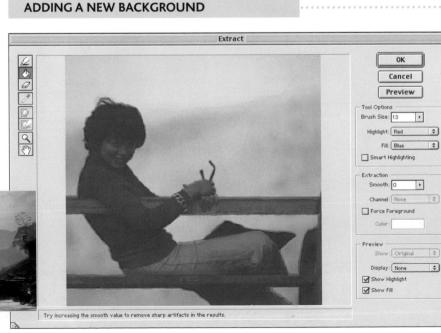

Extract the figure

Extract software from Photoshop was used to isolate the figure, with particular attention paid to the hair. Smart masking of this type is practically essential to retain a realistic hair silhouette. The stage shown here is the completion of the "fill" procedure, ready for the final computation of the mask.

PEOPLE

142

Adding a figure is a two-step procedure, and begins with the routine of making a selection—essentially, removing it from its background. The more different this is, the more precise the selection has to be. The job is made easy if you have shot the figures against a plain backdrop; this becomes the selection, which you reverse. In less planned circumstances, your problem area is likely to be the hair, and here smart masking, described on pages 98–9, is extremely valuable. Pasting the selected figure behind another involves making a second, partial selection in the receiving image.

Faces are so iconic that they lend themselves to all

kinds of manipulation, not necessarily realistic. One technique, useful if you want to create a generic or idealized face, is to split the original vertically down the center, take one half, copy it, and flip it horizontally. Joining this to the original half makes a mirrored image. All faces are to some degree asymmetrical, and this contributes to the character. The perfection of a mirrored face usually gives a strangely depersonalized effect. Another kind of facial idealization is to isolate the elements and apply color and tone correction to them individually until you achieve the desired result.

PURE SYMMETRY

Mirroring

All faces are slightly asymmetrical from the front. Mirroring one half produces a strange kind of graphic perfection. The first step is to ensure that the centerline of the face, through the nose, is vertical—the original (top left) had to be rotated slightly. As an aid to halving the face, a grid overlay was brought into view, and on this a thin gradient was applied to a mask (above). This gradient ensured a softer blending when the selected right half was copied, pasted over, and flipped horizontally (left). To avoid an odd central "parting" in the hair I brushed out part of the upper layer.

Overlay The extracted figure of the woman is copied into a new layer over the chosen background (above). The area to the left of the image will then be cropped out.

Defocus the background As the original portrait was shot with a telephoto—and has the lens' characteristic perspective—it is more realistic to limit the depth of field. This is easily done by applying Gaussian blur to the background (left) for the final image (above).

CAPTURING A SENSE OF PLACE

andscape is deservedly one of the most popular subjects for photography, not least because landscapes themselves have throughout history been scenes for contemplation and enjoyment. Photography is heir to a long tradition in painting, with the major distinction that capturing the image

is instant. Digital photography brings

its own novel possibilities. On the

one hand, the LCD and instant review

of shots taken can improve the

accuracy and speed of taking a picture;

on the other, the opportunities for

One of the appeals of landscape photography is the possibility for individual interpretation

Information vs. atmosphere

Seen from a nearby hill in the morning, the ancient Cambodian temple of Angkor Wat has been shot in a hazy view into the sun—a deliberate choice that sacrifices detail for a more evocative, looming image. As a subject, landscapes are accessible, familiar to everyone, and present no technical problems. Scenic views are, in any case, established stops on virtually any tourist route. One of the appeals of landscape photography is the possibility for individual interpretation, and even the most photographed views can be treated in new ways—just look at the distinctive work of such masters of the genre as Ansel Adams, Eliot Porter, and Emil Schulthess.

manipulation intriguingly take us back to the tradition

of the painted, interpreted landscape.

Compressed planes Shooting down the Grand Canyon from an overlook, a telephoto lens gives the impression of the landscape being stacked in planes. This effect usually looks best with the lens aperture stopped down for good depth of field.

The key lies in recognizing exactly what it is about a landscape that attracts you, and concentrating on that. For example, if it is the freshness of fields at sunrise, you might want to emphasize the dew by shooting into the light. Or it might be the luxuriance of plantlife in a forest, in which case a wide view with green filling the frame might be the answer. Sometimes detail is more telling than a general view; in other situations, widening the view so that the sky dominates may be more effective, and more surprising.

The choice of lens can markedly affect the style of the image, and changing the focal length is often less important for what is included in the frame than for how it changes the character of a photograph. A wide-angle lens not only includes more of the scene, it can capture the sensation of a broad, sweeping view. By choosing the camera position carefully to include a graphically interesting foreground, you can bring depth to the scene and enhance the sense of being there. Viewer "involvement" is one of the classic attributes of the wide-angle lens, and

DIGITAL TRAVEL NOTEBOOK

Most digital cameras allow extra information of various kinds to be stored alongside the images, sometimes even sound. Make use of this when traveling to keep a record of what and where you shoot—and also any technical details in a tricky situation.

exploiting this to the full in a landscape means experimenting with different viewpoints.

In contrast, a telephoto lens selects and isolates elements within the landscape, and gives opportunities to frame any number of graphic compositions. Frame any one viewpoint and there are likely to be more telephoto shots possible than wide-angle. Telephoto also compresses perspective, making distant parts of the scene loom large over nearer objects. Given the right position, typically looking down at a shallow angle, a long focal length can give the impression of stacked planes receding into the distance.

CHECK BATTERIES AND MEMORY CARDS

In landscape photography, as in all location shooting, make sure that you have sufficient batteries and storage space in memory. Packing a spare memory card, or two, is useful insurance.

Near and far

A more subjective impression of a landscape comes from using a wide-angle lens close to a nearby feature, in this case a gnarled old tree. The eye travels easily from close detail to the horizon.

LANDSCAPES

THE IMPORTANCE OF LIGHT

he English landscape painter John Constable considered light "the essence of Landscape," even complaining about the sacrifices he made for it. The quality of daylight is what enlivens —or deadens—any landscape, and probably contributes to its atmosphere more than any other single factor. It

varies with the time of day, the season and the weather, so that the possibilities, if you are able to take full advantage of them, are almost limitless.

The quality of daylight is what enlivens—or deadens—any landscape

The ideal is to have enough time to be able to pick and choose when to shoot a particular view, though this is by no means always possible. If it is, however, the two variables to juggle with are the time of day and the weather. The simplest situation is when the weather is predictable, particularly when that means a cloud-

less day. In that case, you can time your shooting exactly.

Predictability, however, has its own drawbacks, because there are fewer possibilities for

Reflected colors

The light bounces and reflects off the sandstone walls of this deep slot canyon in Buckskin Gulch in the American southwest. Blue from the bright sky mixes with the red of the rocks.

Clearing storm

After a day and night of rain and strong winds, a cold front brought a brief window of sharp light as the sun rose over Dozmary Pool on Bodmin Moor, Cornwall, where the sword of Arthurian legend is supposed to lie.

LANDSCAPES

surprise. A well-known landscape like Monument Valley, on the Arizona-Utah border, has been photographed to death at sunrise and sunset simply because it is predictable. Fleeting conditions of light, on the other hand, such as a rare break in the clouds in stormy weather, have the special value of presenting you with a unique combination. Capturing them means being prepared to work quickly, and for this a handheld digital camera has every advantage. Any doubts about exposure and framing can be eliminated by checking the shot immediately on the LCD display.

What makes good lighting for a landscape is partly objective—how it reveals the texture of rocks or fields, or colors and reflections—and partly subjective. Ruling light, which on a flat or gently rolling landscape means a low sun, is objectively useful, and also generally well liked. Shortly after sunrise and before sunset in clear weather, there is a considerable choice of lighting all at once, depending on whether you shoot with the sun behind you, to one side or facing the camera. The only real disadvantage is that this is exactly when most photographers like to shoot, so it can be a little short on originality. At the other end of the weather scale, rain and snow may be less than comfortable, but offer opportunities of a different kind. The soft light

on a rainy day can help saturate colors—perfect for gardens and greenery.

The weather adds another element to the picture besides its control of the light: the sky. With multilevel clouds of different kinds it can be a subject in itself. Not all landscapes include the horizon line, but when they do, the sky becomes a part of the composition. An interesting sky may be reason enough to lower it.

Layered clouds

Typical of tropical mountain weather, the sun breaks through clouds at different altitudes to create a complex pattern of light in the central highlands of Papua, photographed from a helicopter. The nature of such photography makes it difficult to frame the shot. A digital camera's LCD "preview" display allows you to check the framing immediately.

Summer mist

The water meadows of Dedham Vale in eastern England—Constable country —glow softly at sunrise in a ground-hugging mist that will soon clear. Conditions like this are unpredictable and can clear or thicken at any moment, demanding quick camera response. See pages 156–7 for ways to change lighting digitally.

COLOR CONTROL

he nuances of color in changing daylight affect the mood of a landscape-cool, warm, soft, or hard-and in digital photography you can control them, either in the camera or later, in an image-editing program. Even when the changes are modest, as in the main example here, the effects are striking enough to be worth pursuing.

The overall color of a landscape is affected mainly by

the color temperature (see box) of the The nuances of daylight light. Accuracy is less important than affect the mood of a landscape your own idea of what looks best. Most digital cameras offer a white —and in digital photography balance control, which we have you can control them already seen in action on pages 26-7.

COLOR TEMPERATURE

Color temperature is a color scale that has a particular relevance to photography, especially in landscapes. In practice, it extends from red through yellow, orange to white, and finally blue. In theory, it is the range of color of a notional substance as it is heated up (red-hot to white-hot and beyond), which makes it possible to put a precise figure to each color. On the Kelvin scale of temperature (like Celsius, but starting at absolute zero), white is 5500°K, the color of the midday summer sun in Washington DC, and to the human eye, neutral. Sunrise and sunset are usually somewhere between 3000°K and 4000°K. while open shade under a clear sky is anything in excess of 8000°K.

10000°K	
Blue sky	
7500°K	
Shade under	
blue sky	
6000°K	
Overcast sky	
5500°K Noon sunlight	
Noon suntight	
Spr.+	
3000°K	
Sunset	
1	
2000°K	

In addition, many offer preset refinements, which measure the overall color balance as it is, and adjust it toward one opinion (the manufacturer's) of what it should be. For example, choosing the Overcast setting available on some cameras will remove the slight blueness that is normal under a cloudy sky.

Image-editing programs also allow color correction, but with much more choice-you are not restricted to presets, and while the white point, gray point, and black point settings (see pages 106-7) will establish neutral at different parts of the scene, you can use any of the controls to adjust color to your taste. Extreme correction can even be achieved by use of the gray point with extra adjustment.

Selective color control opens up much greater possibilities, or at the least the chance to improve any disappointments you may have had with the lighting. This was the situation with the original of Machu Picchu in Peru, shown here. The site's situation in relation to the surrounding mountains meant that the best light was in the early morning, but that day the weather was poor. Once again, the first step is to make the selections, and in the case of a landscape there is likely to be more than one. Two kinds of selection are useful: a color range and a physical element. When relevant, color range selection is the easiest, but having made one, you should check the accuracy of its edges before doing anything with it. Examine it as a mask by zooming in on the edge details. You may find that the edges are too sharp, in which case apply a Gaussian blur to the entire mask. Some software includes range selection in the color correction tools, as shown in the example-that is, you pick the color on the screen, then choose how many color steps are to be included around this in the end result.

Select physical elements in the landscape, such as the sky, foreground, or water, by whichever of the selection tools is appropriate. Described in detail on pages 98-103, they each have their uses. Once the selections have been made (and saved), use the curves, levels, or saturation controls as necessary.

COMPENSATING FOR DULL LIGHT

1. Weak sunrise

Because of the orientation of

Machu Picchu, the best time

morning. If the weather is not

ideal, there is no alternative.

of day for the light is early

2. Zoning the image *By painting masks, the image*

is divided into three zones: sky, foreground, and distance. Here, above, the sky is being selected. Handpainting ensures that the wisps of cloud are included.

3. Selecting the sunlit areas In preparation for enhancement, the sunlit parts of the monument are selected by mask painting.

4. Enhancing the sky

Hue and saturation adjustments are made to the sky selection, using the HSB sliders.

5. Intensitying the sunlight

For total control, the contrast and color of the sunlit selection are adjusted channel by channel in Curves.

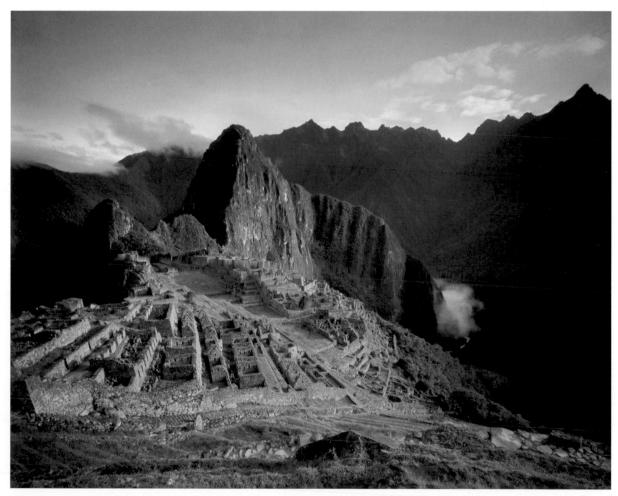

ALTERING DEPTH OF FIELD

ithin certain limits, you can choose the depth of field as you shoot. Greater depth of field means more front-to-back sharpness, more detail in view. Less means that the sharpness is concentrated only on one part of the scene, and that part changes with the focus. Both image styles have their uses: Great depth of field

Not only can you change your mind after shooting, but you can also achieve optically impossible results allows the eye to range over the whole picture; shallow depth of field allows the photographer to select what is important and blur the rest.

The limits in straight shooting are real enough, and don't necessarily coincide with how you would like to

record your chosen scene. Changing the aperture (small equals deep, wide equals shallow) is only part of the answer, because this depends on the lens focal length. Practically, a wide-angle lens will stop down to greater depth of field, which is ideal for a near-far shot that takes in close foreground to distance, while a longfocus lens cannot often record everything sharply even when stopped down. Conversely, selective focus with a wide aperture and all but one point thrown into a blur is a natural for a telephoto lens but impossible for a wide-angle lens to cope with.

Digital cameras are every bit as subject to these laws of optics as silver-halide cameras, but manipulation in an image-editing program opens up new possibilities. Not

only can you change your mind after shooting, but you can also achieve optically impossible results, such as highly selective focus in a wide-angle view and perfect sharpness throughout a deep telephoto image.

Reducing depth of field is the easier of the two, because it requires no advance planning. In principle you simply blur the parts of the image that you want to throw out of focus, and the technique is to select these areas and apply Gaussian blur. If the subject that you want to retain sharply focused is physically separated from the rest—on a different plane, in other words—just make a clean selection around its edge. To be more realistic, vary the density of the mask so that when you apply blurring it increases away from the sharp subject.

As the blurring is not bound to follow optical law you are applying it as you see fit—you can concentrate sharpness on any part of the picture. For instance, blurring an image outward from one point would give a kind of tunnel-vision effect. Alternatively, you could mimic the effect of using the tilts and swings of a largeformat camera by creating out-of-focus blur to the left and right, say, instead of front-to-back.

In a sense, out-of-focusness is a photographic artifact, to borrow computer terminology. Under normal viewing conditions, the human eye does not actually see in this way. Even digital sharpening cannot restore an outof-focus image, so you have to plan for this operation when shooting. Using a telephoto lens on a tripod, take two or more shots identical except in focus. Later, composite the sharp parts of each image, as shown here.

Focusing attention

Selective blurring coupled with extra sharpening of the foreground helps direct the viewer's attention to this pre-Columbian rock carving. The landscape was divided into three zones by painting masks over the rocks, the middle distance, and the far hills. Extra USM was applied to the rocks, and progressive Gaussian blur to the areas behind.

FOCAL LENGTH

1. The limits of focal length Using a medium telephoto lens, it was optically impossible to resolve both the fishing boat and harbor light in this view, even at minimum aperture—the distance betwen the two was

the other could be sharp, and I shot both within seconds of each other. In an imageediting program, the "sharp harbor light" version is placed in a layer over the other image, and aligned.

4. Make background selection

Still in the Find Edges duplicate layer, I used the automatic selection tool to pick up the white background (above)—that is, everything except the harbor light.

6. Brush in sharp background With the selection now "protecting" the light, the background was erased with a brush to reveal the sharper image underneath.

2. Remove blurred foreground 1 be blurring of mode wider than the harbor light, so an

initial step in the procedure is to remove it completely by cloning the water horizontally deross II (ubovo and above left).

3. Find sharp edges I returned to the "sharp harbor light" version, using a Find Edges filter on a duplicate layer (left). To clean up the result, I applied brightness/contrast values, giving me a white background.

5. Apply the selection Switching to the original image layer, I applied the selection—which covers the entire background. However, it is not quite up to the edges of the tower, but this is simply adjusted by expanding the selection by 2 pixels all round.

LANDSCAPES

151

SKY TONES

ot only are skies very amenable to digital change, but they can add to (or detract from) the success of a landscape photograph. The almost endless retouching possibilities exist because the elements that make up skies are, for the most part, soft and vague. Precision detail is simply not an issue. One of the easiest actions is to

The elements that make up skies are, for the most part, soft and vague extend clouds with the cloning tool set to a large, soft brush.

Apart from this kind of local retouching, most operations call for the sky to be selected, as dealt with on pages 98–9. This done, one of the most common practical needs is to bal-

ance the sky tone with that of the landscape. On overcast days in particular, the difference in overall brightness between the sky and the land often exceeds the dynamic range of the CCD or film. In traditional photography the solution to this problem was to hold back the sky when printing in the darkroom. In an imageediting program, simply adjust the Curves or Levels to your own taste. Beyond this, any of the color controls may be appropriate and can be used.

The problem areas that you are likely to encounter when manipulating skies are mainly to do with gradients, most of all on clear skies. Partly this is because of the inherent delicacy of color and tone in a sky, which is by its nature difficult to add to realistically. Partly, though, it involves the limitations of bit depth in a standard 24-bit digital color image. This may be called "true color" and has a range of sixteen million different colors, but each channel has only 256 steps. If you make a monochrome gradient, such as a darkening layer, and this stretches across a large area of the image, the steps are likely to show up, particularly in the midtones, and the result is banding. It is landscape imaging's special concern. The practical solution to the problem is to add a little noise, and to do so

DIGITAL GRAD FILTER

Adjust the brightness

The brightness and contrast sliders give effective control over the strength of the sky darkening when applied to the selection (below).

Gradient mask

The first step is to use the gradient tool from foreground to transparent in masking mode, to create a graded selection for the upper part of the sky (upper right).

Soften the selection

Applying a strong Gaussian blur to the mask removes banding and softens the effect.

ANDSCAPES

channel-by-channel to increase the random scattering that helps to conceal the banding edges effectively.

A technique from silver-halide photography for adjusting the tonal balance between sky and land is to shoot with a neutral grad filter over the lens (glass or plastic dyed to grade softly from clear to darker). The digital equivalent uses the gradient tool and offers more choice of tone and color. Once again, this is more controllable if performed in a separate layer. One method is to set a linear gradient from foreground colour to transparent, with the start point of the tool at the top of the frame (work within a sky selection).

Choose the amount of darkening by using the eyedropper on the top of the sky to set the foreground, then adjust the foreground (double-click the icon) by darkening it. Or use a neutral tone, between light gray and black, and then alter the transparency of the layer. For even more control, make the gradient in a mask channel so that it is a selection. Apply this to the image and adjust the curves or levels. A variation on the theme, which mimics the optics of a wide-angle lens and looks more realistic with a wide vicw, is to use a radial gradient, following the procedure shown for panoramas on pages 162–3.

EXTENDING THE SKY

In a typical instance in publishing, this photograph was to be used on a book cover but more space was needed for the type. As usual, the sky is the cleanest place to put lettering, so it had to be extended by 14 percent at the top and 7 percent to the right. The method was to sample the clear sky tones and create a separate file with a radial gradient of these colors. Having compressed this gradient into an oval for a more natural effect, it was copied into a layer, and blended with the slider and eraser. Extra work involved cloning to the right.

Blending a gradient The original (above), and the finished image (right) after the extension of the sky.

A STORMY SKY

Desaturating the sky Having made a sky selection (below left) from the original image (left), strong desaturation was applied with the HSB slider to lessen the blue.

Contrast reduction

In keeping with a full cloud cover, the contrast was reduced with the RGB curve (below).

A low sun effect

The selection was inverted to work on the ground; then, the greens and yellows were individually saturated (below) for the effect of strong low sun (bottom).

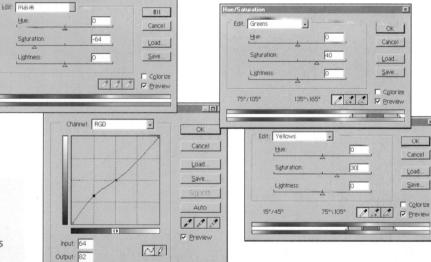

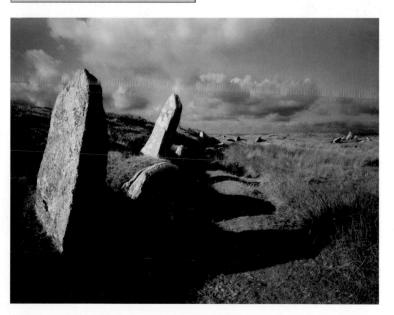

LANDSCAPES

NEW SKIES

ather than work on an existing sky in a photograph, it might be easier or preferable to use another. As long as your selection technique is perfect, there are few complications, and all that you need is a suitable candidate for the transplant. Naturally, this has to be at the right size and resolution. If it is too large, first compare it to that of

Technically, all that has to be done is to select the sky in the receiving image, load the new sky, and paste it in the landscape you are working on. After resizing, you will probably have to sharpen it slightly with the USM; to get the right amount, compare it at a high magnification with the sky that it will be replacing.

Technically, all that has to be done is to select the sky in the receiving image, load the new sky, and paste it in. If the transplanted sky is slightly larger (always an advantage), experiment by altering its position. Finally, track along the horizon at 100 percent magnification or greater to clean up the edges.

The technique may be undemanding, but visual judgement is very important. Any old sky will not do,

and apart from choosing one that will enhance the image, be careful that it matches the landscape. There are certain obvious rules to follow, such as the angle of the sun. Clouds can make this apparent, and if there are shadows on the ground falling in one direction, make sure that the shaded sides of the clouds are approximately the same. Flipping the sky horizontally is a quick fix.

A realistic match also depends on the focal length of the lens. There is a fair amount of latitude here, but a wide-angle sky will look wrong over a telephoto landscape, and vice versa. If the sky is clear, wide-angle optics cause radial shading, as we saw on the previous pages, while the perspective of diminishing clouds is also a giveaway.

Beyond this, the critical zone for matching sky to ground is just above the horizon. Think of the aerial perspective: Most of the features in a sky that you can see, such as clouds and haze, are concentrated in the far distance, close to the horizon. If there is insufficient of this zone in the new sky, the result is likely to look

A SKY LIBRARY

Good skies are worth collecting, with or without the landscapes underneath. Even before digital imaging became practical, I used to shoot any sky that for me had character, for possible use in special-effects photographs (assembled optically in those days). They became a sky library, now scanned to high resolution and stored on CDs. Included among these real skies are some CGI skies created in Bryce.

false. It may even be necessary to retouch this area before compositing.

A radical alternative is to ignore real photography and generate a sky from scratch. Immensely difficult to do by illustration, this is simplicity itself with 3-D software that has realistic rendering. Provided that you do not attempt the more precise types of cloud, like cumulus, CGI skies can be completely realistic, and their lighting and atmospheric qualities are absolutely controllable. The example here was generated in Bryce.

SKY REPLACEMENT

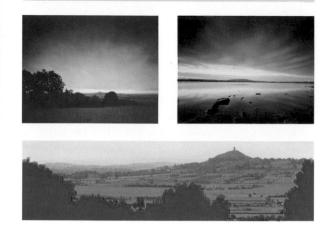

Altering proportions

In preparation for adding a new sky, the original image of Glastonbury Tor, in southwestern England (top), was altered by extracting not just the sky, but the foreground (above), then resizing to give more foreshortening. A sky with more presence was chosen from the same shoot,

Stronger sky

but a different location (top). Having used the Extract tool in Photoshop, the newly composited landscape fitted seamlessly over it (right).

A BRYCE SKY

3-D modeling

This popular terrain-editing 3-D program has excellent tools for creating artificial skies, including libraries of presets (above right) that can themselves be edited. In this example, a water element was included, and the rendering engine records the correct reflections. In the picture above, the rendering process has just started. Once the camera position and angle (here imitating a wide-angle lens) have been established, it is simple to vary lighting and color (right). Sky&Fog

LANDSCAPES

155

CREATING LIGHT

he quality of light, as we have seen, makes a fundamental difference to a landscape. By comparison, the overall color is almost a superficial effect—as evidence the ease with which you can adjust it digitally. Lighting is quite a different matter, particularly sunlight, which throws shadows from every tiny detail. It is so much an integral part of the image that it resists digital manipulation. In

Lighting is so much an integral part of the image that it resists digital manipulation

theory you could add shadows by darkening as shown on page 114, but in practice you would have to do this for every rock, tree, leaf, and so on, which is an arduous waste of time.

That said, there are some specific effects that can be made. One area of adjustment is in the intensity of sunlight. Changing the existence of shadows may be out of the question, but strengthening or weakening them is perfectly possible. The procedure is to alter contrast, which is straightforward, with the curves control allowing the most delicate adjustments. When using it, identify where on the curve the shadow tones lie by clicking on one of them, and alter the shape of the curve to favor them. If you are intensifying, allow the shadows only to darken as much as you like, but do not lose the highlights. After this, make a small adjustment to the saturation, increasing it for stronger sunlight, decreasing it for weaker.

Highlights of various kinds are also possible additions, although the occasions are limited. The effect shown here in the photograph of the cave is an atmospheric one—a shaft of light, something to use very occasionally and with care, as it is easy to exaggerate. To keep it delicate and transparent, as it needs to be, work in a separate layer so that you can adjust the

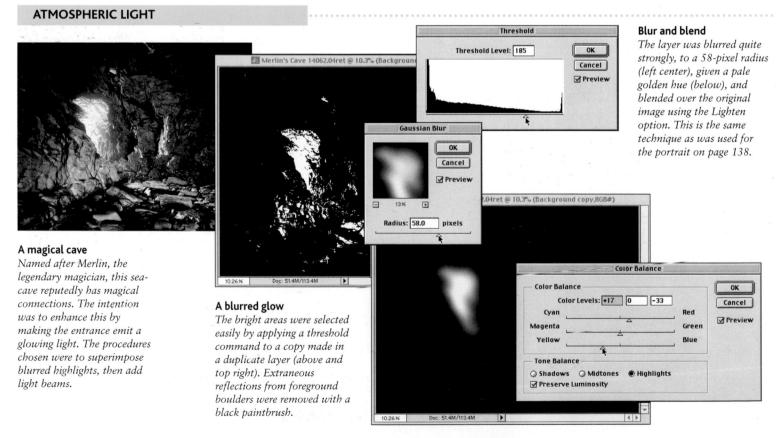

ANDSCAPES

transparency, erase parts and change the position if necessary. One way is to use the airbrush tool with a soft edge and a very long fade-out so that the shaft of light appears to dissipate in the air. Another, used here, is to prepare the shafts with a gradient filter, transform them so they fan out, and then apply them blurred.

One of the most interesting lighting techniques, used in the example to the right, is actually firmly rooted in reality. Nothing is adjusted or added; instead, the lighting from two times of day are combined. The operation needs to be planned before shooting, because you will need two identical shots in which the only thing that changes is the lighting. Not only is a tripod essential, but the camera must not be moved a fraction between the exposurce. The best conditions for shooting are when you can fairly confidently expect the lighting to change.

Both images need to be exactly the same size digitally, down to the pixel, which they should be if you shoot digitally, or scan, at identical settings. Save the images uncompressed. Then, with one image in each layer, combine them as you like, either by brushing one in, or by erasing.

PAINTING THROUGH LAYERS

Two matched originals Shooting began before dawn and continued until the low hill was sunlit. The two most contrasting frames were selected, and the sunlit shot placed in a layer over a predawn shot, aligned exactly.

The image file was saved, and then the sunlit image erased. I then enlarged it and painted in the sunlight with the history brush in Photoshop, which restored it (left). An

> eraser brush added fine control.

Distort and blend With the distort tool, the

beams were spread; then the blending option for the layer they were in was set to Lighten (below).

Pattern for beams

The source for the light beams began as a repeating pattern of gradients created in KPT 2.0 (above). This grayscale image was pasted approximately into position at the cave mouth.

Final effect

For a softer, more realistic effect, the beams layer was blurred, reduced in opacity to 70%, and selectively erased with a large airbrush setting. The finished image combines a diffuse glow and hazy shafts of light.

ENHANCEMENT 1

ow far should you go with the manipulation? Digital tools themselves do not discriminate, and as with any other subject, they can be used to change just about anything. Landscape photography has always favored a large dose of personal interpretation—witness the many different styles, from the romantic impression-

There are numerous third-party filters that will apply set treatments to an image ism of Alvin Langdon Coburn to Edward Weston's "straight" photography, and the metaphysical approach of Alfred Stieglitz and Minor White. Now digital manipulation allows an extra level of treatment.

By using a combination of the techniques just described, from selective color changes to replacement, you can push a landscape more into your own conception of what it should be. In so doing, you will inevitably personalize it, distancing it from more standard photographic treatment.

Even so, it is not a bad idea to have a purpose, if only to avoid mannerism—an addiction to tricks. There are numerous third-party filters, some of which are shown on pages 124–5, that will apply set treat-

REMOVING MAN'S TRACES

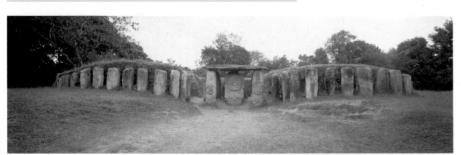

ments to an image, and while there is nothing wrong with pastiches of painting styles, most of these filters are more like games than anything else. If there is any style involved, it is that of the programer who wrote the software rather than the photographer using it.

My examples are intentionally not extreme, although elsewhere in the book there are some stranger landscape creations used in different contexts. As for purpose, the aim in each case has been to establish a particular mood, and there were specific reasons for the changes involved.

1. The originals

The photograph of a pre-Columbian tomb from which the sky was already extracted on page 103 shows evidence of lots of visitors having tramped the grass. Here, we restore it to its natural state—and then add a new, looming sky.

2. Extend the best grass color

Where the grass has not heen worn away, most of the problems can be solved by recoloring it. The lower right corner has grass in the best condition, so the clone brush is set to "color," and this is brushed into the surrounding area.

ANDSCAPES

3. Paste the retouched grass

Once a sufficiently large area of grass has been restored, it is ready for pasting into the worn-out patches near the tomb's entrance. The lasso tool is used to make an irregular selection, and this is copied and pasted into position.

5. Blend with random erasing

The final blending procedure is to erase parts of each layer's selection by soft brushing, using a largediameter airbrush and much less than full opacity (here 40%). Doing this in a random pattern several times, with different layers, means that the cloned patches no longer look similar.

4. Alter brightness and contrast

The process of copying and pasting is continued from one part to another, taking care not to repeat pasted shapes. Brightness and contrast sliders are used to help blend selections and to avoid total uniformity across the image.

Brightness/Contrast		
Brightness:	+16 OK	
Contrast:	Cancel	
	Previe	

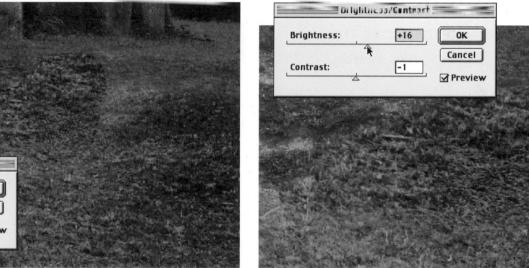

A ROMANTICIZED VIEW

ENHANCEMENT 2

ollowing on from the remarks on the previous spread, in the case of the pre-Columbian tomb, the problem was the light and the setting. Nothing could be done about either at the time, but the megalith, in San Agustín, Colombia, was an important subject, and I liked the shape and rhythm of it. I wanted to give it a darker mood and the tomb more

Without altering the substance of the scene, I wanted to evoke a little of the atmosphere of mythology presence. For this I introduced a stormy sky and made color corrections.

In the photograph of Tintagel Castle, in Cornwall in the southeast of England, the idea was to create a romantic view, very slightly surrealistic in effect but not altered in any obvious

way. By local tradition, this rocky peninsula is one of the contenders for being the site of the legendary Camelot, and the picture was part of a magazine story on the legend of King Arthur. Because of the editorial treatment of the piece, I wanted to convey throughout a slight sense of magic. Without altering the substance of the scene, I wanted to evoke a little of the atmosphere of mythology. The weather and light for the two days that I had set aside for shooting offered nothing special, but at least they were acceptable.

In any case, there was another, pressing need for digital retouching. The English authority that administers historical sites such as this had performed an act of constructive vandalism by building an ugly concrete footbridge visible from every direction, which was also quite effective in destroying the atmosphere. This was one of the reasons for the camera position I chose, but even so my first job was historical restoration, which meant removing the concrete.

After that came the main part of the enhancement, which I foresaw mainly in terms of atmosphere, the color of the sea, and highlighting the rather meager ruins. I worked on the color of the sea in the cove to give it a richer, clearer appearance by adding blue-green, added to the sky and a band of light fog over the peninsula, and increased the brightness and contrast of the castle itself.

1. Original as shot English weather being what it is, I should have been grateful that there was at least some sunlight on the day scheduled

for photography of Tintagel Castle on the north coast of Cornwall. Even so, it fell short of ideal, and I fell back on digital enhancement.

2. Sky removal I had a better sky in mind already in my stock library. The original sky was removed, leaving a slightly hazy horizon.

3. Site restoration

A footbridge and concrete embankment added by the authorities detract from the view, and were easily replaced with the cloning tool. The castle ruins were made brighter to contrast with the surrounding landscape.

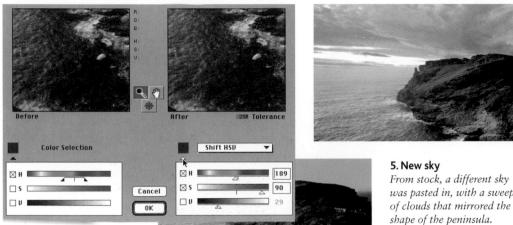

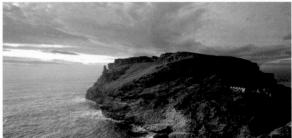

5. New sky From stock, a different sky was pasted in, with a sweep

6. Sea fog

In Bryce, a light, wispy layer of fog was created (below). Opened in an image-editing program, this was pasted over the image using the blending options to keep the edges soft and allow some transparency.

4. Sea color enhancement To give the sea more depth and clarity, I determined a color shift from dark blue to a more saturated blue-green, and brushed in the change.

LANDSCAPES

7. Final color correction A few small color changes, such as to the junction of sea and sky at the top right,

were made before saving the final image.

161

DIGITAL PANORAMAS

andscapes and panoramas are made for each other. The view from an overlook is by nature a panorama, and the format, two, three, or more times longer than the height, mimics the way in which people take it in, looking from side to side. Panoramic photographs have always been popular, and the chief restriction in taking them has been that panoramic cameras are expensive and specialized, increases the resolution of the final panorama. Ideally, use a tripod, setting it up carefully and leveling the head, but you can, in fact, manage quite well without; there may just be a little more work to do later. The argument in favor of handheld shooting is that you can choose to do it in an instant. In either case, first plan the coverage: The start point on the left and the end point on the right (or vice versa). What is essential is to

REPLACING THE SKY

The most difficult part of most landscape panoramas to blend realistically is the sky. The level of detail in the landscape itself can mask inaccuracies, but a smoothly graded sky is unforgiving, and even taxes stitching software. An alternative is to extract the sky from the combination of images, and replace it with a digital gradient, as on pages 152-3. This will look more realistic if you apply the gradient radially rather than linearly. To do this, make a new, square image file the width of the sky that vou want. Make a radial gradient, then squash the image and use the upper half only.

because they use either a large lens with a very wide angle to cover the stretched format, or a mechanism that rotates the lens or moves the film. Some regular cameras offer a panoramic

option that crops down from the normal frame, but this is a perfectly useless function, and a job that is much better performed by cropping the print.

Digital stitching, which we already looked at on pages 116–17, makes panoramas accessible to anyone with access to image editing.

The majority of landscapes are full of irregular texture and detail, which is a real advantage when it comes to joining sections together. Precision is by no means as important as in a manmade scene, where buildings and the like follow certain rules of symmetry. This makes for less work, either for the stitching software, or for you if you choose to do it by hand. Compare the panorama of the River Thames in London on pages 170-71 with the one here. A few quick strokes of the cloning tool to add bushes or a section of hillside can cover over a join with complete realism.

Success depends heavily on how you shoot the strip of frames in the first place. Using a longer focal length reduces edge distortion for easier stitching, and shooting vertical frames

Success depends heavily on how you shoot the strip of frames in the first place

overlap the frames sufficiently, by 50 percent. Unless you are using a panoramic head that has been built for this purpose and which has click stops to indicate where to shoot each frame on

the rotation, you will have to judge the steps by eye. The easiest way is to use the leading edge of the

frame (the right edge if you are swinging from left to

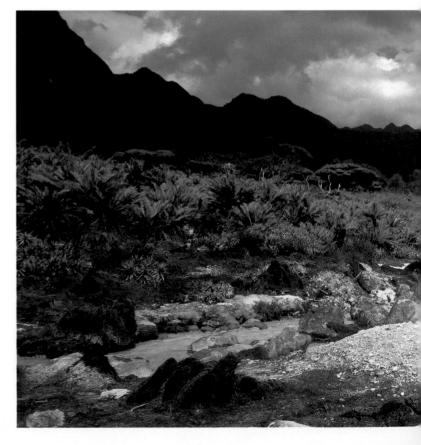

right, the left edge if in reverse) and align that with an identifiable feature in the landscape. Make the exposure, then swing until that feature is in the middle of the frame; identify another feature on the leading edge. Make a second feature, and continue in the same way until you reach the end. It may help to do a dry run first, so that you know in advance where to stop and shoot each time.

To side-step any difficulties when joining together several areas of delicately graded sky, consider replacing the entire sky. Because a panorama includes so much sky area from left to right, to be realistic it should also take in a range of tones, both vertically and horizontally—the more so if the sky is clear. A straight replacement sky photographed with a wideangle lens is unlikely to have a large enough range, and one effective solution is to apply an artificial gradient, but radial rather than linear, as explained in the box on the left of the adjacent page. Alternatively, clouds can be added later by copying and pasting into their own layer (using Lighten mode and some transparency), but this is a rather more difficult and time-consuming process. An alternative is to create a CGI sky in 3-D, setting the angle of view to that of the panorama. Use any appropriate selection tool to isolate the combined landscape, for example the Extract procedure, which has been described on pages 102–3.

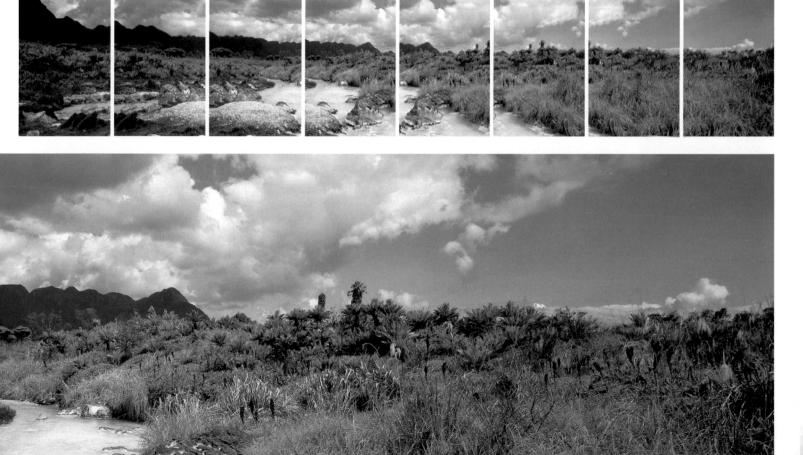

Overlapping sequence

Created in the same way as the panorama on pages 116–17, this Colombian landscape was shot in an overlapping sequence from left to right. Stitching software was then used for the final panorama below.

BUILDINGS ANCIENT AND MODERN

ou can photograph urban landscapes as something apart from the lives of the people who live there—in other words, as architecture. This is not just about photographing new office blocks or ancient cathedrals: In reality architecture means all buildings from the vernacular to the formal. It is as much about terraced brick houses in

Baltimore and cottages in the Lake District as it is about palaces, castles, and skyscrapers.

Inevitably, viewpoint is the first thing to consider. In a city or town this is often a matter of finding simply a clear view. If you know already what buildings or street you want to capture, be prepared to put in some foot-

work. Also consider whether you might be better off trying to shoot from an upper level on another nearby building rather than from the street. This will then involve asking someone for permission, which is not always easy to get, but it may well be worth the effort. One tip is to look around from the building you want to photograph—if you have a direct line of sight to a vantage point, then you will be able to see back from there.

Of all city viewpoints, the overlook is often one of the most sought after—a point that takes in a general

This is not just about photographing new office blocks or ancient cathedrals: In reality architecture means all buildings from the vernacular to the formal

Hi-tech

This modern home in

Tokyo features a strange.

Power cables in the street

cantilevered superstructure.

meant that the building had to be photographed from up close, using a wide-angle lens, but this helped emphasize the mechanical exterior.

view. These are often well known locally, and probably feature in postcards. In general, there are three likely prospects: From the top of a prominent tall building; from any high ground such as a hillside; and from the opposite side of any open area such as a river or a park.

Lighting is as important in urban landscapes as in natural ones—possibly more so as reflections from

glass and the shadows of neighboring buildings add greater variety. More than this, artificial lighting can completely transform the view as evening falls, and may even improve it. Streetlighting, the interior lights in buildings, and occasional floodlighting of major public buildings can combine in a colorful

effect, although it is impossible to predict unless you know the place already. One thing is almost always certain, that the prime time for shooting nighttime cityscapes is the very short period just after dusk. If you wait until darkness, the outline of buildings will fade into the night sky. For this reason, winter is usually better than summer, because shops and offices are still open when dusk falls (depending on the latitude).

The color of artificial lighting varies more than our eyes recognize, because human sight

> accommodates differences quite easily. Fluorescent lighting has breaks in its spectrum, which a CCD (and film) record accurately, and the result is usually greenish. Vapor lighting is often worse in this respect—sodium vapor streetlights give out no blue at all, while old-fashioned tungsten lighting is more orange than daylight. Here, digital photography has the solution, partly in the form of the white balance at the time of shooting, and also later, during image-editing, where even the most intractable color problems are correctable.

Lighting for texture

Fast-moving clouds in the late afternoon provided perfect, shifting lighting conditions for the metallic surface of the huge Grand Hyatt hotel in Pudong, across the water from Shanghai.

Low sun

The low raking light from a clear sun either early or late in the day has many attractive qualities for buildings. In the case of this adobe church in New Mexico, it brings out the warmth and rough surface texture of the earthen structure.

THE URBAN LANDSCAPE

CONVERGING VERTICALS

ost photographs are taken with the camera aimed more or less horizontally, and for the most part this is a matter of no concern. If you tilt the camera up or down to photograph something above or below you, the picture will look as you expect it to. With buildings, however, it does matter, because if the camera is aimed upward, the photograph will look odd, since the

Digitally you can reproduce the effect of a perspectivecorrection lens by working on a tilted photograph

building appears to lean backward. The vertical walls converge.

This is not some optical aberration: The verticals appear to converge even to our eyes and to

the camera lens—but a straightforward matter of perspective. The difference is that in the real scene we accept it as normal, but see it as wrong in a picture. The simple answer is, of course, not to tilt the camera; keep it level and the verticals will not converge. In practice this is often far from easy, because of other buildings or the difficulty of getting a good viewpoint.

There is a traditional photographic solution, but it calls for special equipment—a perspective-correction, or shift, lens. Using one of these, the camera is aimed horizontally, and then the front part of the lens is shifted mechanically upward. This relies on the lens elements being able to cover a much wider area than the film (or CCD) frame; shifting it has the effect of moving the upper part of the view down into the frame. Now, digitally you can reproduce this effect by working on a tilted photograph.

The technique is to change the size of the image progressively, from top to bottom, effectively stretching the upper part or compressing the lower. The perspective tool displays a framing-rectangle with corners that can be moved by sliding one of them inward along one edge of the image. The opposite corner on the

USING PERSPECTIVE

Reshaping the image

The Clock Court at Hampton Court near London appears to lean back in this photograph. Using the digital tool Perspective, the correction must be to squeeze the bottom edge as the convergence is toward the top of the photograph. Gauge the amount of correction by measuring the angle of the maximum distortion at left or right. Drag a line from one lower corner parallel to the convergence, and note the distance it meets on the upper edge (above right).

Execute and crop

Drag one lower corner of the Perspective box right to the distance just measured; the right corner moves in automatically. If all the verticals are now vertical in the preview, execute. The corrected image has empty white triangles left and right, which need to be removed by cropping. The image is then stretched vertically.

THE URBAN LANDSCAPE

same side slides inward to meet it, so that any change you choose to make is symmetrical. The new shape is like a truncated pyramid, and the idea is to make its converging sides the exact opposite of those in the photograph. For accuracy, first show the rulers around the frame. Then (in Photoshop) use the measure tool from one corner, running parallel to one outer wall of the building, as far as the opposite edge. Note the point on the ruler along this edge that it meets. Select the perspective tool and move one corner into this point.

Because you are resizing the image, it will deteriorate slightly, so it will need some USM sharpening, applied progressively. To do this, apply a 100 percent linear gradient to a mask layer, with the midpoint set to 50 percent, and sharpen this selection. In this way, the sharpening will be progressive from top to bottom (or vice versa) to match the stretching. As reducing the scale needs less interpolation than increasing it, the image quality will generally be better if you compress the bottom of the image rather than stretch the top. If you apply the perspective tool to the entire image, you will then have to crop it back into a rectangle, and if the width of the building nearly fills the frame, this will mean losing some of it. The alternative is to add more background, or even replace it. If so, it may be better to select the outline of the building and apply the perspective control to that, which will leave you some background to clone from. This will only work, however, if there are no converging verticals in the background.

Extreme correction

While there are no limite to the amount of perspective correction that you can apply. when the original angle is extreme there are certainly visual problems. This photograph of a group of buildings in Los Angeles was shot with a wide-angle lens from up close, deliberately for the graphic effect. I had no intention of correcting it, and this example is purely an exercise. Full correction has two effects: It requires a much smaller final image to avoid excessive upward interpolation, and it distorts the upper part excessively.

- Tixer Dimer	isions: 13	.8M (was 18.3M) —	OK
Width:	1966	pixels	¢ Cance
Height:	75	percent	Auto.
– Document Width:	Size:		-
Height:	6.09	cm	÷

Restoring proportions

In performing the perspective correction, we have in fact, substituted one kind of distortion for another. This elongation, incidentally, occurs in original photography when a shift lens is used, albeit to a lesser extent. The quick fix is to resize the image without constraining the proportions, reducing its height only, as shown above.

STREET CLEANING

Il urban landscapes suffer from visual pollution—an increasing litter of graffiti, advertising, telephone lines, scaffolding, and satellite dishes, not to mention bad architecture. Fortunately, some of the more egregious examples, like electricity cables, are also among the easiest to remove digitally, and this is one area where it would be difficult

Some of the more egregious examples, like power cables, are also among the easiest to remove digitally to argue against digital editing.

I am distinguishing here between documentary photography—shooting places and things warts and all—and architectural photography, where the point is to show the building as it should be seen. You could say that it is

the unblemished view that the architect would prefer.

If you know in advance that you will be doing this, there are some steps that you can take when shooting to make life simpler. First, identify the obstructions and other elements that will need removing and check whether the areas they conceal can be cloned convincingly from wherever is visible. A patch of bricks will be easy enough, but something less regular may turn out to be a lot of trouble for a small detail. You may be able to work around this by shifting the camera viewpoint a little to one side, but check that this does not create a similar problem elsewhere. Another solution is to take two similar photographs a short distance apart, and rely on parallax to make the concealed parts of one image visible in the other. Then clone, or copy and paste, from one to the other. This technique will work with most things in front of a building, although parked vehicles may need some extra shots. If you can go to the trouble, you could shoot details from the pavement to add later as patches.

People walking around in front of a building, or in an interior, can also be taken care of, if they bother you. This is particularly a problem with ancient monuments swarming with tourists. For only a few people, use the cloning tool in the normal way, but for a crowd use the technique shown on page 158 for combining two different lighting conditions. Without moving the camera (best to use a tripod), make two identical exposures a few minutes apart. Put each picture in one layer of the same image file, and as long as the people are moving, rather than sitting in one place, you can then paint through the visible parts of one image to another.

figure in the steps near by.

This was copied and pasted.

PEOPLE AND SIGNS

A well visited monument As happens more often than not with well known monuments such as the Mayan pyramid of Chichen Itza in Mexico's Yucatan, other visitors clamber over the site. Waiting may be an option, but when the lighting is good, as here, just before a storm, there is nothing to do but shoot and alter later.

168

THE URBAN LANDSCAPE

CITY CONSTRUCTION

1. Temporary cranes

The original shot (left) of the City of London had its inevitable addition of tower cranes—construction here is neverending.

2. Copy and paste

To achieve the final result (right), the basic procedure was to copy clean sections and paste them over areas containing the cranes, using rectangular selections. Cloning was also used in places.

3. Seamless joins

Skies are particularly difficult to paste over because of their fine shading, but one way to overcome this is to flip the pasted copy horizontally, then join to the edge of the original selection (left). In that way the edges blend perfectly, ds they are identical.

4. Window details

The regularity of most buildings (far left) made it possible to copy small selections for pasting over the parts of cranes below the skyline (left).

Repeating the operation

The same technique was used for the rest of the building, to cover over a works entrance, signs, and other figures. Pasting in Photoshop automatically creates a new layer, which is useful for retouching.

A COMPOSITE VIEW

ore than any other kind of view, cityscapes change dramatically between night and day. Partly it is the architecture that is responsible; there are so many different materials present in the centers of great cities, from old stone and brick to steel and glass, that the shifting light and color are constantly being reflected in

different ways. And, if you wait until evening, the effects of manmade lighting, both inside and out, take over.

Only digital photography can draw together these changing states of city life into one

single, seamless image. The idea is simple enough, although horrendously difficult by traditional optical means—it is to combine a series of photographs from the same viewpoint, taken over many hours.

The technique borrows considerably from the painting-through-layers procedure already introduced for landscapes on pages 162–3. The difference between that landscape and this cityscape of London is that the camera was panned between frames, beginning with

the morning shot at the far right of the composite, and ending with the floodlit St. Paul's Cathedral. This last feature determined the shoot, as the floodlighting switches on about an hour after sunset.

Finally, I chose five frames from different times of the day, and used the basic technique of a gradient blend from one to the other. In principle this is

> straightforward: Once the different images, each in its own layer in the image-editing program, are positioned exactly over each other, they are blended together by means of smooth fades. In practice, there

are one or two wrinkles. One is that panning causes a stitching problem in detail because of slight distortion toward the edges of each frame. The solution was to align one image to the next where they overlapped rather than try to fit every part of each one, and then apply the gradient blend only across these restricted areas. The other issue is the old problem of banding (*see page 188*), for which the solution was to apply noise to the mask before deletion.

LONDON NIGHT-TO-DAY

1. A sequence of change

The final selection of five frames from a day's shooting which began at 10:00 am (bottom), continuing to past 8:00 pm (top). The times chosen, concentrated late in the day, reflect the change of light, always fastest when the sun is close to the horizon.

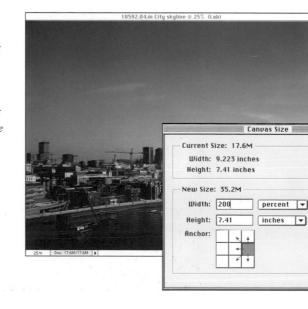

Only digital photography can

draw together these changing

states of city life into a single,

seamless image

2. Canvas extended

OK N

Cancel

In a composited series such as this, it is important to have an anchor for aligning all the images. I chose the morning shot, extending the canvas to its left to give space for the

later frames, initially just doubling its width.

THE URBAN LANDSCAPE

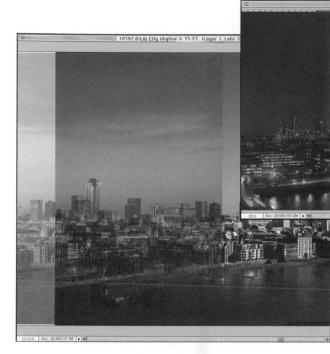

The late afternoon shot is opened, copied and pasted into its own layer above the first. Made temporarily halftransparent for ease of alignment, it is positioned exactly over the base image (far left). An obvious feature—the corner of a building—is selected and dragged over to its equivalent in the underlying picture. The same is done for the other

4. Horizontal blending

Blending begins in the critical area right of St. Paul's between dusk and sunset (top). In mask mode, a gradient is applied from full to transparent, noise is applied to the entire mask, then the selected area of the dusk view is deleted. A selection of St. Paul's is made, and loaded into the gradient selection as a subtraction, to protect it from deletion (above).

5. Final adjustments

Once all the layers have been faded into each other (above), a couple of them are adjusted slightly for brightness to give a smoother visual blend. Here, the central frame is darkened a little. With this done, the layered workfile is saved, and a copy made and flattened (right).

17077.00 workfile @ 25% (Layer 3, Quick Mask)

DIGITAL RESTORATION

hat can be made can be altered. Even apart from the sort of tidying up that we just looked at, there are a number of good reasons for making architectural alterations. One of them is restoration—genuine structural problems that for one reason or another have not been corrected in the real building. Another

What can be made can be altered

is deconstructing a particular type of building to show how it works architecturally—a kind of photo-illustration. Examples of both of these are

shown here, both coincidentally from Thailand.

In the picture below, the problem was subsidence. The piles of the teak pavilion were sinking slowly into the mud of the lake. While in normal circumstances this could have been treated simply as a feature of the building, and left alone, the composition of the shot made it glaringly obvious. Because this was to be the cover of a coffee-table book, the wooden pillars simply had to be straightened to align with the right-hand edge. Worse, the subsidence was progressive, from left to right, so that the pillars closest to the edge of the frame were the most tilted. Tilting the camera in the opposite direction would have made the lake and the other buildings, slope to the left.

The only solution was to do what the clerk of works should already have done: raise and straighten each pillar individually. As with any major piece of manipulation, it pays to think first about the working method. In this case, the sensible approach was to slice the subsiding part of the pavilion into different portions, according to the angle of tilt, put each one into its own layer, and rotate until straight. In detail, this meant considerably more work retouching the joins, particularly as the fretwork had to be kept regular to ensure that the end result looked convincing.

RESTORING A TEAK PAVILION

The original

As taken, the photograph of the Vimanmaek teak palace in Bangkok emphasizes the leaning pillars of the pavilion, but I liked the composition so much that I was loathe to frame it in any other way. Digital restoration was planned from the start.

Rotate selection

Having made a selection of the pavilion, using Paths, a copy of this in its own layer is first rotated to straighten the left edge (below). Showing a grid overlay helped the alignment.

Partly straightened

The result, above, of the first rotation is that the left pillars are now vertical, but more work remains to be done on the others.

Rotate more

A second selection, cut in from the first, is rotated a fraction more to straighten the central pillars.

GENERIC ARCHITECTURE

Wide-angle original

The only camera position possible for shooting this northern Thai rice barn meant a wide-angle shot, which is rather too distorted. The clutter below is inevitable.

Deconstruction

Using Paths, the key components were isolated. Hidden pillars were cloned from those visible. Applying a shadow under the eaves, all of these were combined into a single image.

In the other example, the aim was to create clean architectural views that were typical of types of building, and so needed to be more generic than idiosyncratic. To make the job more difficult, this was decided after the photographs had been taken; otherwise the procedure could have been eased by shooting with this in mind. Fortunately, one characteristic of most architecture is that there is repetition in the façade—windows, tiles, bricks, planks, and so on. Traditional Thai wooden architecture uses prefabricated elements, and while the panels, posts, balustrades, and decorations are not precisely identical because they are handcarved, it meant that only a few sections of each were necessary to build a house digitally.

Composite the rotations

The final adjustment is made on a small section close to the right edge. There are now three overlapping sections, each of which is properly aligned, and these are finally combined, with retouching to cover the joins.

Final composite

The corrected pavilion is now overlaid on the original image, again with retouching (right).

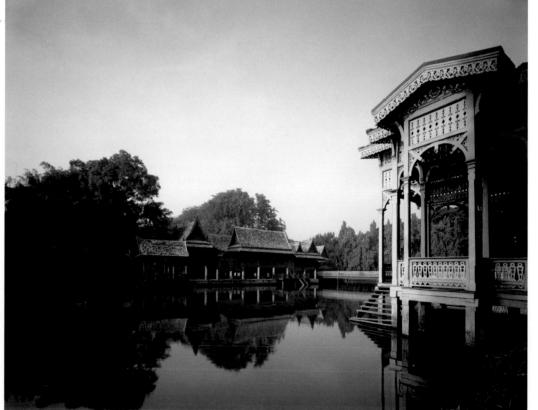

THE URBAN LANDSCAPE

INTERIORS

he interior spaces of buildings, from modest living rooms to grand halls and concourses, are yet another subject with particular and specific opportunities and needs. All but the largest rooms absolutely need a wide-angle lens, and there is little point trying to do justice to a room if the focal length of your lens is no wider than the equiva-

If you stick to daylight, you are likely to find that most rooms are unevenly lit, with windows on one or two sides only lent of 28mm on a 35mm camera. This is, unfortunately, often an issue with the current choice of digital cameras, as was discussed on pages 16–17.

Whatever the lens, you are likely to find that a corner of the space offers good possibilities, if not the best, for

to the red channel.

your viewpoint. This is particularly so in a small room, where it is always difficult to back up far enough to

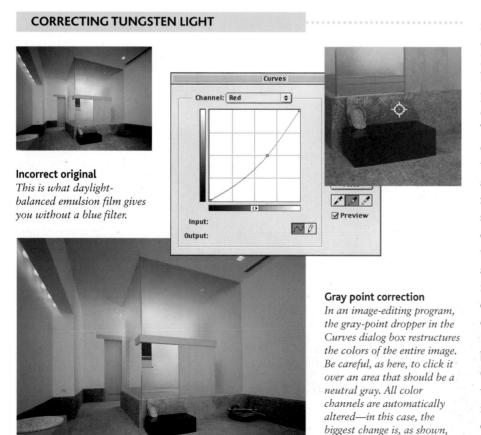

take in some sense of the entire area. Also, most domestic interiors tend to be arranged horizontally, which is to say that there is not likely to be much vertical interest, and there are usually only a few opportunities for shooting to a vertical format.

Once the viewpoint has been established, lighting is paramount. There is broadly a choice of three: Daylight as it filters in through the windows; available light from the room's existing lamps; and photographic lighting (which for most people means flash). You can combine these, such as by switching on room lights during the day, and using photographic lighting as an additional help for shadows. In all cases, the actual light level will be so much less than outdoors that you will have to find some way of keeping the camera stable for a long exposure. A tripod is virtually a prerequisite.

If you stick to daylight, you are likely to find that most rooms are unevenly lit, with a window or windows on one or two sides only. The result is a fall-off horizontally, not something that your eye may take in because it accommodates it, but it will affect the image, particularly if you shoot with the windows on one side of the frame, which often gives the best modeling. There are two traditional professional techniques to deal with this: One is to aim a flash or some other photographic light into the shadow side of the room to balance it; the other is to use a neutral grad filter horizontally to compensate. Digitally, life becomes much simpler; taking the neutral grad idea as inspiration, an easy solution is to apply lightening or darkening across the image with a gradient fill. A more sophisticated approach would be to shoot two frames, one exposed for the highlights, the other for the shadows, and then combine these in the image-editing program in the way described on pages 178-9.

If you use available lighting, the same issue of color balance applies here as it does to nighttime city views. Once again, the camera's white point balance turns what used to be one of the banes of film photography into a simple matter of pressing a button. If there is a color cast that you cannot eliminate in shooting, just take care of it in image-editing.

CORRECTING FLARE

1. Unavoidable window flare In the main hall of Blenheim Palace, near Oxford, England, the camera position was determined by the statue, but there was unavoidable flare from the upper two windows on the image of the fluted pillar to the left.

2. Clone color, then luminosity

To make a clean correction of the less serious flare from the lower window, the pillar was selected to protect the window from any changes. Then, a large, soft cloning brush was used twice—first for color to remove the purple tint, and then for luminosity to darken it.

3. Copy and paste This section is copied, then pasted into another layer and moved up to cover the bad flare. This operation is repeated until a realistic blend is achieved.

Image: Bruth:
Oo

Opacity:

Opacity:
Opacity:

Opacity:
Opacity:
Opacity:
Opacity:
Opacity:
Opacity:
Opacity:
Opacity:
Opacity:
Opacity:
Opacity:
Opacity:
Opacity:
Opacity:
Opacity:
Opacity:
Opacity:
Opacity:
Opacity:
Opacity:
Opacity:
Opacity:
Opacity:
Opacity:
Opacity:
Opacity:
Opacity:
Opacity:
Opacity:
Opacity:
Opacity:
Opacity:
Opacity:
Opacity:
Opacity:
Opacity:
Opacity:
Opacity:
Opacity:
Opacity:
Opacity:
Opacity:
Opacity:
Opacity:
Opacity:
Opacity:
Opacity:
Opacity:
Opacity:
Opacity:
Opacity:
Opacity:
Opacity:
Opacity:
Opacity:
Opacity:
Opacity:
Opacity:
Opacity:
Opacity:
Opacity:
Opacity:
Opacity:
Opacity:
Opacity:
Opacity:
Opacity:
Opacity:
Opacity:
Opacity:
Opacity:
Opacity:
Opacity:
Opacity:
Opacity:
Opacity:
Opacity:<

4. Select a section of pillar

For the more difficult top put of the pilling a ration of the lower, fully corrected area is made, its lower edge softened in the mask. This will aid blending in the next step (above).

THE URBAN LANDSCAPE

ANIMALS

ubjects like landscapes and buildings are so easily available that they lend themselves to interpretation and experiment. Usually, there are time and space to spare. Animals, however, are a very different matter, and while the finest wildlife photography is distinctive in style, the two main considerations are simply getting close and capturing some

Photographing animals relies on both equipment and knowledge; neither one is sufficient on its own

Evening light

Lighting can make a substantial difference—when you have the choice. In a South African wildlife reserve, these compliant impala allowed time to get this backlit angle with a long lens. behavior. There is a sizeable difference here between photographing animals in captivity and in the wild. A zoo, for example, gives you a reasonable chance of being close, but you are less likely to see natural, interesting behavior. In the animals' natural habitat, the

reverse is usually true.

Photographing animals relies on both equipment and knowledge; neither one is sufficient on its own. The key piece of equipment is a telephoto lens, and there are very few situations in which you can shoot successfully without one. This begs the question of how powerful a telephoto—its focal length—but

Catching the moment

Even when the animal is more or less still (lions spend most of the day resting), there are always some examples of behavior that make it worthwhile waiting for them. Even a yawn has picture possibilities—it's simply a matter of being patient, and in this case using a 600mm lens for safety.

longer is nearly always better. Much depends on the kind of animal, how close you can approach it, and the setting, but generally speaking you should have a lens of at least four times normal (remember that a normal focal length is the diagonal measurement of the recording area, which varies from camera to camera). Most professional wildlife photographers use lenses up to ten times normal. These can be very expensive, and while this is not meant to discourage you, you should be realistic about what kind of shooting you tackle. One special advantage of digital cameras—at least those that accept interchangeable lenses—is that the small size of the CCD means that any given focal length magnifies more than it would with 35mm film.

That said, an understanding of animals, their behavior, and their habitats, can go a long way toward

putting you in the right place at the right time. The very first step is to research the best location—some places are wonderful for photography, others hopeless, and the factors are not always obvious from guidebooks. It is even the case that some zoos and wildlife reserves are, for reasons of layout and design, much easier to take pictures in than others. As an example of this, I include a photograph of a Japanese snow monkey that is successful entirely because I knew where to go when the weather forecast predicted snow. Actually shooting was simple, and the lens used was just four times magnification. Action, as in birds in flight, involves skill in shooting quickly and focusing precisely, as well as using a fast shutter speed (which in turn depends on the right ISO setting for the lighting conditions). Fortunately, modern autofocusing mechanisms can generally cope with most movement, but it is still always easier to photograph an animal moving across the field of view than coming toward you (going away from you, which happens all too often if you disturb an animal, is useless for photography, unless you particularly want a back view). For more advice on catching movement see pages 198–201.

Snow monkey

Groups of Japanese macaques have learned to use the hot springs in the mountains of Nagano prefecture during winter. For photography this involves a different aspect of timing—being there when it snows. The actual shooting was no problem, because the macaques are not disturbed by humans.

DIGITAL SOLUTIONS

iven that capturing good, clear images of animals in the wild is by no means a certain thing, and will produce a high proportion of near-misses, this is fertile ground for digital improvement. The primary issue—and usually the hardest one—is getting close access to the animal, which is why long lenses, remote control, camouflaged blinds, and fieldcraft feature so much in professional

The digital manipulation of wildlife photographs has caused more heated debate than most other subjects wildlife photography. The valuable role that image editing can play is in enlarging and enhancing—adding a telephoto extension, as it were.

A camera's digital zoom is still a gimmick, although this is one situation in which there is no harm in using it,

but the useful tools are an image-editing program's resizing procedure using its highest-quality interpolation (bicubic in Photoshop), followed by USM sharpening. You may well be pushing this to the maximum, so make use of every trick mentioned in chapter 10 to improve image quality, including experimenting with combinations of Amount, Radius, and Threshold in the USM filter, and applying them in several small amounts.

Also without changing the substance of the image, there are ways to enhance it using various color controls. Saturation, in particular, can help to make an animal stand out more from its background, if you apply it to a dominant color or if you first make a careful selection of the entire animal and apply it to that. A difference in brightness between the animal and its background will have a similar effect. If the animal is in partial shadow, it may help to lighten this.

Image-editing programs can help in several other ways, such as by dealing with the common problems of

TWO-SHOTS FOR OBSTRUCTIONS

Foreground leaves and branches

As often happens in woodland, out-of-focus vegetation gets in the way. Here, two shots of a Florida blue heron each have good and bad points—the head is better lit in the lower shot, but blurred leaves obscure part of the body.

Image overlay

The version with the obscured body is placed in a layer over the other, and aligned by rotating so that the neck and body fit properly at their junction. As with all such alignments, the upper layer is temporarily made halftransparent so as to be able to see the underlying layer. **Erase to the clear body** All the subsequent operations are made on duplicate layers, for safety. First of all, the version with the obscured body is partially erased so as to reveal the clear version underneath.

obstructions in the line of sight. Whether this is a proper role for them, however, is a matter of opinion.

Needless to say, the digital manipulation of wildlife photographs has caused more heated debate than most other subjects. Arguing against it are most professional wildlife photographers, who see it as dishonest, and a negation of the effort they put into capturing real images. Those who argue for it claim that digital manipulation is an extension of the shooting, fulfilling the same task of showing a clear image. I leave you to decide for yourself. Here is what image editing can do.

Borrowing the two-shot parallax technique used to clean up views of buildings, described on pages 168–9, you can overcome foreground obstructions by shooting two frames quickly, moving to one side between exposures. Depending on the circumstances, you should be able to get two similar images in which the obstructions—foliage, for example, or even the bars of a compound in a zoo—cover different parts of the animal. Choose one image as the principal, and copy and paste clear sections from the other image into it. Success depends on shooting quickly enough for the animal not to have moved between frames.

Lost colors underwater

Even a yard or two underwater, the warm end of the spectrum is stripped away, and without flash unfiltered photographs appear blue or bluish green, as in the original of this Portuguese man-of-war. Color balance sliders were the easiest tool to correct the blue cast, but in order not to lose the blueness behind, the correction was applied to the jellyfish alone.

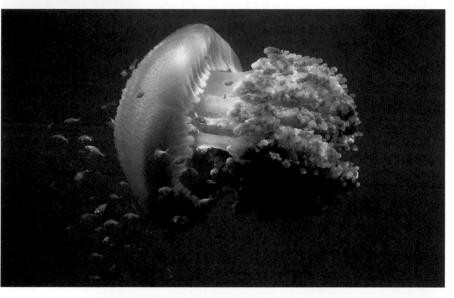

Erase to a clear neck

Several similar operations are performed in order to blend different parts of the neck, each time on a duplicate layer which is then repositioned slightly.

Blend the neck sections

Differences in lighting on the neck are reduced by altering the contrast in different color channels—here increasing red contrast (below). Soft-edged erasing follows.

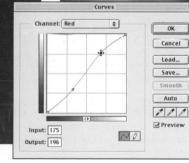

Final composite

In the final combination, the best parts of both images are preserved—a difference of only seconds in the shooting, and about an hour on the computer.

COMBINATIONS

n the photograph on this spread, image editing was used to combine two shots taken a few seconds apart, as small flamingos were taking flight. To be honest, I did this more as an experiment than for a genuine need, since both shots were fine as taken. Nevertheless, it demonstrates very well the power of digital compositing, for better or worse.

The base image is of three flamingos taking to the air from a river. The job is to add another flamingo, in full flight, in the foreground. Both photo-

The key to this composite is perfect blending, which means sophisticated edge control

Two final touches are in the depth of field and in the form of the foreground bird. As the photographs were shot with a 600mm lens, which has very shallow depth of field, the background should actually be out of focus for complete accuracy. I applied some blur to simulate this

effect, though less than it would have been in the cam-

era because I wanted to keep enough of the detail of

the background to convey the situation.

perfect blending, which means sophisticated edge con-

trol. A progressive amount of transparency is applied

to the edge, and the information picked up from here

allows the program to compute the color contribution

of the background. The color cast from the new background will replace the original. Smart masking like

this is ideal for tricky edges like hair that are common

in nature.

graphs were shot on 35mm colour transparency film (Velvia), and scanned at 300 dpi to measure 11 x 7 $\frac{1}{2}$ inches-22 MB each. The compositing was made in a proxy-processing program, Live Picture, but could equally well have been done in Photoshop or in any image-editing program. The key to this composite is

FLAMINGOS

1. Loading the first image The base image is imported with

an Image Insertion command, and sits in its own layer.

2. Silhouetting the second image

In this program, selections are made at the time of importing, and go into a "silhouetting layer." The silhouetting tool is automatic, and asks only that the user selects the outside and inside of the element. Choosing the "Auto" setting and then running the brush around the bird to pick up the range of colors fills the outside.

3. Completing the silhouette over the entire image (below). The procedure not only drops Once the outline looks fairly out the background, but

4. Edge control

The Color Compensation option allows color information from the background, which affects the edge, to be transferred with the mask, which is computed automatically. Zoomed in, the mask is retouched in detail. A small brush set at "Insert" allows the amount of see-through to be adjusted perfectly. The brush actions are limited to the single flamingo, because only its layer is active.

5. Local sharpening

The composite is exported to Photoshop. In going around the edges of the flamingo at this enlargement, I notice for the first time a slight motion blur around the head—or was it camera shake? I select the area that needs sharpening, and then apply a USM filter (below).

6. First composite

The completed image (above) is a seamless blend of the two original shots, with only one oddity—the depth of field is far too good for the long telephoto (a 600mm lens) that was used.

7. Focus adjustment

For realism, I rework a second composite (left), this time applying a slight amount of blur over the entire base image, using the marquee tool set to "Gradient" in the "Sharpen/Blur" layer.

LIFE IN CLOSE-UP

ost of nature is on a miniature scale plantlife, fungi, and insects—which for photography is rather more accessible than mammals and birds. The main issue when dealing with small subjects is how close the camera's lens will focus, and so how much magnification is possible. With a compact camera, the close-focusing

Most of nature is on a miniature scale, which for photography is rather more accessible than mammals and birds ability of the single lens is set by the manufacturer, but most work at very close range. Moreover, parallax, the bane of close-up work with a viewfinder camera, is hardly an issue when you can see your framing directly on the LCD screen. With a digital SLR

you can add a macro lens built for this purpose to your kit, as you would with a 35mm film SLR.

Flowers and fungi are among the easiest outdoor subjects, but the essential skill is, in nearly all cases, to

find a way of isolating them visually. Often, other plants get in the way and clutter up the picture; your eye can ignore this but the camera cannot. Sometimes you can improve the composition with a little judicious "gardening," as tidying-up is called, although rooting up plants is not a good way of treating the environment,

Pattern

Close-ups, largely overlooked by the unaided eye, give the opportunity to explore patterns. Frame carefully to exclude distracting surroundings, as in this photograph (above) of moss on the red sandstone cliffs of the Bay of Fundy in New Brunswick.

Color

Tree fungus growing on a log makes a splash of bright color, aided by the contrast with the gray wood. and may even be illegal. Shooting with daylight, a tripod is nearly always essential, to keep the camera steady enough for the inevitable long exposures. Because most close-up subjects outdoors are close to ground level, use either a small tripod or one whose legs can be spread wide. Alternatively, on some tripods the column that carries the head can be reversed so that the camera is suspended.

A key technique is to use depth of field intelligently. The closer you focus a lens, the shallower the depth of field, and this is very characteristic of close-up photography. A flower with a complicated background will usually benefit from having only just enough depth of field to keep it sharp while throwing the surroundings out of focus. This usually more best if you are shooting horizontally rather than downward, at the height of the flower itself. Use the depth of field preview button, if your camera has one, to find the best compro-

mise aperture setting. Set the shutter accordingly, or use whatever program an auto camera has to give aperture priority. Another possibility is to introduce your own background; black velvet or a white card, for example, hung a little way behind the flower will create a near-studio setting. Here is a tip to deal with the effects of a breeze during a long exposure: Hold the flower steady by coiling a piece of soft, thick copper wire around the stem (out of sight), and fixing the other end in the ground.

Flash involves a rather different technique, and for insects and other small animals is virtually essential. For this kind of subject, good depth of field is highly desirable, and this means that the lens must nearly always be stopped down to a very small aperture. With natural light, even on the brightest day, the shutter speed would then have to be extremely slow—too slow to prevent camera shake without a tripod, and too slow to freeze the movements of an active subject.

On-camera flash, however, has the drawback that the lens extension may block its light from reaching a close subject. More useful is a detachable portable flash that you can position close to the plantlife, fungi, or insect. Although a single flash head is satisfactory, the close working distances often mean that it has to be positioned to one side of the subject, and as a result casts a strong shadow. Better is to position a reflector (mirror, foil or white card) or a second flash unit on the other side.

A dedicated flash unit, linked to the camera's metering system, is obviously a convenience, but photographers who specialize in close-up work usually devise a fixed setup, with the flash units in a preset position, so that at each of a few lens extensions they are familiar with the aperture settings. With this method, which calls for testing beforehand, even small, inexpensive nonautomatic flash units can be used. In any case, a flash extension load util give you much more freedom in positioning the light; for example, overhead to simulate sunlight.

Using depth of field

A praying mantis in a Japanese rice-field merges delicately with the pervading green by my deliberately limiting the depth of field, at an aperture of f5.6. In this type of treatment, the head or eyes should usually be the point of sharp focus.

Backlighting

Shooting into the sun highlights the morning dew. The lens aperture was adjusted carefully to control the apparent size of the sun so that it matched the body of the insect.

NEW TREATMENTS

ature as a whole is possibly the richest source of color and form for photographic experiment, and digital procedures are made for this. The possibilities are almost without limit, but by way of samplers I include two very different ones here.

You can think of a scanner as a kind of camera, and

a flatbed model, with its large, open glass scanning area, is very adaptable. The automatic focusing and depth of field are surprisingly well suited to threedimensional objects as well as flat artwork and film, and the

A scanner's automatic focusing and depth of field are surprisingly well suited to three-dimensional objects

level of detail that you can capture is equivalent to that of an oversized plate camera. The two obvious limita-

SCANNER AS CAMERA

This selection of dried plants and fungi from a potpourri was an ideal subject for scanning. The lotus bulbs, corn husk, and fungus were scanned together in one pass, with the flatbed scanner head fully open. A black velvet cloth over the objects kept the background black. In a second pass, a cluster of dried pine cones was scanned, at a different scale. Both images were cleaned up in an image-editing program (with objects like these, dust and bits fall onto the platen, where they register brightly) and then composited.

The long strip of light that travels along the bed gives a soft, diffused light that cannot be reproduced by normal optics—thus a soft modeling. I now use my flatbed scanner regularly to shoot flowers and other natural objects.

tions are that the lighting is absolutely frontal and the

exposure takes a number of seconds, but if you can live

with that, a direct scan of flowers or anything motion-

less can be a fascinating starting point for creating an

image. Drawing on the compositing techniques already

described in pages 114-15, you can build up a final

image from the raw material of different scans-and

incidentally enhance the appar-

ent depth of field as you do this.

is quite different in character

from the harsh and generally

unsatisfactory effect that results

from a camera's built-in flash.

In fact, the frontal lighting

Use the setting for a reflective rather than transparent original, and lay the objects on the bed. The cover will have to stay open, but provided that there is little ambient lighting in the room, the scan should not pick up much of the background above. If it does catch reflections, try covering the objects with black cloth (velvet reflects the least light). Alternatively, experiment with adding lighting from the side, and with different background coverings.

Another, less documentary, approach is to use natural subjects as a kind of still-life component, and incorporate them into other settings and scenes. Once again, you have the full array of digital manipulation techniques at your disposal, beginning with the allimportant selection procedures. If you know in advance that you will be doing this kind of compositing, try to shoot the originals against backgrounds that are fairly plain and contrasting in color—that will make it easier to create a selection outline.

In the example to the right, the idea was to have the brightly colored lizard emerge from an old map of tropical South America, something that could be achieved only with digital techniques.

A SURREALIST COMPOSITE

1. Lizard selected

As a first step, the lizard was selected and isolated from its original background, a leaf.

2. Paste in The lizard selection was pasted into a layer over the specially shot still-life, and positioned approximately.

Input: 0

Output: 82

3. Scale down Slightly too large for the map, the lizard layer was resized.

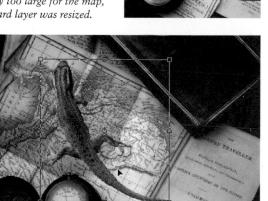

4. Drop shadow

A soft shadow was added, using Eye Candy's Drop Shadow filter, being careful to match the direction and diffusion of the still-life lighting.

NO

In masking mode, a gradient was applied so as to create a gradual selection of the lizard, grading from full at the tail to none at the midpoint of the body (top left). Lightening and desaturation were then applied, one at a time, to the lizard layer, using HSB dialog box.

6. Duplicate layer

For further fine-tuning, a duplicate layer of the edited lizard was mude, and the opacity of this reduced until the tail was just faint enough.

7. Gentle fading

Finally, a soft eraser brush was gently applied to parts of the original lizard layer, to fade it selectively to the duplicate, low-opacity layer

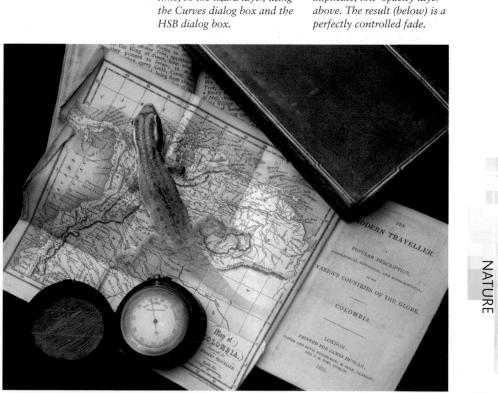

STILL LIFE

he epitome of object photography is the stilllife composition, a tradition of imagery that goes far back into painting and drawing. It first came to prominence with Dutch painters of the seventeenth century, and has attracted a wide range of artists ever since. Much of the appeal of stilllife photography, as with still-life painting, lies in its

Much of the appeal of still-life photography lies in its exploration of composition and lighting

St. John's Bible

The subject of this cover

story and of the still life

to the right is the first illustrated Bible with

hand calligraphy to be

commissioned in over

500 years.

exploration of composition and lighting. Indeed, one way of approaching the still life is as a kind of exercise in the problems of imagery—such problems as how to reveal texture, the play of light between objects, modeling, and balance—regardless of the impor-

tance of the actual objects.

Coming hard on the heels of a painterly tradition, photography brings its own technical influences to the still life, although now we have a new freedom to experiment even more. There is a basic difference between the planned and the found still life. Considered, ordered arrangements are typical of the studio, which includes any makeshift studio at home. Typically, the photographer selects from a group of

Snoithsonian

interesting objects and proceeds to compose and light them in a completely controlled way. A contrasting approach is the found still life—the discovery of a natural arrangement at a moment when the available lighting works some magic.

The method of arranging objects is a major part of the creative process, and for this reason is subject to no rules. Certainly, there are recognized harmonies in composition, but any formula that you follow is likely to be sterile, and it is much better to go with your feelings for how things fit together. While there need be no compulsion to fill the frame every time, the relationship between its shape and edges and the objects inside

Depth of field

What was needed here was to show the entire illustration but concentrating on fingertip detail. A wide-angle lens was used from low, with the smallest aperture. In addition to the diffused overhead light, smaller spots lit up the rolls in the background and the burnishing tool a few inches from the camera.

it is crucial. This is much easier to appreciate in two dimensions than through a viewfinder, and for this a digital camera, with its LCD screen, is ideal. It goes without saying that a tripod is particularly useful, so that camera and view are fixed, allowing you to work on the arrangement.

Lighting is fully a part of the composition, for it not only reveals form, texture and color, but through the combination of shadows and highlights it plays a

major role in the balance of the image. The quality of the light—chiefly the degree and type of diffusion or hardness—is of great importance, and is worth experimenting with. Expensive professional lighting attachments are convenient but by no means essential, and any household material that can pass light or reflect it has a potential use. The one essential is that the lighting should not be boring.

Close-up photography can also be a form of still life, subject to the same possibilities in composition and lighting. It has the added advantage that at this different scale there is a fresh range of images. Depth of field is naturally shallow at these magnifications, but this, as you can see from the example here, can be used to focus attention and to add layers of softness.

Pearls in close-up

These rare orange pearls were an exquisite subject for closeup photography, revealing color and texture under a simple diffused light not immediately obvious to the unaided eye. They needed a contrasting background for both the color and the texture; I chose water-washed pebbles painstakingly blackened with shoe polish. The geometry of digital camera optics and CCDs is such that extensive depth of field is possible—successfully used here to enhance the textures. Many such cameras have "macro" capabilities that can produce imagery that is not readily possible with equivalent conventional cameras.

A classic arrangement

This antique military uniform was left in an old, uninhabited country house, but piled up. It needed rearrangement to be photographed, but I did not want to completely abandon the idea of it being "found." The composition is a compromise between order and casualness. Though a similar image could have been created with a conventional camera, there is no denying that the use of the digital camera's CCD preview screen (along with the option of taking "test" shots that are immediately visible) is a significant aid in both creative and compositional terms.

187

CLEANING UP

fair proportion of object photography calls for clean, neutral backgrounds, and still-life studios keep a selection of seamless backdrops, from rolls of plain paper to still-life light tables with curved sheets of translucent Plexiglas for backlighting. Commercial product photography, in particular, often isolates objects. White, or lightly

Digitally excising background may be the only way of isolating very large objects shaded, backgrounds are the most common choice because they are the least obtrusive, and in this case one of the exposure issues is to peg the brightest part close to the minimum density, without losing any detail.

Scanning digital backs for large-format cameras, as on page 33, are capable of recording a greater dynamic range than film, and are perfect for this kind of shot, although very expensive. (This quality is one of the reasons for their being adopted so readily by professional studios.) Handheld digital cameras suffer in this respect, but color correction during image editing is able to take care of the problem. When shooting, use

PATHS AND BÉZIER CURVES

The ideal technique The flowing lines of Thailand's finest example of a walking Buddha (which could not be moved) are ideally selected with Bézier curves.

Complete the outline Draw the outline, dragging slightly at each anchor point to approximate the curve.

Adjust the curves Once the path is complete, go back to correct the curves by tweaking the handles.

One of the standard professional studio backgrounds is a seamless curve of plain material, which if lit from above naturally shades off behind the object. Digitally you can create this by applying a gradient to the inverse selection of the object. However, beware of banding deal with it by selecting the dithering option in Photoshop, and by applying a small amount of noise in each channel, one at a time.

the white balance point to make sure that nothing is irretrievably overexposed; check with the in-camera histogram if there is one, and later use the Levels or Curves controls to extend the highlights.

> It may be worth selecting the background to apply color and tonal changes to it alone. Having gone this far, it may be easier or more effective to replace the photographed background entirely, with a gradient or a digital texture, or both. In any case, digitally excising the background has an important part to play in object photography, and may provide the only way of isolating very large objects.

> The clean, sharp edges of most manmade objects need a different treatment from natural landscapes, people, and animals (where foliage, hair, and fur rule). The technique of choice is the Paths tool. It takes time to make an accurate outline, and some skill in manipulating Bézier curves, but has the considerable advantages of being precise and occupying very little file space.

A path is a vector outline, meaning that it is calculated by its shape and location, and not by the pixels it connects. Indeed, it is resolution-independent, so that once you have completed it, you need to convert it into a selection of pixels—a simple, one-command operation. Drawing a path makes no change to the pixel image; you use a "pen" cursor to locate points around the edge of the object, and these are connected automatically by line segments.

These points are known as anchor points, and the lines can be straight lines or curves. The curves, known as Bézier curves, are controlled by pairs of handles, which can be pulled in or out and altered in their angle—a procedure that is easier to show than to describe. Typically, you would work around the outline, placing anchor points at corners and changes in direction as necessary. Complete accuracy is not important at this stage, because once you are finished, you go back with the editing tool to move the anchor points and adjust the handles so that the curved segments match the outline precisely. You can add and delete anchor points as necessary.

More anchor points give a more detailed outline, but require more processing power. Moreover, a smooth curve is better followed with one or two segments rather than many. Judging the number of points

that you really need comes with experience, but as a guide, work on what you can see at 100 percent magnification.

A SMOOTHER BACKGROUND

1. Original This painted sculpture by artist Yukako Shibata, had to be photographed in shu

3. Inverse selection A selection is made from the path, inverted, and the background deleted.

5. Correct the verticals Back in the sculpture layer, the distortion tool is used to straighten up the converging verticals.

7. Remove upper shadow Only the lower part is needed for a shadow; the upper is erased.

8. Shadow blur

The remaining black shadow is blurred strongly.

9. Blending the shadow

The opacity of the shadow layer is weakened to give a realistic tone, and the entire selection moved down so that it appears below the sculpture. The finished result is as if the sculpture had been photographed under controlled studio conditions.

2. Make a path *The sculpture is outlined with the path tool, working close at 100%.*

4. Gradient background In a separate underlying layer, a new background is created with the gradient tool, from top to bottom.

6. Shadow procedure To create a drop shadow, the sculpture selection is duplicated, and filled with black.

REWORKING LIGHT

ith lighting playing such a critical part in still-life photography, digital adjustment is particularly valuable, usually in correction and fine-tuning. Heavy manipulation is beyond the scope of bitmap image editing, as we saw in the previous section on landscapes, but in

still-life photography you have the option of changing the lighting itself as you shoot.

Still life's problem materials are those that reflect and refract -chrome, mirrors, glass, and so on-and a number of special-

Small reflections are so easy to remove with a cloning tool that they don't have to influence the way you set up the lighting

OK

Cancel

Load...

Save...

□ Invert

ized techniques have been developed over the years by studio professionals to deal with these. A curved, highly reflective surface is difficult because it shows up all of the studio surroundings, including lights and the camera itself. One classic solution is to surround the object with a seamless translucent material such as tracing paper or milky Plexiglas, just out of view, and place

ARAR!

the lights outside this. A small hole is cut in this "light tent" for the camera's lens to shoot through.

This is not, however, a complete solution, as the lens is still likely to be reflected, and the almost shadowless lighting that results may not be what you would have wanted for any surrounding objects or back-

> ground. Here, digital retouching comes into its own. Small reflections, intractable for traditional photography, are so easy to remove with a cloning tool that they don't have to influence the way you set up the lighting.

Larger reflections can be blurred, and the shading lightened. An important precaution is not to overdo any of this; the equivalent technique in early black-and-white product photography was airbrushing of the print, but it often introduced a patently false perfection.

Glass objects, particularly when filled with liquids, also need special care in lighting. To prevent them look-

-

Channel: RGB

Curves

\$

NO

OK

Cancel

Load...

Save... Smooth Auto 100 Preview

Backlit colored transparent objects like this antique perfume bottle nearly always benefit from brightening. Simply increasing the backlighting or the exposure only causes flare.

Select blue

Only the colored glass is to be enhanced, not the silver attuchments, so the first step is to select the color, using Color Range in Photoshop. For precision, the exact blue is sampled.

Input: 96

Output: 160

On this selection of blue, the entire RGB curve is pulled upward in the center, which brightens the color. This is sufficient enhancement (right), and there is no need to increase saturation.

190

ing "dead," some kind of backlighting is usual, but some parts, like the shoulder of a bottle, can refract awkwardly. Again, cloning, blurring, and tone control are the digital help. One problem with backlighting is that certain shapes, especially rounded ones, may lose their definition—edges that curve away from the camera have a tendency to reflect the background, and if this is bright, they may appear to merge with it. You can correct this digitally with a gentle, thin darkening of these edges.

Light involves color, and as all these techniques are, in a sense, ways of focusing attention on the principal subject, another interesting digital technique is to selectively desaturate the setting. There are any number of ways of doing this, but in the example here, worked in Thotoshop, the entire image is desaturated, and then the History brush is used to paint back in the original color. An alternative would be to make a selection of the object that you want to preserve, invert this, and desaturate. In this case, the desaturation is total, but a slight amount would give a more subtle enhancement to the subject.

SELECTIVE COLOR

Desaturated background In this photograph of an old apothecary's shop, the arm is to enhance the book. As a first step, the color image is completely desaturated using the HSB sliders (above).

Background tint

With the book restored to full color, the background can be altered, first by selecting it with an auto select tool (left).

The original color can now be selectively painted back in with Photoshop's History brush (above). Any mistakes can be corrected by stepping back through the History palette.

Sepia tone

By increasing yellow and red in the midtones (top), the background is given the effect of sepia toning—a warm brown (above).

REWORKING SHADE

he reverse side of lighting is shadow, and if you make digital changes to one, you will have to consider the other. For example, if you are replacing a background completely, as on the previous pages, the object will need to have its natural shadow restored. The purpose of this is to help it sit realistically in its new setting. In fact, shadows are

The important issue is that the shadow looks right rather than is optically accurate a digital specialty, and are both easy to add and very effective in locating an object on an apparent surface.

In principle, you add a shadow by creating a blurred percentage of gray underneath a selection of the object

but over the background, so this is essentially a layer operation. A common piece of computer layout jargon that crops up is "drop-shadow," meaning an edge of shadow offset below an object. This is used frequently with images viewed from directly above. If you were

A QUICK 3-D GUIDE TO SHADOWS AND REFLECTIONS

Using a basic shape, such as a cube or a sphere, you can see how shadows and reflections appear according to the three important variables: lighting, textural quality of the background, and camera angle.

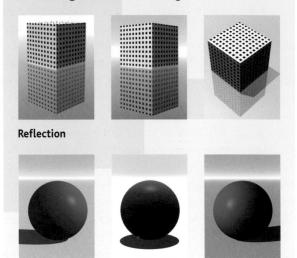

Shadow

PERSPECTIVE SHADOW

8

An unsatisfactory shadow This strongly angled, spotlit still-life of a Dunhill table lighter and its pocket companion has one problem—the lumpy shadow at the base. A longer, more shapely shadow would be better, and would not look inaccurate.

dialog box, and is then applied over the unselected background (right). Perspective Shadow Vanishing Point Direction (*) Shadow Color C) Draw Everywhere Vanishing Point Distance 48 93

Shadow plug-in

from Eye Candy comes to the

rescue, and requires the object

to be selected first. In one

version (left) a moderate

angle is chosen in the

192

shooting straight down onto an arrangement of objects, with the light source above and to one side, this is the shadow effect you would see—a soft darkening around the outline of each object on the side opposite the light.

Although this is only one kind of still-life arrangement, the digital technique used to reproduce it can be translated to most setups. The idea is to make a copy of the object itself, turn it into a solid block of black or gray, blur it, and slip it under the object. There are three things to consider: The direction of the light (the shadow must fall opposite); the quality of the light (the more diffuse, the softer the shadow edges); and the height of the object above the surface on which it sits (the lower, the closer and denser the shadow will be). Most of this is intuitive and a matter of observation.

With a tall object and a low light, the shadow will be long, so another factor to consider is perspective. Having created the basic shadow selection by copying the outline of the object and filling it with gray, use one of the distortion tools to stretch it lengthwise and compress its width at the far end. Alternatively, third-party plug-ins can do this for you, such as Perspective Shadow in Alien Skin's Eye Candy. However you do

it, the important issue is that the shadow looks right rather than is optically accurate, so judge it by eye.

Very occasionally, you may need to introduce reflections when you transfer an object from one background to another. This depends entirely on the reflective qualities of the new background. The principle is, once again, to use a copy of the object: Invert it vertically and apply an amount of transparency. The texture of the back-

ground, and the angle of view, will both have an effect, and for realism you will probably need to apply some distortion, such as with a customized displacement map, as well as fading the reflection out progressively.

Manually controlled shadows

For a watchface overlaid on a landscape as if floating, new shadows were added one at a time in separate layers with a gradient tool. Shadow boundaries were limited to selections created with paths drawn as cones from the sun.

A longer shadow Experimenting with the shadow angle (above), I decided that a longer and harder shadow angled more to the right would give a better composition, but if applied, I

would also need to add a

shadow from the smaller

lighter falling across the

vertical side of the larger one.

Refining the effect

The shadow filter is applied, as before, to a selection of the lighters (above). However, a separate selection had to be made of the smaller lighter; also its shadow needed a distortion correction in Photoshop to change it from a horizontal surface to a vertical one.

ALTERING FOCUS AND FOCAL LENGTH

ven lens characteristics can be changed later in the computer. In certain kinds of still-life photography, one technique that moves in and out of fashion is selective focus, in which only a small part of the image is sharp, the rest being a blur of color. Food photography in particular makes great use of this for its impressionistic effect. In the camera this is achieved

by extremely shallow depth of field-a lens with a wide maximum aperture used wide open, sometimes aided by lens panel

Even lens characteristics can be changed later in the computer

16

A. T

00

500

swings (a feature of large-format view cameras). The effect is difficult to pull off with a small-format camera because of the inherently good depth of field.

Digitally, however, selective blur is easy to applyand with much greater creative freedom than in the camera. You are not bound by the laws of optics, only

SELECTIVE FOCUS

Gaussian Blur

ŧ

Radius: 15

Photoshop's History brush allows the blurred state to be brushed back in over the original-and of course, any mistakes can be recovered by stepping back in the History window.

by your skill at selecting the appropriate areas of the image to unsharpen. Real depth of field is progressive, meaning that it falls off more and more from the point of focus both toward and away from the camera. The tool to reproduce this effect digitally is a gradient, and the simplest method is first to apply a transparent-toforeground radial gradient in a masking layer, centered

on what is to be the point of sharp focus. Then use Gaussian blur on this gradient selection.

Between the two tools there is considerable choice and range of effect. For more control, make a blurred copy in a separate layer and erase

As we saw with filters in pages 118–23, one of the great advantages of working digitally is that you don't necessarily have to commit yourself to one technical

it selectively, using brush or airbrush as appropriate.

4. Second blurring

For the parts of the image furthest from the camera, the blurring is repeated to a 15-pixel radius. In the History window this strong blurring is then brushed in with the History brush.

1. Deep-focus original

For full control over selective focus, start with an image that has full depth of field. The technique here is to paint in from a blurred version.

D. 1 87 Q

3. History brush

OK Cancel Preview

pixels

OBJECTS

2. First blurring The entire image is blurred

quite strongly, to a radius of 5 pixels. Then, using the History window, it is reverted to its original, sharp state.

style at the time of shooting. As long as you don't use JPEG compression, digital copies are always exact and perfect. In fact, there is a good argument for capturing the maximum information in the camera (good depth of field in this case), and using this as the raw material for out-of-focus effects. Blur is a kind of image degradation, so it is better to do it on a copy unless you are absolutely certain of what you want to do.

Focus is not the only lens characteristic that can be altered after the fact. With rather more effort, and a knowledge of how focal length affects the proportions of an object and its setting, you can turn a telephoto shot into a wide-angle, and vice versa. There is a certain amount of work involved, so this may not be a procedure to undertake casually, but you may want to do it when compositing images, for more realism.

First see what effect a spherizing filter has, as shown on pages 140–41. As you are looking only for a good visual match rather than an optically exact result, you are not likely to need any extreme distortion. In addition to this, you will also need to consider parallax. My example here is an aircraft, the SR-71 Blackbird. Moving closer and using a wider angle lens would have hidden more of the engine nacelles. Shortening the "focal length" digitally meant selecting parts and moving them inward, behind the main body.

TELEPHOTO TO NORMAL

1. Telephoto original The starting point here in making a photograph look as if it were taken with a different lens is a 600mm shot of the SR-71 Blackbird. **2. Selecting the aircraft** *The first digital step is to select the aircraft, here using smart masking.*

4. Selective distortion

In the image-editing program used, Live Picture, applying the distortion brush counter clockwise enlarges the area it touches (lower left). This is applied to the main fuselage to change the perspective. Then the engine nacelles are enlarged and shifted slightly to mimic the parallax effect of a closer viewpoint. A last touch was to change the background (below).

3. Wings and cockpit

Using cloning and painting tools, the wings (which were clipped off in the original shot) are extended, and the cockpit is closed. Given the symmetry and smooth monochrome surface of this titanium aircraft, these are both quite simple jobs to achieve realistically.

ADJUSTING THE COMPOSITION

arlier in this chapter I touched on the importance of composition in still life. The process of careful arrangement and rearrangement is integral to this genre, and can take as long as you are prepared to give it. Digital photography, in

Provided that you follow certain rules of lighting, scale, and perspective, you can partly create—or adjust—a still life on the computer postproduction, offers a new possibility —digital composition. Provided that you follow certain rules of lighting, scale, and perspective, you can partly create—or adjust—a still life on the computer. One reason for wanting to do this might be in order to achieve a juxtaposition that is physically impossible, such as putting together objects

that were not available to shoot at the same time, or when it was difficult to hold several things together in position. Another reason is simple flexibility—deferring the creative decisions until later. The latter was the chief motivation for the food image that is shown below. The plan called for a series of photographs of different kinds of noodles, each of which was treated in a slightly unusual way.

The solution was to shoot all the components together at the same time, under the same lighting, backlit on a light table for easy selection, and with the camera aimed straight down. These components included the final dishes as well as the individual ingredients, both cooked and uncooked, to act as a kind of deconstruction. The backgrounds were to be digitally created separately on a computer. In this way, the creativity of the shoot was moved from the camera to the computer.

On a larger scale, digital composition might be the only practical method of creating a single image. In the

DIGITAL ASSEMBLY

Digital water

The basic water texture was a digital creation from a software supplier—Xaos Tools' Artist In Residence series. The original color (left) was altered with the Color Balance sliders toward blue.

Adding layers

The components were added, a layer at a time and individually selected, beginning with the bowl of noodles. The scallop shell, which was to appear submerged, was first given a ripplelike distortion using the Wave filter in Photoshop (below).

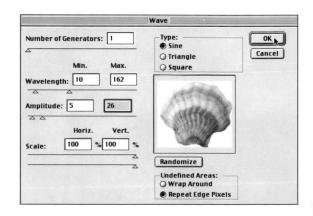

Ingredients

For this still-life food shot, all the components were photographed separately to allow freedom in composing them. This dish of seafood ramen included shrimp and scallops. case of the Apollo and Soyuz spacecraft in Washington DC's Air and Space Museum, joined together by the ASTM module, the entire assembly took up the length of one large hall, and there was simply no overall view because of other exhibits in the way. The answer was to photograph each of the three units separately, though all from exactly the same distance to maintain scale, and join them together later. In any case, the setting made it desirable to cut out the spacecraft, so linking the elements was very little extra work. Interestingly, the originals were photographed many years ago, before digital imaging was so readily available, and the original joining was done, with great difficulty, at the printing stage. The new reworking took about an hour (including making the detailed path selections) on a laptop

On the same principle, you can build up a single image of anything by shooting it in many small sections, as a mosaic. There is even specialized software to aid with the stitching, which is just a more complicated version of a stitched panorama of the kind on pages 116–17. Image Assembler and RealViz Stitcher are two of an increasing number of programs available.

Apollo-Soyuz

With no camera viewpoint possible for a complete shot, this large exhibit in the National Air and Space Museum in Washington DC, was shot in three frames. The three components were then selected and isolated using the Paths tool, and composited very simply, by butting together (below). The only precaution taken was to maintain the same distance when shooting to keep the scale the same.

Underwater blending

The rippled scallop, a smaller copy of it and the shrimp, each in its own layer, were blended to appear as if underwater by choosing the Lighten option in the blue channel, and slight adjustments to the opacity. Note that they appear under the water layer, even though their layers are, in fact, above it.

	Layer Style	As ing phten : ading nding rec : Read for days as Group Blend Cherpher Lifects as Group Blend Strate Lifects as Group Strate Lifects as Group Strate Lifects as Group Strate Lif		
Styles	Blending Options General Blending	OK N		
Blending Options: Custom	Blend Mode: Lighten	Cancel		
Drop Shadow		(New Chate)		
Inner Shadow				
Outer Glow	Advanced Blending	Preview		
Inner Glow				
Bevel and Emboss	Channels: R G G B			
Contour				
Texture		A REAL PROPERTY OF A REAL PROPER		
Satin				
Color Overlay				
Gradient Overlay	This Layer: 0 255			
Pattern Overlay	A A			
Stroke	Underlying Layer: 0 66 / 255			

MOVEMENT IN DETAIL AND IN FEELING

or good reason, action provides many of the most telling images in photography. These are moments that are frozen, never to be repeated, and one of the still camera's irreplaceable functions is to reveal motion as a slice of time in a way that the human eye cannot see. Whatever other talents are involved in photography, shooting action calls for

Capturing fast movement is mainly a matter of being thoroughly familiar with your camera and of practicing the most basic of all skills—perfect and immediate camera handling. Uncertainty and fiddling around with the controls is guaranteed to lose you the shot. In other words, capturing fast movement is mainly a matter of confidence—of being thoroughly

familiar with your camera and practicing.

For the most part, you need a high shutter speed, and because this cuts down the light reaching the CCD,

you will then have to either open up the aperture or increase the ISO setting, or both. Exactly which shutter speed will freeze the action depends not so much on how fast the subject is moving, but how fast it moves through the frame. Imagine a cyclist on a track in front of you. If the figure takes up just a small part of the image frame it might take a second or two for him or her to cross from left to right, and a shutter speed of, say, 1/125 second, might be sufficient to capture the image reasonably crisply. Now rack the zoom forward so that the cyclist almost fills the frame. You would need a much higher shutter speed because the figure would be in and out of shot in a fraction of a second. The same applies to direction: Stand on the track itself and if the cyclist is approaching you, there will be hardly any movement across the frame (although there would be a focus issue, which might be problematic).

Timing and speed

This is the classic treatment of action: A fast shutter speed and the perfect moment. Here, in this shot of a Japanese macaque, from the same sequence as the one on page 177, leaping across an icy river from boulder to boulder, the shutter speed was 1/500 sec. and the midair moment was anticipated.

One of the most obvious techniques for dealing with continuous movement like this is panning, which comes naturally. It simply means following the movement with the camera, keeping the subject more or less in the center of the frame, which is what most people would do anyway. Then what happens if the shutter speed is still not fast enough is that the background becomes blurred with streaks, and this is no bad thing. Motion blur, as it is called, helps to convey the sense of motion, often better than a completely frozen image. As long as the essential details of the subject are sharp enough to be recognizable, this might be the most effective kind of image.

You can capture motion blur in another way, using flash synchronized to the end of a slow exposure. With focal-plane shutters used in SLR cameras, this is called rear-curtain sync. because the flash discharge is timed for when the shutter blind closes. In the indoor tennis example below, the camera was fixed on a tripod to keep the surroundings sharp, and the shutter speed set to 1/30 second. The result is blurring of the player, racket and ball, but it all trails back from a sharply frozen image caught by the flash.

High speed

Two contrasting treatments were used for these shots of a horse and carriage driving at Syon House near London. In the frame at left, the shutter speed was 1/250 sec., just fast enough to freeze the trotting movement of the horse.

Low speed

Reducing the shutter speed to 1/30 sec. and panning the camera to follow the movement gives a different impression—and to my mind better. Key parts remain sharp because of the panning, while the blur of legs, wheel spokes, and background give a sense of motion.

Rear-curtain sync.

For a game of indoor Real Tennis, ambient lighting had to be used to show the setting and spectators, but even at a high ISO sensitivity there was insufficient to capture the action. On-camera flash was used (with a second flash in sync. from the right), and was synchronized with the closing of the shutter at a speed of 1/30 sec.

DIGITAL MOTION

s we saw on the previous spread, motion blur is often considered an asset in an action photograph, but it is difficult to plan for and

predict. Digitally, this is a popular enhancement, and there are several motion-blur programs available. In the example of a Chipmunk aircraft, the original photograph is a success in that the image is Focusing accurately under these circumstances is never easy, with everything moving quickly, and a high shutter speed is essential, in this case 1/500 second. Any

Digitally, an extraordinarily effective treatment is to stitch the series together into one image

sharp—always an issue when shooting air to air through an open window, because vibration and the buffeting airflow increase the risk of camera shake. accurate kind of motion trail from the subject is out of the question at the time of shooting, but there are alternative post-treatments you can try.

The standard filter available in Photoshop allows the direc-

tion and length of the trail to be set, but this must then be composited with the original. The normal technique is to apply the blur to a duplicate image in another

COMPOSITE PICTURES

Motor-drive sequence

The originals were a panned burst at high speed of the flight of a Changeable Hawk Eagle toward its handler.

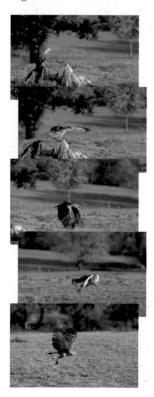

Layered combination

First, each image is placed in its own layer in one image file. With the middle shot in the series as an anchor, each image is then repositioned to fit perfectly. The layers are set at 50% opacity.

Clone blend

The images are then blended by a combination of gentle erasing at the edges with a large-diameter airbrush, and cloning from one to another to fill in gaps, particularly in the height of the composite.

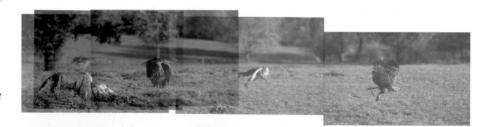

Final composite

Once seamless blending has been achieved, the layered workfile is saved (in case of any need to retweak the image), and a flattened copy is made.

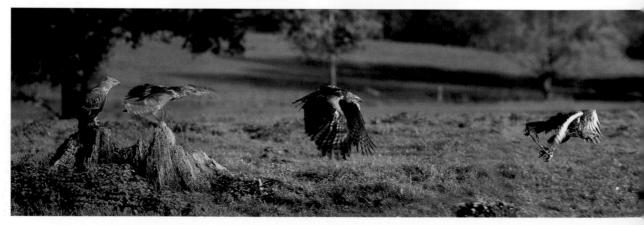

layer, and then use blending controls to meld it to the original. The leading edge of the blur must then be erased. Third-party filter manufacturers usually try harder, since this is their sole business, and the Eye Candy plug-in available from Alien Skin gives more options, as the screenshot shows. More important, it applies the trail in one direction to a selection (which you must first make and load before opening the filter dialog box), and so is a one-step operation. Here, one trail has been applied as long streaks, MOTION BLUR

another in an optically more accurate, but degraded way, and a third applied just to the background.

This is a fairly standard way of mimicking what happens in real shooting—or at least a cosmeticized version that looks right—but there are other ways of revealing motion that go beyond the single photographic image. The five images of a hawk eagle launching into flight at a falconry center were shot at four frames a second at 1/250 second with the camera panned so that the bird remained more or less center frame. In the ordinary way, either the best frame would have been chosen, or they could all have been reproduced as a strip. Digitally, however, an extraordinarily effective treatment is to stitch the series together into one image so the eagle flies across a single landscape.

The technique is similar in principle to other forms of stitching, but because of the panned and largely outof-focus background the frames are very easy to blend by brushing with an eraser. The essential preparation is to align the frames in a single composite file before starting, which is done one at a time, from left to right.

3. Bidirectional streak The Photoshop-blurred image is combined with the underlying original using the blending option (above). The shadow point slider of the upper layer is moved inward to remove the darker areas of the blurred layer.

4. Blended and retouched With the blend adjusted to a more subtle effect than that above, the blur trail at the front of the aircraft is erased, using the inverse of the aircraft selection (right).

1. Air to air

The original (top left) is a 1/500 sec. shot of a Chipmunk aircraft. The dialog box (above) for Eye Candy's filter gives full control. The plane (left) was selected and the trail applied.

2. Photoshop blur

Motion blur in Photoshop has a more limited range of controls (right), and so here is applied to a duplicate layer.

DIGITAL **IMPROVEMENTS**

dding motion blur is easier than removing it, but the problem is that only certain kinds of streaking and unsharpness are acceptable. Personal taste comes into this, but as a gen-

eral rule the key details of the subject-however you define them-need to be sharp. If you inadvertently set too slow a shutter speed, or even if you are deliberately trying for a partly blurred

There will be times when the sharpness is not in the right place

image, there will be times when the sharpness is not in the right place. The only possible recourse is digital sharpening, despite the limits to what it can do.

The trick here is to sharpen selectively, just in the

COMBINING MOMENTS

Paste and blend

The dark, almost featureless earthen floor of the cockpit made an easy background for pasting in the birds, but to aid the realism of the composite, a slight amount of noise was added to the birds to simulate grain.

OK

Cancel

Preview

=

Amount: 4

Distribution

O Uniform

Gaussian

Monochromati

blurred image-soft streaking which will simply gain a grainy appearance. The way around this is the USM sharpening filter, which allows you to set the threshold -in other words, you can leave the very smooth areas alone, and concentrate on the nearly sharp edges.

key areas. The obvious tool might seem to be a sharp-

ening brush, but beware, because almost all of these

apply the crudest form of sharpening on the digital

menu. As discussed in the Filters chapter, basic sharp-

ening works on all the pixels

indiscriminately, and this is a par-

ticularly bad idea if there are

smooth nondetailed areas in the

photograph. And that is exactly

what you have in a motion-

This alone is not likely to be enough. The technique of choice is to paint over the areas to be sharpened in a mask layer first. Use a soft-edged brush to blend in the

> eventual sharpening with the rest of the image, and set the mask color to a fairly light opacity so that you can see what you are doing. Loading this as a selection, experiment with the USM controls in preview until you reach the maximum sharpening that appears natural. For people in motion, the face and eyes are likely to be

the areas that should be sharp.

There is another digital procedure for improving an action shot which is not completely honest, but might be justified occasionally. This is to combine the best action captured from two frames. It often happens if you are shooting rapidly and continuously that of all the things going on in the picture some work better in one frame, and some in another. If the basic framing is more or less the same, there are no special difficulties in stripping a part of one image into another, using the techniques discussed in Chapters 9 and 10, and creating a combination.

The best of both

In a sequence of shots of a cockfight in rural Colombia, the two best pictures each lacked something-the audience reaction of one and the birds leaping in the other.

Fighting cocks

The best shot of the two birds in midair was selected and copied for pasting onto the best of the overall shots, using a mixture of autoselection and mask painting (for the blurred wings).

SELECTIVE SHARPENING

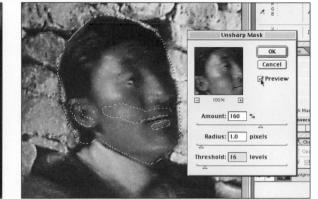

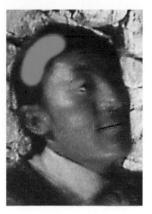

4. Extra hair sharpening Finally, a small dose of sharpening was applied to the central strands of the hair. The result (below) adds a small but significant improvement to the original photograph.

In this photograph of Tibetan pilgrims in the dark interior of a gompa near Mount Kailash, the blur from a slow shutter speed helps the sense of action, but the man's face should be a little sharper.

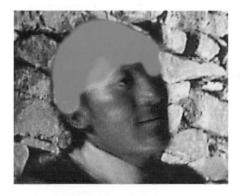

2. Paint mask and sharpen

Sharpening was applied in stages. In the first step, a mask was painted over the entire face bit by bit (above), and USM sharpening applied (below) with a high threshold to protect the skin smoothness.

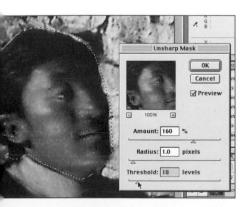

3. Retouch mask, resharpen For a second round of sharpening, the mask was reduced (left) and more highthreshold USM applied (above).

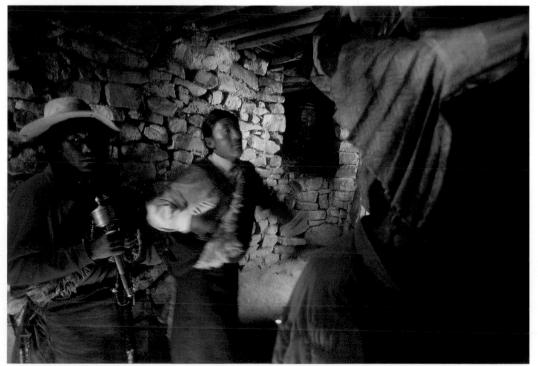

SECTION 4 NEXT STEPS

s you can see by now, there are no limits to what you can do with and to a photograph. There are some practical constraints, such as the amount of time and trouble it may take, and some procedures really do call for specialized software, but the underlying feature of digital imaging is that every pixel that makes up a photograph can be changed.

Up to now, we have been applying digital changes to pictures in the sense that the image remains essentially, recognizably, photographic. The tacit assumption has been that the original photograph *is* the image, and that the digital work is simply altering it to a greater or lesser degree. However, the seeds of something more radical have already been sown, because the very fact that anything in a digital image can be changed in any way opens limitless possibilities. It is possible to look at digital imaging in which photographs contribute rather than dominate.

For the most part we have been concerned with preserving photographic realism so that the image betrays none of the adjustments. But what happens if the starting point for the image is not a photograph but an idea? Digital editing allows you to build an image from scratch, as if on a blank canvas, using photographs as source material for illustration—and also adding, if you like, nonphotographic sources. You can keep the realism of texture and lighting, something which has never been easy using traditional artists' techniques, while being free to create images that are clearly not from the real world.

In this short final section, therefore, I introduce a completely different approach to digital photography. Here, we plan the image first, then shoot and select photographs to order. There are obviously many commercial and advertising applications for this approach, but it is also a wonderful medium for personal creative expression. By its nature, this type of work is always time-consuming, because this is really a form of photo-illustration, but the results can be spectacular.

Much of the success of this kind of fantastic imagery depends on bringing together different picture sourcesoften referred to as elements in this context-so that they appear to mesh. This relies partly on your skill with onscreen techniques, such as selection, edge blending, color matching, and brushwork in general, but it also goes a step further back, to the choice of individual photographic elements. Scale, perspective, and lighting are all important, and this means that if you shoot photographs with the specific purpose of adding them to an image you have thought of, you should work these out for each shot. As far as scale is concerned, you never want to have an image too small, because resizing it will give it a different pixel texture, but then nor is there any point shooting it too large. Perspective depends on the focal length of lens and the apparent distance of something from the camera. Lighting involves not only direction but also a choice between hardness or softness (soft, diffuse lighting is always easier to blend).

Depending on the scale of your ambitions for an image, there may be any number of elements, and some of the examples that follow are quite heavily loaded in this tense At first, the idea of stacking layer upon layer may seem complicated, but having mastered the combination of two or three elements, adding more comes fairly easily. It is certainly possible to begin making an image without a clear idea in mind, and you may enjoy the freedom, but the more complex the image, the fewer difficulties you will have if you actually sketch it out first. Ultimately, the most important stage in creating this kind of image is in exercising your imagination to envisage an exciting result.

CONCEPTS AND SYMBOLS

ne of the most important commercial uses of photography is in illustrating generalized themes. Given that most photographs are by their nature quite specific, this may sound a little strange, but in practice it means creating an image that conveys more than the immediate sub-

Concept shots tend to be the best-selling images in the stock photography market ject. Concept photography, as it is sometimes called, deals with ideas.

The concepts for which this kind of photography is used are often fairly abstract, or at least difficult to pin down visually. In the business world,

examples are found in insurance, investment, and the money markets, while concept photography also plays a major role in advertising, in book and magazine covers, and, especially, in music CD covers (unless you

SKY BOX

Shots from the library

various cloud pictures.

The original elements were

PICTURES FROM THE IMAGINATION

Strong perspective *Each image was distorted strongly to give a firm sense of wide-angle perspective.*

Completing the box *At the far end, the remaining white space was autoselected (left) and filled with a gradient (below), for the finished image.*

Picture wrap

In a variation of texture wrapping, a photograph of foxgloves was wrapped on the three visible sides of a cube. Each was first treated differently with third-party effects filters. With as simple a geometric shape as a cube, wrapping was a straightforward manual operation using the distort tool.

show the musicians or the composer, what else would work?). As a result, concept shots tend to be the bestselling images in the stock photography market. Moreover, the photographers who specialize in them were the first to embrace digital imaging techniques because these provided the perfect way to create a photorealistic image to exact specifications.

There are a number of ways of dealing with concepts, but the most common one is to use symbols. This is not limited to photography, as painters and illustrators have been doing it since time immemorial. However, a photograph still has the useful quality of appearing real—though for how much longer this is true is in doubt, while we continue to create this kind of image. Inventing the symbol is the key in concept photography, and there is a fine line to walk between choosing something that is appropriate and something that is a cliché. The most obvious ideas, such as an umbrella to represent insurance, or an egg to represent new beginnings, have been flogged to death, and visual symbols have a measurable lifespan.

One approach to concepts is to turn a subject into a graphic shape, such as a cube, a sphere, or a box. There is proprietary software that will wrap twodimensional images around a 3-D object, but images like the ones shown here are easy enough to create with the regular tools available in an image-editing program. If the shape is composed of flat planes, the distort tool is all that you need.

AN INTERNET METAPHOR

2-D ingredients

Monitor screens, photographed and edited, together with textures created in KPT, formed the twodimensional elements to be added to the 3-D CGI.

1. Basic grid

The structure was created in the 3-D program Bryce, from intersecting long cylinders.

2. Sun and atmosphere The sun and haze were added using the Sky controls.

3. Grid texture

The surface of the tubes was a combination of the materials editor in Bryce (left) and a central step-and-repeat 2-D texture image (from top left).

4. Monitor alignment With the basic grid in position, the main monitor was added in an imageediting program in a separate layer.

5. Monitor assembly In the image-editing program, the various monitors were positioned at the grid nodes at different scales.

7. Extending the grid The receding grid, also created in Bryce, was added in the image-editing program.

6. Adding screens The floating screens, represented as textures (shown above), were pasted in front of the main monitor.

8. Final composite The two principal layer groups were composited for the final result (right).

LAYER UPON LAYER

or a good part of this book we've looked at layers as devices for compositing images. They are absolutely integral to the process of adding one photographic image to another, and it's as

well to remember that they are not an invention of Photoshop but a very basic principle of imaging. This multiple image has had two incarnations—first, an opti-

Layers are absolutely integral to the process of adding one photographic image to another

cally created version with lith film masks, and now this digital solution—and both use layers.

The subject of the main picture on this spread is the De Lorean flying car from the film *Back to the Future*,

while a model represented it in flight. The model was mounted on a rig, and was separated from the studio background for insertion in any given scene by an old Hollywood technique, bluescreen.

OK]

Cancel

•

-

which in its day used state-of-the-art special effects.

The studio responsible for the special-effects work was

ILM-Industrial Light and Magic-which was origi-

nally set up by George Lucas to produce the effects for

Star Wars. My image was part of a magazine story about the work behind the scenes. For the movie a real, full-sized automobile was used for the actors,

PICTURES FROM THE IMAGINATION

BACK TO THE FUTURE

ave Selection		
Destination		Ok
Document: car crash.psd	•	Can
Channel: New	•	-
Name: car matte		
Operation		
New Channel		
C Add to Channel		
C Subtract from Channel		
C Intersect with Channel		

3. Paste in beauty pass With the layer set at halfopacity, the beauty pass, out of black, is pasted over the bluescreen and positioned accurately (below).

4. Load matte selection The previous selection, the

The previous selection, the "car matte," is loaded to give an outline.

5. Knock out background The "car matte" selection is inverted and deleted, to leave just the car.

6. Blend landscape and sky *The sky and a landscape from Iceland are combined in layers, and retouched with a soft eraser.*

The idea of bluescreen is to provide a featureless background that will contrast with an actor or object. The blue is strong, so it could be used later to create a mask—what used to be called a traveling matte because it could be followed from frame to frame. Blue was chosen because flesh tones don't contain it; nowadays a greenscreen is normally used, for the same reasons. As part of the story, I wanted to use some of the same technique, so I made my mask with bluescreen.

The idea of the shot is for the car to be in flight, crossing over from the mundane reality of the studio into a fantasy landscape. This determined the layout the car would be center§-stage and in the foreground, but the background would be split between the studio at left, blending into a landscape at right. For this I chose a shot that I already had, of a slightly unrearthly area of geysers in Iceland.

For the movie itself, the car was filmed twice for each scene. The first was fully lit, with the bluescreen behind—what is known as "the beauty pass." The second was "the smoke pass," for which all lights are off except those within the model, and the room is filled with smoke. Two passes were needed to maintain detail. I followed the same procedure for both, except that for my "beauty pass" I switched the bluescreen off; that gave me more lighting control, and it was no extra trouble to add a bluescreen silhouette. At the end of shooting I had four photographs from the studio and one of the landscape. Each of these went into a layer, and the compositing followed the sequence shown here to create the finished image.

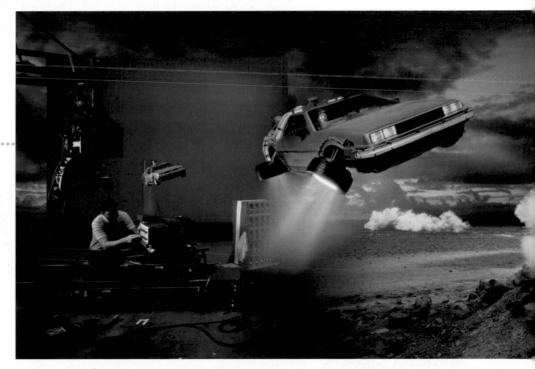

7. Paste bluescreen setup

8. Fade out bluescreen A gradient from foreground to transparency is created horizontally in mask mode. This selection is then used to

delete the right-hand part of

the studio set.

The isolated car is added in

9. Paste in car

position.

10. Add the smoke The smoke pass is added, and this new layer blended with the opacity sliders to fade out its black background.

11. The final blend

The finished composite involved five different image layers and two channels. Using the layer blending options, such as for the smoke, reduced the need for more channel selections.

CONSTRUCTS

ne feature of digital imaging that most of us now take for granted is perfect copying. In traditional film photography, copying meant losing quality and detail. Not so, however, with a digital image. Here, each copy is perfect—a clone, in fact. This may seem obvious, possibly

This opens up a new area of special-effects photography, in which a picture can be made the source of a much larger, and quite different image trivial, but it opens up a new area of special-effects photography, in which a picture can be made the source of a much larger, and quite different image with a strong impact.

The idea, shown here, is to treat a single picture element as a kind of building block for copying and past-

ing, and then by careful distortion to view the result from any angle and perspective. In this case, I had a 35mm transparency of a single 1-kilo bar of gold, and the idea to make something like a landscape of bars. The original shot was taken for use with part of a magazine story on gold, and although we had access to some vaults, there was never enough gold visible to be able to produce what I wanted in a single photograph. The digital step-and-repeat process, however, removed all creative constraints on the idea.

The first step was to straighten the bar on all sides (as shot it was almost, but not exactly, face-on), by selecting the outline and then using the distort tool to make it a perfect rectangle. This then became the basic unit for constructing the new image. The ultimate effect was to be a mass of gold bars, stretching to the horizon and at quite a strong perspective. Although using the perspective tool in image-editing programs

ENDLESS GOLD

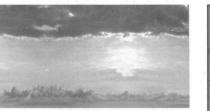

1. One bar and a sky The origin for the entire image is a one-kilo bar that was photographed at a foundry, together with a sky in a matching color.

2. Gold bar aligned The bar is rotated so that one edge is exactly horizontal, as below.

3. Squared up All edges are squared up with the distortion tool.

4. Selected and isolated *The bar is outlined with the path tool. Then the path is converted to a selection, inverted, and the background deleted (below).*

5. Copy and paste The first copies of the bar are added one at a time in a strip (above).

6. Downsize *The strip is then downsized and copied and pasted.*

1 1 1 1	144	**	**	100	1.1	1 1	1 1	**
1 1 1 1 1 1	100	9- 41	2 12	100	4.194	1 8 1		1
	1 1 1	2 2	**	100	2.02	1	1	1 . 4
6. 700 90.3	6 8 4 6 4	100	10 10	40.9	1. 40.	10.10	10 m	2. 3
		1 1	1.1	100	1 Y 1	1 1	11	1.1
1 1 1	1 1 1 1 1 1 1 1 1 1 1 1 1 1 1 1 1 1 1	200	1 2 1	10 Y	6 YE	1 2	1.1	1 1
	2 2 2	1 1	1	100	8 YE	1	11	11
E 10 34 7	1 3 . 3	10 Ac.	1 1	100.0	7 9 5	AL 201	1 1	1 1
2 40 40 4	1.1	1. 1.	1	41.4	1 - A - 1	4 H H H	1. 30	1 1
		1 1	1 1	11	6	11	11	11
N 40 46 8	0.30.30	10.00	10.20	20.0	1.51	1. 10	1 1	1 1
	1 1 1	1	11	100		1	11	1 1

7.480 gold bars

Stepping-and-repeating produces a block of 480 bars, which is then downsized.

8. 2400 bars With the 480-bar block increased to 2400 bars, the perspective tool is applied.

is simplicity itself (dragging a corner handle of a rectangular selection into a keystone shape), the problem was one of scale. It meant starting with a much larger image, which placed considerable demands on processing and memory. A tip here, for a situation like this where the operation is too calculation-intensive for your computer, is to perform two perspective distortions, one on each half of the image, and later paste the two sections together.

The single gold bar was first copied and pasted into a strip, then this was copied and pasted until a block of 480 bars was produced. This block was copied and pasted vertically five times, and the perspective tool applied to it, extremely. This wedge shape, considerably oversized, then had to be downscaled to the width of the horizon.

The original bar still had more work to do. A set of tumbling bars was created, one at a time, from the original, each held in its own layer. Drop shadows were created for these with alpha channels, using the techniques described in the Objects chapter on pages 192–3. The floating bars were copied into a channel

9. Bars in perspective The first stage in the perspective distortion.

and filled with solid black, then Gaussian blur was applied to soften the edges. A further embellishment was the sky, which was extended horizontally from a section of a 35mm Kodachrome with the same kind of step-and-repeat technique. To match it, the "landscape" of bars was lightened progressively toward the horizon by applying the gradient tool in mask mode, then adjusting the brightness of the selection.

10. Squashed perspective *The second distortion step is to reduce the height of the block of bars, and then to crop it.*

11. Floating bars

Copies of the single but we added in layers above the "landscape." Shadows are added by taking copies of these bars, filling them with black, and then blurring and weakening their opacity.

PICTURES FROM THE IMAGINATION

PHOTOGRAPHY AND ARTWORK

f you are prepared to make use of a wide range of effects within a pixel-based editing program, there are few limits to the kind of image you can create. In particular, a blend of photographs and illustration can be a powerful combination—always provided, of course, that they fit together visually. The key to success in this kind of special-effects picture is matching a

A blend of photographs and illustration can be a powerful combination variety of images in one frame, and like so many computer operations it is much more a matter of visual skill and judgement than of technique. Certainly, technique plays a crucial

role in building the complex image shown here, but the tricks are easily learned. Giving the illustrated elements the same tone, range, and texture as those of the photographed elements was a question of judging by eye on screen. A tip here is to use the main photographic image—the woman's face—as the benchmark.

The idea of the image was to build a virtual reality machine of the future—something that would input sight, sound, and other senses directly to the brain. The two key "inventions" here are a kind of helmet and goggles, with the goggles displaying such intense images that they actually emit light. One option was to build these as full-size models—indeed, before computers, this would have been the only solution—but digital illustration turned out to be far quicker and more flexible. The basis of the helmet was a photomicrograph of a microchip; extended into a large array, this could then quite simply be spherized. Applying the spherize filter to a rectangular rather than square section gave an ovoid, which was more interesting than a perfect sphere would have been.

The goggles and various accessory details were drawn with circles and rectangles that were then distorted in various ways. The real contribution here came from a proprietary piece of software (Kai's Power Tools) that offers a number of third-party plug-in filters. The most useful one here turned out to be a set of gradient fills—in particular the metallic ones.

The final touch, which gives life to the image, is the light appearing to burst from the goggles. The trick here is to use a diffuse painting tool with a very gradual fade-out rate. This fade-out means that the effect white light in this case—dies away along a straight line, which is perfect for this job.

Norma

1. Chip array A shot of a microchip is copied and pasted into an array of 64, ready for spherizing. To keep the image size manageable, the original has to be reduced.

2. Spherized array A spherizing filter is applied to the entire array at 100%, creating an ovoid.

3. Dividing ovoid

To split the ouoid into two halves—one for each side of the helmet—a copy of the original array of 64 microchips is made, a center section filled with white, the remainder with black. This is given the same spherize treatment and used as a channel to split the ovoid (which has had shadows and highlights added).

4. Face

The almost-white background in this scanned studio shot is autoselected and inverted to make a selection of the head.

5. Placing helmet *Each half of the helmet is pasted over the face, and scaled.*

6. Pasting supports

The pistonlike supports are copied from a photograph of an old NASA spacecraft. Outlined and isolated, the object is pasted onto the right helmet, then flipped and pasted onto the left.

7. Goggles

The hi-tech goggles begin with a colanderlike grille, constructed from circles filled with a metallic sheen. The resulting grille is spherized, and rivets are pasted onto the rim one at a time (right).

9. Final composite

The finished image, with more detailing (such as the insides of the helmets, accessories, and shadows around the goggles). A very labor-intensive image, but a blend of reality and invention that could hardly be created in any other way.

8. Emanating light

Light beams are created by using a paintbrush tool set with a fade-out rate. One click on a hole marks the start of the beam, a second Shift-click a distance away creates the diminishing beam.

PHOTOGRAPHY AND CGI

he most radical blend of imaging techniques is that of photography and 3-D computer generation. We already saw the usefulness of CGI skies on pages 154–5; once created and rendered as a two-dimensional bitmapped image, they can be treated as any other, real sky. Stripping them into a photograph is the usual procedure. On this spread,

though, is an image in which the proportions of photography to CGI are reversed—the basis of it is a landscape generated in 3-D, and into this are introduced photographic elements. As I have mentioned before, the

As I have mentioned before, the most useful kind of software for blending with photography to create pictures in this manner is a program that can generate randomness in textures, and which has high-quality rendering.

High-end programs of the type used for motionpicture special effects, such as SoftImage, can perform near miracles of photorealism, down to particle effects, hair, and fur, but they are expensive and demand professional operation. With this kind of image we are already close to the limits of photography—maybe even beyond—and embarking on a full investigation of 3-D possibilities is the subject for another book. For this image, as for the CGI skies, I used Bryce, which is inexpensive and also works very well for certain kinds of landscape creation.

Most 3-D software fails at a realistic representation of vegetation, because of the complexity of detail coupled with a fair amount of precision. A tree has to grow in a certain way—trunk, branches, leaves—

> to look convincing, even at a distance. This is much more demanding than the randomly eroded texture of rock or sand, and for this reason, arid landscapes with a lot of obvious geology are the easiest natural

views to tackle. The basic procedure is to divide the landscape into its main elements—plain, groups of hills and mountains—and each of these is created separately. Each is scaled and stretched into the shape you want, then fitted together, all as wireframe objects without any texture.

During the construction process, I would do a quick render to see how the model was looking. Where two objects intersect, they simply grow into each other, and by adjusting their height and position I was able to make this look reasonably natural. Once this operation was complete, I selected the texture and color in

IMAGINARY MOUNTAIN

1. Elements

The two-dimensional originals are a herd of elephants and a woman's face, the latter converted to a grayscale bump-map with some retouching. The idea of this is that the lighter areas represent higher relief.

High-end programs of the type

used for motion-picture special

effects can perform near

miracles of photorealism

2. Face as terrain In Bryce, the retouched face is loaded as a terrain map, and then eroded fractally to give it the appearance of a rocky mountain.

3. Scaling the wireframe The "face" mountain is reduced vertically as a wireframe object.

4. Pasting the elephants In the rendered landscape, opened in an image-editing program, the herd is selected and pasted.

5. Adding dust and shadow Dust clouds are added with an airbrush over the elephant selection, and shadows are drawn in underneath.

6. Adding tracks The final touch is tracks in the sand, created with a deformation brush.

7. The finished image Color correction helps to blend the layer of elephants realistically with the 3-D landscape.

PICTURES FROM THE IMAGINATION

the materials editor, and for this Bryce conveniently offers a range of presets from which to choose. If you are prepared to delve deeply into the software, every aspect of the material is editable. I worked on the lighting and atmosphere last of all. After positioning the sun, I set the haze level and color, and then the sky color.

The single photographic element was a herd of elephants, taken as an aerial photograph from a helicopter, which was composited in the usual way, taking special care over the edge selection. I added light shadows below them, and the stirred-up tracks in the sand behind them with a deformation brush. However, the key element in this picture—the whole idea behind it—was a mysterious mountain in the form of an eroded human face. As it turned out, this was not such a complicated procedure. The principle bears some relation to displacement mapping, which we saw on page 123, in using a grayscale image to plot the height of terrain (a bump map). In this case, the brighter the pixel, the higher it is above the ground plane—a convenient way of creating 3-D from 2-D. I used the woman's face from pages 212–13, but adjusted the shading so that the appropriate parts would be elevated. Once I had applied this to the terrain, I eroded it slightly, flattened it, and sank it partly beneath the sand plane.

GLOSSARY

omputing is awash with jargon. No, worse than that — it *breeds* jargon, making a large part of most computer magazines, for example, unintelligible to any but the initiated. This probably has much to do with the persistence of acronyms and odd terminology — understanding the language is a sort of *de facto* diploma in the self-education that all computer users have to go through. It is, of course, fairly childish and should be unnecessary. Unfortunately, right now it *is* necessary as a form of shorthand to refer to things that would otherwise need wordy explanation.

Despite rigorous attempts at editing, I realize that this book still uses a fairly full complement of jargon, and to be honest, removing any more than I already have would not help. A term such as 'clipboard' may be unfamiliar when you first open the book, but it is such a basic idea that to have to explain it in several words every time would simply become irritating to read, as well as to write. I'm afraid that we're stuck with much of this jargon — and in any case, as photographers we have our own. The best solution seems to me to have a substantial glossary to cope with it. In fact, I began writing the book here, with the glossary, as a way of getting to grips with computing myself. It is one of the components that contribute to yet another piece of computing's in-grown language — its 'steep learning curve'.

3-D digitizer Device and software that converts a real object into a 3-D computer model. Methods vary from optical stereo scanning to a digitising pen.

3-D effects (program) Program that creates images that look three-dimensional on a computer screen.

accelerator board Board added to a computer to increase its processing speed. Some accelerators add support for additional monitors. See also video card.

access time The speed at which the computer can communicate with its hard drive, measured for a desktop computer in milliseconds (ms).

active matrix display An LCD monitor using tiny transistors to generate the display.

additive primary colours The three colours red, blue and green, which can be combined to create any other colour. When superimposed on each other (added to), they produce white. (See also **RGB** and **subtractive primary colours.**)

algorithm Mathematical procedure that allows the stepby-step solution of a problem.

aliasing The unwanted jagged appearance of diagonal lines in an image caused by the square shape of pixels.

alpha channel A grey-scale version of an image that can be used in conjunction with the other three colour channels, such as for creating a mask.

anti-aliasing The smoothing of jagged edges on diagonal lines created in an imaging program, by giving intermediate values to intermediate pixels between the steps.

application (also **program**) Software designed to make the computer perform a specific task. So, **image-editing** is an application, as is wordprocessing. System software, however, is not an application, as it controls the running of the computer.

artifact/artefact A flaw in a digital image.

ASIC Application-Specific Integrated Circuit A custom silicon chip that is dedicated to one particular function, such as to graphics processing, or to a specific program, such as Photoshop. Used in an accelerator board, this is the fastest solution for any one application, but of course it has limited uses.

aspect ratio The ratio of the height to the width of an image, screen, or page.

authoring (program) Programming instructions designed for creating presentation software, such as multimedia products. backup A copy of either a file or a program, for safety reasons, in case the original becomes damaged or lost. The correct procedure for making backups is on a regular basis, while spending less time making each one than it would take to redo the work lost.

banding Unwanted effect in a tone or colour gradient in which bands appear instead of a smooth transition. It can be corrected by higher resolution and more steps, and by adding **noise** to confuse that part of the image. (See also **noise filter**.)

baud The frequency of switching (and so bits) per second in a communications channel.

baud rate A measurement of communication speed - at lower speeds equivalent to the number of bits per second (bps), although at higher speeds equivalent to two or more bits per second.

Bézier curve An irregular curve described by a mathematical

formula. In practice, it is produced by manipulating control handles on a line that is partly held in place by anchor points.

bit *BInary Digit* The basic data unit of binary computing. (See also byte.)

bit depth The number of bits per pixel (usually per channel, sometimes for all the channels combined), which determines the number of colours it can display. Eight bits per channel is needed for photographic quality imaging.

bitmap, bitmapped image Image composed of a pattern of pixels, as opposed to a mathematically defined object (an object-oriented image). The more pixels used for one image, the higher its resolution. This is the normal form of a scanned photograph. (See also object-oriented (image).)

bits-per-second (bps) A measurement of communication speed. (See also baud and baud rate.)

BMP Image file format for bitmapped images used in Windows. Supports RGB, indexed colour, greyscale and bitmap.

brightness The level of light intensity. One of the three dimensions of colour. (See also hue and saturation.)

buffer An area of temporary data storage, normally used to absorb differences in the speed of operation between devices. For instance, a file can usually be sent to an output device, such as a printer, faster than that device can work. A buffer stores the data so that the main program can continue operating.

bus Electronic pathway for sending data within a computer or between a computer and an external device. A 'data highway'. byte Eight bits - the basic data unit of desktop computing. (See also bit.)

cache An area of information storage set aside to keep frequently needed data readily available. This allocation speeds up operation.

cache card A card that can be added to a computer to increase its performance. It contains certain common instructions and data in a special form of memory that the computer's processor can access quickly. A cache card acts as a kind of acceleration, less expensive than an accelerator board.

calibration The process of adjusting a device, such as a monitor, so that it works consistently with others, such as scanners and film recorders.

CCD Charge-Coupled Device A tiny photocell, made more sensitive by carrying an electrical charge before it is exposed. Used in densely packed arrays, CCDs are the recording medium in lowto medium-resolution scanners and in digital cameras.

CD *Compact Disc* Optical storage medium originally developed by Phillips.

CD-R *Compact Disc-Recordable* A writable **CD-ROM**. Designed for desktop production using a relatively small recorder, CD-R discs look like ordinary CD-ROMs and are compatible with CD-ROM drives, but have a different internal structure. They can be used as high-volume removable storage (600MB in contrast to, say, a 88MB SyQuest cartridge), and for producing multimedia projects and portfolios.

CD-ROM *Compact Disc Read-Only Memory* A high-volume storage medium in which the information can only be read, not altered. The information is 'written' onto the disc by a laser that creates small pits in the surface, and so cannot be changed.

CGA Colour Graphics Adapter A low-resolution colour video card for PCs.

CGI Computer-Generated Image Electronic image created in the computer (as opposed to one that has been transferred from another medium, such as a photograph).

CGM Computer Graphics Metafile Image file format for both bitmapped and objectoriented images.

channel Part of an image as stored in the computer; similar to a layer. Commonly, a colour image will have a channel allocated to each primary or process colour, and sometimes one or more for a mask or other effect. (See also alpha channel.)

clipboard Part of the memory used to store an item temporarily when being copied or moved. (See also cut-and-paste.)

clip art Simple copyright-free graphics stored on disks or CDs that can be copied for use in a layout or image.

clip library Collection of simple units in any recordable media (such a graphics, photographs, sound) stored on disks or CDs, and that can be copied into an application.

clip photography Photographs stored on disks or CDs, and that can be copied into an application.

cloning In an image editing program, the process of duplicating pixels from one part of an image to another.

CMOS Complementary Metal Oxide Semiconductor Energysaving design of semiconductor that uses two circuits of opposite polarity. Pioneered in digital cameras by Canon CK.

CMS Colour Management System Software (and sometimes hardware) that ensures colour consistency between different devices, so that at all stages of image-editing, from input to output, the colour balance stays the same.

CMY Cyan, Magenta, Yellow Process colours.

CMYK Cyan, Magenta, Yellow, Key (Black) The four process colours used for printing.

colour depth See bit depth.

colour gamut The range of colour that can be produced by an output device, such as a printer, monitor or film recorder.

colour model A system for describing the colour gamut, such as RGB, CMYK, HSB and Lab.

colour separation The process of separating an image into the process colours cyan, magenta, yellow and black (CMYK), in preparation for printing.

colour space A model for plotting the hue, brightness and saturation of colour.

Compact Flash card One of the two most widely used kinds of removable memory card in digital cameras. CF cards are used by Canon, Fuji, and others.

compression Technique for reducing the amount of space that a file occupies, by removing redundant data.

continuous-tone image An image, such as a photograph, in which there is a smooth progression of tones between black and white. (See also half-tonc image.)

contrast The range of tones across an image from highlight to shadow.

CPU *Central Processing Unit* The processing and control centre of a computer.

CRT *Cathode Ray Tube* The imaging system for a monitor - and in television - in which a cathode fires a beam of electrons onto a screen that is coated on the inside with phosphors; these glow when struck.

cropping Delimiting an area of an image.

cursor Symbol with which the user selects and draws on-screen.

cut-and-paste Procedure in graphics for deleting part of one image and copying it into another.

DAT *Digital AudioTape* Tape medium commonly used for back-ups.

database A collection of information stored in the computer in such a way that it can be retrieved to order — the electronic version of a card index kept in filing cabinets. Database programs are one of the main kinds of application software used in computers.

default The standard setting or action used by a computer unless deliberately changed by the operator.

densitometer Instrument (or software tool) for measuring the density (brightness/darkness) of small areas of an image.

desktop On a monitor display, the background area of the screen on which icons and windows appear.

desktop computer Computer small enough to fit on a normal desk. The two most common types are the PC and Macintosh.

device Hardware unit that handles data, such as a scanner, printer or modem. dialog box An on-screen box, part of a program, for entering settings to complete a procedure.

digital A way of representing data as a number of distinct units. A digital image needs a very large number of units so that it appears as a continuous-tone image to the eye; when it is displayed these are in the form of **pixels**.

digital zoom A false zoom effect used in some cheaper digital cameras; information from the centre of the CCD is enlarged with interpolation.

digitize To convert a continuoustone image into digital form that a computer can read and work with. Performed by scanner.

digitizer tablet A flat rectangular board with electronic circuitry that is sensitive to the pressure of a stylus. Connected to a computer, it can be configured to represent the screen area, and used for drawing.

dithering Technique of appearing to show more colours than are being used, by mingling pixels. A pattern of adjacent pixels of two colours gives the illusion of a third colour, but at the cost of a lower resolution.

DMax Maximum Density The maximum density — that is, the darkest tone — that can be recorded by a device.

DMin Minimum Density The minimum density — that is, the brightest tone — that can be recorded by a device.

DOS Disk Operating System The operating system based on Intel processors used by Microsoft.

download Sending a data file from the computer to another device, such as a printer.

dpi Dots Per Inch A measure of resolution in half-tone printing. (See also ppi.) drag Moving an icon or a selected image across the screen, normally by moving the mouse while keeping its button pressed.

drag-and-drop Moving an icon from one file or application to another by means of dragging (see drag), then dropping it at its destination by releasing the mouse button.

draw(ing) program Objectoriented program for creating artwork, as distinct from painting programs that are pixel-based.

drive Hardware device containing one or more disks.

driver Software that sends instructions to a device, such as a printer, connected to the computer.

dye sublimation printer A colour printer that works by transferring dye images to a substrate by heat, to give near-photographic quality prints.

dynamic range The range of tones that an imaging device can distinguish, measured as the difference between its DMin and DMax. It is affected by the sensitivity of the hardware and by the bit depth.

EPS Encapsulated PostScript Image file format developed by Alsys for PostScript files (that is, for object-oriented graphics as in draw programs and page layout programs.) (See also objectoriented image, draw(ing) program.)

extrude, extrusion 3-D technique for extending a 2-D object along a third axis.

fade-out The extent of any graduated effect, such as blur or feather. With an airbrush tool, for example, the fade-out determines the softness of the edges as you spray. feather edge A border effect around a selection.

feathering Digital fading of the edge of an image.

file format The method of writing and storing a digital image. Formats commonly used for photographs include TIFF, PICT, BMP and JPEG (the latter is also a means of compression).

film recorder Output device that transfers a digitized image onto regular photographic film, which is then developed.

filter Imaging software included in an image-editing program that alters some image quality of a selected area. Some filters, such as Diffuse, produce the same effect as the optical filters used in photography after which they are named; others create effects unique to electronic imaging.

frame grab The electronic capture of a single frame from a video sequence. A way of acquiring low-resolution pictures for image editing.

fringe A usually-unwanted border effect to a selection, where the pixels combine some of the colours inside the selection and some from the background.

gamma A measure of the contrast of an image, expressed as the steepness of the characteristic curve of an image.

GB *GigaByte* Approximately one billion bytes (actually 1,073,741,824).

GIF Graphics Interchange Format Image file format developed by CompuServe for PCs and bitmapped images up to 256 colours (8-bit).

gigabyte See GB.

global correction Colour correction applied to the entire image.

greyscale A sequential series of tones, between black and white.

GUI *Graphic User Interface* Screen display that uses icons and other graphic means to simplify using a computer. The Macintosh GUI was one of the reasons for Apple's original success in desktop computing.

half-tone image An image created for printing by converting a continuous-tone image into discrete dots of varying size. The number of lines per inch (lpi) of the dot pattern affects the detail of the printed image.

handle Icons used in an objectoriented draw program which, when selected with the cursor, can be used to manipulate a picture element. They usually appear on-screen as small black squares. (See also draw(ing) (program) and object-oriented (image, program.)

hard disk, hard drive A sealed storage unit composed of one or more rigid disks that are coated with a magnetically sensitive surface, with the heads needed to read them. This can be installed inside the computer's housing (internal), or in a separate unit linked by a bus (external). (Scc also **bus**.)

hardware The physical components of a computer and its peripherals, as opposed to the programs, or software.

histogram A map of the distribution of tones in an image, arranged as a graph. The horizontal axis is in 256 steps from black to white, and the vertical axis is the number of pixels.

HSB Hue, Saturation and Brightness The three dimensions of colour. One kind of colour model.

hue A colour defined by its spectral position; what is

generally meant by 'colour' in lay terms.

icon A symbol that appears onscreen to represent a tool, file or some other unit of software.

image file format The form in which an image is handled and stored electronically. There are many such formats, each developed by different manufacturers and with different advantages according to the type of image and how it is intended to be used. Some are more suitable than others for highresolution images, or for objectoriented images, and so on. (See also BMP, CGM, PCD, PICT, Scitex CT, TIFF).

image-editing program Software that makes it possible to enhance and alter a scanned image.

imagesetter A high-resolution optical device for outputting images on film or paper suitable for reproduction from a digital file.

image compression A digital procedure in which the file size of an image is reduced by discarding less important data.

index In a database, an internal table that speeds up searches.

indexed colour A digital colour mode in which the colours are restricted to 256, but are chosen for the closest reproduction of the image and to make the best use of the Macintosh and Windows platforms. Used to guarantee optimum display on most monitors.

interface Circuit that enables two hardware devices to communicate. Also used for the screen display that allows the user to communicate with the computer. (See also GUI.)

interpolation Bitmapping procedure used in re-sizing an image to maintain resolution. When the number of **pixels** is increased, interpolation fills in the gaps by comparing the values of adjacent pixels.

ISDN *Integrated Services Digital Network* A high-speed digital telecommunications technology for transmitting data.

JPEG Joint Photographic Experts Group Pronounced 'jay-peg', a system for compressing images, developed as an industry standard by the International Standards Organisation. Compression ratios are typically between 10:1 and 20:1, although lossy (but not necessarily noticeable to the eye).

KB *KiloByte* Approximately one thousand bytes (actually 1,024 or 2).

key field In a database, a field that can be searched.

kilobyte See KB

Lab, L*a*b* A three-dimensional colour model based on human perception, with a wide colour gamut.

lasso A selection tool used to draw an outline around an area of the image.

lathing 3-D technique in which a 2-dimensional image plane is rotated around one of the axes, as a piece of wood being turned on a lathe. The result is a 3-D object which, viewed along the new axis, is a disc. Used for creating symmetrical objects.

layer One level of an image file, separate from the rest, allowing the image to be composed of different elements.

LCD *Liquid Crystal Display* Flat screen display used in digital cameras and some monitors. A liquid crystal solution held between two clear polarizing sheets is subject to an electric current, which alters the alignment of the crystals so that they either pass or block the light.

logic board The main circuit board in a computer that carries the CPU, other chips, RAM and expansion slots.

lossless Type of image compression in which no information is lost, and so most effective in images that have consistent areas of colour and tone. For this reason, not so useful with a typical photograph.

lossy Type of image compression that involves loss of data, and therefore of image quality. The more compressed the image, the greater the loss.

lpi *lines per inch* Measure of screen resolution. See also ppi.

luminance Brightness in a particular direction.

macro A single command, usually a combination of keystrokes, that sets in motion a string of operations. Used for convenience when the operations are run frequently.

mask A greyscale template that hides part of an image. One of the most important tools in editing an image, it is used to make changes to a limited area. A mask is created by using one of the several selection tools in an image-editing program; these isolate a picture element from its surroundings, and this selection can then be moved or altered independently. (See also alpha channel and selection.) In a database, a mask controls the way that data is entered in a field: for instance, it may limit entry to a 'Y' or 'N' (for Yes/No).

MB *Megabyte* Approximately one million bytes (actually 1,048,576 or 2.)

megabyte See MB.

memory See virtual memory.

menu An on-screen list of choices available to the user.

MHz MegaHertz One million cycles (electrical vibrations) per second; a measurement of the clock speed of a computer.

Microdrive Miniature hard disk designed to fit in the memory card slot of a digital camera and so increase the storage capacity.

mid-tone The parts of an image that are approximately average in tone, midway between the highlights and shadows.

millisecond (ms) One thousandth of a second.

mode One of a number of alternative operating conditions for a program. For instance, in an image-editing program, colour and greyscale are two possible modes.

modem MOdulator/DEModulator A device for transmitting data on a telephone line. It converts the digitized information from the computer to the analogue, modulated form that telephone systems use (designed that way to transmit human speech, which is modulated). Modems can be internal or external, and the connection with the telephone socket is made from the computer's serial port.

mouse Handheld input device that rolls on a ball set into its underside.

ms millisecond

MS-DOS MicroSoft Disk Operating System The standard operating system used in IBM (and compatible) computers. It uses a command line: the user must type in abbreviated commands, line by line, at the flashing cursor prompt on-screen.

noise Random pattern of small spots on a digital image that are generally unwanted, caused by

non image-forming electrical signals.

noise filter Imaging software that adds noise for an effect, usually either a speckling or to conceal artefacts such as banding. (See also **artefacts** and **noise**.)

object-oriented (image, program) Software technology using mathematical points rather than pixels to describe an image element. Scalable, in contrast to bit-mapped elements. Paths and Bézier curves are object-oriented.

paint program A variety of pixelbased image-editing program with tools and features geared to illustration rather than to photography.

paste Placing a copied image (or other digital) element into an open file. In image-editing programs, this normally takes place in a new layer.

PCD Photo CD Image file format developed by Kodak for Photo CD.

peripheral An additional hardware device connected to and operated by the computer, such as a drive or printer.

Photo CD A type of CD-ROM developed by Kodak for storing scanned photographs in Kodak's proprietary format.

photo-composition The traditional, non-electronic method of combining different picture elements into a single, new image, generally using physical film masks. The electronic techniques that replace it are selection, cut and paste, and the various paint tools for blending the edges between picture elements.

PICT A file format developed by Apple that supports RGB with a single alpha channel, and indexed colour, greyscale and bitmap modes. Very effective at compressing areas of solid colour. **pixel** *PICture ELement* The smallest unit of an digitized image — the square screen dots which make up a bitmapped picture. Each pixel carries a specific tone and colour.

pixel depth See bit depth.

plug-in module Software produced by a third party and intended to supplement a program's performance.

ppi *Pixels Per Inch* A measure of resolution for a bitmapped image.

processor A silicon chip containing millions of microswitches, designed for performing specific functions in a computer or digital camera.

program A list of coded instructions that makes the computer perform a specific task. **Software** is composed of programs.

QuickDraw System software that controls colour graphics in a Macintosh computer. (See also accelerator board.)

RAID *Redundant Array* of *Independent Disks* A stack of hard disks that function as one, but with greater capacity.

RAM *Random Access Memory* The working memory of a computer, to which the central processing unit (CPU) has direct, immediate access.

ramp Gradient, as in a smooth change of colour or tone.

real-time The appearance of instant reaction on the screen to the commands that the user makes — that is, no appreciable time-lag in operations. This is particularly important in bitmap image editing, such as when using a paint or clone tool. Because picture files are relatively large, and changes demand many calculations, it is expensive to achieve the computing speed necessary for real-time operation. (See also accelerator board.)

render(ing) The process of performing the calculations necessary to create a 2-D image from a 3-D model.

Res *RESolution* Abbreviation used for metric resolution. Thus, Res 12 is 12 lines per millimetre.

re-sampling Changing the resolution of an image either by removing pixels (lowering resolution) or adding them by interpolation (increasing resolution).

resolution The level of detail in an image, measured in pixels (e.g. 10248 by 768 pixels), lines per inch (on a monitor), or dots per inch (in a half-tone image, e.g. 1200 dpi).

RGB *Red*, *Green*, *Blue* The primary colours of the additive model, used in monitors and image-editing programs.

RIP *Raster Image Processor* Either hardware or software that controls the imaging of a bitmapped picture. RIPing is the process of converting a vector graphic to bitmap.

ROM Read-Only Memory Memory, such as on a CD-ROM, that can only be read, not written to. It retains its contents without power, unlike RAM.

rubber-stamp A paint tool in a image-editing program that is used to clone one selected area of the picture onto another. It allows painting with a texture rather than a single tone/colour, and is particularly useful for extending complex textures such as vegetation, stone, brickwork, and so on.

saturation The purity of a colour; absence of grey, muddied tones.

scanner Device that digitizes an image or real object into a bitmapped image. Flatbed scanners accept flat artwork as originals, slide scanners accept 35mm transparencies and negatives, drum scanners accept either film or flat artwork.

Scitex CT Image file format developed for use with the Scitex Prepress system (CT = Continuous Tone.) A widely used high-resolution format.

screen dump Print-out of the current display on the monitor screen.

screen refresh The re-display of an image on the computer screen.

SCSI Small Computer System Interface (pronounced 'scuzzy'). Interface standard that allows peripheral devices such as scanners, printers and removable storage drives to be daisy-chained to the computer.

selection A part of the on-screen image that is chosen and defined by a border, in preparation for making changes to it or moving it. One of several selection tools available in an image-editing program can be used to make this selection. (See also mask.)

serial port Port used for sending and receiving information in a continuous stream of bits. Used particularly for connecting a computer to modems, serial printers and other computers.

slot Receptacle in a computer for an additional circuit board to enhance performance or capabilities.

software Programs that enable a computer to perform tasks, from its operating system to jobspecific applications such as image-editing programs and third-party filters.

stylus Pen-like device used for drawing and selecting instead of a

mouse. Used with a digitizer tablet.

submarining Screen display fault in which the cursor temporarily disappears when moved.

subtractive primary colours The three colours cyan, magenta and yellow, used in printing, which can be combined to create any other colour. When superimposed on each other (subtracting), they produce black. In practice a separate black ink is also used for better quality. (See also RGB and additive primary colours.)

SuperCCD A CCD in which the pixels are oriented as diamonds. Processing the read-out of each line of pixels requires some interpolation, but gives a resolution higher than the pixel count.

thumbnail Miniature on-screen representation of an image file.

TIFF Tagged Image File Format A file format for bitmapped images. It supports CMYK, RGB, and greyscale files with alpha channels, and Lab, indexedcolour, and bitmap files without, and it can use LZW 'lossless' compression. It is now the most widely used standard for goodresolution digital photographic images.

tiling A method of creating or reproducing a large image area by adding adjacent sections all in the same basic shape, usually a square. For instance, a texture can be extended across the entire screen by copying a small square of the texture and joining up the copies. One essential is that the joins are seamless, to give the appearance of being continuous.

tool A program specifically designed to produce a particular effect on-screen, activated by choosing an icon and using it as the cursor. In image-editing, many tools are the equivalents of traditional graphic ones, such as a paintbrush, pencil or airbrush.

toolbox A set of programs available for the computer user, called tools, each of which creates a particular on-screen effect. (See also tool.)

trackball An alternative input device to a mouse, used to move the cursor on-screen. Mechanically, it works as an upside-down mouse, with a ball embedded in a case or the keyboard.

transparent Invisible to the user.

TWAIN A cross-platform interface developed as a standard for acquiring images from scanners and digital cameras and the computer software.

unsharp mask A sharpening technique achieved by combining a slightly blurred negative version of an image with its original positive.

upgrade *Either* a new version of a program *or* an enhancement of hardware by addition.

USB Universal Serial Bus A relatively recent interface standard developed to replace serial and parallel ports. It allows peripherals to be plugged and unplugged while the computer is still switched on, and permits data to be moved at high speeds.

vector graphic Computer image in which the stepping effect of bitmapping is removed to give smooth curves (See also objectoriented (program)).

video card A board installed in a computer to control or enhance a monitor display

virtual memory The use of free space on a hard drive to act as temporary (but slow to access) memory. Windows Operating system for PCs developed by Microsoft, using a graphic interface that imitated that of the Macintosh.

workstation A computer, monitor and its peripherals dedicated to a single use.

BIBLIOGRAPHY AND USEFUL ADDRESSES

BOOKS

Digital imaging and photography

Digital Photography Handbook Tim Daly, Argentum, London 2000 Electronic Imaging for Photographers

Adrian Davies, Phil Fennessy, Focal Press, Oxford 1994

Silver Pixels Tom Ang, Argentum, London 1999

The Digital Imaging A to Z Adrian Davies, *Focal Press*, Oxford 1998

The Digital Photography Handbook Simon Joinson, Metro Books, London 1998

WEB SITES

Note that Website addresses may often change, and sites appear and disappear with alarming regularity. Use a search engine to help find new arrivals or check addresses.

Photoshop sites (tutorials, information, galleries)

Absolute Cross Tutorials (including plug-ins) www.absolutecross.com/tutorials/photoshop.htm

Dsigning Tutorials www.dsigning.com/photoshop/tutorials/

Laurie McCanna's Photoshop Tips www.mccannas.com/pshop/photosh0.htm

Planet Photoshop (portal for all things Photoshop) www.planetphotoshop.com

Ultimate Photoshop www.ultimate-photoshop.com

Digital imaging and photography sites

Creativepro.com (e-magazine) www.creativepro.com Digital Photography www.digital-photography.org Digital Photography Review (digital cameras)

photo.askey.net

ShortCourses (digital photography: theory and practice) www.shortcourses.com

Everything Photographic www.ephotozine.com

Software

Photoshop, Photoshop Elements, Photodeluxe www.adobe.com
Photosuite www.mgisoft.com
Paintshop Pro www.jasc.com
Photo-Paint, CorelDRAW! www.corel.com
Picture Publisher www.micrografx.com
PhotoImpact, PhotoExpress www.ulead.com

USEFUL ADDRESSES

Adobe (Photoshop, Illustrator) www.adobe.com Agfa www.agfa.com Alien Skin (Photoshop Plug-ins) www.alienskinsoftware.com Apple Computer www.apple.com Association of Photographers (UK) www.aophoto.co.uk British Journal of Photography www.bjphoto.co.uk Corel (Photo-Paint, Draw, Linux) www.corel.com Digital camera information www.photo.askey.net Epson www.epson.co.uk www.epson.com Extensis www.extensis.com Formac www.formac.com Fractal www.fractal.com Fujifilm www.fujifilm.com Hasselblad www.hasselblad.se Hewlett-Packard www.hp.com Iomega www.iomega.com

Kingston (memory) www.kingston.com Kodak www.kodak.com Lexmark www.lexmark.co.uk Linotype www.linocolor.com LaCie www.lacie.com Luminos (paper and processes) www.luminos.com Macromedia (Director) www.macromedia.com Minolta www.minolta.com www.minoltausa.com Microsoft www.microsoft.com Nikon www.nikon.com Nixvue www.nixvue.com Olympus www.olympus.co.uk www.olympusamerica.com Paintshop Pro www.jasc.com Pantone www.pantone.com Philips www.philips.com Photographic information site www.ephotozine.com Photoshop tutorial sites www.planetphotoshop.com www.ultimate-photoshop.com Polaroid www.polaroid.com Qimage Pro www.ddisoftware.com/qimage/ Ricoh www.ricoh-europe.com Samsung www.samsung.com Sanyo www.sanyo.co.jp Shutterfly (Digital Prints via the web) www.shutterfly.com Sony www.sony.com Sun Microsystems www.sun.com Symantec www.symantec.com Umax www.umax.com Wacom (graphics tablets) www.wacom.com

INDEX

A

accessories 34-5 action images 198-201 Adobe Photoshop, domination of 42-3, 88-9 Alien Skin 124-5 algorithms 118 Andromeda Series 1-4 124-5 animals 176-7 anti-aliasing 95 apertures 18 Apple Macintosh (Mac) 38-9 architecture 164-75 archiving 62-3 artifacts 15, 23, 67 Artist in Residence 196-7 artistic filters 118-19 artworks 212-13 atmosphere 144 authoring 82-3 Authoring Studio 116 automatic selection tools 100-101

B

back-ups 62-3 backgrounds 102-3, 142-3, 188-9 batteries 34 birds 178-81 bit depth 15, 52, 110 bitmaps 88 black point 59-9 black point balance 106 black-and-white 110-11 blending 124, 170-71, 180, 200-201 bluescreens 208-9 blurring 102, 120-21, 138, 150, 181, 194 BMP files 66 brightness of screen display 78

browsers 42–3 brush tools 112, 136 Bryce 154. 207

C

calibration, screens 39, 48-9 cameras entry level 28-9 midrange 30-31 SLRs 32-3 Canon G1 30 casual portraits 132-3 cataloging images 64-5 CCD see charge-coupled device CD storage 60-3 CD-ROM authoring 82-3 CGI see computer-generated imaging channels 104-5 charge-coupled device (CCD) 12 - 13circles of confusion 17 cityscapes 170-71 cloning 112-13, 136, 142-3, 158 close-ups 182-3 CMOS see complementary metal-oxide semiconductor CMYK color 68-9 color 12-13, 68-9 adding 139 adjustment 106-7 balance 26-7 channels 104-5 CMYK 68-9 correction 161 management 76-7 range 101 RGB 68-9 screens 46-7 temperature 148 underwater 179 compact cameras 28-31

complementary metal-oxide semiconductor (CMOS) 13 composite views 170-71 compositing 114-15, 142-3, 154, 180-81 composition 186-7, 196-7 compression 23, 66-7, 166 computer operated shots 44-5 computer-generated imaging (CGI) 92-3, 155, 214-15 computers 36-9 concept shots 206 connections, computer 42-3 copy-and-paste 112-13, 168-9, 210-11 copyright 85 Corel Photo-Paint 89 corrections, in-camera 26-7 cosmetic enhancement 138-9 creative images 205 curves 108, 188

D

DAT storage 63 databases 65 defining colors 76 Deneba Canvas 89 depth of field 19, 150–51, 183, 194 details 14 displacement maps 123, 215 distortion 122–3, 140–41, 211 double scanning 58 drop-shadows 192 drum scanners 54 dye-sub printers 72 dynamic range 15, 59

E

edge control 102–3 editing in-camera 25 effects filters 124–5 entry level cameras 28–9 EPS files 67 erasing 158 exposures 18–19 extending skies 153 Extensis 55 Eye Candy 124-5

F

f-stops 18-19 faces 143 fading 115, 212-13 file formats 66-7 file storage 22-3, 60-3 film 52 recorders 75 scanners 54 filters 34, 118-25, 152, 158-61 Flaming Pear 124-5 flare 124, 175 flash 21, 44-5, 131, 183 flatbed scanners 55 flesh tones 135 focal length 16, 33, 129, 162, 194-5 focus, altering 194-5 foreground obstructions 178 frames 78-9

G

Gamma, calibration 48 generalized themes 206 ghosting 115 GIF files 67 GIMP 89 gradient filters 152 graphics tablets 50–51 grayscale mode 110

Η

halftoning 69 hard drives 60–61 health tips 37 highlights 156 histograms 26, 108 horizons 154

Ι

icons, toolboxes 94–5 illustrations 212–13 image management 64–5 imaginative images 205 immersive imaging 116 in-camera corrections 26–7 ink-jet printers 70–71 inks 71 input devices 50–51 insects 183 intensity of light 156 interiors 174–5 interpolation 14–15, 97 Iris prints 74–5 isolating objects 188–9

J JPEG files 22–3, 66–7

K

Kai's Power Tools (KPT) 124-5, 207 keyboards 50 Kodak Photo CD 53

L

landscapes 93, 144–63, 214–15 laser printers 73 layers 104–5, 192, 205, 208–9 LCD screens 24–5, 47 MAY 2002 flare filters 124, 175 depth of field 150 focal length 129 interiors 174 landscapes 145 SLRs 32 types 16-17 wildlife photography 176, 178 levels 108 lifespan, ink-jet prints 70 light architecture 164 creating 156-7 dullness 149 landscapes 146-7 levels 131, 133 lightboxes 48 lighting changing 190-91 frontal 184 portraits 134-5 still life 186-7 tungsten 174 Liquify 141 Live Picture 195 locations, wildlife photography 177

M

macro shots 25 magnetic storage disks 60–62 marquees 98 masking 98–9 mattes 208–9 memory cards 23 memory size 40–41 metaphors 206 metering 20–21 midrange cameras 30–31 mirroring 143 modes, color 77, 106, 110 monitors see screens motion blur 200–201 mounting prints 80–81 mouse, the 50 movement 177, 198–201

N

navigation, CD-ROMs 82–3 Newton's rings 57 Nikon Capture 42 Nikon Coolpix 11, 30, 31 Nixvue digital album 79 Nodestar 116 noise 15, 121 non-photographic sources 205

0

observation 128–9 on-line storage 63

P

Paint Shop Pro 89 paint tools 94 painting through layers 157, 170-71 PanDC 116 panning 199 PanoramIX 116 panoramas 116-17, 162-3 PanoTools 117 paper, ink-jet prints 71 parallax views 168, 179 paths 98-9, 172-3, 188-9 PCD files 67 performance, computer 40-41 personal computers (PCs) 38-9 perspective 122, 166-7, 211 photo CDs 53 Photo Vista 116 photographic output 57 Photoshop see Adobe Photoshop physical features, cameras 30 PICT files 66

pinching 140 pixels 11, 12-13, 14 planned portraits 134-5 plants 182-3 point balance 58-9, 106 Polaroid PhotoMax 79 portraits 132-5 pre-scans 56 printers 70-73 printing 68-9, 74-5 prints 56-7, 68-9, 70-71, 74-5,80-81 programs 42-3, 45 3-D 92-3, 214 calibration 38-9, 49 drawing 90-91 framing 80 image management 64-5 image-editing 87-9 paint 90-91 Photoshop 42-3, 88-9 plug-in filters 124-5 QuickTime 78 stitching 116 video drivers 38-9, 49 projectors 78-9 PSD files 67 PTPicker 117 PTStitcher 117 Q Quick Time VR 116

Pictography 74

R

rasterization 90 RAW files 67 red-eye 133 reflections 193 reflective materials 190–91 removing objects 168–9 rendering 92 replacing skies 154–5, 160, 161 reportage 128–9 resolution 11, 12–13, 14 cameras 29, 30 scanners 52–3 screens 46 restoration 172–3 retouching 136–7 RGB color 68–9 rotation 172

S

saturation 178 scanners 52-9, 184-5 scanning backs 33 screens calibration 39, 48-9 camera 24-5 display 78-9 types 24-5, 46-9 sectional images 196-7 selections 98-103 sepia tone 110-11 shade 192-3 sharpening 27, 120, 151, 160, 202-3 shots, computer operated 44-5 shutter speeds 198 sizing images 96-7 skies 152-5 SLR cameras 32-3 soft focus 138 software see programs special effects photography 206 - 11speed, processing 40-41 spherization 122-3, 140, . 212-13 Spin Panorama 116 spontaneity 132 still life 186-7 Stitch Assist 116 stitching 116-17, 162-3, 200-201 storage, file 22-3, 60-63 stretching 166 symbols 206

T

techniques, traditional 127 textural filters 118–19 3-D images 92–3, 214–15 TIFF files 23, 66 tolerance 100 toolboxes 94–5 transparencies 55, 75 transparency 115 travel notebooks 144–5 tripods 34 truthfulness 127

U

Ultimate Paint 89 underwater colors 179 unsharp mask 120, 202–3 upsizing images 97 USM sharpening 53

V

vector graphics 90–91, 189 vegetation 214 video cards 41 video drivers 38–9 viewpoints 164 visualization 24

W

Wacom tablet 51 watermarks 85 weather 146–7 web output 56 Websites 84–5 white point 58–9 wildlife 176–81 work photography 130–31 workstations 36–7

Xaos Tools 196-7

X

Acknowledgements

The publishers would like to thank Nikon UK Ltd for the loan of a camera and the following for their help in supplying software: Deneba, Extensis Europe, and Paragate Systems.